The Exposition of Artistic Research Publishing Art in Academia

The Exposition of Artistic Research Publishing Art in Academia

Edited by Michael Schwab
& Henk Borgdorff

Leiden University Press

The publication of this book is made possible by a grant from the University of Arts The Hague.

Cover design and lay-out: Mulder van Meurs, Amsterdam

ISBN 978 90 8728 164 9
e-ISBN 978 94 0060 092 8
NUR 640

Contents

Introduction

By Michael Schwab & Henk Borgdorff

Over the last two decades, the relationship between art and academia – under the heading of 'artistic research' – has been widely discussed. The border between these two domains, constantly renegotiated and transgressed, remains unstable and contested. Although art now contributes to academic knowledge, and academia in turn offers forms of knowledge that may be interwoven with or based on art practices, their relationship is far from settled.[1] Because of the need for a constant renegotiation, one might say that 'artistic research is an activity for border-crossers' (Dombois et al. 2012: 11), who, while violating boundaries, create new relationships and knowledges. Lacking established languages and disciplinary frameworks for the multiplicity of possible crossings, it seems that each and every artistic proposition needs to have the capacity to 'expose' itself as research in order to create a link to academia. The contributions in this volume address, from different perspectives, the consequences of this relationship between art and academia for the publishing of art as research, as well as looking at how artists have been engaging with publishing in order to make epistemic claims.

As a new term with a comparatively short history, 'artistic research' may signal a shift in the practice of art. However, it is one that many commentators do not perceive or value.[2] Indeed, before art academies reinvented themselves as research institutes and, as a consequence, began to advertise and fund artistic practice as research, the notion did not have much currency either in the art world or the world at large. It may thus be speculated that 'artistic research', rather than defining practice, simply announces the arrival of the art academy into academia. This is seen by some (Cf. Sheik 2006; Busch 2011) as the integration of art into the 'knowledge economy', threatening the autonomy of both art and the academy. In Europe, for example, discussions around 'artistic research' coincided with the development of what is known as the 'Bologna Process', which attempts to implement a particular educational model that is striated into bachelor, master and doctoral programmes within the European

1. Cf. Borgdorff (2012, pp. 56-73) for a discussion of the uneasy relationship between artistic research and academia.

2. For example, Elkins (2009, p. 148) suggests that 'artistic research' may be detrimental to artistic practice.

Higher Education Area (EHEA). Using a notion such as 'artistic research' may thus express compliance with a contested development.

There is, however, another way of looking at it. If we were to accept that historically art has always been an epistemic activity that has never required a notion such as 'artistic research' nor institutes of higher education for its existence, we might accept that art is already part of 'knowledge society'.[3] If this is the case, the focus should be placed not on establishing the epistemic qualities of art, but on the way in which those qualities can be made known, in particular in the context of academia, where other epistemic practices, most importantly the sciences, have a longer history. The danger is that as the art academy enters academia, art may be subjected to epistemic regimes that are not suitable to, and thus might compromise, the kinds of practices and knowledges in which artists engage.

In the short history of artistic research in academia, a fixed framework has in most cases been enforced, requiring an artistic as well as a written component that together form a proposition. To take one example in the UK, the Arts and Humanities Research Council (AHRC) 'expect[s] … practice to be accompanied by some form of documentation of the research process, as well as some form of textual analysis or explanation to support its position and to demonstrate critical reflection', stating that without such support artists 'would be ineligible for funding from the Council' (AHRC 2009: 59). How are we to understand statements such as this?

If one of the two components – artistic or written – were missing, research could still be proposed, but it would either be outside of academia (as 'art') or it would be research of a different, non-artistic type. Implicit in this arrangement of two components is academia's fear of having to assess work without the props that would help evaluate its epistemic relevance or provide a language to discuss and defend what such relevance may be. In this case, art would need to be judged in the way it is weighed up in art competitions, where the view of the jury is final, disagreement is pointless, and the jury refuses to discuss and defend its decisions. In an academic context, not to have the right to understand or contest a judgement contradicts all ideals of impartiality and fairness. Thus in academia, beyond the simple presentation of art, discourse needs to be entered into.[4]

3. 'Knowledge society' is a much wider term than 'knowledge economy'. Following the 2005 UNESCO World Report 'Towards Knowledge Societies', there are different types of knowledges, only some of which are deemed useful for the 'knowledge economy'. The term 'knowledge economy' describes 'a particular knowledge-driven stage of capitalist development' (UNESCO 2005, p. 46), which fuels a 'knowledge divide' both in terms of skills and access and also in terms of the value placed on different types of knowledges (UNESCO 2005, p. 22).

4. Traditionally, art criticism has provided discursivity in art. A possible role of art criticism for artistic research requires further investigation.

However, the double construct of art and writing that in most cases justifies art's entry into academia does not simply require discursivity, since an argument could be made that all art counts as discourse. This explains the use of words such as 'explanation', 'support' and 'demonstration' in the above-quoted example from the AHRC: all these terms suggest that one must defend one's artistic proposition as research.[5] It is thus not a question of ontology – is art research? – but a question of epistemology – how do we know that a certain practice is research?

Here, we are faced with a problem, since if art does not already offer its own demonstration or explanation 'to support its position and to demonstrate critical reflection' – in short, its own discourse that confers its meaning – then anything that is said in relation to it through this supplementary piece of writing might be without ground. However, this fundamental epistemological problem, which we believe handicaps artistic researchers, who are asked to deliver artistic claims through academic writing without reliable epistemologies that connect such writing with their art, seems not to affect the current pragmatics of academia.

In some countries and regions – usually where artistic research is already incorporated into the research infrastructure – people no longer seem to see the need to convince academia of the validity of practice-based research in the arts or to engage the art world in the relevance of research; in many others, however, the feeling of unease and tension is still manifest. In Germany, for example, the German Research Foundation (DFG) was called upon to support arts-based research.[6] However, to date it is reluctant to do so, since it cannot provide a fit with the conventional criteria for the conduct of academic research. Other funding agencies in Germany, such as the Ernst Schering Foundation and the Volkswagen Foundation, are more open to experimentation with the boundaries of academia and are seriously considering funding projects where art and writing are intertwined. The Berlin University of the Arts does not acknowledge advanced art practice as research at the doctoral level,[7] while in some other German higher education institutes (e.g. in Hamburg and Weimar), doctoral programmes in the creative and performing arts have been established. In Sweden, a new artistic doctorate was introduced in 2010 that foregrounds the artistic component of the research proposition. However, it is unclear to many how that component relates to or coheres with the written component, the documentation.[8] In Austria, a new funding scheme,

5. Schwab (2008) compares this construct to the possible defence of art as described in Book X of Plato's Republic.

6. See http://www.hkw.de/media/en/texte/pdf/2012_1/programm_5/thesenpapier_kuenstlerische_forschung.pdf (accessed 29-11-2012).

7. http://gs.udk-berlin.de/ (accessed 29-11-2012).

8. http://www.konstnarligaforskarskolan.se (accessed 29-11-2012).

the Programme for Art-based Research (PEEK), was introduced.[9] Although it is furnished by the Austrian Science Fund (FWF), by avoiding the German term *Forschung* (research) in its programme description, it displays scepticism towards its academic validity. And in the Netherlands – where so far no third cycle in higher arts education exists – arts-based projects in higher education are only eligible for funding when they address societal needs and contribute to social welfare and economic growth. This instrumental view of research in the arts, under the label of 'validation', does not leave much room for a more nuanced understanding of the relationship between art and academia. Meanwhile, research on art and design practice-based PhDs (Hockey 2007) has shown that the tension between art and writing is one of the central problems experienced by both students and their supervisors in the degree programmes. This unease is persistent even where degree programmes have been in place for more than fifteen years, as in the UK, Australia or Scandinavia. This points to a more fundamental problem.

A fresh approach

This book attempts to question the still-dominant distribution of research between art ('practice') and writing ('theory') and to lay new foundations for a more considered approach. In order to explain its context, it is important to stress the international and networked activities around the *Journal for Artistic Research* (*JAR*), the Society for Artistic Research (SAR) and the Artistic Research Catalogue (ARC) project.[10] These connected initiatives neither operate within a singular national framework, nor are they bound to the limits of academic institutions. This allows for a wider perspective on academia and a degree of flexibility that would otherwise not be possible, in particular since they engage in a pragmatic, bottom-up approach that aims to demonstrate new possibilities for the academic publication of artistic research. However, rather than reiterating *JAR*'s position, which is discussed both in its editorials[11] and in Schwab (2012a; 2012b), in this book we wish to trace responses and possible connections in the wider field.

Due to this flexibility, it has become possible to suspend assumed or existing definitions of 'art' and 'writing' and instead engage in what may be called an experiment set up to create new orientations for artistic research practice. In this experiment, the overriding concern lies with the types of practices and knowledges (and their interrelationships) that may emerge as publications of artistic research before a particular purpose is inscribed that may narrow outcomes. More specifically, the experiment to which we refer raises the distinct

9. http://www.fwf.ac.at/en/projects/peek.html (accessed 29-11-2012).

10. Borgdorff (2012, chap. 11) describes the genesis of these initiatives.

11. http://www.jar-online.net/ (accessed 07-10-2013).

possibility that if space is to be provided for fundamentally artistic processes in academia, then academia may need to be critiqued and transformed. This is also the reason why this book is firmly rooted in artistic concerns, while further publications will need to address in more detail possible consequences for academia.

Art is not the only field that calls for change from academia. What has been summarised as 'mode 2 knowledge production' (Gibbons et al. 1994; Nowotny et al. 2001) can be seen as a corrective to the standard model of scientific research that has dominated all research policies in the twentieth century. In contrast to 'mode 1 science', 'mode 2 knowledge production' takes place in the 'context of application'. It is interdisciplinary or transdisciplinary, involving both academics and other parties. Its research is localised in heterogeneous, diversified, often transitory configurations made up of universities, governmental agencies, third-party organisations and other actors that assemble around a particular set of issues. And – importantly in the context of this volume – the research is assessed by an extended peer group in which the voices of those who do not traditionally belong to academia are incorporated. On a theoretical level, this transformation of academia parallels a broader understanding of 'research' that allows for non-discursive knowledge forms, unconventional research methods and enhanced means of documentation and presentation, as witnessed by developments in areas such as visual anthropology and cultural studies that are increasingly acknowledged by national and international research councils and funding agencies.[12]

In this general transformation of academia, art may be the most extreme case to date, and perhaps offers the most radical challenge due to its association with 'autonomy' (going back to Kant) or 'negativity' (Adorno). Although Romantic definitions of art that stem from the nineteenth century have been withering, art remains connected with notions of 'resistance', in particular regarding what has been called its 'academization' (Cf. Steyerl 2010; Busch 2011). Rather than suggesting that such positions are outdated and that the conflict between art and academia has either diminished or has disappeared into some form or 'third culture' (Snow 1998), it seems more appropriate to accept that they persist because they defend a set of values that is important to practitioners of art.

Without speculating on what exactly 'art' is, it may be sufficient for the purpose of this introduction to state two of these values that we believe underpin most of today's art education:

1. Art is self-determined and suffers when it is told what to do.
2. Art challenges existing forms of practice.

12. Recently, the European Research Council has acknowledged artistic research as eligible for funding. Cf. the statement of its president, Helga Nowotny, in Biggs and Karlsson (2011, p. xxii).

From these assumptions, a number of conclusions can be drawn, which appear in varying degrees in the literature on 'artistic research'. For example, despite talk of 'discipline formation', there seems to be continued doubt regarding the possibility of providing a definition of 'discipline' that could be used for the regulation of artistic research.[13] A notion such as 'transdisciplinarity' seems to offer a way out, since it proposes a relationship both to disciplinarity and to its transgression (Mittelstraß 2000; Borgdorff 2012: 235f.). Likewise, it remains questionable whether artistic research applies methods like other fields of study (Slager 2009; Boomgaard 2011), or whether its ability to break with accepted methodologies and to facilitate paradigm shifts is not one of its key powers (Feyerabend 1990). It seems that whatever we think art is, we have to allow for the possibility that something else, while still remaining art, will come along that breaks with all such understandings. In fact, it may be questionable whether our Western definition of art even allows us to accept something as art that does not surprise us by extending the possibilities of what art might be.[14]

The lack of disciplinary frameworks puts some strain on key academic processes, such as peer review, which in their criteria make reference, for example, to existing disciplines, fields of study and methods. If, as suggested, art may transgress any criterion for its evaluation, since it transforms the ground on which the evaluation takes place, a practical solution needs to be found that allows for academic evaluation processes and peer-review without fixed points of reference. The fact that academic processes of evaluation are challenged does not, however, signal the fact that artistic research may not fit into broad definitions of research, as employed, for example, by the current Research Excellence Framework (REF) in the UK, which defines research as 'a process of investigation leading to new insights, effectively shared'.[15]

In order to explain those essential aspects of artistic research that cannot be governed by disciplinary or methodological frameworks, reference is often made to experiential, embodied or material dimensions (Cf. Carter 2004; Pakes 2004). Linked with these are notions of situatedness, transformation and difference that contradict a possible transparency, universality and objectivity of knowledge and which suggest a fundamental openness of art and meaning.

13. The question of 'discipline' is an ongoing concern. Most recently, for example, the dOCUMENTA(13) conference 'On Artistic Research' asked: 'What do we mean by "artistic research"? Is research a discipline in its own right?' http://d13.documenta. de/#programs/the-kassel-programs/congresses-lectures-seminars/on-artisticr2 (accessed 04-11-2013).

14. The same has been said about 'knowledge': 'You won't, for example, tell us, nor could you possibly tell us, what the criteria are by which we know which uses of "know" in the future will be legitimate' (Putnam 1995, p. 32).

15. http://www.ref.ac.uk/pubs/2011-02/ (accessed 07-10-2013).

However, in a more radical understanding, this openness may need to include the questioning of any fixture, whether it is 'art', 'the body' or 'material' that is meant to provide an origin to knowledge, since those fixtures may be the outcomes of particular epistemic regimes that have inscribed them *as origin*. A perspective onto artistic research through deconstructive approaches (Schwab 2009; Öberg 2010) supports the idea that attention needs to be paid to how knowledge is constructed and proposed, which in turn requires one to question whether the 'written component' in fact represents the sole site of writing.

The distribution of research between art and writing might also be considered from the perspective of Science and Technology Studies, which acknowledge that between the world and our understanding of it transformations take place that constitute both world and understanding. This dynamic condition of research tells us that in our understanding of the world, understanding is already presupposed and at work, and that in our understanding of understanding, world is already presupposed and at work. Latour's notion of 'constructivist realism' (Latour 1999: 135) captures this interdependence of world and understanding, which – transposed to art and writing – underscores the idea that in all art practice a form of writing is at work.

The exposition of practice as research

With the notion of 'exposition', we wish to suggest an operator *between* art and writing. Although 'exposition' seems to comply with traditional metaphors of vision and illumination, it should not be taken to suggest the external exposure of practice to the light of rationality; rather, it is meant as the re-doubling of practice in order to artistically move from artistic ideas to epistemic claims. As suggested elsewhere (Schwab 2012b), depending on the practice in which one is actually engaged, constructs such as 'to perform practice as research', 'to stage practice as research', 'to curate practice as research', etc., are all equally suitable. Through such re-doubling, artistic practice is able to install a reflective distance within itself that allows it to be simultaneously the subject and the object of an enquiry. In this way, practice can deliver in one proposition both a thought and its appraisal.

As is illustrated by the many examples – past and present – that are mentioned in this book, artistic practice is already very much engaged in such reflective structures, and a notion such as 'artistic research' is not necessary to trace its operation. At the same time, an investigation into the various modes that can deliver varying degrees of reflexivity and the development of an awareness of those modes seems important. Moreover, the distinct possibility exists that reflexivity may be engaged along other, potentially non-epistemic dimensions, such as ethics or aesthetics, which in addition complicates the appreciation of any one example. In fact, it might be fair to say that pure forms of artistic research may not exist. However this may be, it is clear to us that much more

work needs to be done to better understand what it means to expose practice as research; this book may offer a few hints into possible avenues for investigation.

As discussed above, existing institutional frameworks for artistic research fundamentally operate according to the same principle, since art is also put forward and appraised. Here, however, a second practice – that of academic writing – is required, which artists are usually unable to negotiate as part of their practice, since it is determined by academic standards that are difficult to challenge in any one publication. If, as part of the suggested re-doubling, what is expected of writing is actually carried out as a component of practice, the need for additional academic texts may vanish, or, more provocatively put, we may open our eyes to modes of 'academic writing' that produce hybrid texts, or even no texts at all. Debates around the publication of artistic research may thus contribute to the wider developments in the field of enhanced publication, where, likewise, non-textual and often interactive elements are used to facilitate particular types of communication.

In order to support a workable model for 'the exposition of practice as research', two arguments need to be won. The first is to prove that writing (or 'theory') can be exercised in artistic practice that may not produce text. Assuming a positive answer to this, as a second step it needs to be argued that this writing can actually be conceived of as academic so as to facilitate exchange with other research cultures in academia. While the first part requires attention to artistic practice and reference to art theory, the second part requires a critique of academic standards of writing and a demonstration that more complex models can practically be managed in editorial processes and peer-review. Needless to say, with this book, we can only offer potential inroads into this wide and complex field.

Regarding the first argument, it is possible to trace how notions of 'exposition' have emerged from debates around artistic research. Although earlier publications such as Graeme Sullivan's *Art Practice as Research: Inquiry in the Visual Arts* (2005) carry the construct 'as research' in their titles, it is in particular *Thinking Through Art: Reflections on Art as Research* (2006) by Katy Macleod and Lin Holdridge that makes its relevance clear. Two aspects in the book's introduction deserve particular attention. The first is the 'as', or rather the 'counting as', that the authors take from a catalogue essay by Stephen Melville (2001). In it, Melville makes the point that a painting is not simply a painting, but rather, a work that counts as painting, and that, moreover, the counting may be done by the work itself insofar as 'matter thinks' (Melville 2001: 6).[16] The second aspect is the suggestion made by Macleod and Holdridge that such thinking matter may be related to the writing practice of 'artist scholars', and that 'we need to bring our writing nearer to our making' (Macleod and Holdridge 2006: 12).

However, while both Melville and Macleod and Holdridge suggest thought in art, they fall short of calling it writing. Melville contrasts the works

on show with the texts in the catalogue, which 'explore in the most general terms the conceptual apparatus we take to be entailed by the work itself' (Melville 2001: 2), thus seeming to define the works on show as art rather than writing. Likewise, Macleod and Holdridge suggest that we take inspiration from the *writing* of artist scholars in order to 'build an appropriate vigorous research culture' (Macleod and Holdridge 2006: 12) without questioning whether making and writing may actually be one and the same activity to those artist scholars when they produce academic texts. However, if the distribution of research across predefined components (art and writing) is to be challenged, this is precisely what is at stake, so as not to contradict the first assumption made above – art is self-determined – and not to limit *artistic* ownership of the proposition as a whole.

Just as Melville sees a painting as a work that counts as painting, it must be possible for a work to count as research. As suggested above, 'counting as' is ingrained in material practice that, depending on how it counts, can be perceived as either painting or research (or any other form as which it counts). What a work is supposed to count as is as important in the overall artistic proposition as what the work is. When practice counts as research, however, a simple description of that practice as 'thinking' is not sufficient, since a number of specific activities are associated with 'research' and usually require a researcher to engage with academic writing, since otherwise the work may not count successfully as research. This can again be illustrated using Melville's example of painting: if a work does not engage with what we may expect from 'painting' it may be difficult for the work to count as such. In other words, artistic practice that strives to count as research needs to engage in notions of research and academic writing.

Although criteria for the identification of research differ in detail from discipline to discipline, there is a broad degree of agreement as to what should be understood by research. It often begins with questions or issues that are relevant in the research context (academic and/or societal), and it employs methods that are appropriate to the research and which ensure the validity and reliability of the research findings. From this generic description of what research is, the criteria for the assessment of research can be distilled. These pertain to the research questions, the methods, the contexts and the outcomes of the research. One may ask of every study to communicate what it is about,

16. Melville references a number of theories to make his point, including work by Claude Lévi-Strauss, Maurice Merleau-Ponty, Michael Fried, Martin Heidegger, Jean-Luc Nancy, Immanuel Kant and G.W.F. Hegel. We believe that the work of further thinkers, such as Walter Benjamin, Georges Didi-Huberman, Gilles Deleuze or Jacques Rancière is also pertinent to the debate, as is the research on experimental science by, for example, Hans-Jörg Rheinberger or Steven Shapin, where matter is equally conceived as 'active'.

why and for whom it is relevant, how it investigates the issue, and what the outcomes are.

Usually, this is done in the form of a text that adheres to standards of academic writing. In order to understand how art may be perceived as academic writing, one needs to look at the purpose of academic writing rather than particular conventions of language. Focusing on writing for art students, for example, Apps and Mamchur (2009: 271f.) suggest four fundamental writing skills (discovering a subject, sensing an audience, searching for specifics, creating a design) that may equally be found in artistic practice and that allow for the 'thesis to be a complete *work of art*' (Apps and Mamchur 2009: 272). Needless to say, such statements are the result of a long-standing and ongoing transformation of the art academy that, according to Holert (2009), provides the historical trajectory for current debates on artistic research and that allowed for 'talk' to enter the studio.

If we look more specifically at academic writing, its key characteristics may be: complexity, formality, precision, objectivity, explicitness, accuracy, hedging and responsibility (Gillett 2010). But in one way or another those expectations of academia may equally be traced in art that exposes itself as research in practical terms. It needs to be said, however, that most of those characteristics are highly problematic and that the critical discourse in and around art is so advanced as to require a rethinking of the types of values that academia might expect. Most prominently, ideas of 'objectivity' have all but vanished and have been replaced by the creation of sometimes temporary communities and a striving for transpersonality. The same is true of the other points on the list: it is not that art does not wrestle with the values that those characteristics represent; it is just that simplified expectations – for example, when a study is assessed in terms of 'academic writing' – are not possible for artistic reasons.

One can see in the dominant two-component model of art and writing a first, primitive approximation of artistic research where thinking is spread across the two components while art and writing are not. Pragmatically, this has the advantage of leaving art largely undefined, while the written component delivers an academically credible case for this art to count as research. The conceptual disadvantage, however, is that practice can potentially remain unchallenged by what we may mean by 'research' as long as the written component can operate as a supplement that compensates for this. It is important to keep in mind, though, that all possible distributions of research across art and writing are perfectly acceptable; the point to be made here is only that some of those are less artistically owned than others and that academic frameworks may distort practice if they do not allow for a self-determined negotiation of writing. Moreover, it should also be said that the writing of academic texts may, in fact, be one element of an artistic practice. Artwork and text are non-correlated variables that can both be used for the exposition of practice as research.

This volume is organised in four sections: *Considering, Publishing, Practising* and *Placing*. Each section is introduced by a short editorial statement and comprises four chapters. In the first section, *Considering*, we aim to open the horizon to questions of exposition and ask what 'exposition' may mean to the different authors. The second section, *Publishing*, introduces the concrete backdrop of academic publishing and, in particular, the work carried out in the context of the Artistic Research Catalogue (ARC) project. Section three, *Practising*, adds more specific artistic approaches that show how 'exposition' may be approached in practice. The last section, *Placing*, looks at how, as a consequence, spaces for a public may be conceived.

We would like to acknowledge the contribution that Daniela Büchler, one of the authors of this book, has made to the field of artistic research. She sadly passed away before we could go to print.

References

AHRC, 2009. Research Funding Guide. Available at: http://www.ahrc.ac.uk/FundingOpportunities/Documents/Research%20Funding%20Guide.pdf [Accessed 2 July 2009].

Apps, L. and Mamchur, C., 2009. 'Artful Language: Academic Writing for the Art Student.' *The International Journal of Art & Design Education* 28(3), 269-78.

Biggs, M. and Karlsson, H. eds., 2011. *The Routledge Companion to Research in the Arts*. London: Routledge.

Boomgaard, J., 2011. 'The Chimera of Method.' In: J. Wesseling, ed. *See it Again, Say it Again. The Artist as Researcher*. Amsterdam: Valiz, 57-71.

Borgdorff, H., 2012. *The Conflict of the Faculties. Perspectives on Artistic Research and Academia*. Leiden: Leiden University Press.

Busch, K., 2011. 'Generating Knowledge in the Arts – A Philosophical Daydream.' *Texte zur Kunst* (82), 70-9.

Carter, P., 2004. *Material Thinking: The Theory and Practice of Creative Research*. Melbourne, Victoria: Melbourne University Press.

Dombois, F. et al., eds., 2012. *Intellectual Birdhouse: Artistic Practice as Research*. London: Koenig Books.

Elkins, J. ed., 2009. *Artists with PhDs: On the New Doctoral Degree in Studio Art*. Washington, D.C.: New Academia Publishing, LLC.

Feyerabend, P., 1990. *Against Method*. London/New York: Verso.

Gibbons, M. et al., 1994. *The New Production of Knowledge: The Dynamics of Science and Research in Contemporary Societies*. London, Thousand Oaks, New Delhi: Sage.

Gillett, A., 2010. 'Features of Academic Writing.' Available at: http://www.uefap.com/writing/feature/featfram.htm [Accessed 3 October 2010].

Hockey, J., 2007. 'United Kingdom art and design practice-based PhDs: evidence from students and their supervisors.' *Studies in Art Education* 48(2), 155-71.

Holert, T., 2009. 'Art in the Knowledge-based Polis.' *e-flux journal* 3. Available at: http://www.e-flux.com/journal/view/40 [Accessed 4 February 2009].

Latour, B., 1999. *Pandora's Hope: An Essay on the Reality of Science Studies*. Cambridge, Massachusetts, and London: Harvard University Press.

Macleod, K. and Holdridge, L. eds., 2006. *Thinking Through Art: Reflections on Art as Research*. London and New York: Routledge.

Melville, S., 2001. 'Counting / As / Painting.' In: *As Painting: Divison and Displacement*. Columbus: Wexner Center for the Arts MIT Press, 1-26.

Mittelstraß, J., 2000. 'Transdisciplinarity – New Structures in Science.' In: *Innovative Structures in Basic Research*. Ringberg Castle. Available at: http://xserve02.mpiwg-berlin.mpg.de/ringberg/Talks/mittels%20-%20CHECKOUT/Mittelstrass.html [Accessed 18 April 2011].

Nowotny, H., Scott, P. and Gibbons, M., 2001. *Rethinking Science: Knowledge and the Public*. Cambridge: Polity Press.

Öberg, J., 2010. 'Difference or Différence?' In: C. Caduff, F. Siegenthaler, and T. Wälchli, eds. *Art and Artistic Research: Music, Visual Art, Design, Literature, Dance*. Zurich Yearbook of the Arts. Zurich: Zurich University of the Arts/Scheidegger & Spiess, 40-45.

Pakes, A., 2004. 'Art as action or art as object? The embodiment of knowledge in practice as research.' Available at: http://www.herts.ac.uk/__data/assets/pdf_file/0015/12363/WPIAAD_vol3_pakes.pdf [Accessed 7 October 2013].

Putnam, H., 1995. *Pragmatism*. Oxford: Blackwell.

Schwab, M., 2008. 'First, the Second: Walter Benjamin's Theory of Reflection and the Question of Artistic Research.' *Journal of Visual Art Practice* 7(3), 213-223.

Schwab, M., 2009. 'The Power of Deconstruction in Artistic Research.' *Working Papers in Art & Design* 5. Available at: http://sitem.herts.ac.uk/artdes_research/papers/wpades/vol5/msfull.html [Accessed 25 November 2011].

Schwab, M., 2012a. 'Exposition Writing.' In: *Yearbook for Artistic Research & Development*. Stockholm: Swedish Research Council, 16-26.

Schwab, M., 2012b. 'The Research Catalogue: A Model for Dissertations and Theses in Art and Design.' In: R. Andrews et al., eds. *The Sage Handbook of Digital Dissertations and Theses*. London, Thousand Oaks, New Delhi: Sage.

Sheik, S., 2006. 'Spaces for Thinking.' Available at: http://www.textezurkunst.de/NR62/SIMON-SHEIKH_en_1.html.

Slager, H., 2009. 'Art and Method.' In: J. Elkins, ed. *Artists with PhD: On the new Doctoral Degree in Studio Art*. Washington: New Academia Publishing, LLC, 49-56.

Snow, C.P., 1998. *The Two Cultures*. Cambridge: Cambridge University Press.

Steyerl, H. ed., 2010. 'Aesthetics of Resistance? Artistic Research as Discipline and Conflict.' *MaHKUzine* 8, 31-37.

Sullivan, G., 2005. *Art Practice as Research: Inquiry in the Visual Arts*. London, Thousand Oaks, New Delhi: Sage.

UNESCO, 2005. *Towards Knowledge Societies*. Paris: Unesco Publishing. Available at: unesdoc.unesco.org/images/0014/001418/141843e.pdf [Accessed 9 November 2012].

Considering

In order to consider the publishing of art in academia, emphasis must be placed on the borders, limits or gaps between established identified territories, whether within or outside both art and academia. Thus, rather than looking at those in-between spaces from a secure position, we propose a thinking situated in a border space, so that an intellectual landscape may be constructed. However, while from a centre all borders look alike, at the margins they multiply, become specific and local, making an overview over those border spaces impossible. This, in turn, handicaps epistemological and even methodological responses to the question of art and research.

While there may be many more approaches that can explain such border-thinking, for this first section we selected four chapters, each one of which in its own way highlights contexts and languages through which expositions of artistic research may be reflected upon. As is the case throughout the book, our approach is strictly multiple. We refuse to single out any particular intellectual or artistic framework, but those presented here make space for modes of reflective redoubling and an exposition of artistic practice as research that is built from within rather than constructed using external scaffolds and conventions.

In *Notes on Media Sensitivity in Artistic Research*, Mika Elo uses the notion of 'touch' to describe how integrity may be maintained across the diverse faculties of intellect and intuition. To Elo, 'touch' implies 'tact' and with it, an ethical dimension. Only through tact, through what is touched, can we speak of meaningful contact between, say, an artwork and an audience. This suggests that if something lacks the tact that allows for touch (for example, through institutional regulations), the exposition of artistic practice as research may not go as deep as it could. Elo explains the quality of touch in reference to Walter Benjamin's notion of 'translation', which is not simply the passage of meaning from one context, language or medium to another, but a reflective relationship between those contexts, languages or media across which meaning is established. To highlight the role and importance of touch, Elo pits it against modes of research that engage in generalisation to make their claim. He suggests that artistic research through touch has the capacity to approach epistemically that which is specific to a phenomenon, and which may otherwise be missed, and to engage with the limits of knowledge.

Ruth Benschop, Peter Peters and Brita Lemmens approach the publish-

ing of artistic research from the perspective of Science and Technology Studies (STS). Following Bruno Latour, in their chapter *Artistic Researching: Expositions as Matters of Concern*, the authors discuss the fundamental operations of agency through which objects of knowledge (including works of art) may be characterised. While agencies may be different across science and art, the authors argue that at the heart of any discipline lies the ability to preserve the flow of meaning (and its translation) across diverse moments of action, including publishing. The authors suggest that in expositions, 'matters of concern' that engage with extended agency can emerge from those trajectories, allowing for the inclusion of more complex characteristics that may otherwise be seen as external to works of art.

In his chapter *Exposition*, Rolf Hughes focuses on the ways in which art itself might count as research. The chapter starts with the tension between writing and rhetoric, between critical and creative practice, and refers to the problem of communicating, even identifying, the experiential content of what artistic research aims to address. Surveying central difficulties with the documentation of art and with its exposition as research – contemplating, among other things, the nature of the author in reflective art practice – Hughes asks whether or not our focus should shift to the quality of the encounter and the conversation in artistic research.

Marcel Cobussen, in his chapter *Aesthetic Sensibility and Artistic Sonification*, bases his account of artistic research on a close reading of Immanuel Kant's third critique. Following Kant, he characterises artistic research as free play between imagination and understanding, which in order to remain 'free' needs to be defended against notions of translation or interpretation based on understanding rather than imagination. Having shifted that basis, Cobussen emphasises the need for aesthetic sensibility that allows knowledge and non-knowledge to come together in the aesthetic output of an artistic research project. Looking at a number of examples, he argues that attention needs to be paid to the gap between the gathering of information in a research project and the creation of aesthetic output, through which artistic researchers are destined to expand what is possible for scholars, thus enriching academia. More specifically in relation to the fields of music and sound art, he illustrates his argument by reinterpreting 'sonification' in the light of aesthetic sensibility.

As all the chapters in this first section suggest, there are good reasons to believe that art can engage with academia if the specific complex negotiations between artistic and academic standards are accepted as part and parcel of an artistic proposition, and not ignored or removed in an attempt to comply with more traditional notions of knowledge – notions that even in some corners of the sciences lose credibility. The following section focuses on what academic publishing might be if we accept that its form and function may need to shift to accommodate the negotiations that art brings to the table.

Notes on Media Sensitivity in Artistic Research

By Mika Elo

Art can be research in so far as it is exposed as such. The question of what might be at stake in such an exposition is not just a matter of research politics. As I will argue, the question concerns the very medium of research.

The inception of artistic research can be seen as a symptom of an extensive cultural shift that has led to a situation where the non-discursive conditions of knowledge production are gaining currency. This shift has been described from different points of view in terms of various turns, such as 'medial turn' (Münker 2009: 12-13). In terms of 'medial turn' we can observe a shift in the main focus of cultural theories away from the symbolic structure of languages and 'symbolic forms' towards an examination of their material-sensory structure (ibid.). Using Marshall McLuhan's famous dictum, 'The medium is the message', we could say that the 'medial turn' implies the recognition of the medial embeddedness of all forms of communication as well as a certain destabilisation of hierarchical relations between different media or modes of signification. On the level of research institutions, this shift is manifested in a destabilisation of the structure and status of modern disciplines and faculties, among others those of art and aesthetics.[1] The cognitive model on which the division of academic labour depends is under transformation, and the search for a legitimate frame for artistic research is part of this process.

This cultural shift makes up something of a precondition for the discursive emplacement of artistic research. Artistic articulations that are not based on propositional statements can gain the status of research only in a situation where the instrumental supremacy and functionality of the most widely established medium of research – the verbal language – has become questionable. As regards exposing art as research, the term 'exposition' would thus not only concern the institutional frame; it would also name a particular mode of presentation, that is, presentation of artistic work as research.

How might one develop, assess and facilitate appropriate forms of such exposure? I will suggest that the debates concerning the question can be described as 'the touch of the faculties'[2] – in terms of colliding interests and critical confrontation as well as contamination and crossbreeding. Hereby, the

1. As Samuel Weber notes, the legitimacy of the disciplinary structure of the university system, with its claim on the critical autonomy of faculties is neo-Kantian in character (Weber 1996, p. 24).

term 'faculty' needs to be understood as referring both to institutional frames and subjective powers.

Legitimising Artistic Research

The criteria that could be used to legitimise the use of images, installations, bodily performance or other forms of non-verbal articulation instead of a propositional text in the presentation of arguments and research results are still in many cases ambiguous. The problem is double-edged: at times, theoretical elaboration truly suffers from the passage to non-verbal forms of articulation; at other times, however, it is the sensitivity to non-verbal elaborations that is failing. In order to develop the sensitivity that is necessary for estimating the research potential of the arts in an appropriate way, we need to reconsider the status of the non-intelligible aspects of experience, such as different modes of 'feeling', flatly termed as 'intuition', and see them as 'co-rational' rather than irrational elements of thinking.[3] This requires the reassessment of both artistic and scientific patterns of thinking. On the one hand, intuition needs to be recognised as something that necessarily belongs to an open rationality of experience and not only to its irrational depths. On the other hand, one has to avoid escaping into visionary speech in the name of the immediacy of intuition. In other words, it is only through sensitivity and tact on both sides that art and research practices can develop productive contact points. Here, discursive negotiations are unavoidable, since disciplined research is 'owned' by science and its discursive formations (Borgdorff 2010: 53). The reflections on the notion of exposition in this article aim at contributing to this process.

The way in which Bernhard Waldenfels describes the discursive tensions between the faculties of intellect and intuition is reminiscent of the current struggles for the legitimacy of artistic research:

> Irrationality that disguises itself as a higher or esoteric form of knowledge derives most often from a reaction against a restricted form of rationality that subtracts from experience everything that is abysmal and excessive. Rationalism and irrationalism enforce each other. A desiccated ground asks for artificial watering. In this sense irrationalism has a symptomatic meaning (Waldenfels 2010: 20).

The emergence of new research programmes at art universities has led to a situation where the differences between artistic and scientific thinking become visible mainly against the institutional frame. In a situation where the arts are

2. This is one of the research themes of the project in which I was recently involved. See figuresoftouch.com.

3. I adopt the term 'co-rational' from Bernhard Waldenfels (Waldenfels 2010, p. 18).

looking for legitimacy as research, that is, when the conditions in which *even art* can be research are being considered, the research potential of the arts tends to be explored and articulated in accordance with, or in contrast to, dominant scientific points of view. This situation calls forth the kind of cognitive *ressentiment* that Waldenfels captures in the metaphor 'artificial watering'. It is tempting to an artist-researcher to create new watering systems.

This symptomatic 'irrationalism', which tends to take the form of either esoteric formulations or (quasi-)intellectual hubris is, however, not the only way to respond to the struggle of faculties – nor is it a responsible one. More productive paths can be found in the margins, lacunae and fracture lines of experience that urge one to ponder details, nuances and intensities. Related to these, perhaps less spectacular and potentially uncanny aspects of experience, neither visionary nor programmatic thinking constitutes a sustainable approach. What is needed is sensitivity to fine shifts. Here, the most thought-provoking forms of intuition can perhaps most aptly be described as 'touch'.[4] The 'touch of the faculties' that, in my view, is behind the symptomatic struggles needs to be explicated. Hence, a short excursion to the sense of 'touch' seems appropriate.

Touch as Response

It is in regard to the sense of touch that the difficulty of relating rational reflection to non-intelligible aspects of experience in a non-hierarchical way finds its culmination point. This is because touching brings pathic, gnostic and practical aspects of sensing together in a peculiar way (Waldenfels 2010: 20-21).[5] In touch, knowledge, skill, affectivity and sensitivity meet. In fact, our sense of reality is often conceived in terms of touch. As regards the arts, Henk Borgdorff aptly observes that '[w]hen we listen to music, look at images or identify with body movements we are *brought into touch* with a reality that precedes any re-presentation in the space of the conceptual' (Borgdorff 2010: 60, my emphasis). But how should we understand 'touch' here?

In contrast to other senses, in touch, the sensing and the sensed coincide. When I see a stone, it is 'out there' and does not see me, but when I touch that stone, it is 'right here' and touches me. This sense of concreteness and immedi-

4. Waldenfels uses the term *Gespür*, which refers to a wide range of affections as well as to a sense of their significance in regard to a particular situation (Waldenfels 2010, p. 20).

5. The term 'gnostic' derives from the Greek word *gnostikos* (literally: 'that which is related to knowledge'). The term 'pathic', in turn, derives from the Greek word *pathos* that refers to sensibility, affectedness and suffering. Inherent to the term, although normally ignored, is the concrete sense of being exposed to something excessive and unexpected that can even leave painful marks, such as wounds. Experience in general is marked with such pathic 'fracture lines' (Waldenfels 2002, passim).

acy lends the sense of touch a certain credibility. A seen stone can be made of plastic even if it looks just like a stone, but when I touch it I can feel the material. It is due to this fullness of touching that the tactile metaphor of 'grasping' can stand for 'fully understanding something'. On the other hand, the sense of touch has been considered too diffuse to offer a proper model for knowledge. I can only touch things that are nearby, and not too many at a time, whereas sight offers me a wider range and a better overview of complex relations. This is why visual metaphors and structures dominate Western conceptions of knowledge. There is a clear hierarchy between vision and touch in our tradition. Building up general knowledge presupposes the coordination of different points of view, and accordingly, a 'view from a distance', that is, theory. On this general level of visually constituted knowability, touching can only confirm what has already been ordered by vision. On its own, touching is always particular: instead of categorising, it singles out. Its 'knowledge' is of a different kind.

The matter is further complicated because touch exceeds the tactile world – as the phrase 'touch of the faculties' at the outset of this excursion already indicated. The scope of touching covers mental, social and spiritual as well as corporeal processes. Because of this heterogeneity, its status as a domain of sense experience remains ambiguous. If vision has more gnostic qualities, the sense of touch is a pathic sense. It is a sense of being in the world, of being exposed: to touch is always also to be touched. Although touching is contact with the touched, something inaccessible and withdrawing, even untouchable, remains inherent to the touched; and it is exactly this foreign element that makes it 'touching'. Given that the contact in question can be social, mental or spiritual as well as physical, an artwork can, in this sense, also be touching. It can touch us by retaining something beyond our grasp. In other words, touching is overdetermined by otherness, and it turns out to manifest traits of a 'foreign sense', with respective ethical significance (Waldenfels 2002: 64). There is a demand for tact inherent to contact that links the pathic moment of touching to ethical questions. Tact signifies answering to and for singular otherness. This elemental asymmetry tends to be ruled out when touching is studied in terms of immediacy and symmetry, which is the case in 'haptocentric' conceptions of the sense of touch as the guarantor of sensory certainty (Elo 2012). With regard to the pathic character of touching, tact, rather than tactility, turns out to be the common denominator of the different aspects of touching. The sense of touch implies a sense of tact.

Tact tells us what is peculiar to the sense of touch on sensuous, mental and social levels; touch does not abolish the difference between touching and the touched, but exposes it. The contact deepens due to tactfulness in touching that implies sensitivity to the untouchable in the other. Of course, there is always also the possibility of hurting, clinging and fear of contact. Besides this, there is a tendency towards fusion inherent to contact, with a resulting confusion in questions of responsibility and otherness.

For art research – including the whole scope of differentiations between research about/through/for/as art and art about/through/for/as research (Dombois 2009) – the question of tact constitutes a multifaceted research challenge with aesthetic, ethical and methodological aspects. The link between pathics and ethics that I have schematically pinpointed offers possibilities for foregrounding various openings towards an enhanced situational sensitiveness and sense of concreteness in art research. In Waldenfels's terms, touch as a 'foreign sense' invites us to develop ways of conceiving of non-intelligible aspects of experience as 'co-rational' rather than as irrational elements of thinking.

I have proceeded to the point where it starts to become clear that the relation between art and research is a delicate matter and that the touch of the faculties is a matter of tact. What, then, would be a 'tactful' or appropriate way of exposing art as research? What kind of challenges is the publication of artistic research facing?

In German there is an apt word for appropriateness: *sachgemäss*, which means literally 'according to the matter'. Using the terms I have just introduced, one could say that it is a question of developing an appropriate 'feel' or 'touch' for the presentation of artistic work as research. What *matters* in the artistic work, however, is something that has a tensional relation to presentation, which means that the presentation itself becomes part of the matter according to which the work proceeds. As concerns artistic work, the appropriate presentation form is anything but pre-given.

This kind of presentation involves exposure, a gesture of unsecuring. In so far as the exposure takes place in regard to research – that is, in regard to an activity that aims at knowledge – we can say that, in the last instance, exposition is about exposing artistic work to knowledge. Here, the crucial question is: what qualifies as knowledge in this context? And, even more importantly: how do we conceive of the relation between artistic work and striving for knowledge?

In order to indicate what I think is at stake in exposing artistic work as research, I will bring into discussion two theoretical concerns vis-à-vis the question of knowledge in the arts. In this way, I attempt to indicate two openings towards an enhanced situational sensitiveness and sense of concreteness in art research from the artist-researcher's point of view. The first has to do with *translation* and the second with *tactics*. I will also indicate why it is productive, speaking of artistic research, to think of both of them in terms of touch. This, I hope, will further clarify why I needed to make the excursion into the meandering topic of the sense of touch.

Translation

Normally when we think of translation, we have in mind some kind of facilitation of communication across the borders of different languages. We trans-

late a Finnish book into English, for example, in order to make its contents available and communicable to English-reading people. This, however, is only one side of the coin.

I would like to illuminate another aspect of translation – we might call it 'philosophical' – which is particularly important from the artist-researcher's point of view. One essential task of the artist-researcher is to provide well-articulated passages between different media or languages while maintaining a high sensitivity to their mediality. I think of this task of the artist-researcher in terms of translation following the lines of thought that Walter Benjamin developed in his writings on language and translation.[6] For Benjamin, translation is essentially more than the transportation of meanings. It provides access to the experience of language by exposing language as meaningfulness that communicates itself. Besides bringing forth this self-relation of language, translation also shows that different languages make sense by relating themselves to each other. In other words, a singular language finds its mode of articulation only insofar as it is exposed to the multiplicity of languages. It is not only we who 'are a conversation', as Hölderlin once wrote,[7] but languages converse among themselves, turning towards each other.

As to Benjamin's thinking, 'language' must be understood in a specific sense. It is not limited to verbal language; all modes of articulation qualify as languages. For Benjamin, language is something that precedes even the division between the intelligible and the sensible. In other words, language is not a sign system; rather, it is something we could call the 'emergence of sense'.[8] (Here we have to keep in mind that the word 'sense' has a wide variety of meanings, just as the German *Sinn* stands both for meaningfulness and for sensuality). This wide sense of 'language' implies that language is not a *means* of communication; it *is* communication insofar as we understand communication in terms of 'immediate impartability' (*unmittelbare Mitteilbarkeit*), an immediate or *un*mediated capacity to bring things into mutual relationships while partaking in the event (SW I: 63-64). In other words, language 'communicates' by 'communicating' itself. This event of 'communication', however, is at the same time one of alteration. Language imparts by 'parting with itself', as Samuel Weber puts it (Weber 2008:

6. I will refer to two key texts here: 'On Language as Such and on the Language of Man' and 'The Task of the Translator', both published in English translation in *Selected Writings*, Vol.1 (Abbr. SW I).

7. The line in the poem *Friedensfeier* that I am alluding to is translated into English as follows: 'Since we have been a discourse (*Gespräch*) and have heard from one another' (Hölderlin 1990, p. 235). I translate the word *Gespräch* as 'conversation' in order to emphasise the spatial constellation of multiple voices implied by the German word that is a combination of the collective prefix *Ge-* and the verb *sprechen* ('to speak').

8. Peter Fenves puts this in terms of the appearance of a 'pre-spatial space of pre-logical sense' (Fenves 2001, p. 204).

42). It is never fully present to itself. Our conversations never fully converge. In this way, language as immediate impartability is also a symbol of the non-communicable or inexpressible (SW I: 74). Language refers infinitely beyond itself. Or, to use the terms I have just introduced: language as the emergence of sense comes to its limits relative to the insensible.

When language is invested with epistemic interests (Benjamin calls this the 'Fall' (SW I, 67-74)), it tends to become codified, instrumentalised and mediated. Only virtual traces of its immediate impartability remain (Weber 2008: 47). These traces, however, can be made legible through translation. Translatability, for Benjamin, is an essential feature of artworks that incorporate the experience of language in their structure (SW I: 254-255). This structure marks and is marked by the 'peculiar convergence' of the multiplicity of languages, the fact that languages somehow relate to each other. Benjamin writes: 'languages are not strangers to one other, but are […] interrelated in what they want to express' (SW I: 255). All languages aim in their own singular ways at 'one and the same thing'. His term for this is 'pure language' – a dimension of language that cannot be attained in any single, separate language, but only in the multiplicity of mutually supplementary different languages (SW I: 257). 'Pure language' as 'one and the same thing' at which all languages are aiming, is the *origin of sense*. 'Origin' here, however, is not a ground or a stable point of reference, such as God or the Divine (at least not in any conventional sense). Rather, it is an 'eddy' (to use Benjamin's word, *Strudel*[9]) that brings heterogeneous elements together according to a logic that is historical.

Benjamin suggests that translation 'gives a voice' to the intention of a language by making the different languages recognisable 'as fragments of a greater language, just as fragments are part of a vessel' (SW I: 260). As fragments of the great vessel of 'pure language', the individual languages are supplements, substitutes for each other. What a language adds to another language is the lack of itself. The work of translation brings out something that I am inclined to call the 'hospitality' of a language, making it resonate and urging it to sense itself through the other.[10] In short, languages are at least partially translatable because they supplement each other in their ways of making sense, not because they carry comparable meanings.

As I indicated earlier, the task of an artist-researcher operating in the interstices of different media can be likened to the task of the translator. For Benjamin, the task of the translator is to re-create the work of art in his own language in such a way that the pure language finds resonance in it.[11] The artist-researcher

9. This characterisation of origin appears for example in Benjamin's 'epistemocritical' preface to his study on the idea of the German baroque mourning play (GS I/1, p. 226).

10. Christopher Fynsk expresses this resonance in terms of 'singing' (Fynsk 1996, p. 187).

11. In Benjamin's words: '[The task of the translator is] to release in his own language that pure language which is under the spell of another, to liberate the language imprisoned in a work in his re-creation (*Umdichtung*) of that work.' (SW I, p. 261).

who has assumed this task must tune his or her language to accord with the density of the work of art. One essential aspect of this tuning that I see at the core of the gesture of exposing art as research is to refrain from instrumentalising the medium of research. Following Benjamin, we can consider the practice of art as a 'densification' of its language, increasing the degree of its translatability and expanding its possibilities of articulation. It is noteworthy, however, that we are dealing here with virtual density, because a translation can only actualise part of the original work (Elo 2007: 149-153). This implies that an exposition (as translation) should be assessed in terms of its relative density, that is, in terms of its resonance with the work. Its communicative capacity with regard to a context is a secondary matter here. The work, in turn, remains always open to reassessment, and is in this sense beyond any definite meaning.

To focus on this 'philosophical' aspect of translation is for me to distance myself from dialogical models of artistic research that are based on a kind of product-development schema, which has become prevalent in many art universities. Benjamin's claim that an ideal translation is something that always remains a virtual one opens transformative possibilities for conceptualising artistic research. In the light of his language philosophy, the relation between art and research practices, rather than appearing as a dialogue leading to an actual synthesis appears as a touch or resonance inviting art and research to a critical altercation, *Auseinandersetzung*. With the help of Benjamin, we can reveal the limitations of conceiving of language as a means of communication, especially in connection with those modes of articulation that are sensitive to their own medium, that is, paradigmatically, artworks. Insofar as artistic research aspires to sensitivity to its own ways of articulating knowledge, it cannot afford to instrumentalise the medium of communication. This implies that the performative aspects of an exposition gain a particular importance. When exposing artistic work as research, one should not be satisfied with simply transposing contents and topics from one context (or language) to another. The shifts taking place in the process should somehow be incorporated into the exposition as well. In other words, the research exposition should be tuned to accord with the artistic work. This tuning is nothing other than striving for an appropriate 'feel' or 'touch'. In short, the artist-researcher is facing the challenge of finding medium-sensitive ways of articulating his or her epistemic interests and of looking for productive contact points between the different modes of articulation – without any pre-established hierarchies, which would limit what can be exposed.

It is in regard to these contact points that the potential of publishing art in academia comes to the fore. Various publishing platforms for artistic research that are currently emerging could develop into medium-sensitive environments where the different modes of articulation could look for productive contact points without any pre-established hierarchies. The development of this kind of medium-sensitive platform is, of course, an immense task, since non-hierarchical medium sensitivity implies that every detail is potentially sig-

nificant. As regards appropriate peer-reviewing processes, one can see far-reaching questions arise. Can, for example, an artistic-research exposition be assessed in non-verbal ways, or is logocentrism still an unsurmountable fact? Language without grammar is, to be sure, a utopian idea and the history of languages carries hierarchies with it. Nevertheless, I think that an artist-researcher, in the best case, operates with the kind of sensitivity towards the multiplicity of languages that invites working with and against the grammar, pushing the limits of a pre-established order. The question of 'pushing the limits' brings me to my second theoretical concern: tactics.

Tactics

In order to gain new knowledge, a researcher has to make use of some kind of tactic in sorting out and categorising whatever is under scrutiny. Usually we speak of this in terms of method. What counts in scientific research is an identifiable corpus from which to extract samples that can be analysed and, accordingly, grasped. In order to have a good research touch, a scientist has to be clear about his or her method.

The arts, too, have their 'tactics of grasping' or methods. Artists, too, make their 'takes' or tryouts. These resemble scientific takes or samples by being bound to their limits. The artistic 'take', however, does not aspire to overcome those limits and establish general rules. This kind of aspiration, at least, does not constitute a standard by which its quality or relevance could be judged. The artistic 'take', instead, works on its own limits and is taken by them.

While aware of the risk of being too blunt (since the range of possible positions on both sides is wide), I would like to schematise the difference between the arts and the sciences in their relation to tactics as follows: scientific thinking proceeds as *tactics of generalisation*, whereas thinking in the arts follows *tactics of touch*. The arts are concerned with details and features that give their 'take' a distinctive character, a singular touch, whereas in the sciences this is mostly not desirable since the 'take' is expected to be made reproducible. In the arts, the method cannot be reduced to a means to an end. The artistic method is something that also means *in* the end. It is inscribed in the work itself. This complicates the way in which we can conceive of artworks as research results. The artwork is an end point of a process that results in something rather than an end point as a simple outcome.

In a strict sense, touch is always at the limit (Derrida 1993: 126-128). Only by touching its own limit can touching get in touch with itself, or rather, with a self, which in and as touching may become something we could call 'itself'. This structure, however, is not entirely reflexive, since touching is always also transitive. It goes across a distance without any guarantee of securing a return. The limit here, even if it might be called definite, does not serve definitions. It serves differentiation and exposition. In so far as the limit is touched,

it is differed and deferred, pushed further – at the same time as the touching feels limited and vulnerable. 'Artistic touch', a touch taken by its limit, seeks intensity rather than solution. It never gets a definite grip. Or more precisely, it is never satisfied with a definite grip. Its form is that of repetition, which, to be sure, is something other than the reproducibility of a scientific experiment. What counts here is difference.

The way in which traditional art research tries to seize hold of the arts differs significantly from the way an artist seizes fine traits and the ways works of art seize us. This difference cannot be reduced to an opposition of intelligible and sensible, or to that of rationality and affectivity. The touch of the arts takes its measure from sense in all senses of the word, which imposes a challenge on this kind of categorical division.

The research gesture inherent to the formative powers of the arts manifests itself in and as 'artistic touch'. The research potential of this touch cannot be grasped in scientific terms, since its relation to knowledge follows a logic that differs from that of scientific appropriation, which has its established methods of securing new knowledge. Traditional art research aims at gaining knowledge of art and identifying and documenting this knowledge as knowledge. Artistic research, in turn, investigates knowability by constantly seeking new relations to knowledge. Even if all research is driven by a state of not (yet) knowing, differences between scientific and artistic approaches arise in regard to the ways of consolidating knowledge. What is at stake in art as research is touch (or even retouch) in the sense of a repetitive search for fine differentiations related to a particular situation. The source criticism and contextualisation central to scientific research remain secondary matters here. What is under scrutiny is not a corpus (a systematic data collection assembled for the purpose of studying), but a singular, incompletely articulated body (a singular point of reference) in its anticipated knowability. In this sense, 'artistic touch' is constantly on the threshold of knowledge. In and as its own gesture, it singles out pleasure, intensity and tact as matters on which to focus.

Even if art can be just as technical as scientific research, it is still not a matter of the mechanical application of a technique to the smallest detail. Art is a technique of the detail in a much stronger sense: it is the technical production of details (Nancy 1996: 20). 'Artistic touch' is in this sense technical. Against this background it would seem that something like a universal touch or Art with a capital A are products of science fiction, since details to be worked on only exist in so far as they are put forward in a singular presentation.

The arts, nevertheless, do relate to each other. The plurality of the arts does not, however, consist of parts that would constitute a disciplinary and coherent whole. This remains a scientific aspiration. The arts are heterogeneous in relation to each other. They relate to each other like different languages that supplement one another by adding their own lack to each other (Elo 2007: 153-155). Each one of the arts opens infinite possibilities and thus becomes

something like a 'total part' of the multiplicity of the arts. This structure is repeated, fractal-like, on the level of details. Even a singular hue or gesture can constitute a total part – and open up a whole world (Merleau-Ponty 1997: 134).

Another way to say this is to point out that different artistic techniques share an aim, or even a sense: they strive to please themselves as their own gesture. Touch in the arts is nothing other than the self-feeling of the gesture as a longing for form. In this sense, what is common to the arts is the relation to the forming of the form.[12] In other words, what is at stake in the arts is 'design', in so far as 'design' designates a desire for form that articulates or 'draws' itself as fine traits and nuances, or strokes. Jean-Luc Nancy, to whom I am referring here, summarises this by saying that '[t]he stroke executes the gesture of its desire' (Nancy 2009: 36).

According to Nancy, this formative power of the arts can be thought of as 'auto-affection', that is, as the forming of a self as the gesture of turning towards that which is outlined or drawn up as the gesture itself (Nancy 2009: 39-40). Against this background, the distance between art and design can be estimated on the basis of their connecting Latin word *designare*. This raises far-reaching questions concerning signifying forms and forms of signification. The questions concerning the relation to the forming of the form become decisive. A thinking of form dissociated from function should be developed in order to gain a more differentiated view of the research potential inherent to the arts. A 'meaningful connection' between making and reflecting need not be a functional one. Or to put it in other terms: the way in which an artwork results in something, that is, appears as an outcome of research, doesn't have to be programmatic in order to 'make sense'. What is implied in the work has the potential of becoming unfolded as its effect. In other words, the exposition of art as research understood as an explication process doesn't have to be explicit in a discursive sense. What counts is the sensitivity towards its non-discursive gestures.

In my view, these questions are more than relevant as concerns the development of publication platforms for artistic research, since what is at stake here is nothing other than the design of artistic research, the drawing of lines according to which we think of the arts in relation to knowledge. Publishing art in academia is about exposing artistic work to knowledge and formatting this exposition.

In one of his central works, *Corpus*, Nancy states that in the 'world of bodies' (that is, in our globalised world that no longer has any transcendental order) writing (as the articulation of sense) is to be seen as 'the anatomized body of a sense that doesn't present the signification of bodies and, still less, reduce the body to its proper sign' (Nancy 2008: 83). Writing, however, signifies, since we are 'organized' for signification (ibid.). As I already noted, language without grammar is a utopian idea. Writing (understood as the articulation of sense)

12. Following Hölderlin and Benjamin we might even speak of 'pure form' here.

works with the tension of the signifying system at the same time as it takes part in it. In this tension, according to Nancy, 'organisation' turns into 'anatomy' (ibid.). Writing is ex-scription of the body rather than articulation of meanings. In other words, untied from the burden of signification, the body is exposed as sense.

What, then, does this 'anatomising of organisation' imply in terms of the research potential of the arts and artistic research? How should one think of the difference between 'organisation' and 'anatomy'?

The word 'organisation' comes from the Greek *organon*. It refers to instrumentality and its scope reaches from bodily organs to organs of administration, business, communication and research. The word 'anatomy', in turn, derives from the Greek *temnein* ('to cut'). The prefix *ana-* attached to it has the curious double meaning of 'with' and 'against'. 'Anatomy', accordingly, means 'cutting with and against'. It is the articulation of details, as it were. 'Anatomising of organisation' could thus be rephrased as 'striving for singular touch', which in regard to knowledge production is something like an 'anarational' operation, since it treats non-intelligible aspects of experience as 'co-rational' rather than as irrational elements of thinking. What is at stake is 'touch' in the strict sense, that is, touch at the limit, touch taken by its limit – or as I like to put it, 'artistic touch'.

In Conclusion

By taking up the themes of *translation* and *tactics*, and by relating them to the senses of touch, I have tried to indicate some ways of considering the arts as research in their own right. The challenge of finding an appropriate touch or tact connects the questions of medium and method with each other and marks the culmination point of questions concerning the research potential of the arts. This constellation needs to be taken seriously when new institutional settings of artistic research are emerging and looking for ways to legitimate themselves as research.

The 'touch of the faculties' currently taking place in art universities and on various platforms for publishing artistic research is an ever-changing state of affairs. In these contexts, one needs constantly to negotiate between sustainability and transformation, both in terms of technology and discursive ramifications. As I have indicated in this article, the negotiations between aesthetic stakes and epistemic interests that are unavoidable whenever one attempts to expose art as research are very much about translation and tactics. Open-ended questions of how to assess non-verbal articulations and the singular touch of artistic and design decisions – in short, the medial density of an research exposition – are encountered in these contexts on a regular basis. Developing medium-sensitive platforms for exposing art as research is a highly demanding task, since non-hierarchical medium sensitivity implies, as I have indicated above, that every detail is potentially significant.

The question of how to make sense of non-verbal articulations should be

taken seriously, since it touches the core issues of artistic research. One way in which artistic research differs from more traditional forms of academic research is its willingness to operate with something that I would call 'open formats'. When publishing art in academia, the artist researcher is allowed, sometimes even expected, to invent or reinvent the format of presentation. This implies that the relations between 'form' and 'content', as well as these notions themselves, are necessarily under negotiation. On the other hand, it is clear that the format of publication platform is not totally open even if it might wish to operate with 'open formats'. This constitutes a theoretical problem that is virtually impossible to solve. On a practical level, it can be handled from case to case, but it is difficult to see any possibility for a general rule or convincing recipe. This means that evaluating the quality of artistic research expositions remains an open-ended task.

The real hubs of the 'touch of the faculties' that are at stake here are not faculties in the institutional sense but faculties in the sense of mental and physical powers. The subversive potential of artistic research and its 'anarational' operations only become visible when we start to recognise how the research potential inherent to the arts can destabilise the cultural dichotomies, such as mind/body, theory/praxis and intelligible/sensuous, on which the knowledge production of scientific thinking is based. It is in regard to these dichotomies that artistic research can challenge the prevailing regimes of knowledge and make the research discourses more responsive to phenomena belonging to those areas of experience that are difficult to verbalise. In order to investigate the contact points between different faculties with the 'anarational' operations of artistic touch, we need to shift the focus away from the institutional frame of artistic research to its formative powers. Consequently, instead of the institutional frame, or 'organisation', our main concern should be the desire of knowledge on the 'anatomical' level, which artistic tactics and medium-sensitive translation work are pondering with their gestures. If form is born of the form-desire of knowledge, what, then, could research made for the sake only of the forming of the form be?

Last, but not least, I would like to add that by focusing here on artistic research I have highlighted only one side of the coin. In the wake of the cultural shift that I schematically outlined in terms of 'medial turn', it has become clear that work on details and nuances as concerns materiality, forms and formats cannot be considered a trademark of artists and designers alone; it is becoming increasingly important to scientists, scholars and theoreticians as well. The epistemic interests of artist-researchers articulated in the form of artistic research find their counterpart in the recognition of the material and aesthetic aspects of scientific work, studies and deconstructive thinking.[13] In

13. See for example Rheinberger 2010, pp. 244-245. As regards philosophical tradition, the writings of Derrida have been considered representative of the 'medial turn' (Münker 2010, p. 32).

short, we have to think of the relation between art and research in terms of a double-bind. The various turns that constitute this double-bind do not relate to each other in any symmetrical way. Consequently, publication platforms of artistic research cannot successfully provide a happy medium between art and research. What they can achieve instead, is to become loci of critical altercation, *Auseinandersetzung*, in the arts and research practices – by touching the limits of knowability.

References

Benjamin, W., 1991. *Gesammelte Schriften.* Rolf Tiedemann and Hermann Schweppenhäuser (eds.), Frankfurt: Suhrkamp. (Abbr. GS).

Benjamin, W., 2004. *Selected Writings.* Michael W. Jennings et al. (eds.). Cambridge, MA, and London: Belknap Press of Harvard University Press, vol. 1. (Abbr. SW).

Derrida, J., 1993. 'Le Toucher – Touch/to touch him'. *Paragraph* Vol. 16.2, 122-157.

Dombois, F., 2009. '0-1-1-2-3-5-8. Zur Forschung an der Hochschule der Künste Bern'. In *Forschung.* Jahrbuch Nr. 4/2009. Bern: Bern University of the Arts, 11-22.

Elo, M., 2007. 'The Language of Photography as a Translation Task'. In Elo, Mika (ed.), *Here Then – Photograph as Work of Art and as Research.* Helsinki: University of Art and Design and Finnish Academy of Fine Arts, 134-187.

Elo, M., 2012. 'Digital Finger: Beyond Phenomenological Figures of Touch'. *Journal of Aesthetics and Culture*, vol. 4 (2012). http://aestheticsandculture.net/index.php/jac/article/view/14982 [Accessed 7 October 2013].

Fenves, P., 2001. *Arresting Language. From Leibniz to Benjamin.* Stanford: Stanford University Press.

Figures of Touch research project: http://www.figuresoftouch.com [Accessed 7 October 2013].

Fynsk, C., 1996. *Language and Relation.* Stanford: Stanford University Press.

Hölderlin, F., 1990. *Hyperion and Selected Poems.* Eric L. Santner (ed.). New York: Continuum.

Merleau-Ponty, M., 1997 (1968). *The Visible and the Invisible.* John Wild et al. (eds.). Evanston: Northwestern University Press.

Münker, S., 2009. *Philosophie nach dem 'Medial Turn'. Beiträge zur Theorie der Mediengesellschaft.* Berlin: Transcript.

Nancy, J.L., 1996 (1994). *The Muses.* Stanford: Stanford University Press.

Nancy, J.L., 2008 (2006). *Corpus.* New York: Fordham University Press.

Nancy, J.L., 2009. *Le Plaisir au dessin.* Paris: Galilée.

Rheinberger, H.-J., 2010 (2006). *An Epistemology of the Concrete. Twentieth Century Histories of Life.* Durham and London: Duke University Press.

Waldenfels, B., 2002. *Bruchlinien der Erfahrung. Phänomenologie, Psychoanalyse, Phänomenotechnik.* Frankfurt am Main: Suhrkamp.

Waldenfels, B., 2010. *Sinne und Künste in Wechselspiel. Modi Ästhetischer Erfahrung.* Frankfurt am Main: Suhrkamp.

Weber, S., 1996. *Massmediauras. Form, Technics, Media.* Stanford: Stanford University Press.

Weber, S., 2008. *Benjamin's Abilities.* Cambridge, MA, and London: Harvard University Press.

Artistic Researching:

Expositions as Matters of Concern

By Ruth Benschop, Peter Peters & Brita Lemmens

Imagine a practice room in a theatre academy. A group of students discuss the films that their supervisor has suggested they should see, their favourite artists and what they value in their work, and the short performances they prepared the night before and have just shown to one another. They are exploring the possibilities of new theatre technologies in a project called *The Virtual Body*. Later, they gather for a week to work in a huge barn, where their supervisor assembles what can only be called 'stuff'. They experiment with spraying chalk on the planes of the small greenhouse with which they are to work. They gauge whether the resulting opacity will allow it to become a screen for a projected virtual reality. They worry about the expected confusion between the real and the non-real, live and non-live that will result. There are fierce, painful silences among the students over the issue of where and when theorising is appropriate. They search for evidence that their work is converging into a necessary thing, but right up to the premiere, they have no idea whether or not this is true.

Now imagine a fado café in the streets of the Lisbon neighbourhood of Bairo Alto. Inside, a group of people listen to a singer performing the song 'Carmencita'. They have assembled, as they do every night, to listen to fado. The singer has explained to them how and why she wants to learn to sing fado: by listening to other fado singers, taking lessons, practising at home, through reading and writing about fado. The people in the café are sceptical. *O fado não se aprende* – Fado is not something one can learn, they say – one is born with fado. The singer wants to refute this claim by using her own voice and convincing her audience that she has fado, while at the same time learning more about her audience's claim that *O fado não se aprende*.

These two situations tell us something about the practice of artistic research. It is open-ended, messy and uncertain. The artists are making, questioning, refuting, hoping, all at the same time. They are concerned with an idea, a claim, a technology, an experience, a question, and they are working on it, assembling new ideas, claims, technologies and questions in the process. Yet when we reflect on this practice of doing artistic research, we are often trapped in dualisms: art and science, words and worlds, art practice and art writing, discursive and embodied knowledge, original artworks and their representations.

When looking in more detail at the first dualism, between art and science, one often finds oneself rehearsing clichéd notions of what characterises

art as well as science. Art becomes a paragon of non-methodological, auton-omous and intuitive work, while science appears uncreative, methodological and articulate. This dichotomy serves an important purpose: it creates space for a notion of artistic research as a potent mixture of the two, or a productive middle ground. The task that then emerges is to sort out what features, prac-tices and norms from each side can be taken up by artistic research without immediately losing the hard-won territory to one or other originating field.

The problem of how to retain the productive middle ground is also prominent when discussing the *exposition* of art as research.[1] How is the expo-sition to be related to the art practice that it sets out to expose? To what extent does the exposition enable the artist to present his or her work as knowledge? Do the various ways in which the work of art is communicated as research make a difference to what can actually be known through the exposition? In this article, we argue that the field of Science and Technology Studies (STS) of-fers valuable strategies with which to answer some of these pressing questions. In mobilising insights from STS and, more specifically, building on the work of Bruno Latour, we will suggest new ways of thinking about the exposition of artistic research. Central to this line of thought is the notion of 'matters of concern' (Latour 2004; Latour 2005a). Rather than staying within the repre-sentational register that characterises much dualist thinking, we will argue in a performative register that focuses on the 'work of art' as an ongoing endeavour of assembling agencies, rather than constructing a finished work that can be (re)presented in a more or less unproblematic way.

First, we will briefly introduce this move and the field from which it originates, after which we shall elaborate on the way in which it can be linked to the exposition of artistic research (for instance, see Nowotny 2011: xxii-xxiii). We will then recount two examples from our respective practices of artistic research, allowing us to demonstrate the advantages of our approach over the dualist register that this paper sets out to criticise. We conclude by evaluating the idea of exploring expositions as 'matters of concern'.

From Research to Researching

Science and Technology Studies (STS) is an interdisciplinary field of research that emerged as a response to problems in the philosophy and sociology of sci-ence during the 1960s and 1970s. Philosophers of science tended to focus on the normative discussion of scientific results, while sociologists of science drew

1. 'Exposition' is the word developed within the Artistic Research Catalogue (ARC) project to denote what in academic research is known as 'publishing research'. The aim of this concept is to open up a wider field of possible ways of thinking about the making public of art as research, relating, for instance, to terms besides publishing, such as exhibiting, curating, unfolding, etcetera. See Schwab 2010.

Ruth Benschop, Peter Peters & Brita Lemmens

attention to social factors at work in scientific practice. Neither saw the other as particularly relevant. STS underwrote the normative intentions of philosophy of science, but argued that to do so productively, more attention should be paid to, in a famous phrase of Latour, 'science-in-the-making'. This should be studied, however, not by focusing only on the social aspects of scientific practice, but by following all the work involved in producing scientific matters of fact. By doing so, scientific results appear not as either correct or false representations of nature, as facts or mistakes, but as intrinsic and understandable parts of science-in-the-making. The advantage of this symmetrical approach, is that it allows us to study science without having to side with those whom history has shown to be the 'winners' or 'losers', those scientists whom we, with hindsight, take to be right or those we take to have been mistaken. For it is only such hindsight, STS argues, that allows us to make these categorisations. If we want to understand science, we should refrain from such *a priori* taking of sides, for in the process of finding out what is true and what is not, scientists themselves do not yet know. And such processes can be traced only by ignoring our current normative ideas about scientific outcomes and by focusing on all the work done to create matters of fact.

Besides problematising the difference between the context of discovery and that of justification (Popper), and asking STS researchers to refrain from focusing not only on what we take to be social work but on all work, as well as from taking sides when they study scientific practice, STS also problematises the opposition of fundamental scientific knowledge and its application in the real world. When you study the work done to create matters of fact, STS argues, what you see is that in order to become true, the world in which these facts become true has to be adjusted to them. A famous example of this line of argument is Latour's analysis, in his book *The Pasteurization of France* (1988), of Pasteur's discovery of penicillin. Against common wisdom, Latour argues that facts are not true irrespective of where they are situated. On the contrary, they can only become true in worlds constructed precisely to reveal their truth. Penicillin could only become a proper and effective cure because the world of farmers and cows was made to resemble the laboratory in which Pasteur worked so successfully, and then there, too, penicillin 'worked'. To put it differently: facts are like trains. They cannot move through the world without the infrastructure of tracks, tickets, stations, conductors, etc. Looking at science-in-the-making thus involves not only ignoring the outcome of all the work, ignoring differences in the role played by social and non-social, but also ignoring the seemingly self-evident boundaries that scientists erect to differentiate their scientific work from the rest of the world.

Chains of transformation

In our description of STS, we are focusing in particular on the research tradition called Actor Network Theory (ANT).[2] The central idea behind ANT,

one that we have implicitly been using above, is relationality. This relational approach has been developed in countless case studies and theoretical contributions in very different domains, from medicine to law, economics, history of science, political theory and human geography. To describe and understand a phenomenon or the workings of an artefact, we have to study how it becomes related to a range of entities, human and non-human, material and discursive.

> We don't know yet how all those actors are connected but we can state as the new default position before the study starts that all the actors we are going to deploy might be *associated* in such a way that they *make others do things*. This is not done by transporting a force that would remain the *same* throughout as some sort of faithful intermediary, but by generating *transformations* manifested by the many unexpected *events* triggered in the other mediators that *follow* them along the line (Latour 2005a: 107).

Thus, no *a priori* empirical or conceptual categories can be taken as explanations. That which is taken as a stable explanation can itself be explained from its place in the various webs of agency. What actor network researchers are interested in is that:

> To designate this thing which is neither one actor among many nor a force behind all actors transported through some of them but a connection that transports, so to speak, transformations, we use the word translation [...] So the word 'translation' now takes on a somewhat specialized meaning: relation that does not transport causality but induces two mediators into coexisting (Latour 2005a: 108).

To grasp what this means more concretely, let us briefly consider an article in which Latour takes the reader to the Amazonian jungle of Roraima to follow 'in the wild' the way in which scientific certainty is created (Latour 1999). Rhetorically, Latour suggests that he is there to trap the moment when science manages to bridge the gap between reality and fact, between the world that is there and the scientist's confident rendering of it. He observes geomorphologists and pedologists in their research practices. The scientists researching the Amazonian soil have selected their samples, which they detach, separate, preserve and classify. From plants the samples have turned into abstractions that have become scientific referents. The scientific text differs from other nar-

2. Actor Network Theory is associated in particular with Bruno Latour, Michel Callon and John Law. For an introduction to ANT, see Latour (2005). Approaches 'after' ANT focus particularly on notions of subjectivity and on political questions. See, for instance, the work of Gomart (2002) and Marres (2007).

rative forms, for it mobilises its own internal referent and therefore carries in itself its own verification (Latour 1999: 56). Acts of reference do not rely on resemblance to the reality from which the samples were extracted; they rely on a regulated series of transformations, transmutations and translations. Reference, according to Latour, 'is our way of keeping something constant through a series of transformations' (Latour 1999: 58):

> [P]henomena are what circulates all along through the reversible chain of transformations, at each step losing some properties to gain others that render them compatible with already established centers of calculation (Latour 1999: 72).

In describing these chains of transformation, Latour makes two arguments. First, although it seems he is far away from scientific institutions and practices, the way in which the situation is assembled in the forest already bears scientific marks. The forest is not pristine, or rather, the situation in which he finds himself – soil, instruments, people, questions, footnotes, paper, texts – can only be understood by referring both to nature and to scientific culture. Second, as soon as the scientists present at the scene start to work, two things happen. Their acts *reduce* the situation they find themselves in: they do not take home the forest, but a particular framed residue of the forest. And through that reduction, they *perpetuate* the forest: the framed residue of the forest that they take home will later allow them to speak confidently about the forest, to take it up in research and publications. What Latour shows in this paper is how this movement of translation is fundamental to the whole scientific process. Every step along the way is one of translation, and also – and this is crucial for our argument here – the last step in making the research public: publication.

To summarise, using an ANT approach to study a given practice means turning a blind eye to common knowledge and the self-understanding of science, and instead becoming a meticulous follower of the relationality of practice, of what is actually done. Doing so allows us to see the translations that let categories, definitions, things appear. But what does it mean to take this basically ethnographic approach to the examination of artistic research? A subtle shift in the kind of questions asked comes about: what happens to the clichéd image of artistic research as a tug of war between science and the arts? The question is not how to differentiate artistic research either from scientific research or from art, but how within the practice of artistic research, artistic research itself becomes defined and differentiated, and from what. The question is not whether we can or should use academic or artistic criteria to evaluate artistic research, but what kind of processes of evaluation are emerging in the practice of artistic research. The issue is not whether artistic research can produce knowledge, but how in practice artistic research takes itself as doing so, and what concept of knowledge then comes to the fore.

Tracing the work of art

Before applying these agnostic and meticulous questions to the practice of artistic research, we need to stop for a moment to consider how appropriate an STS approach is to the issues at hand. Since STS originated from, and was elaborated through, the study of science, can we usefully apply it to the study of artistic research? And if we decide we can, what do we need to take into consideration when doing so?

First of all, our rough introduction of STS sketches a research tradition that has long since extended and branched out. Although it still employs the principles noted above, in response to requests for its application in new domains as well as to academic critique on several positions and consequences of the STS approach, it now includes studies that are more interested in processes of attuning and attachment than in construction, and, most relevant to our argument here, is focused on fields other than science.

From the outset, STS has not focused only on science. Following its own principles, this makes sense. If ignoring the definitions, boundaries and differentiations that science itself uses to produce matters of fact is what an STS approach entails, there is no guessing where you might end up. Following what is done in practice can take you far afield. More prosaically, STS researchers have studied various boundary crossings between science and other neighbouring disciplines, as well as studying different aspects of artistic practice.[3] In such studies of artistic practice, a similar approach is taken to that of science. Like the departure from science's self-understandings, ANT opposes itself to art's focus on notions such as originality, autonomy and creativity as relevant causal explanations. In a recent polemical article, Latour attacked the notion of the 'original' in art. Great art is not a point of origin, he argues, but a trajectory that can be compared to a river:

> A given work of art should be compared not to any isolated locus but to a river's catchment, complete with its estuaries, its tributaries, its dramatic rapids, its many meanders and of course also with several hidden sources [...] To give a name to this catchment area, we will use the word 'trajectory'. A work of art – no matter of which material it is made – has a trajectory (Latour 2008b).

This way of framing the work of art in its double connotation as an object and an activity underlines the fundamental performative nature of any artwork. In order to be, art has to be done. Following this line of argument, there

3. For research on boundary crossing that is relevant here, see for instance, Star & Griesemer 1989; Galison 1987. For examples of STS research of the arts, see Gomart & Hennion 1999; Van Saaze 2009; Yaneva 2003.

Ruth Benschop, Peter Peters & Brita Lemmens

would not be an *a priori* distinction between scientific facts and works of art. Both come into existence only through the kind of work that Latour has described for the Amazonian soil as well as for Hans Holbein's 1533 painting *The Ambassadors* in the National Gallery in London (2008b). In both cases, the starting point is not the dualism between words and world, the original and the facsimile, but the fascinating trajectories that are created through the work of science or art.

Whereas the notion of the trajectory of 'matters of fact' recalls STS moves on science, Latour has developed the notion of 'matters of concern' largely in the study of politics and the arts (Latour 2004; Latour 2005a). Underlying the idea of 'matters of concern' is a critique of the realist idea that facts are simply there. Instead, we should see them as agencies 'with their mode of fabrication and their stabilizing mechanisms clearly visible' (2005a: 120). Considering the connotation of performativity in his rendering of 'matters of concern', it is no surprise that Latour mobilises the metaphor of the theatre:

> A matter of concern is what happens to a matter of fact when you add to it its whole scenography, much like you would do by shifting your attention from the stage to the whole machinery of a theatre [...] Instead of simply being there, matters of fact begin to look different, to render a different sound, they start to move in all directions, they overflow their boundaries, they include a complete set of new actors, they reveal the fragile envelopes in which they are housed. Instead of 'being there whether you like it or not' they still have to be, yes (this is one of the huge differences), they have to be liked, appreciated, tasted, experimented upon, prepared, put to the test (Latour 2008a: 39).

The notion of 'matters of concern', in another register, is reminiscent of related work on 'good experiments' (based on work by philosopher Isabelle Stengers and by Vinciane Despret (2004; 2005)). Good experiments are those that are able to develop enough relevant interest in a phenomenon to allow it to express itself in a novel way. Rather than stepping back from the phenomenon, experimental research is here characterised by the construction of intense and forceful, yet sensitive and interested, conditions for surprising insights to emerge. The image of the stage and the machinery of a theatre resonates in the distinction that Latour makes between matters of concern not as objects but things, or as he phrases it, as 'gatherings' (Latour 2005b) or '[a] controversial *affair*, a *cause*, yes a *res*' (Latour 2008: 48, italics in the original). How can we use the concept of 'matters of concern' to rethink some of the dualisms that have been outlined at the beginning of this chapter? To answer that question in our concluding remarks, we will first recount two examples of artistic researching.

Example 1: The Virtual Body

'ILLBEGONE' was a project in which two groups of students from different backgrounds and theatre traditions worked together with supervising artist Peter Missotten at the Maastricht Theatre Academy to create a performance. The aim was to explore the use of virtual technologies as part of a larger project called *The Virtual Body*. After it was finished and the performances done, Missotten decided to commission a documentation of the project, partly because it had been intense and difficult. This documentation would examine the way in which virtuality was at stake in the project. It also addressed performance issues such as the relationships between real/non-real and live/non-live. Moreover, the documentation would question why, how and for whom one would want to maintain what to all intents and purposes was gone: 'I'll be gone' (Benschop 2011).

This assignment was taken on not only as a representational question, but as an artistic-research challenge. It was to serve two functions: to help create insights into what was learnt about virtuality through this project, and to serve as an experiment in creating a contribution to the Research Catalogue (RC). What would it involve to turn the documentation process into a feasible exposition for the RC then being developed?

To document the project, interviews were conducted with eight students from both institutions involved, as well as with Missotten. The video that was made of one of the performances was also used.[4] In the interviews, the participants were not only asked to give their accounts of what happened during the project, but also their views on virtuality, as well as on documenting artistic processes such as this one. Moreover, these issues were discussed reflexively, not only asking what participants thought of documentation, but also what its impact and role might be in their practice.

The resulting document currently has the status of a written text, with added visual documentation and links to websites. It is also an exposition in the RC (Benschop 2011) aiming to introduce a number of additional formal qualities that are relevant here. The document's opening page invites readers to identify themselves and their interests. The aim was to allow visitors access only to a particular part of the document created especially to address their concerns based on their identification. Moreover, the intention was to allow entry to this part of the document only once and thus be given both partial and limited access to the documentation. Due to technical problems, this limited access was only partly realized. Furthermore, the part of the documentation that is addressed to the participants in the project does not contain information about the project or the performance, but rather a call to participants to remember (or forget) the project. This was inspired by some of the interviewees' requests not to document the project but to bring it regularly to their attention. This

4. See http://www.filmfabriek.com (accessed 07-10-2013).

Ruth Benschop, Peter Peters & Brita Lemmens

would make them remember it, a more proper mode of documentation, so they claimed. It also invited participants to forget the project, in keeping with the comments of other interviewees who had stressed their dissatisfaction with, and hope to remain distanced from, the project.

Let us for a moment examine the relationship between 'ILLBEGONE' and its documentation from the point of view of the dichotomous categories that we are attempting to leave behind. It seems obvious: on the one hand, we have an artistic project, on the other an investigation of that project resulting in its representation; a neat distinction between artistic work and academic reflection, between practice and its documentation after the fact. We can use artistic criteria to evaluate the theatrical performance, and academic standards to decide whether the research of the project merits peer-reviewed publication. The documentation itself, however, creates a confusion of this dichotomy stemming from, and intending to nudge the reader towards, the approach put forward in this chapter. From the start, it aimed to refuse several implications: it tried to refuse being after the fact, to refuse its status as research of practice and to refuse its status as definitive and straightforward representation.

By representing 'ILLBEGONE', the documentation aimed to perform it, thus disturbing the dichotomy between artistic performance and academic reflection. Rather than drawing only on a representational style of rendering the project (with all its empiricist connotations), the documentation tried to develop a form of reporting that also performed some of the issues brought up within and through the project. For example, rather than only writing about the importance that the interviewees attributed to the singularity of performance, the documentation aimed to create a similar singularity by allowing only one reading of the text. If we use the notion of trajectory, the documentation of 'ILLBEGONE' insists on its belonging to the trajectory of 'ILLBEGONE'. As such, it is a comically trapped enterprise: stuck between the logic of theatrical practice, insisting on art as a practice that finds its fulfilment in the moment of performance, and the logic of naïve representation that agnostically describes and analyses practice without touching it as it flows. The documentation of 'ILLBEGONE' can be understood as artistic research in its attempt to work somewhere in the middle of those two logics.

Example 2: *O fado não se aprende*

Fado is a type of song that has developed since the mid-nineteenth century in the Portuguese capital Lisbon. It is performed by a fado singer and accompanied by at least one classical guitar and a twelve-stringed Portuguese guitar. Today, performances can be experienced in professionally organised fado houses and more informal settings such as fado bars, neighbourhood festivities and concourses. Fado music can also be heard at concerts and, since the 1920s, many recordings have been made available to a wide audience. The musicians,

singers (fadistas) and frequent attendees of fado performances together constitute the fado milieu, which shares a particular mode of discourse, conventions and rules. The performances are occasions on which different groups within this milieu meet to listen and discuss what fado is.

The statement that 'one cannot learn fado' is part of this Lisbon musical subculture. The project '*O fado não se aprende*' (Lemmens 2011) investigated the meaning and implication of this statement in relation to the learning process of fadistas within the fado milieu. If we were to take the sentence at face value, we would assume that it claims the impossibility of learning fado. The meaning of the word 'fado' is not explicit within the expression. Before the statement can be refuted or argued for, the definition of 'fado' has to be clear. In practice, however, there are many definitions of 'fado'. Within the central expression naming the project, the article '*O*' also has to be taken into account when considering the meaning of 'fado'. As fadista and researcher José Manuel Osório explains, the '*O*' makes all the difference: it changes 'fado' into 'the fado'. 'The fado' is a general indication of a certain music practice and thus also incorporates its socio-historical and discursive expressions, which are indeed not consciously learned. 'Fado' without the article refers to the specific music and performance skills associated with this genre. If one were to refer to 'fados' in the plural, one would be referring to the songs themselves, which surely are learned by young fadistas through oral tradition. The article thus takes the word to an abstract level that goes beyond what one could learn.

Inquiring into the importance of the article '*O*' in the sentence '*O fado não se aprende*', has set the research into motion. The first question has arisen: what is the difference between 'the fado' and 'fado'? The statement no longer stays untouched since questions challenge and investigate its meaning, its performative force and its consequences. The claim '*O fado não se aprende*' has turned into the research question of the project '*O fado não se aprende?*'. The leading question in the project therefore becomes: how can we understand the learning processes of fadistas in light of this statement? At this stage of the project, the researcher came up with a way of approaching this expression and of addressing the leading question. She asked herself: can I learn to sing fado? And if the answer turned out to be affirmative, would it prove the statement wrong? If the answer were negative, would it confirm the assertion?

Over seven months of research, the researcher used her own voice as a research tool in order to find out whether she could learn to sing fado, and how this learning process would take shape. The research setup departed from auto-ethnographic methods, using the researcher's own experiences and voice as objects of reflection throughout the project. Within the framework of ethnomusicology and artistic research, artistic practices were staged at the centre of this research. The relatively new academic field of artistic research allowed for a creative exploration of research methods and forms of presentation. This explorative mode made it legitimate to write and present the project in an

unconventional manner. The exposition of this project in the RC aimed to propose an exploration of new means of presenting research. It questioned the rigid structures of academic essay writing in order to present the reader with an unusual autonomy and consequently with a responsibility. In the RC exposition, autonomous readers are presented with many choices and options regarding the path they wish to take through this writing. They could choose to read it from start to finish, ignoring the visual cues of the hyperlinks, or they could surprise themselves with the invitations to pursue relating texts. The words that appear in the text as blue can be clicked on. One is then forwarded to the related page somewhere else in the project. Either way, one is confronted with an unusual order of chapters. This places responsibility on the reader to be active in the process of discovery. As in any website structure, the information only appears through active clicking and does not present itself naturally as it would when turning a page of a book.

The exposition explicitly aims at giving the visitor to the catalogue the experience of following a series of trajectories. In these travels, the expression 'O fado não se aprende' is the guide through the presentation of the research. The individual words of the Portuguese sentence form chapters, of which some contain various subchapters. By clicking on a word in the sentence, the visitor thus encounters a perspective, or rather several perspectives, on the statement. Each chapter, and sometimes subchapter, contains its own story, which the researcher chose for diverse narrative or argumentative reasons, depending on the atmosphere or context she was attempting to create. She experimented with an alternating use of passive and active voice in the texts, although emphasising her own presence in both cases. Several chapters contain audio and video material rendering the sonic aspects of the learning process. The audio files are not easy listening material: they not only contain recordings of fado nights, but also lessons and rehearsals. On some recordings one hears parts of the same fado again and again in order to show the development of the learning experience. Visitors are free to browse the audio and video files and to listen to the parts they are interested in.

Like the documentation of 'ILLBEGONE', 'O fado não se aprende?' refuses to accept the dichotomies of artistic creativity and academic research. It also aims to do what it claims by giving one the possibility to create one's own trajectories throughout the written, audio and video material. In both cases it can be said that the expositions are part of a chain of transformations reminiscent of the journey of Amazonian soil to the publication of a scientific article. Instead of bridging a gap between the artistic event and the presentation of this event after the fact, the expositions are part and parcel of the artistic-research process from the very start. They are part of the assemblage, or *gathering* in the Latourian sense, that emerged through the performance of virtual bodies and the learning process that explores the culture of fado – thus articulating them as 'matters of concern'.

Concluding remarks

Speaking in terms of 'matters of concern', as Latour suggests, enables us to move beyond the dualisms of science and art. There is no need to answer the question regarding how to expose art as research in terms that belong exclusively to either the domain of science or the arts. Instead, we can think of the exposition of art as research as part of the gathering of agencies that form 'matters of concern'. In the example of the fado project, the exposition can be seen as a simultaneous 'mapping' and 'assemblage' of the multitude of attachments that perform the fado as a 'matter of concern', rather than the 'matter of fact' of fado singing as a practice that can be explained from culture and context. The exposition in the RC enables an artistic researcher to trace the non-linear, relational and heterogeneous character of this gathering. There is no privileged point of view, nor are there hegemonic categories such as 'science' or 'art' to navigate these mappings and assemblages. Consequently, what we know from artistic research is provisional.

As it is, the exposition is not only a passive mapping, but actively invites the attachment of new agencies, thus enriching the situation. The exposition *is* not a part of the work of art, it *does* part of the work of art. In fact, it is precisely through this work that it can be said to characterise the existence of the 'artwork' as the 'work of art', which is not just a descriptive, but also a normative insight. As Latour phrases it: 'the more *attachments* it has, the more it exists. And the more mediators there are the better' (Latour 2005a: 217). Good art, in this view, as a matter of concern assembles more mediators and thus reinforces its existence, not as an object of knowledge, but as a trajectory of performances and translations.

To see the exposition of art as research as a 'matter of concern' can help us to rethink how these expositions work in the practice of artistic researching. First, they change our notion of the ontology of art: expositions as 'matters of concern' are part of what brings the work of art into existence, not just the representation or documentation of this work of art. Second, and consequently, the exposition can be seen as an arena that organises the gathering of agencies that would previously have been external to the works of art, such as fellow artists, critics, academic scholars and the general public. Reasoning in a Latourian register, the exposition enables us to perceive the work of art as if we have been invited to a gathering about an issue that involves us, that we care about, that we like, with which we would want to experiment; in short, of which we want to become a part.

References

Benschop, R., 2011. 'I'll be Gone Again. Documenting the Virtual Body.' *Research Catalogue.* Available at: http://www.researchcatalogue.net/view/5496/5497 [Accessed 22 November 2012]. Written documentation available at: http://www.thevirtualbody.org/ [Accessed 22 November 2012].

Despret, V., 2004. 'The Body We Care For: Figures of Anthopo-Zoo-Genesis.' *Body & Society* 10(2-3), pp. 111-34.

Despret, V., 2005. 'Sheep Do Have Opinions.' In: B. Latour & P. Weibel (eds.), *Making Things Public: Atmospheres of Democracy.* Karlsruhe & Cambridge, MA: ZKM/ Center for Art and Media, MIT.

Galison, P., 1987. *How Experiments End.* Chicago: University of Chicago Press.

Gomart, E. & Hennion, A., 1999. 'A sociology of attachment: music amateurs, drug users.' In: J. Law & J. Hassard (eds.), *Actor Network Theory and After.* London: Blackwell.

Gomart, E., 2002. 'Methadone: Six Effects in Search of a Substance.' *Social Studies of Science* 32(1), pp. 93-135.

Latour, B., 1988. *The Pasteurization of France.* Cambridge, MA: Harvard University Press.

Latour, B., 1990. *Drawing Things Together.* In: M. Lynch & S. Woolgar (eds.), *Representation in Scientific Practice.* Cambridge, MA: MIT Press.

Latour, B., 1999. 'Circulating Reference. Sampling the Soil in the Amazon Forest.' In: *Pandora's Hope: Essays on the Reality of Science Studies.* Cambridge, MA: Harvard University Press.

Latour, B., 2004a. 'How to Talk About the Body? The Normative Dimension of Science Studies.' *Body & Society* 10(2-3), pp. 205-29.

Latour, B., 2004b. 'Why has Critique Run out of Steam? From Matters of Fact to Matters of Concern.' *Critical Inquiry* 30 (Winter 2004), pp. 225-248.

Latour, B. 2005a. *Reassembling the Social. An Introduction to Actor-Network Theory.* Oxford: Oxford University Press.

Latour, B., 2005b. 'From Realpolitik to Dingpolitik. How to Make Things Public. An Introduction.' In: B. Latour & P. Weibel (eds), *Making Things Public. Atmospheres of Democracy.* Cambridge, MA: MIT Press.

Latour, B., 2008a. *What Is the Style of Matters of Concern? Two Lectures in Empirical Philosophy.* Assen: Van Gorcum.

Latour, B., 2008b. 'The Migration of the Aura, or How to Explore the Original Through its Facsimiles.' Available at: http://www.bruno-latour.fr/node/151 [Accessed 8 June 2013].

Lemmens, B., 2011. '*O fado não se aprende.*' *Research Catalogue.* Available at: http://www.researchcatalogue.net/view/1445/1446 [Accessed 22 November 2012].

Lemmens, B., 2012. 'The learning process in fado through artistic research'. *Journal for Artistic Research* 1(2). Available at: http://jar-online.net [Accessed 18 June 2013].

Marres, N., 2007. 'The Issues Deserve More Credit: Pragmatist Contributions to the study of public involvement in controversy.' *Social Studies of Science* 37(5), pp. 759-780.

Nowotny, H., 2011. 'Forward.' In: M.A.R. Biggs & H. Karlsson (eds.), *The Routledge Companion to Research in the Arts.* London: Routledge, pp. xvii-xxvi.

Saaze, V. van, 2009. *Doing Artworks. A Study into the Presentation and Conservation of Installation Artworks.* PhD dissertation, Maastricht University, Netherlands Institute for Cultural Heritage.

Schwab, M., 2010. 'Works and Expositions in the ARC.' In: *Work-in-progress conference Artistic Research Catalogue: Works and Expositions.* Discussion paper. Gothenburg, Sweden, 10-11 December 2010.

Star, S.L. & Griesemer, J.R., 1989. 'Institutional Ecology, "Translations" and Boundary Objects: Amateurs and Professionals in Berkeley's Museum of Vertebrate Zoology, 1907-1939.' *Social Studies of Science* 19(3), pp. 387-420.

Exposition

By Rolf Hughes

The simplicity of nature is not to be measured by that of our conceptions.
Pierre-Simon Laplace, *Exposition du système du monde* (1796)

I say no world
shall hold a you
Edward Estlin Cummings, from *Four Poems* (1940)

'How splendid it would be', muses the French poet Paul Valéry, 'to think in a form one had invented for oneself' (Valéry 1962: 649). This implies that as long as we are *not* thinking in a form we have invented for ourselves, we are obliged to adapt, translate or otherwise shape our thinking to the vehicle of its expression. If we then make an additional claim for this expression – e.g. as research – we face a further separation between what may be considered *the work itself* and *the account* given concerning its significance. Here we have a preliminary definition of what distinguishes artistic research from artistic practice *per se* – the challenge of giving an account of a work or method, of 'making a claim', while still respecting a work's intentions and coherence on its own terms.[1] Such an account may be articulated from *within* a community of practitioners, yet addressed to an audience *beyond* such a community (and therefore concerned with both *strengthening* and *extending* a practice). It follows that the question of exposition becomes a vital consideration, for it is here that the work's wider significance is articulated, defended and assessed.

Changing definitions of 'exposition' hint at the rise of scientific thinking over several centuries as the term evolves from notions of displacement to those of setting forth and explaining. Hence under 'exposition' in the Oxford English Dictionary (1989) we read:

being put out of a place, expulsion (C16-C17); 'aspect' i.e. situation in regards the quarter of the heavens (C16-C19); action or process of setting forth, declaring, or describing either in speech or writing (C14-C20); action of expounding or explaining; interpretation, explanation (C14-C19); an expository article or treatise; a commentary (C15-C19).

1. On the notion of giving an account see, for example, Hughes 2007 and Butler 2001.

Over the same period, the shift in emphasis from oral to literary modes of exposition eventually produced the conventions of academic writing – arguably, the pinnacle of this process of 'technologising' exposition.[2]

In the Enlightenment shift from *scientia* as knowledge of God to *scientia* as knowledge of nature, the written account of experiments became 'an exercise in the rhetoric of truth', which could be set forth by the writer without 'the transcendental-theoretical problems of theological argument':

> The scientific report would not be a set of instructions to be replicated or a set of arguments to be deconstructed, but a claim to significance by a 'modest witness', who must firmly position themselves in what Traweek calls a 'culture of no culture.' Lorraine Daston describes this culture as reliant upon a moral economy of 'gentlemanly honor, Protestant introspection, [and] bourgeois punctiliousness.' In this mode, the written report must be seen to 'guarantee' the validity and transferability of knowledge as a unit of truth. Ironically, this 'transferability' would be obtained through the suppression of both the written rhetorical skills of the creator and their tacit experimental knowledge. Science would philosophically appropriate writing as a supposedly neutral container for knowledge in general. To achieve credibility the scientist must suppress the subjective conditions of production to construct a blank neutral facticity, guarding against the dread errors of 'idolatry, seduction, and projection' that might compromise objectivity and breach decorum (Butt 2012).

2. Simon Goldhill has outlined how the development of the prose of philosophy and science was inseparable from the vigorously contested issue of 'giving an account', or *logon didonai*, in the classical city of Plato and Socrates. Each was based on an unresolved tension between authority and persuasiveness – the seemingly irreconcilable impulses of disclosure and dissimulation. At the same time as Plato is designing a formal model of philosophic argumentation – effectively setting up philosophy as *the* authoritative model for understanding the world – he is also, according to Goldhill, 'brilliantly adopting and adapting the persuasive, dramatic power of the dialogue format and its lures of narrative and characterization'. The project hinges on Plato's characterisation of Socrates as 'the authority figure who claims and disclaims (his own) authority', a strategy that allows Plato 'not to represent his own voice but always to remain concealed within and behind the conversation of the bare-footed wandering gadfly, questioning and teasing whomever he happens to meet'. With Aristotle's treatises on logic, however, argument becomes its own master. 'Argument's truth or authority does not depend on an ability to persuade an audience, but on its own rules', Goldhill writes. Debate – the clamour of competing voices – becomes silenced by the authority of philosophic argument. And with the arrival of prose, comes a new sense of humankind as a responsible and knowing agent, making prose 'the medium of the intellectual, cultural and social revolution of the Greek enlightenment' (Goldhill 2002, pp. 109-10).

A further suppression concerned that of writing's own materiality. Berel Lang writes:

> The assumption [...] is that the act of writing has nothing – at least nothing *essential* – to do with the act of philosophy; that philosophy as spoken, 'oral' philosophy, would have the same character that written or 'literary' philosophy does, and that the two of them would be identical to philosophy as it might be thought but not yet expressed, or even to philosophy in its hidden truth before it had been thought at all (Lang 1990: 11).

Academic writing accordingly developed its own codes of complexity, formality, precision, objectivity, explicitness and accuracy (using tools, devices or materials 'appropriately' and involving a tuning or calibration process). It incorporates *hedging* (defined as the limits that a work accepts in order to be comprehensible within a specified genre), and *responsibility*, the notion that the author is a trustworthy authority whose arguments are made in good faith (Schwab 2012: x). Over recent decades, the proliferation of critical perspectives such as feminism, Marxism, postcolonialism and the self-reflexivity of postmodernism, alongside much emerging artistic research, has brought about a multiplicity of voices (what Milan Kundera celebrates as 'polyphony' in *The Art of the Novel*), as well as an increasing diversity of presentational forms (Schwab 2012). Such increased self-reflexivity has brought the concerns of rhetoric – here understood as 'the inventive and persuasive relation of speakers and audiences as they are brought together in speeches or other objects of communication' – sharply into focus (Buchanan 1989: 91).[3] Herbert Simons even claims:

> Broadly speaking, virtually all scholarly discourse is rhetorical in the sense that issues need to be named and framed, facts interpreted and conclusions justified; furthermore, in adapting arguments to ends, audience, and circumstances, the writer (or speaker) must adopt a persona, choose a style, and make judicious use of what Kenneth Burke has called the 'resources of ambiguity' in language. That the style of a scholarly article may be influential in a given case need not invalidate its logic and may even enhance it (Simons 1990: 9).

At the same time, a great deal of artistic research, particularly in the performance arts, is committed to the pursuit of insight via methods and processes that do not necessarily lend themselves to textual documentation:

3. Some claim a 'counter tradition to objectivism' has existed since the time of Vico and Nietzsche and trace a 'new sophistic' through the work of such figures as Freud, Wittgenstein, Heidegger, Arendt, Foucault, Derrida, Hayden White and Kenneth Burke. See, for example, Nelson 1983, p. 7, cited in Simons 1990, p. 7.

The research field has emerged partly from a need to formulate, deepen and systematise artistic activities, and partly from an increased interest in knowledge-generating processes with greater elements of innovative thought, interpretative and critical reflection, design, representation and communication *using techniques other than verbal text* (Hughes, Dyrssen & Hellström Reimer 2011, my emphasis).

Artistic research opens the possibility of a productive interplay between differing ways of thinking, interacting, experiencing and of thereby creating new modes of discourse and argumentation, as well as research methods and artefacts. This suggests that it engages the play of multiple 'rationalities' or sensibilities, even provoking cognitive dissonance in its audience as an appropriate framing of its unresolved questions.[4] Henk Borgdorff concludes his paper 'Artistic Research within the Fields of Science', by celebrating the field's protean and transformative qualities:

> What is artistic research all about? It is about cutting-edge developments in the discipline that we may broadly refer to as 'art'. It is about the development of talent and expertise in that area. It is about articulating knowledge and understandings as embodied in artworks and creative processes. It is about searching, exploring and mobilising – sometimes drifting, sometimes driven – in the artistic domain. It is about creating new images, narratives, sound worlds, experiences. It is about broadening and shifting our perspectives, our horizons. It is about constituting and accessing uncharted territories. It is about organised curiosity, about reflexivity and engagement. It is about connecting knowledge, morality, beauty and everyday life in making and playing, creating and performing. It is about 'disposing the spirit to Ideas' through artistic practices and products. This is what we mean when we use the term 'artistic research' (Borgdorff 2008).

Artistic research, then, is expected to develop autonomously, on its own terms and according to its own precepts (the artist's assumed prerogative), while yet being charged with a revitalising function since it is additionally expected to add new methods and imaginative possibilities to established scientific conventions. Freed from the restrictive rigours of mono-disciplinary logics, artistic research becomes a force field of shape-shifting potentiality. The attraction of such potentiality, in contrast to the ruins of once optimistic disciplinary desires, is obvious.

4. 'The theory of cognitive dissonance says that people reject ideas which are violently at odds with their preconceptions. The theory of selective perception says that people may simply screen out impressions which are at variance with their existing beliefs' (Hedges, Ford-Hutchinson & Steward-Hunter 1997, p. 66).

And yet the term 'artistic research', as with related terms such as 're-search into art', 'research through art', 'research for art', 'arts-based research', 'practice-based research', yokes together research and art in a way that seem-ingly frames thought 'such that it excludes the possibility that the practices of art include practices that merit the label research, or that its products include outcomes that contribute to knowledge and understanding', as Stephen Scriv-ener remarks (2011: 259).

Critics such as Danny Butt bemoan works that 'groan under pointless descriptions of dull making processes, overblown and unconvincing attempts by artists to write their own work in an art historical tradition, or perhaps worst of all, interesting practices (de)formed into "research questions" that the works are then supposed to answer'. The written exegesis required by artistic research has led, in Butt's view, to 'crimes of writing'. Why? Because 'art points to the emergence and decline of stable discourses, zones where the seeable moves into or out of the realm of the sayable'. Furthermore, the art market itself favours the artist as a 'a producer of mystery rather than an explainer'. The exegesis of the artwork thus becomes 'a particularly useless form both in the university and in the art world, existing only to allow a bureaucratic calculation of the student's acceptability for an awarded degree' (Butt 2012).

At the other end of the scale, how are we to respond to an artistic work that 'prefers not' (like Melville's Bartleby) to document its own processes? In Carsten Höller's *The Baudouin/Boudewijn Experiment: A Large-Scale, Non-Fa-talistic Experiment in Deviation* (2001) , Höller invited 100 people to spend twenty-four hours in the space of Brussels' landmark Atomium, stepping out of their usual 'productive' lives for one day.[5] Höller stipulated:

> *The Baudouin/Boudewijn Experiment* will not be documented by means of film or video; the only 'recordings' will be the memories of the par-ticipants, and these will be disseminated through the stories they may tell after the event. The experiment will thus be completely unscien-tific, since objectivity is not the aim. Rather, it will be a unique op-portunity to experience together the possibilities of escape from one's daily routine, to participate in a unique event with an unclear outcome (Höller 2001).

For the critic Boris Groys, Höller's project, far from eradicating documenta-tion, actually reinforces its central importance:

5. The project was inspired by the example of the late H.M. Baudouin, King of Belgium, whose Catholic beliefs forbade him from signing into law a bill permitting abortion, as a result of which the king, in agreement with the Belgian government, had himself declared incapable of ruling the country for twenty-four hours on 4 April 1990, suspending his royal activities so that the legislative procedure could be enacted.

Höller frequently engages in transforming the 'abstract,' minimalist spaces of radical architecture into spaces for experience – another way of transforming art into life by means of documentation. In this case, he chose for his performance a space that embodies a utopian dream [...] Primarily, however, the work alludes to commercial television shows such as 'Big Brother', with its portrayal of people forced to spend a long time together in an enclosed space. The difference between a commercial television documentation and art documentation becomes particularly clear. Precisely because television shows uninterrupted images of these enclosed people, the viewer begins to suspect manipulation, constantly asking what might be happening in the space hidden behind these images in which 'real' life takes place. By contrast, Holler's performance is not shown but merely documented – specifically, by means of the participants' narratives, which articulate precisely that which could not be seen. Here, then, life is understood as something narrated and documented but unable to be shown or presented. This lends the documentation a plausibility that a direct visual presentation cannot possess (Groys 2002).

But, Groys continues, an important question remains unanswered, namely:

if life is only documented by narrative and cannot be shown, then how can such a documentation be shown in an art space without perverting its nature? Art documentation is usually shown in the context of an installation. The installation, however, is an art form in which not only the images, texts, or other elements of which it is composed but also the space itself plays a decisive role. This space is not abstract or neutral but is itself a form of life. The siting of documentation in an installation as the act of inscription in a particular space is thus not a neutral act of showing but an act that achieves at the level of space what narrative achieves at the level of time: the inscription in life (Groys 2002).

'Artistic documentation', while problematic, would appear to be less fraught than the pairing of the terms 'artistic research', which suggests a similar sort of *neither/nor* and *both/and* paradox as can be found in the literary genre of the prose poem (being neither prose nor poetry, yet prose in appearance while using all the techniques of poetry internally).[6] A liminal space opens – the threshold between two concepts – demanding the reader/viewer's participation to activate the play of hermeneutic potentialities. This might be compared to the curious term 'unfinished thinking', which Borgdorff uses to characterise the sort of 'embodied' experiences and insights that artistic research offers, the material outcomes of which, he claims, are 'non-conceptual and non-dis-

6. I discuss this question at greater length in Hughes 2011, pp. 109-110.

cursive', and the persuasive quality of which is located in 'the performative power through which they broaden our aesthetic experience'. Again, the value of safeguarding a provisional indeterminacy is emphasised, and the field is accordingly characterised as 'the articulation of the unreflective, non-conceptual content enclosed in aesthetic experiences, enacted in creative practices and embodied in artistic products' (Borgdorff 2011: 47). Whether one accepts such a formulation or not, it does vividly foreground the problem of the assessment and evaluation of artistic research. Many artistic researchers are keen to stress the notion that established models of assessment from the sciences and humanities are not applicable to artistic research. What, then, is applicable as a measure of assessment? How do we establish the basis of judgment? Are such values transferable or peer-specific? How can the established conventions of peer review serve the double demands of artistic research?[7]

Artistic research raises many questions about our assumed relationship to knowledge. What is 'knowing' for artists? How do they know what they know? Can they communicate this knowledge to a third party, one outside their community of practitioners? And, if so, what might be the most apt form, performance or 'structure of attention' for doing so? The problem of exposition becomes particularly acute in the performing arts, where the experiential basis of artistic process and encounter is central. Michael Biggs has written of artistic research (or 'practice-led research' as is common in the UK) as comprising an experiential component that is communicable to others. But the core of the problem, Biggs claims, is indeed the communication of experiential content. To attempt such communication is to take decisions about the meaning of an experience, its experiential content and how that might be related to our shared context. Biggs argues that the question of whether one can reflect upon experience and the extent to which either reflection (i.e. cognition) or expression (i.e. linguistic or non-linguistic representation) 'corrupts' the experiential content is a profound ontological and epistemological question. 'We can translate the problem of experiential content into one of representation', Biggs writes:

> [W]e can identify a feature that is sufficiently important as to underlie the most intractable problem of research in this area. The problem is that the experiential feelings that represent experiential content are private to the experiencing individual. Experiences must be expressed in the first person; 'I feel ...'. While they remain private experiences they cannot reasonably be regarded as research because they do not meet the criterion that research should be disseminated [...] But the problems of identifying and communicating first person experiences to second and third persons is notoriously difficult (Biggs 2004).

7. These questions have been addressed in detail by the editors of and contributors to *JAR* since its inception.

Each artistic research project, then, is obliged to find or design the most appropriate form to express (or stage, exhibit, unfold etc.) its findings resonantly.[8] What are the implications of this for an academic culture built on the standardisation of formats and the duplication and wide dissemination of results?

For some, the return of writing, now operating under an expanded, shape-shifting 'creative and critical' brief, conscious of its own logocentric biases – and thus fully capable of snuggling up to the very forces that were supposed to resist its overbearing charms – might undermine the special characteristics of artistic research as an extra-linguistic mode of research. What happens to Michael Polanyi's notion of 'tacit knowledge' – the idea that 'we can know more than we can tell' – if we can write crisp, peer-reviewed essays defining it and extolling its central importance?[9] What happens to the sensory encounter with the material qualities of a specific artefact if this aura-rich experience may be satisfactorily invoked via an *ekphrastic* catalogue essay or research article? Can one describe in words the tactile qualities of a craft object such that it enters our thinking and emotions through our fingertips? Artistic research acknowledges the full range of conceptual and sensory information that can be brought to bear in an attempt to make sense of something. But this brings the risk that under cover of the supposed 'ineffability' of the artist's or designer's material practice, the onus of interpretation is shifted (some would say unduly) to the work's intended audience, reader – or examiner. How 'translatable' is aesthetic pleasure or sensory experience generally?[10]

While it is important, of course, to acknowledge that there is in artistic research a widespread description problem, it may be equally important to note that questions of research relevance, impact and evaluation are not infrequently deferred in favour of investigations into 'the creative process', or mappings of form, influences or other varieties of introspective inquiry subsumed under the sometimes solipsistic concept of 'reflective practice'.[11] Reflective practice in the arts often assumes an individual agent toiling away to 'author' creative work

8. Schwab lists the modes of writing typically associated with artistic research exposition as: exposure, staging, performance, translation, exhibiting, reflection, curating, unfolding. These, he claims, are furthermore being extended through the RC project (Schwab 2012, p. 342).

9. Polanyi 1967, p. 4. Tacit knowledge is described by the philosopher of science Thomas Kuhn as 'knowledge that is acquired through practice and that cannot be articulated explicitly'. See *The Structure of Scientific Revolutions* (1962).

10. Ludwig Wittgenstein asks the following: 'Describe the aroma of coffee. Why can't it be done? Do we lack the words? And for what are words lacking? But how do we get the idea that such a description must after all be possible? Have you ever felt the lack of such a description? Have you tried to describe the aroma and not succeeded?' (Wittgenstein 1986, p. 159, § 610).

11. I discuss this description problem in Hughes 2009, pp. 247-259. See also Jones 2009.

– a modern self, in short, and with it a theory of cultural production. Since this conceptualisation of authorship underpins much of the debate around exposition, it is worth pausing to consider what it means to assign a certain body of work to a specific individual. How do categories of *author* and *work* inform each other when documenting artistic research that is typically a complex weave of collaborations? What interdisciplinary perspectives might we bring to investigate the cultural, technological and economic aspects of cultural production – not least the institutions of *ownership* and *reward* that historically legitimise and reinforce the bond between author and intellectual property? Michel Foucault's observation that 'it would be worth examining how the author became individualized in a culture like ours, what status he [*sic*] has been given, at what moment studies of authenticity and attribution began, in what kind of system of valorization the author was involved, at what point we began to recount the lives of authors rather than of heroes, and how this fundamental category of "the-man-and-his-work criticism" began' (Foucault 1977), should be borne in mind lest exposition becomes simply another device for claiming ownership of overlapping processes and diverse inputs.

Authorial identity historically derives from a paradox: mastery of the materials of authorship in their passage from idea, inspiration or commission to audience involves a surrendering of self-mastery (to influences 'beyond one's control' such as divine afflatus or Romantic inspiration) combined with a highly disciplined command of materials (and therefore self). The patriarchal notion of an author 'fathering' his text, rather as God purportedly 'fathered' the world, has been all-pervasive in Western literary civilisation, so much so that the metaphor is built into the very word *author*, with which writer, deity and *pater familias* are identified.[12] In England, the modern representation of the author as the originator and proprietor of a special commodity – the oeuvre – derives from blending Lockean discourses of property and selfhood with the eighteenth-century discourse of original genius. By the early nineteenth century, the figure of the Romantic author brought the notion of the author as a creative individual who, by virtue of stamping the imprint of a unique personality on original works, takes them into ownership and thereby provides the paradigm and reference point for intellectual property law. At the same time, copyright discourse has always struggled with the paradoxical notion of 'incorporeal property', with its analogous relations between corporeal and incorporeal, material and immaterial, body and consciousness.[13]

12. See Márton Dornbach's review of Timothy Clark (Dornbach 2003). Dornbach comments 'Inspiration … places the author in a precarious constellation with two forms of otherness: the dictating authority and the audience. The resultant "crisis of subjectivity" explains the often ambivalent role played by inspiration in many writers' self-understanding.'

13. See Biagioli & Galison 2003. On authorship in the humanities see, for example, Minnis 1984 and Burke 1992.

Furthermore, as in the multi-authorship of a typical scientific-research project, an artistic-research project might involve an artefact (or series of artefacts), a collection or archive (library or database), a series of collaborations (both acknowledged and unacknowledged), resulting in a final exhibition, performance (or series of performances), and/or publication. The outcome, in other words, is a distillation of a longer process of interpreting, adapting and applying information derived from various collection systems (historical, methodological, educational or technical), made available to an audience via an experience in (or across) time.

The time-based arts have the potential to explore and express 'embodied knowledge', to place the body centre stage in artistic research, while calling into question the appropriateness of language for communicating research processes and results. This poses further challenges when it comes to exposition. Caroline Rye writes:

> Issues of documentation are of critical concern to the question of practice as research in performance and are particularly charged for two paradoxical reasons. First, because the research may be concerned with exactly those qualities of the live encounter and the production of embodied knowledges which cannot, by definition, be embedded, reproduced or demonstrated in any recorded document. Second, more pragmatically, if one wishes one's research to have a life beyond its original live manifestation, and thus be available to a broader research community, the practitioner/researcher has to engage with the creation of appropriate performance documents (Rye).

As in other forms of artistic documentation – the exhibition catalogue is a prominent example – the risk is that the record eclipses the event it supposedly re-presents, diminishing (or even eradicating) the distinctive, living qualities of embodiment and encounter in a time and space framed as singular, transient, site-specific and non-repeatable. We again confront the challenge of designing an appropriate encounter and conversation around a work that, at a minimum, satisfies the sometimes diverging priorities of researcher and creative practitioner.

It is not difficult to agree with Valéry that it would be best to think in a form that one had invented. We can look forward to artistic research rising to this challenge. Yet each way of encountering the world also contains elisions and exclusions. When we privilege a particular way of seeing or speaking or moving, we are also closing off other courses of action. A vantage point is partial; materials, languages, conventions, genres, institutions – all contain their own constraints. Lawrence Weiner famously designates 'language + the materials referred to' as the medium for his work, allowing him to situate his textual-sculptural practice in a wide range of geographical locations and cultural systems (or 'points of reception', in Weiner's words). Expositional

writing seeks closer contact with artistic, craft and design practices. Multiplying areas of interest increasingly crowd the curriculum: art writing; materiality and genre; the aesthetics of the dematerialised artefact; language as sculpture; sound art; the role of language in Conceptual art, not to mention the work of Barbara Kruger, Jenny Holzer, Fiona Banner and Gillian Wearing.[14] How do the characteristics of literary, critical and philosophical genres of inquiry shape relationships to spatial, (im)material and experiential practices through materialised descriptions, installations, performances, philosophical dialogues and critical poetics? How might artistic-research practitioners rethink the relationship between critical and creative practice through a close engagement with genre, style and related questions of voice, subjectivity, point-of-view, spatiality, perspective, embodiment and materiality?

At Konstfack University College of Arts, Crafts and Design in Stockholm, I run an elective Masters course titled *Language + Materials: Word, Image, Sound, Performance.*[15] The course explores the age-old conflict between meaning and persuasion (or philosophy and rhetoric). Through works associated with different media and forms of presentation (books, posters, videos, films, records, sound art, drawings, multiples, installations, and more) students are invited to explore such themes as conceptual writing, epistemological conceptualism, the boundaries of genre, hybrid text/material hybridity, transdisciplinary textual strategies, topographic writing, site-specific art involving words, fictocriticism, haunted writing, architectural writing/writing architecture, interactive text, the fragment, the collage, the labyrinth, hypertext, performance writing (writing in/as/through performance) and sound art involving language, language as sculpture, ineffable experience, the limits of expressivity, *ekphrasis*, giving voice to a mute object (*prosopopeia*), bringing an object vividly into the reader's imagination (*enargia*), rhetoric, form, content and ethics, robotic poetics, generative art, random poetry, comics and the graphic novel, typography and authorship, the 'art of authenticity', conventions of reading, 'iconic writing' – writing captions and/or catalogues for exhibited artefacts, the tension between artefact (or device) and response, performance and review, experience and articulation.

If artistic research is conceived (as I do here) as disruptive, dialogic, polyphonic, animal, monstrous even, we might justly ask what forms of research exposition are likely to emerge when such dichotomies as image/word, artefact/language, origin/caption, event/narrative, artwork/exposition are supplanted by the logic of the 'device'? Does our focus shift to *the quality of the encounter*, and the *conversation* by which we configure and hopefully *understand each other's experience?* Might this ultimately become an instance of a *difference that makes a difference?*

14. For an excellent overview of such work, see Morley 2003.

15. A professional education version of the course is also scheduled, starting Spring 2014.

References

Biagioli M. & Galison, P., 2003. 'Introduction.' In: *Scientific Authorship: Credit and Intellectual Property in Science*. Mario Biagioli & Peter Galison (eds.), New York & London: Routledge.

Biggs, M., 2004. 'Learning from Experience: approaches to the experiential component of practice-based research.' In: *Forskning, Reflektion, Utveckling*. Stockholm: Vetenskapsrådet, pp. 6-21.

Borgdorff, H., 2011. 'The Production of Knowledge in Artistic Research.' In: Michael Biggs & Henrik Karlsson (eds.). *The Routledge Companion to Research in the Arts*. London & New York: Routledge.

Borgdorff, H., 2008. 'Artistic Research within the Fields of Science.' Available at: http://www. utbildning.gu.se/digitalAssets/1322/1322679artistic-research-within-the-fields-of-science.pdf [Accessed 20 November 2012].

Buchanan, R., 1989. 'Declaration by Design: Rhetoric, Argument, and Demonstration in Design Practice.' In *Design Discourse: History, Theory, Criticism*. V. Margolin (ed.). Chicago & London: University of Chicago Press.

Burke, S., 1992. *The Death and Return of the Author*. Edinburgh: Edinburgh University Press.

Butler, J., 2001. 'Giving An Account of Oneself.' *Diacritics* 31(4, Winter), pp. 22-40.

Butt, D., 2012. 'The Art of Exegesis.' *Mute*, (10 April). Available at: http://www.metamute.org/ editorial/articles/art-exegesis [Accessed 20 December 2012].

Dornbach, M., 2003. 'Review of the book: *The Theory of Inspiration: Composition as a Crisis of Subjectivity* by Timothy Clark:' In: 'Romantic and Post-Romantic Writing.' *Studies in Romanticism* 42(2).

Foucault, M., 1977. 'What is an Author?' In: *Language, Counter-Memory, Practice: Selected Essays and Interviews*. Donald F. Bouchard (ed.). Oxford: Basil Blackwell.

Goldhill, S., 2002. 'Philosophy and Science: The Authority of Argument.' In: *The Invention of Prose*. Oxford: Oxford University Press.

Groys, B., 2002. 'Art in the Age of Biopolitics: From Artwork to Art Documentation.' Steven Lindberg (trans.), In: *Catalogue to Documenta 11*. Ostfildern-Ruit: Hatje Cantz, pp. 108-114. Available at: http://www.ranadasgupta.com/notes.asp?note_id=34&page=1 [Accessed 20 November 2012].

Hedges, A., Ford-Hutchinson, S. & Steward-Hunter, M., 1997 [1974]. 'How People Deal with Conflicting Ideas.' In: *Testing to Destruction: A critical look at the uses of research in advertising*. Ch.7, rev. ed., London: Institute of Practitioners in Advertising, pp. 66-70. Available at: http://apgsweden.typepad.com/apgsweden/files/TESTINGTODE-STRUCTION.PDF [Accessed 22 October 2012].

Höller, C., 2001. THE BAUDOUIN/BOUDEWIJN EXPERIMENT:A DELIBERATE, NON-FATALISTIC, LARGE-SCALE GROUP EXPERIMENT IN DEVIATION. Available at: http://www.nettime.org/Lists-Archives/nettime-bold-0109/msg00168. html [Accessed 20 November 2012].

Hughes, R., 2007. 'THE DROWNING METHOD: On Giving an Account in Practice-based Research.' In: *Critical Architecture*. J. Rendell, J. Hill, M. Fraser & M. Dorrian (eds.). London & New York: Routledge.

Hughes, R., 2007. 'The Hybrid Muse: Creative and Critical Writing in/as Practice-Based Research.' In: *The Unthinkable Doctorate*. Brussels: Sint-Lucas School of Architecture.

Hughes, R., 2009. 'Pressures Of the Unspeakable: Communicating Practice as Research.' In: *Communicating (by) Design*. J. Verbeke & A. Jakimowicz (eds.). Gothenburg & Brussels: Chalmers University of Technology & Sint-Lucas School of Architecture, pp. 247-259.

Hughes, R., Dyrssen, C. & Hellström Reimer, M., 2011. 'Artistic research today and tomorrow.' In: *Form och färdriktning. Årsbok KFoU 2011, Vetenskapsrådet* (Swedish Research Council, Annual Yearbook on Artistic Research), pp. 19-37.

Jones, R., 2009. 'Omphaloskepsis.' *Frieze* (13 May). Available online: http://blog.frieze.com/omphaloskepsis/ [Accessed 7 October 2013].

Lang, B., 1990. *The Anatomy of Philosophical Style*. Oxford: Basil Blackwell.

Minnis, A.J. 1984. *Medieval Theory of Authorship: Scholastic Literary Attitudes in the Later Middle Ages*. London: Scolar Press.

Morley, S., 2003. *Writing on the Wall: Word and Image in Modern Art*. Berkeley, CA, & Los Angeles: University of California Press.

Nelson, J.S., 1983. 'Political thinking and Political Rhetoric.' In: *What Should Political Theory Be Now?* John S. Nelson (ed.). Albany, NY: SUNY Press, pp. 176-93.

OED, 1989. *Oxford English Dictionary Second Edition*. J.A. Simpson & E.S.C. Weiner (eds.). 20 vols. Oxford: Clarendon Press.

Polanyi, M., 1967. *The Tacit Dimension*. New York: Anchor Books.

Rye, C., 'Incorporating Practice: a Multi-viewpoint Approach to Documentation.' *Journal of Media Practice* 3(2), pp. 115-123. Available online: http://www.bris.ac.uk/parip/scr.htm.

Schwab, M., 2012. 'The Research Catalogue: A Model for Dissertations and Theses in Art and Design.' In: *The Sage Handbook of Digital Dissertations and Theses*. London et al.: Sage, pp. 339-354.

Scrivener, S., 2011. 'Transformational Practice: On the Place of Material Novelty in Artistic Change.' In: *The Routledge Companion to Research in the Arts*. Michael Biggs & Henrik Karlsson (eds.). London and New York: Routledge.

Simons, H.W., 1990. *The Rhetorical Turn: Invention and Persuasion in the Conduct of Inquiry*. Chicago & London: University of Chicago Press.

Valéry, P., 1962 [1941]. 'Rhumbs.' In: *Oeuvres. Vol. 2*. Paris: Bibliothèque de la Pléiade.

Wittgenstein, L., 1986. *Philosophical Investigations*. trans. G.E.M. Anscombe, Oxford: Basil Blackwell.

Aesthetic Sensibility and Artistic Sonification

By Marcel Cobussen

> *It is not that art is the expression of the unconscious, but rather that it is concerned with the relation between the levels of mental process [...] Artistic skill is the combining of many levels of mind – unconscious, conscious, and external – to make a statement of their combination. It is not a matter of expressing a single level. Similarly, Isadora Duncan, when she said, 'If I could say it, I would not have to dance it,' was talking nonsense, because her dance was about combinations of saying and moving.*
>
> Gregory Bateson, *Steps to an Ecology of Mind* (1972)

Artistic Research I – Three Examples

Example 1. During a research seminar in Ghent (Belgium), guitar player Laura Young, investigating the (im)possibilities of transcribing, arranging and playing Max Reger's solo cello and viola suites on guitar, explains her project through the performance of certain parts of the scores she is studying. After her presentation, a philosopher-musicologist asks her whether she can legitimate some of her musical and technical decisions on the basis of a clear (discursive) rationale. After a brief silence Young has to admit that her choices cannot easily be supported by logical and verbal argumentation. A prolonged debate ensues from this: is she just relying on certain aesthetic and performance conventions, or are her choices inspired by some implicit knowledge? Was her performance mainly directed by an embodied routine, which Merleau-Ponty would describe as 'habitude', or was a certain 'reflection-in-action', as coined by Donald Schön, prevailing?

Example 2. The second chapter of Henrik Frisk's PhD dissertation *Improvisation, Computers and Interaction* discusses his musical piece *etherSound*. Put simply, *etherSound*, an improvisation for sax, drums and electronics, includes an invitation for listeners to send SMS messages to a specific phone number. These messages – the conditions are that they should have a reasonable word length (not too long and not too short) and enough vowels (as a means to increase the chance that it is indeed a meaningful word); preferably, they should make sense – are digitally translated into sonic material, directly audible for both players and audience. This audience-generated electronic input thus immediately affects the course of the improvised music.

Most pages in the dissertation are dedicated to a description of the tech-

nical sides of the project, including mathematical formulas, the use of Max/ MSP, and amplitude envelopes. In a short paragraph, Frisk discusses the translation of the SMS data into musical sounds:

> The choices that had to be made in the mapping of input to output in the program are the same kind of choices I make when I compose or improvise. I would call these compositional choices. They are based on my musical experience and what it is I want to achieve – for whatever reason – at any particular moment (Frisk 2010: 42).

Frisk reinforces his argument with a quote from the Italian computer engineer Antonio Camurri, who states that 'the designer of the performance introduces sound and musical knowledge into the system, along with compositional goals' (Frisk 2010: 42).

Example 3. One of the recent projects of Ton Koopman, famous scholar and performer of early music, is the recording of the complete works of the seventeenth-century Danish-German composer Dieterich Buxtehude. During a lecture, Koopman describes to the audience his preparations preceding the recording sessions: he visited the houses where Buxtehude had lived, investigated the churches where his music had been played, scrutinised scores, tracked down instructions that Buxtehude had left about how to perform his works, studied information written down by his students, and so on. The gathering of all this information forms the basis of the final goal: CDs and concerts.

According to Henk Borgdorff, artistic research remains naïve if it is not embedded in history and culture (Borgdorff 2007: 10). This naivety is certainly bypassed by Koopman. Although not really making distinctions between them, Koopman clearly refers to three types of authenticities distinguished by music philosopher Peter Kivy in his book *Authenticities*: authenticity as intention (the original intentions of the composer), authenticity as sound (the original sounding of the music), and authenticity as practice (the original practice of the performers) (Kivy 1995). However, Koopman never refers to what Kivy calls a fourth type of authenticity: a personal authenticity, derived from the performer's own integrity and reflecting his or her own creativity. Apparently Koopman finds it hard, impossible or perhaps even unnecessary to elaborate on this fourth type, which Kivy calls artistic integrity.[1]

Why are these three examples gathered here? What do they have in common? What is it that I want to show with these case studies?

1. Stefan Östersjö rightly claims that every serious performance of music composed in the past has to deal with a certain tension between these two imperatives: on the one hand, the obligation to conform to historical accuracy and informedness, on the other hand, the call for a creative originality that should make a 'version' into a work in its own right (Östersjö 2008, p. 104).

Although at different stages in their career, the three people mentioned are all artistic researchers; they are all starting from more or less clearly defined research questions or hypotheses; all three are collecting information in order to provide some answers to their questions or to test their hypotheses; and the final results are new works of art or at least new interpretations. However, they are also encountering more or less the same problem. The first example shows a clash between the (academic) request for legitimisation of (artistic) choices that determine the research, and the researcher's inability to provide this legitimisation on academic terms. In the second example, many pages are spent on the description of the parts of the project that can indeed be put into words or formulas. Conversely, the explanation of the aesthetic decisions upon which the translation from the SMS data into musical sounds is based is almost neglected and only dealt with in a few sentences. The third example places much emphasis on historical informedness but does not elaborate on how these data are translated into the final aesthetic results (CDs, concerts).

What these three examples have in common is that they make clear that a direct correlation between the research data, objectives, and findings and the music that is the effect of that research is problematic, to say the least. In other words, the connection between the (academic) research being done and the aesthetic results of this research is not straightforward or unambiguous; it is hard to substantiate the transition through logical or rational arguments. However, the translation or transformation of research data into aesthetic products or events is part of a highly skilled professional practice and not simply based on some kind of 'gut feeling', indicating that 'knowledge' must clearly be involved. But this knowledge cannot be reduced to the representation of mere conventions, due to the fact that it is precisely these conventions that are questioned through or in these artistic research practices; they all add something new to the existing music world (including its prevailing discourses). More than that, unlike a lot of academic knowledge, this knowledge is not representational in the first place; rather, it is experiential, embodied, intuitive and singular.

To summarise, my interest here lies in the space between the gathering of information that is necessary to establish a project as research on the one hand, and the aesthetic output affected by that information on the other. Instead of defining the translation of research data into music as some kind of interpretation, I would rather consider it as a matter of aesthetic sensibility, a creative development and application of scholarly material. What I shall investigate in this essay is the connection between cognitive and affective knowledge, or what the French philosopher Jacques Rancière calls the connection between logos and pathos. In fact, this essay will thematise the undefined (and perhaps undefinable) but productive and creative space between scholarly data-gathering and artistic exposition. I consider an engagement with this space-between – engagement instead of removal – typical of artistic research.

Artistic Research II – Aesthetic Sensibility

In the most general sense, one could say that artistic research is a type of research that cannot be done by anyone but an artist. It includes knowledge that escapes other scholars, since it is embodied in art practices. This knowledge can be called implicit, tacit, embodied or practical (as opposed to rational, discursively articulated knowledge). According to Michael Polanyi, we know more than we can tell: for example, we are very well able to recognise faces even though it is almost impossible for us to describe their exact characteristics (Polanyi 1966: 4). And although he hardly mentions art in his writings, we could assume that art is one of those cultural fields through which this tacit knowledge is produced and transmitted. Hence, alongside mere aesthetic pleasure, art can give food for thought, and this is even its main cultural value, as Immanuel Kant had already stated at the end of the eighteenth century.

According to the American philosopher Susanne Langer, artistic and intellectual discourses, based on expressing ourselves, respectively, in works of art and in texts, are the two tools that human beings have at their disposal in order to try to understand the world. However, when these two strands combine in artistic research – for example, when artists enter the academic world and do research that should result in a PhD degree – scepticism still rules in the academic ranks and order. Especially when the dissertation (partly) consists of artworks or performances, objections arise: can these works or events be considered (a contribution to) knowledge? Are those research outcomes verifiable or falsifiable? How can we assess the academic level of an art product(ion)? Is there not too much non-rationality forming the basis of artistic product(ion)s in order to qualify as PhD-worthy?

Undoubtedly, these are relevant questions, and advocates of artistic research cannot ignore them. However, behind or below these questions, there is a more fundamental issue: if (as is the case with the three examples mentioned above) the outcome of artistic research should be one or more artworks, the translation of research data into art requires 'something' that only an artist has: a sensibility (in)formed by artistic and aesthetic experiences. Can the academic world accept this aesthetic sensibility – a sensibility that cannot be traced back to rational argumentation and/or objective generalisations – as relevant academic knowledge, or at least as relevant for academic knowledge? The sometimes reluctantly admitted idea that emotions and other aspects of subjectivity form an inextricable part of scientific research certainly does not lead automatically to an acceptance of a research field where emotions, affects, aesthetic judgments and artistic sensibilities co-determine the production of knowledge.

Hence my proposition that artistic research and exposition can contribute in a very specific way to (academic) knowledge, precisely through presenting art as the result of a research process. Artistic research has the potential to break and enrich accepted academic knowledge by effecting the acceptance

of emotions, affects, intuitions and sensibilities as relevant carriers of (new) knowledge, still commonly regarded as unavoidable infringements of objective research strategies. In what is to follow I shall briefly investigate this artistic sensibility and aesthetic judgments in relation to the production of knowledge before returning to their relation to artistic research.

Kant's Aesthetic Ideas

Looking back into the history of Western philosophy, we find in Plato's works a plea for the unity of beauty, the good and truth. Plato presupposes a 'World of Ideas' as the ultimate and perfect reality. In this perfect world, absolute knowledge (truth), morality (the good) and aesthetic aspects (the beautiful) converge and coincide. These ideas survive and even prevail in some form or another until the eighteenth century, when Immanuel Kant unfolds them into three separate domains.

In the last quarter of the eighteenth century, Kant publishes his three famous critiques: in 1781 the *Kritik der reinen Vernunft*, focusing on the *a priori* principles of knowledge (epistemology); in 1788 the *Kritik der praktischen Vernunft* about the *a priori* principles of will (ethics); and, finally, in 1789 the *Kritik der Urteilskraft* (KdU) with its main focus on feeling and imagination. In this third critique, Kant tries to explain the *a priori* principles of specific feelings of pleasure and discomfort through the analyses of taste and aesthetic judgment. Herewith he may be considered the founding father of modern philosophical aesthetics: aesthetics obtains its own space alongside knowledge and morality. In order to achieve this position, aesthetic judgments must be defined by Kant in their purest form, that is, separated from cognitive, moral and sensual supplements. In a pure aesthetic judgment there is no place for the pleasant, for 'Reiz und Rührung' (KdU §13), nor for usefulness, purposiveness or conceptualisation. That is why he stresses – especially in the first two modalities that describe this pure aesthetic judgment – that it is independent of all interest, that it does not provide the satisfaction of desires (which is the purpose of agreeable arts), and that the beautiful should not be connected to any concepts, thus not aiming at acquiring knowledge about an object. Reflecting on a rose, we need not know that it is a rose, or even what a rose is, in order to find it beautiful; what matters is how the rose appears in our perception (KdU §8: 215).

An aesthetic judgment is a reflective judgment, which means that the subject is searching for a concept that is adequate for the perception at hand. This cannot be rule-governed, for rules are given in concepts, and aesthetic judgments differ from cognitive ones because they have no concepts *a priori* available. Hence, a reflective judgment must be grounded in feeling and through a certain harmony between imagination and understanding, a harmony between intuition and something that can grasp that intuition. Kant calls this the free play of imagination and understanding (KdU §7: 214).

It is Kant's achievement that he gives an individual and autonomous place to aesthetic experiences and the arts, but in order to do so, he has to disconnect them from the realm of the cognitive. At first sight, this separation of the arts from cognition seems to make Kant an (anachronistic) adversary of artistic research based on the assumption that through art knowledge can be gained. However, according to Kant, it is the purpose of fine arts to connect pleasure to ways of cognising the world (KdU §44: 305). Pleasure engendered by fine art requires that 'this pleasure must be a pleasure of reflection rather than one of enjoyment arising from mere sensation' (KdU §44: 306). These special cognitions, Kant terms 'aesthetic ideas'. Artworks express aesthetic ideas: thoughts on the part of the artist, an artwork created in order to 'prompt' those thoughts, and thoughts on the part of the audience prompted by the artwork (eliciting a condition of free play of imagination and understanding).

Aesthetic ideas surpass the confines of mere experience, and in doing so approximate a presentation of rational concepts. However, they cannot simply be equated with the latter. According to Kant, a rational idea is a concept to which no intuition (the representation of the imagination) can be adequate. With an aesthetic idea, it is the imagination that undermines reason and produces something that cannot be classified within the categories of reason. It induces much thought, yet without the possibility of any conceptualisation. Consequently, Kant states, language can never render it completely intelligible (KdU §49: 314). He refers to words such as 'eternity', 'love', 'creation' and 'death' as they are used in poetry. A poet wants to give 'sensible expression' to say, love, 'with a completeness for which no example can be found in nature' (KdU §49: 314). An aesthetic idea thus gives the imagination an impetus to bring more thought into play (though in an undeveloped manner), more than what can be revealed in concepts, or therefore, through formulations in language. Jacques Rancière calls this thinking 'sensible knowledge' (Rancière 2009: 5).

Kant distinguishes two ways, two *modi*, of arranging our thoughts: the *modus aestheticus* (manner) and the *modus logicus* (method). The former has no standard other than feeling; the latter follows determinate principles. Stated differently, the artist has a way of proceeding that essentially involves feeling, whereas a scientist proceeds logically. The first mode alone applies to fine art, however, only when the manner of carrying the idea into execution in a product of art is aimed at singularity, instead of being made appropriate to an idea (KdU §49: 318-19).

In spite of the difference between an aesthetic and a rational idea, a fundamental opposition between the cognitive and the aesthetic seems absent in Kant's thinking. The expression of aesthetic ideas appeals to something that can rightly be called cognitive. However, the cognitive in art should be understood in a specific way. Kant is not arguing that an artwork 'says' something about the external world – that is, makes a reference to something outside itself. The cognitive in art does not necessarily aim at stating truths, nor can

it be considered as a sample of the real; it is not limited to referencing or representing. Instead, art's cognitive features consist of the fact that it will stimulate thinking. (Kant's problem with music is that it leaves nothing to think, since it appeals only to the senses. Music is therefore limited to animating conversations, suggesting affects and refreshing the body. It is music's fate to remain eternally expelled from the life of the *Geist*. Without taking the space to unravel and refute Kant's prejudice against music with sufficient arguments, I confine myself here to the remark that this thought can be regarded as superseded.) In fine art, 'pleasure is at the same time culture, and disposes the soul to ideas' (KdU §52: 264).

Artistic Research III – From the Academic to the Artistic

Where do Kant's observations take us with regard to artistic research in general and the central topic of this essay – the relation between research data and artistic exposition – in particular? Kant provides us with an important argument to underpin the statement that artistic research can contribute to the development of knowledge. Knowledge emanating from the production of art cannot be disclosed through scholarly research methods; it cannot be captured in discursive formulas and formulations. Through art, we gain access to knowledge about the world, to ideas that cannot be articulated otherwise. Kant attributes this capacity to produce aesthetic ideas or sensible knowledge to the powers of the mind that constitute artistic genius: 'Fine art is the art of genius. Genius is the talent (natural endowment) that gives the rule to art' (KdU §46: 307).

However, he has nothing to say about the possibility that an artist arrives at his production on the basis of data collected through scholarly research and methods, confining himself to the remark that genius 'uses' a free play of understanding and imagination. Can we get to grips with this free play when a certain understanding based on scholarly research somehow blends with the imagination in the production of artworks that result from this research?

Henk Borgdorff states that in order to be regarded as 'real research', artistic research, especially when its goal is to obtain an MA or a PhD, should be based on clear research questions or problems. Furthermore, one or more research methods must be specified that will be applied to address and possibly answer the research questions and problems. And, finally, the results of the research should be appropriately documented and disseminated, in principle through art (Borgdorff 2007: 8). The point I want to stress here is that the translation of discursively articulatable knowledge into artistic products or events cannot be postulated just like that. There is no one-to-one relation between the solid research strategies and methods resulting in (academic) knowledge and the new art performed by the artist-researcher. With Kant, I would say that artistic research is a free play of understanding and imagination. How, then, is it possible to legitimise certain artistic products or events by regarding

them as the results of academically informed knowledge-gathering? I am not claiming that this process of transposing, translating and transforming research data into art is merely arbitrary; rather, my statement is that this process is formed and informed by something that might be called 'aesthetic sensibility'. It is this aesthetic sensibility that connects the two parts of artistic research, the 'academic' part and the 'artistic' part. Moving from conceptual to non-conceptual knowledge, or from the (primarily) cognitive to the (primarily) affective, requires a certain susceptibility informed by aesthetic and artistic experiences. In other words, it is in and through this aesthetic sensibility that the conceptual and non-conceptual meet. In the next section I will elaborate on this thought with the help of the work of Jacques Rancière.

Rancière's Logos and Pathos

Jacques Rancière's *The Aesthetic Unconscious* begins by asking why Freud's interpretation of artistic figures, artworks and literary texts occupies such an important strategic position in his demonstration of the pertinence of analytic concepts and forms of interpretation. He refers here to Freud's special and copious interest in Leonardo da Vinci's biography, Michelangelo's *Moses* and Goethe's *Faust*, among others. According to Rancière:

> these figures are not the *materials* upon which analytic interpretation proves its ability to interpret cultural formations. They are *testimony* to the existence of a particular relation between thought and non-thought, a particular way that thought is present within sensible materiality, meaning within the insignificant, and an involuntary element within conscious thought (Rancière 2009: 3).

Through his reading of Freud's interest in art, Rancière aims to show that artworks are things of thought or 'the thought of that which does not think' (Rancière 2009: 5). Approvingly, he refers to Baumgarten's *Aesthetica*, published in 1750, and Kant's *Kritik der Urteilskraft*, which do not so much present a theory of art as address the 'domain of sensible knowledge, the clear but nonetheless "confused" or indistinct knowledge that can be contrasted with the clear and distinct knowledge of logic' (Rancière 2009: 5). The distribution of the sensible in and through art thus determines a mode of articulation between forms of action, production, perception and thought. It is only in the context of Romanticism and post-Kantian idealism that this 'confused knowledge' occurs under the name of aesthetics.

Rancière's ideas make art the territory of a thought that is present outside itself and identical with non-thought. It unites Baumgarten's definition of the sensible as 'confused' idea with Kant's contrary definition of the sensible as heterogeneous to the idea. Henceforth confused knowledge is no longer a

lesser form of knowledge but properly the thought of that which does not think (Rancière 2009: 6). Rancière labels this 'identity of contraries', which he regards as proper to art, the 'aesthetic revolution'. This revolution, already begun in the eighteenth century, opens a regime of thinking about art in which it is regarded as a combination of a conscious procedure and unconscious production, of willed actions and involuntary processes, of *logos* and *pathos* (Rancière 2009: 28).

In *The Aesthetic Unconscious* Rancière presents two different ways to think about the identity of contraries or the connectivity between logos and pathos. On the one hand this identity can be seen as the immanence of logos in pathos, of thought in non-thought, which Rancière summarises as 'the speech of mute things' or 'buried secrets'. This mute speech must somehow be restored to a linguistic signification. In other words, nothing is insignificant: there is meaning in the density of colour, in the sonorous quality of language and in the compactness of sculpted stone (Rancière 2009: 29). On the other hand, this identity can be characterised by an immanence of pathos in logos. Through the rational, the known, or logos, through the order of the same as Levinas would have it, one can also encounter the unknown, the uncanny, the meaningless, the other, 'the voiceless speech of a nameless power that lurks behind any consciousness and any signification' (Rancière 2009: 41). According to Rancière, this second option is a direct mark of an 'inarticulatable truth', undoing the logic of a well-arranged story and a rational composition of elements (Rancière 2009: 63). He concludes that the attention of both Freud and his followers has, up until now, mainly been concentrated on the first mode, to find meaning in every sign, in every object, in every event – this at the expense of the anonymous voice of unconscious and meaningless life. It is not that he wants to shift the attention purely to the second mode; rather, he wants to keep the tension between the two modes intact, and art somehow embodies this tension.

Approvingly, he states that Freud saw very well how in art, knowing and not-knowing, sense and non-sense, logos and pathos manifest themselves simultaneously. According to Rancière, Freud makes clear, especially in *Delusions and Dreams in Jensen's 'Gradiva'*, that artists' knowledge of the human mind is ahead of that of scientists. 'They know things that the scientists do not, for they are aware of the importance and rationality proper to this phantasmatic component that positive science either sees as chimerical nothingness or attributes to simple physical or physiological causes' (Rancière 2009: 48). However, says Rancière, this doesn't mean that Freud's goal was to exhibit the secret behind the myth of creation. Rather, he calls on art to bear positive witness on behalf of the profound rationality of *fantasy* and thus lend support to psychoanalysis that claims to put fantasy, poetry and mythology back within the fold of scientific rationality (Rancière 2009: 49). In this sense, Freud strongly affirms pathos, the brute meaninglessness of life. And Rancière concludes as follows: 'The voiceless power of the Other's speech must be valorized as something irreducible to any hermeneutics' (Rancière 2009: 88).

Artistic Research IV – Artistic Sonification

Where has this short exegesis of Rancière's thoughts on the identity of contraries brought us? Where has it brought us in relation to artistic research, in relation to the connections between collecting data, critical reflections, and discursive analyses on the one hand and the production of new art and artistic exposition on the other?

According to Rancière, Freud's use of artistic figures shows that there is always logos in pathos as well as pathos in logos. With regard to artistic research, a specific pendular movement from pathos to logos and vice versa needs to be added. Kant and Rancière provided arguments to rethink and deconstruct the opposition between the cognitive and the aesthetic, or between logos and pathos. The pendular movement is especially operative and even more complex in the space between the collecting and organising of research data and the artworks that are the aesthetic results of that research, since in this space the pathos and logos of academic knowledge encounters and interacts with the logos and pathos of artistic exposition. This space contains many traces of undecidability, or at least types of decisions that cannot be traced back to forms of logic or logocentrism, directly connected to the research data. (See also the case studies with which I began this essay.) As I argued before, this space is formed by an *artistic integrity* and *aesthetic sensibility* that cannot be legitimated further through scientific objectivity or rational considerations. Aesthetic sensibility consists of a subtle, perpetual and complex play between understanding, imagination and informed intuition, a play between cognitive and affective knowledge, and a play between discursivity and corporeality.

Aesthetic sensibility is an essential feature of artistic researchers and challenges the territory of accepted means of contribution to academic or scholarly knowledge. Research data determine to a certain extent the artistic exposition but, conversely, aesthetic intuitions filter through the research questions, methods and structure of the research; the one informs the other in an infinite movement.

When the research results in musical works and performances, one could speak of a process of aesthetic or artistic *sonification*. In the most general sense, the latter term can be understood as the representation of data by using sound. In an attempt to get sonification accepted as a legitimate tool to increase and facilitate the accessibility and examination of certain data, German physicist Thomas Hermann formulated four requirements that 'true' sonification should meet:

1. The sound reflects objective properties or relations in the input data.
2. The transformation is systematic. This means that there is a precise definition provided of how the data (and optional interactions) cause the sound to change.
3. The sonification is reproducible: given the same data and identical interactions (or triggers) the resulting sound has to be structurally identical.

4. The system can intentionally be used with different data, and can also be used in repetition with the same data. (Hermann 2008: 2)

Adapted to the transposition of research data into artworks in artistic research, 'true' sonification does not seem feasible. Without being able to discuss all four requirements in detail here, the translation from research data into sound in the case of producing a work of art would, most probably, not be considered objective enough, since the whole process is mediated by aesthetic sensibility.

However, in a less orthodox view of sonification, Paul Vickers and Bennett Hogg write that data can be mapped to sound in two ways: '*direct* mappings impose a one-to-one relationship between data items and sonic events (possibly involving some scaling and quantization) whilst *metaphoric* or *analogic* mappings impose interpretive filters or mapping functions to the data before it is rendered' (Vickers & Hogg 2006: 210, italics added).[2]

Nevertheless, Vickers and Hogg, as well as Hermann, make a clear distinction between sonifications and musical works. Although Vickers and Hogg describe the differences between sonification and a musical work as 'largely one of perspective', they also state that 'when the primary motivation is musical expression and experience (rather than communication of data)', music enters a realm that may be hard to connect to sonification (Vickers & Hogg 2006: 215). And according to Hermann, sonification and music operate on different levels, on different layers of interpretation: sonification is expected to realise a precise connection to the underlying data; conversely, in music the focus is aimed more towards the listening experience (Hermann 2008: 3).

Through the three examples with which I opened this essay, a third manifestation of sonification might appear, an *artistic sonification*. The musical works of Laura Young, Henrik Frisk and Ton Koopman sonically '(re)present' data that were gathered earlier during the research process. More than that, if those data could be presented in an extra-musical form, it would make a musical presentation unnecessary; however, in all three cases, musical performances are absolutely necessary in order to display the research results.

This type of sonification is grounded less on hard science paradigms and more on insights from the social sciences and humanities. However, Vickers and Hogg's notion of interpretative mapping could very well be related to artistic research: producing new art on the basis of thorough research – whether historical, philosophical, physical or otherwise – implies a type of data sonification, actualised through the application of aesthetic sensibility. This may sound vague, dubious, questionable and even reprehensible from an academic point of view. However, is not the very same strategy used by many scholars

2. Alongside metaphoric mappings, Vickers and Hogg also use the term 'interpretive mappings'. Hermann prefers to call this metaphoric or interpretative mapping 'data-inspired' or 'data-controlled music' instead of sonification.

when they 'translate' all kinds of 'non-discursive facts' observed in various kinds of realities into words?

Afterword – After Words

In *Steps to an Ecology of Mind* Gregory Bateson quotes the famous dancer Isadora Duncan, who apparently once said: 'If I could say it, I would not have to dance it' (Bateson 2000: 470). According to Bateson, Duncan was 'talking nonsense', because art is concerned with the relation between unconscious, conscious and external levels of the mind, and Duncan's dancing was about combinations of saying and moving. (Note the resemblance to Rancière, for whom art is defined by conscious procedures and unconscious productions.) Rethinking Bateson's comments in the light of exposition and artistic research, I could add that the saying could never replace the dancing completely. Artistic research makes clear that certain knowledge cannot be conveyed but through art. This implies, however, that there can never be a one-to-one correlation between the data collected in non-artistic forms and the artworks resulting from this collection. Applying this to music, one has to assess the data and make decisions as to how best to present them sonically. This process of *artistic sonification* requires an *aesthetic sensibility* that is reserved only for fine artists with sufficient scholarly baggage.

References

Bateson, G., 2000 [1972]. *Steps to an Ecology of Mind*. Chicago: The University of Chicago Press.

Borgdorff, H., 2007. 'The Debate on Research in the Arts.' In: *Dutch Journal of Music Theory* 12(1), pp. 1-17.

Frisk, H., 2010. *Improvisation, Computers and Interaction. Rethinking Human-Computer Interaction Through Music*. Saarbrücken: VDM.

Hermann, Th., 2008. 'Taxonomy and Definitions for Sonification and Auditory Display.' In: *Proceedings of the 14th International Conference on Auditory Display (ICAD)*. Paris, France, 24-27 June. P. Susini & O. Warufsel (eds.), Paris: IRCAM (Institut de Recherche et Coordination Acoustique/Musique), pp. 1-8. Available at: http://icad08.ircam.fr/static/ [Accessed 20 November 2012].

Kant, I., 1987 [1790]. *Critique of Judgment*. W. S. Pluhar (trans.). Indianapolis, IL: Hackett Publishing Company.

Kivy, P., 1995. *Authenticities. Philosophical Reflections on Musical Performance*. Ithaca: Cornell University Press.

Östersjö, S., 2008. *Shut Up 'n' Play. Negotiating the Musical Work*. Doctoral Studies and Research in Fine and Performing Arts no. 5, Lund University.

Polanyi, M., 1966. *The Tacit Dimension*. London: Routledge & Kegan Paul.

Rancière, J., 2009. *The Aesthetic Unconscious*. D. Keates and J. Swenson (trans.). Cambridge: Polity Press.

Vickers, P. & Hogg, B., 2006. 'Sonification Abstraite/Sonification Concrète: An 'Aesthetic

Perspective Space' for Classifying Auditory Displays in the Ars Musica Domain.' In: *Proceedings of the 12th International Conference on Auditory Display.* London, UK, 20-23 June, pp. 210-216.

Publishing

I n the previous section, it was argued that through its very constitution, artistic research cannot simply add knowledge to academia without at the same time engaging with the mode in which that knowledge appears and with the contradictions that exist between the different faculties that make up our intellectual lives. While it is possible to claim that artistic research does not lend itself to academic publishing and that it should instead focus on artistic formats such as exhibition or performance, one could ask if it would not be possible for artistic research, supported by advanced rich-media publishing technology, to engage with one of the most valued formats for academic publishing, the peer-reviewed journal article.

This second section zooms in on the research that was carried out between 2010 and 2012 as part of the Artistic Research Catalogue (ARC) project, which was closely related to the *Journal for Artistic Research* (*JAR*) and its online software framework, the Research Catalogue (RC), whose foundations were laid during ARC. Initiatives like these that aim to facilitate the publishing of artistic research in academia need to take into consideration the academic realities that exist for artistic researchers and the technologies that can be utilised to support expositions of artistic practice as research. The contributions in this section address such considerations.

In their chapter, *The Meaningful Exposition*, Michael Biggs and Daniela Büchler discuss the wide range of research-output formats in the UK Research Assessment Exercise 2008, with a focus on what formats, significant for the artistic research community, communicate content best. Although the transformation of traditional output categories by artistic researchers – the authors name the experimental journal, the book-as-artefact and the tailored conference exchange – has little impact on how academia at large defines these categories, the use of these experimental forms do, Biggs and Büchler suggest, underscore the value of meaningful experiences for the artistic research community.

In *Expositions in the Research Catalogue*, Michael Schwab describes the conceptual and technical framework of the RC that was developed in response to the needs of the artists and researchers in the ARC project. He describes the kind of technology that may be necessary to give ownership of both the content and the form of a publication to an artist without compromising sustainability, for example. The chapter explains how in practice a researcher might go about

making an online exposition and what this entails with regard to data storage, design or authorship, etc. Schwab argues that the technical framework that the RC provides gives options and control to an artistic researcher without determining how in a particular case practice is exposed as research.

In the following chapter, *Practising the Artistic Research Catalogue*, Ruth Benschop provides a summary and an analysis of the final conference of the ARC project, which took place on 1-2 March 2012 in The Hague. Benschop's reflections give access to both the difficulties and the prospects that the ARC artists and researchers experienced during the project. In her account, it becomes clear that any publishing framework will pose a challenge to a research community, both practically and conceptually, and that much depends on finding the right purpose for a technology, in particular when compared with more established modes of presentation. This includes the question of when a publication is actually finished and how and at what stages a researcher might engage with processes of 'publication'. When new publishing technologies such as the RC enter the field, she suggests, new communities may arise.

Lucy Amez, Binke van Kerckhoven and Walter Ysebaert, in their chapter *Artistic Expositions within Academia: Challenges, Functionalities, Implications and Threats*, expand on the wider technological context of the ARC project. The authors describe how in academic publishing in general developments have been taking place that embrace the advantages of digital ways of working and that allow for more complex types of propositions in so-called 'rich internet publications', where multi-media or interactive content makes up the core of a publication rather than simply being offered as illustration or additional resource. The chapter makes the point that increased levels of complexity are experienced by all actors involved in a publishing process, including authors, editors and readers. Despite the emphasis on technology, the authors maintain that complex publishing solutions will only be successful if they serve the needs of a research community and add value to the work of its members.

By focusing on digital technology, this section suggests that only in recent years has academic publishing become capable of accommodating in principle the types of negotiation at the border of the sayable in which artistic researchers may engage. At the same time, developing technologies such as the RC should not be seen simply as productive tools but also as obstacles in a practice that aims to expose itself as research. In the next section, a selection of four voices illustrates how practice may respond, outside of the question of technology, when challenged with the question of exposition.

The Meaningful Exposition

By Michael Biggs & Daniela Büchler

Our aim in this chapter is to discuss the potential of different types of exposition of artistic research. In order to do this we will first challenge the myth that there are subject-specific output formats, or in other words, the idea that exhibitions are particularly suited for the exposition of artistic research or that journal articles are particularly suited for the exposition of traditional research. Having argued that the format of exposition is not subject-specific, we reveal that the meaningful exposition is the one that communicates the content that is significant to a community. Within this framework we will reconsider the potential of the different exposition formats for the communication of significant artistic-research content.

Mythologies

Prior to discussing the exposition of artistic research and publishing art in academia, we will consider what defines an exposition of any kind of research and what it is to publish anything in academia. In this first discussion, we want to address a preconception that is widely held: that publishing in academia consists in the production and dissemination of books and journal articles. Although this is indeed the most common format of academic output, we want to challenge the idea that it is synonymous with publishing in academia. If one looks at contemporary academia one will find a much wider range of output formats than just these text-based ones; for example, academics produce patents, objects and artworks as well as papers, chapters and reports. From our previous experience in a range of different academic cultures we have come to understand that publishing, as an act of dissemination, can occur in a number of formats and communicate various content (Biggs & Büchler 2011b). We have identified environments in which there is a top-down definition of what constitutes academic publishing based on a conventionalisation of format, of which Brazilian academia is an example. We have also identified more responsive environments, such as UK academia, in which the definition of what constitutes publishing is constructed from the bottom up, as a function of the content that needs to be communicated.

The definition of publishing in academia that is adopted by the Brazilian academic community can be inferred from what is known as the 'Lattes platform' (CNPq 1999). This is a national database – named after the Brazilian

scientist César Lattes – added to by each researcher with all sorts of professional and academic activity. The Lattes is an online resource that can be accessed by the community at large, acting as both an informal peer-review system as well as a formal assessment tool towards the production of official institutional rankings. All academic promotions and research-funding awards are made based on the curriculum vitae that each researcher keeps regularly updated on his or her personal Lattes pages. What is interesting to observe in the organisation of the platform, besides the impressive efficiency and community endorsement of this system, which contains more than 1.6 million curricula, is how it expresses what Brazilian academia sees as research and what falls outside and can therefore be claimed, at best, as professional practice. The Lattes has the advantage of enabling the researcher to include a wide variety of activities. However, the fact that the database makes a distinction between bibliographical output – that which is traditional, text-based and used to assess academic productivity – as opposed to technical output – which is, by exclusion, non-academic professional practice – results in making academic research synonymous with bibliographic production. In Brazil, academic research is traditional text-based output and is contrasted with professional practice. In our view, the structure of the Lattes platform defines publishing in academia top-down, because users have to enter their data via a series of drop-down menus, and they cannot create new fields of entry that might better express the academic content of that activity. In practice, a journal article can only be entered under 'bibliographical production' (academic) whereas an exhibition can only be entered under 'technical production' (non-academic). The implication, of course, is that the exhibition format cannot contribute academic research content because that kind of content comes only in the format of text-based bibliographical entries. From observing the structure of the Lattes platform we can understand that, to the Brazilian academic community, publishing in academia can refer only to outputs that come in traditional text-based formats, that is, journals, books and book chapters, journal and book editing, conference proceedings, etc.

In contrast to the Brazilian system, we characterise the UK as having a bottom-up definition of publishing in academia. We base our opinion on the nature of the UK Research Assessment Exercise (RAE), which is a periodic quality assessment in which institutions submit a representative selection of their best research under subject headings. In 2008, the RAE received submissions under twenty categories of standardised output types, which were assessed without preference for type. Within the list one can find output types such as authored book, edited book, chapter in book, journal article, conference contribution, internet publication, scholarly edition, research datasets and databases, research report for external body and confidential report, all of which would be classified as 'traditional text-based' formats, and therefore academic, under the Brazilian Lattes system. The important difference is that the RAE list also permits types of academic outputs that the Brazilian system considers to be

non-academic professional practice: performance, composition, design, artefact, exhibition, devices and products, digital or visual media, patent/published patent application and software. The fact that this list derives from a consultative exercise in the design stage of the RAE, and that the researcher is allowed to submit any of these activities as academic research, is what characterises academia in the UK as a more responsive environment. Furthermore, there is an additional RAE output type called 'Other form of assessable output' that is user-defined and therefore allows the researcher to bypass the question of physical output format and describe the content of the research activity differently (RAE 2009).

The UK RAE assesses national research activity, organised under subject-based Units of Assessment (UoA). However, the categories of output submission are not subject-specific but are equally available to all researchers. This means that exhibitions and journal articles can be, and indeed are, submitted by any subject area. For example, in the 2008 RAE, researchers in the Computer Science and Informatics UoA submitted exhibitions, and researchers in the Art and Design UoA submitted journal articles. This structure has implications for the definition of what it is to publish in UK academia: one can no longer assume that academic content comes only in the format of the journal article or traditional text-based media. In the UK, academic publishing can occur just as readily using non-textual formats such as exhibitions. Similarly, on the basis of the RAE, one cannot assume that the format of an exhibition implies that the content is about the subject of art and design because the exhibition format is both available and used in other subject areas.

From this discussion of academic myth and practice, in this chapter we define 'publishing in academia' in a broader sense, in a way that remits to the concept of the 'exposition of research'. Instead of focusing on the format of the outcome, the exposition of research focuses on the content of what is being communicated. We claim that the exposition of research not only sets out information and data but also supplies a reading or interpretation of that data. Thus we can say that the data is not just 'exhibited' but instead that the content or meaning is revealed or exposed. This 'exposition' is an intentional act to communicate a particular interpretation and the interpretation of the data constitutes the intellectual property of the author. This is the 'argument' that one finds in academic publishing. If one construes publishing in academia more broadly – as the exposition of research – one can see a variety of formats from which to choose, so the question then becomes: why do certain communities seem to favour some formats over others?

This question can be answered within a framework that connects meaningful actions to significant outcomes (Biggs & Büchler 2011a). What is meaningful to a community is determined by the values that the community holds. These values determine what the community sees in the world and where its interests lie. Values and beliefs are invisible, often even to the community and individuals themselves, but they reveal themselves as espoused justifications and rationalisa-

tions that determine what should be done that is in line with those values and beliefs. Behaviours and actions are the manifestation of values and emerge in accordance with the espoused doctrine by which a community defines itself.

In the case of the traditional academic community, a core value is the accumulation of knowledge. The accumulation of knowledge in an academic context is not merely the accumulation of quantity but is a selective process in which old knowledge is superseded by new knowledge in the pursuit of an objective truth (Searle 1993). This kind of accumulation is embodied, for example, in the structural arrangements for publishing peer-reviewed journal articles. The link from the core value of accumulation of knowledge to the manifested behaviour of publishing in journals can be traced through a series of espoused values and rationales. For example, there is the espoused value that in order to produce significant knowledge it is necessary to communicate outcomes explicitly. The need for explicit communication leads to the convention that a text-based format must be used because of the apparent precision of language. A journal is such a text-based format, but its significance to the academic community is not merely that it enables explicit communication; it also sustains the core value of accumulation in other ways. For example, the journal's peer-review process ensures that the knowledge that is communicated is original, topical and cutting-edge. Expressing the contribution in written form also facilitates explicit argumentation for the nature of the original contribution. Furthermore, the frequent publication of issues of the journal means that this format sustains the concept of accumulating new knowledge, in contrast to the book, which establishes and confirms the corpus of existing knowledge in the field. The journal article allows for the dialectical building of new knowledge in a way that challenges and overturns old knowledge through a process of conjecture and refutation (Popper 1963). Thus we can explain the dominance of the journal article format in traditional academia in terms of fitness for purpose, that is, not only the content of the article but also the format of peer-reviewed journal-article publication facilitates knowledge building that is regarded as significant by the traditional academic community.

In the case of the arts community, value is placed on the experience that is provided by the direct encounter with the artefact (Biggs & Büchler 2011a). Experience as a core value is espoused in the necessity of showing, presenting or displaying created artefacts. This leads to an artistic convention that sense-based formats, such as exhibition or performance, are the most appropriate for fostering the meaningful experience. The fact that the exhibition is primarily a sense-based rather than text-based medium fits the artist community's core valorisation of the experience, and responds to the understandings and conventions that the community espouses. However, the exhibition has other defining characteristics that make it especially suited for enabling the experience through the direct encounter with the artefact. For example, the exhibition displays artefacts in a venue that is accessible to the audience. The exhibition format therefore contributes by enabling first-hand contact between the audience and

the artefacts, which in turn enables experience. The exhibition also brings all these elements together in the same space and at the same time, and thereby offers a forum dimension, which further contributes to the communication, expression and encounter with the work, artist and audience more generally. The forum dimension of the exhibition facilitates a proliferation and surplus of interpretations and experiences, which is regarded as a benefit and a strength in the community (Gadamer 1975). Subsequent exhibitions in the same venue do not render previous ones redundant, but instead add to the richness of multiple experiences. Individual experience is meaningful to the artist community since it is the fruit of the direct encounter with the artefact. Finally, the exhibition allows an unmediated experience of the artefact that has come straight from the artist's studio. The artist may have 'designed an experience' in the studio that is embodied in the artwork and, one theory goes, by moving the artwork into a public display space and exposing the viewers to it, each viewer will be able to live an experience. Therefore, the exhibition format enables the lived experience in a way that cannot be duplicated to the satisfaction of the artist community by formats that document, record, reproduce or in some way represent the work.

Realities

In order to understand the relationship between the format and content of expositions in academia, in 2011 we undertook a review of the type of exposition used by academic researchers in the UK. As our sample we chose the publicly available data from the 2008 RAE, for three reasons: it is a large database of over 200,000 research outputs representing all subjects in academia, it classifies and describes twenty output types, and its breadth and depth offers a view of academic practices that is not restricted to the UK. In addition to an analysis of output types we also undertook an in-depth quantitative and qualitative analysis of the outputs submitted under 'UoA63 – Art and Design'. The reasons for selecting this UoA were, first, that it contains fine art, which was our main focus of interest, and second, it is the UoA that submitted to the largest number of output types (nineteen out of twenty). We compiled and analysed the full population of 7,966 outputs that were submitted to UoA63. Our database revealed both the range of expositions used by artistic researchers and compiled qualitative data about their claims for research content.

The line graph and table below will enable us to discuss some of the findings of the study. We have reproduced the graph and table here as a visual guide to the patterns and tendencies that can be observed, and on which we will comment in the remainder of the chapter. It should therefore be highlighted that although we have included the percentage of use of the nineteen output types in the table, the statistical values do not form our focus. The information in the table is included for the interested reader and because it supplies details for the line graph – the visualisation that we find more relevant to the discussion that follows.

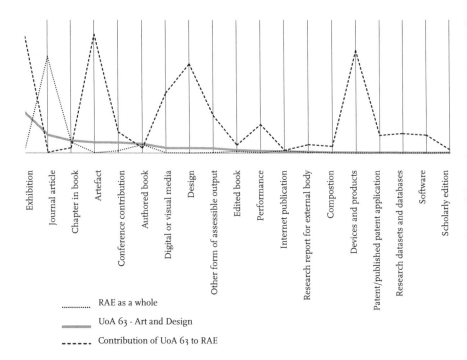

Exhibition
Journal article
Chapter in book
Artefact
Conference contribution
Authored book
Digital or visual media
Design
Other form of assessible output
Edited book
Performance
Internet publication
Research report for external body
Compostion
Devices and products
Patent/published patent application
Research datasets and databases
Software
Scholarly edition

............ RAE as a whole

▬▬▬ UoA 63 - Art and Design

- - - - Contribution of UoA 63 to RAE

The line graph exposes three relevant findings for academic publishing and the exposition of artistic research. Our first finding relates to the RAE as a whole and describes what was submitted as academic research by UK institutions in 2008. We found that the journal article was the largest single contributor format. If we add to this the second and third largest contributors, chapter in book and authored book, we find that these three text-based output formats account for just over 90% of the total submissions. From this number it would appear that the myth that we set out to challenge in the beginning of this chapter is not a myth at all but is corroborated by the actual practice of academic researchers in the UK. However, the myth that we were challenging was not that it *is* thus but that it *must be* thus – that academic publishing is inherently in text-based format and that this is not a choice but a natural state.

This leads to our second finding, which is about the production of artistic research and the use of exposition formats, and is visible in the line that represents the UoA63 submissions. As a counterpart to the myth that academic publishing focuses exclusively on text-based formats, one might correspondingly expect that publishing art in academia would focus exclusively on non-textual, 'non-traditional' formats, such as the exhibition. Although the exhibition is indeed the format that was adopted the most in UoA63, the proportion of exhibitions submitted was by no means as expressive as the proportion of journal articles submitted to the RAE as a whole. Furthermore, the range of formats used in UoA63 was much more evenly distributed and consisted

RAE 2008 Outputs by Type	RAE as a whole	UoA63 – Art and Design	UoA63 contribution to RAE
Exhibition	1.25%	32.01%	94.24%
Journal article	75.29%	14.27%	0.70%
Chapter in book	8.50%	9.78%	4.23%
Artefact	0.33%	8.41%	92.76%
Conference contribution	1.86%	8.23%	16.30%
Authored book	6.61%	7.22%	4.01%
Digital or visual media	0.32%	4.05%	47.14%
Design	0.21%	3.99%	69.60%
Other form of assessable output	0.47%	3.77%	29.34%
Edited book	1.38%	2.40%	6.38%
Performance	0.29%	1.73%	22.28%
Internet publication	2.01%	1.20%	2.19%
Research report for external body	0.59%	1.06%	6.58%
Composition	0.34%	0.48%	5.16%
Devices and products	0.02%	0.45%	80.00%
Patent/published patent application	0.11%	0.42%	13.69%
Research datasets and databases	0.06%	0.25%	15.15%
Software	0.05%	0.20%	13.91%

of a much more balanced combination of 'traditional' and 'non-traditional' formats. The formats that were used the most by the art and design community were exhibition, followed by journal article. In the next bracket of significant participation we found chapter in book, artefact, conference contribution and authored book. Finally, in the last bracket of significant participation were digital and visual media, design, and other form of assessable output. This is a less dramatic percentile spread if compared to the RAE as a whole, and there is an even mix between traditional and non-traditional formats.

The third relevant finding describes the contribution of the UoA63 submission to the RAE as a whole. This line reveals that nearly all of the research submitted in exhibition format came from UoA63. However, expressing it this way merely reinforces the preconception that we initially identified and challenged: that the format of an exhibition implies that the content is about the subject of art and design. As a result of our discussion above we can now make a stronger claim: that through its practices the community of art and design researchers is defining how the exhibition format can contribute research content, that is, how art research can be published. Indeed, we have shown that UK academia as a whole has few other sources than the UoA63 exhibitions to go on when considering what constitutes publishing in academia. In other words, adopting the bottom-up strategy, academia must define what constitutes publishing using the exhibitions output type based on how the art and design community uses it. Similarly, the devices and products output

type is also almost single-handedly defined for UK academia as a whole by the research in UoA63. However, because the artistic-research community makes less use overall of this output format, the community is perhaps less aware of its impact on the nature and definition of the output type. In contrast, the line also shows that innovations in the journal article format – which art and design researchers adopted as their second most popular output type – are probably not influential on this exposition format in UK academia as a whole owing to the inexpressive volume that UoA63 contributes to the RAE.

In the second bracket of significant participation, we found output types that relate to the 'book' format, whether authored book or chapter in book, as well as artefact and conference contribution. If we superimpose the graph line for 'RAE as a whole' and the one for 'UoA63' we can see that the lines come close together in these formats. The proximity of the two graph lines shows that the proportion of use of these formats is comparable in the two communities. However, what is perhaps less obvious is related to the profile of each line and requires a comment about how to read each of the lines. The reading will reveal that although the proportion of use of the book categories is comparable, the significance of these categories to the communities in question is not. The line for the 'RAE as a whole' describes an extreme curve in which the journal article eclipses all other forms of output. This expresses a fundamental difference between the journal article format and all other types, in which the former is the most relevant form of publishing in academia. The implication is that the other forms are less significant to the academic community when it comes to communicating meaningful knowledge. On the other hand, the line for UoA63 describes a much more uniform curve and therefore suggests that there is a relation between the output types. One can consider the exhibition as the preferred format but the journal article is also important, as are the next seven output types. In the relational curve described by the UoA63 submissions, the formats used are different but equal in their potential to produce meaningful contributions. We can therefore discuss the categories that are found along the line of the UoA63 submissions in a comparative and relational way.

Meaningfulness

If we turn our attention to the qualitative dimension of our study, we can discuss the potential role of exposition formats for artistic research. Initially, let us address the presence of the 'book' categories alongside the artefact output type in the second bracket. This makes us think of the book as artefact rather than as merely a vehicle for publishing content. Because the art audience is used to, and indeed values, the engagement with artefacts, one of the roles of the book format as an exposition of artistic research is to enable the direct encounter with the artefact. We could speculate that the content of the book is embodied in the book much as it would be in an exhibited artwork. This description

of the book remits to the 'artist's book' format that is familiar to the artistic researcher. Other forms of book publication come to mind, such as the artist's log, the sketchbook, etc. In contrast to the traditional book, the important features of the book-as-artefact are a consequence of its physical form – it is significant that pages are opened and turned in a sequence, so that when one page is open another page is closed and there is a temporal dimension to the experience of the book format. In contrast, the book-as-content is not wedded to the physical properties of the bound-book format. In the traditional book, these aspects are not significant but merely facilitate access to the text string.

The artistic researcher makes considerable use of the journal article as an exposition format. However, its role for the artistic researcher might be different from that for more traditional research areas, as we explained earlier. When the artistic researcher uses the journal format, they may be doing so for the same reasons as the traditional researcher; at other times, we might expect the artistic researcher to be using the journal format to express the values of the artistic community. In such cases, we might expect to find the format being transformed to better fit the needs of the community, in order to enable, for example, a sense-based experience. Indeed, one can find new forms of journals emerging in the art and design area. The transformations that are being implemented in journals that cater to art and design include open-access, multimedia, user-defined content, forums for discussion, visual-only or visually led submissions and community-led review processes.

The conference contribution output type is also used to an expressive degree by the art and design community. As in the case of the journal article, the artistic researcher uses the conference format as a vehicle for accessing and testing content against the criticism of an informed audience. This is very much how traditional research areas employ the conference format. However, it is the congregation dimension of the conference format which is perhaps more significant for the artistic community. Given the importance placed by the artistic community on the experiential aspect, the conference as congregation provides an opportunity for the direct encounter. The forum dimension of this format of exposition, in which exchange of ideas is not only possible but also encouraged, contributes to the production of multiple interpretations of the content that is being presented. Furthermore, there is a dynamic between author and audience in the conference format that offers the potential for interaction. We have seen this potential explored by presenters at conferences in the field, in events where the formal divide between author and audience is disrupted in favour of an open floor in which the content is co-created through dialogue.

We identified a tendency in the UoA63 submissions to transform the given output types so that they reflect what is of value in that format for the artistic community. This was visible in the experimental initiatives in the journals that have been developed in the field, the concept of book-as-artefact and the tailored conference exchange. The 'other form of assessable output' output type

further reveals what is at times insufficient or unsatisfactory about the named RAE output types and also what is instrumental about the concept of output for the art and design community. Under the 'other' format, the researcher is asked to give a description of the output and also to detail what is relevant about that submission. This information revealed that the 'other' output type enabled the art and design researcher to submit an output of physical type that is not named in the twenty RAE output types, to compile and combine various outputs and output types, and to place emphasis on a particular type of content rather than format of output.

On a practical level, the 'other' output type is used when the existing named categories do not cater to the output that is being submitted. Certain activities that are relevant as a demonstration of meaningful research do not fit under any of the named output types, for example, having led a research project, organised a conference/event/symposium, founded/edited a journal, established a professional group/organisation/centre. The 'other' output type is also used to include a mixture of named output types – for example, something described as a funded research project that serves as a vehicle for several journal articles, conference participations, organisation of an exhibition and related symposium and which ultimately resulted in the researcher being invited to or awarded a residency at a prestigious art institution. What is interesting to note about such submissions is that when the relevant details are explained, the researcher often focuses on the relationship between these activities. There is also a focus placed on the output as phenomenon rather than the physical manifestation of the research. This suggests that the experience of the activities is more relevant to the artistic researcher than the actual physical result of it, which might be a journal article, artwork or exhibition.

Whereas for the RAE, the concept of output is primarily categorised by physical type, the concept of output that artistic researchers hold is revealed by their use of the 'other' output type. For example, artistic researchers will include a period of time as a unit of output, as in the case of an artist's residency or a research fellowship. The package of the experience is what makes it meaningful rather than a particular materialised output. There are also some artistic researchers for whom a thematic interest supplies the underlying thread that is of relevance rather than the particular work itself – for example an artist who explores the theme of death and makes projects populated by a series of different activities and outputs that are related to that theme. Sometimes the creative process or style of working provides the conceptual unit, such as when a series of action paintings is produced or the output of a collaborative project is less important than the participatory experience itself. Artist researchers also seem to emphasise the importance of the personal exchange that occurs in the process of work and life. This is visible when invitations and commissions result from natural networking and are central to the resulting output – especially when these encounters evolve from common interests. There is also a tendency

for artist researchers to relate current work to earlier, original and pioneering initiatives with which they were involved. This often highlights the notion of a larger body of work as an indicator of a longer trajectory that defines the artist. Each of these expressions of artistic research focuses attention away from the physical object as the bearer of content to the content itself, which may, however, still be conceptualised as an identifiable coherent unit.

We have discussed the meaningful exposition of artistic research through a discussion of output formats and how art is published in academia. At this point we would like to return to the claim we made at the beginning of this chapter about the exposition of *any* kind of research, so that we can conclude what is significant as exposition of *artistic* research. We claimed that exposition remits to content rather than format. This is what we found when exploring what was relevant about the format of the artistic research expositions to the artistic community. The meaningful experience for the artistic community does not come in a particular format but essentially involves exchange and interaction, collaboration and co-creation. It guarantees the involvement of an audience and dynamic engagement but does not of necessity include a physical manifestation as output – the output as result is more significant. What is of relevance is the relationship between elements that enables the proliferation of interpretations rather than the singularity of a specific format and its consequently determined content. To achieve effective publishing of art in academia, artistic researchers need to design meaningful encounters between the audience and the content, in which there is an exposition of what is significant about that content.

References

Biggs, M.A.R. & Büchler, D., 2011a. 'Communities, Values, Conventions and Actions.' In: *The Routledge Companion to Research in the Arts*. M. Biggs & H. Karlsson (eds.). London: Routledge, pp. 82-98.

Biggs, M.A.R. & Büchler, D., 2011b. 'Transdisciplinarity and New Paradigm Research.' In: *Transdisciplinary Knowledge Production in Architecture and Urbanism*. I. Doucet & N. Janssens (eds.). Dordrecht: Springer Verlag, pp. 63-78.

CNPq, 1999. 'Plataforma Lattes.' Available at: http://lattes.cnpq.br/ [Accessed 5 July 2013].

Gadamer, H.-G., 1975. *Truth and Method*. London: Sheed and Ward.

Popper, K.R., 1963. 'Science: conjectures and refutations.' In: *Conjectures and Refutations*. London: Routledge, pp. 43-86.

RAE (2009). RAE Manager's Report. London: HEFCE. Available at: http://rae.ac.uk/pubs/2009/manager/ [Accessed 5 July 2013].

Searle, J.R., 1993. 'Rationality and realism, what is at stake?' *Daedalus* 122(4), pp. 55-83.

Expositions in the Research Catalogue

By Michael Schwab

The Research Catalogue (RC)[1] and the *Journal for Artistic Research* (JAR)[2] are related projects with very different aims and purposes. The RC is a free, online, collaborative and mostly private workspace that also allows for the (self-)publication of artistic research. *JAR* is an academic, peer-reviewed and open access journal for the publication and dissemination of artistic research. *JAR* functions as the first in a series of planned, specialist portals to selected research published on the RC that utilises the latter's technology, including the design interface and the integrated submission and publication workflow. *JAR*'s editorial policy and peer-review procedures are based on the concept of 'expositions' – online objects on the RC that are meant to expose practice as research – which the journal actively promotes (cf. Schwab 2011). While the RC supports the generation of such expositions, it neither limits its users to disseminating their research as expositions nor enforces a particular approach to publication – as long as this is not outside the legal confines of the licence agreement, as will be discussed later. When talking about 'expositions', it would thus appear natural to focus on *JAR*'s editorial policy, since – it may be assumed – this is where the concept must most clearly be defined. At the same time, such a focus potentially misses the less explicit conceptual space that the RC software provides, which both enables and limits expositions in *JAR*. Since *JAR*'s editorial approach may be traced on its website and the editorials that introduce past issues, this chapter focuses on the RC and the particular solution that it offers to the problem of how to expose practice *artistically* as research in an online environment. To do this, I will discuss the technical reality of the RC as part of an enterprise that investigates how artistic research can be published in academia rather than suggesting tight definitions of what may or may not count as exposition.

In general, the exposition of artistic practice is an everyday occurrence – whether in exhibitions, concerts or theatre performances. In fact, one may say that 'exposition' is what artists essentially do, since there is no art without the presentation and the setting forth (from the Latin *exponere*) of their work.[3] At the same time, artists have found it very difficult to expose their practice

1. http://www.researchcatalogue.net.

2. http://www.jar-online.net.

in ways that are acceptable as research. This has raised the fear that while the influence of academia on art academies has increased (through developments such as the 'Bologna Process'), artistic values may be compromised (cf. Sheikh 2006; Busch 2011). This is particularly the case given that claims towards research are usually made in the form of academic writing through which – amongst other things – academia polices the borders of knowledge (Münch 2011). While the use of the term 'research' in everyday language, including in the art world, is commonplace, it is far from easy to define what kind of epistemology may provide a bracket that links it with a more narrow – that is, positivistic – scientific notion of research. Thus epistemologically credible and methodologically explicit expositions of artistic practice as research tend to fall back on such modes of academic writing as are practised in the humanities and which equally expose practice as research, albeit in a non-artistic manner. As I argue elsewhere (Schwab 2012c), it is necessary to extend the definition of academic writing in order to accommodate artistic modes of exposition into what is currently known as 'enhanced publications' – media-rich, interactive and socially porous texts that engage with the creation of knowledge outside the confines of propositional language. This is not an issue that is limited to the creative sector; rather, non-propositional modes of communication are of increasing importance in other academic fields as well, whether these modes are the browsing of source data, its visualisation, sonification or interactive modelling, which adds extra layers of meaning to traditional texts or – as may be the case in the arts – which completely replace a central text with non-propositional and artistic modes of argumentation.

The Artistic Research Catalogue (ARC)[4] project, through which the first version of the RC software was developed, set out to investigate from the bottom up what kind of functionalities artistic researchers needed in order to publish their research online.[5] It started from the premise that a simple display of media files related to an artwork might represent that work in a museum catalogue or in the archives of a dealer or publisher, but that such representation might fail to bring out the particular knowledge claims that are made in, by or through that work. While digitalising art for upload into the RC, more general questions of documentation need be raised, such as how a particular practice or a work of art can be documented in such a way as to highlight its epistemic relevance.

3. Depending on the context, alternative notions may be the staging, performance, translation, reflection, unfolding, exhibiting or curating etc. of practice as research. Please refer to the introduction for a discussion of the term.

4. The Artistic Research Catalogue (ARC) project was funded by the Dutch government, organised through the University of the Arts, The Hague, and led by Henk Borgdorff and myself. For more information on the context and genesis of the project, see Borgdorff 2012, pp. 214ff.

5. See the chapter by Ruth Benschop on pp. 105ff. for more information on the ARC project.

With regard to digitalisation, for the most part a single depiction or recording may not be sufficient, either because a work is too complex to be represented in a single file or because different modes of documentation will bring out different aspects of what is fundamentally the same work. Furthermore, all those documents that are made in relation to a work or a research project might be produced in different media, which when digitalised often require different file formats. It was thus safest to assume that in the most general case a researcher would approach the RC with a research project and a pile of documents ranging from text to image, video and audio (and potentially vector drawings or complex data sets) with the need to apply some kind of order to those documents during the writing process, where 'writing' may in extreme cases be nothing but an ordering process. The RC proposes the following concepts to transform such a pile of documents into the exposition of art as research.

Works and Simple Media

In the context of the RC, a work is a coherent unit of meaning, which is indicated by metadata such as author, title and year of production or publication. In the RC, 'works' not only refers to art objects (such as paintings, sculptures or movies) but also to publications (such as journal articles, DVDs or books) and events (performances, exhibitions or conferences). Any number of documents (in any acceptable file format) may be associated with a work. For example, a theatre play (a work) may have associated documents such as recordings of various performances, still photographs, sketches of the set design, the script and potentially comments by the director, actors or even critics. Works on the RC are equivalent to items that one would deposit in a traditional institutional repository, to which suitable documents are attached.

Still assuming a researcher who approaches the RC with such a pile of documents, one would expect that many of these documents can be organised into works and uploaded to the RC. However, during ARC it became clear that not all documents relevant to the publication of a piece of research fit into this category. For example, a piece of text may be written that compares two works, or a video may be made that shows the state of an artist's studio as an illustration of the context in which a particular piece of research is situated. Rather than forcing all possible documents into the work category, the RC provides in its repository a second category, the *Simple Media*, for all documents that are not seen as belonging to works. In fact, if we were to look, say, at a traditional critical piece of writing, we would expect most of it – the text (including footnotes and references etc.) – to be uploaded as *Simple Media*, while the one or two artworks that are illustrated may find their way into the *Works* repository.

As the beginning of writing, the organisation of a researcher's docu-

ments into *Works* and *Simple Media* is by no means a trivial matter, nor one that is free of meaning. With works, we do make some form of value judgement, which is the reason why some artists prefer not to organise their material in such way, or, conversely, if they are commercially oriented, desire a clear identity for their products as works. Even if the category of works is accepted, it may be difficult to decide where a work starts or finishes. For example, a sketch made in preparation for a painting may be part of the painting; it may also be a work in its own right, a decision that says much about the significance the artist attributes to the sketch. The situation is even more complex where documents pertaining to research are concerned: they might not be part of the work but intrinsically linked to it, or they might form a work in their own right, depending on how a researcher interacts not only with the notion of work but also with that of research.

These problems of organisation raise the question of why we chose to complicate the repository side of the RC by introducing a notion of works into what is supposed to be a platform for the exposition of practice as research, rather than allowing for a simple collection of documents. The first answer to this question is simple: because works are facts out there in the real world on at least two levels, personal and institutional. On a personal level, its seems that by and large, artists who engage with research do not give up making works, or at least use the category actively to structure their research and practice. On an institutional level, all key players (commercial galleries, art academies and museums) operate with the notion of works that they hold in collections, archives or institutional repositories, in particular if this notion also includes non-artistic outputs, such as journal articles or book publications. In terms of the common ground that exists between artists, such institutions and the RC, an acknowledgement of the work category seemed pertinent, and on a more technical level, it promises interoperability and data exchange with existing online archives that do not foreground research expositions.

This implies a further reason for a focus on works: the work category is needed to differentiate expositions. Although relying heavily on the archiving of documents, the RC is not devised simply as yet another media repository. Its purpose is first of all to expose rather than to archive research. This amounts to saying that the RC's role in the research process is seen as actively enabling – as a research infrastructure – rather than passively registering – as the after-the-fact deposit of research. The conceptual reason for this lies in the fact that if the RC is supposed to deliver the possibility of an *artistic* exposition of practice as research, it needs to be a medium in and through which expositional transformation can take shape; Mika Elo, for instance, discusses this as 'translation' (Elo 2007: 135ff.). When comparing artistic to scientific research, Henk Borgdorff describes this particularity as the primacy of publication, asserting that 'in the case of artistic research [publication] is

the starting point' (Borgdorff 2012: 197f.).[6] While a work presumably has its life elsewhere, so that it needs to be documented and re-traced on the RC, the life of an exposition is on the RC alone, where practice is enacted as research that engages in some form of reflective doubling.

While this distinction is a good first approximation of the difference between works and expositions, their relationship is in fact much more complex. A focus on the difference between exposition and works also 'liberates' works in the context of the RC rather than rendering them redundant. Documents in the *Simple Media* repository are limited to the exposition to which they belong, but *Works* are accessible in the context of all expositions, including those authored by people other than the artist. While these features are still in development, future versions of the RC may promise that the multiple roles that *Works* may play in different expositional contexts may be traced and that their respective meaning may be compared in order to understand their epistemic potential more fully.

Furthermore, as indicated above, in the RC, the *Works* repository is defined with sufficient breadth to include not only artworks but also general publication output. Since this is the case, an exposition on the one hand contains *Works*, which with the help of *Simple Media* are exposed as research, while at the same time an exposition may also be looked at as a work in its own right. This construction indicates that there is no hierarchy in place, with works as basic units and expositions as 'higher' forms of transformation; rather, the separation between works and expositions is permeable. In the one direction, online expositions are created that are works in their own right and thus not secondary to the art, which is at the core of the artistic challenge to academic writing and publishing. In the other direction, it becomes conceivable that works are made, documented and uploaded that do not require any *Simple Media* or any other additional labour in order to claim expositional status. This has the effect of allowing the notion of exposition to enter the practice of artistic research outside and beyond an online workspace – for instance, in the studio, the concert hall or the museum. Although a distinction between works and expositions cannot in principle be drawn, it may be used to speak about the structure of reflective distancing within the notion of work, if 'work' remains the primary site of research. Conversely, when focusing on the expositional side of the spectrum, making works may become less appealing.

In this section, I have introduced the RC's repository, which is organised in documents held in the *Works* and *Simple Media* repository, in order to

6. In my own writings, I discuss the essential role of what in many places are considered secondary formats, for example in relation to Walter Benjamin's notion of critique (Schwab 2008), the role of supplementation (Schwab 2009a; Schwab 2009b), the differential function of the 'as' in constructs such as 'practice as research' (Schwab 2012a) as well as more specifically in relation to exposition writing (Schwab 2012b).

illustrate that at the core of the RC is the idea of exposing practice as research, and how this is structurally implemented. Based on this, it might appear that the generation of an exposition on the RC requires substantial conceptual investment and a rather steep learning curve for both researchers and readers. This is, however, not the case. For readers, the distinction between *Works* and *Simple Media* in the repository remains completely hidden, because the structure of the archival system does not automatically enter the presentation layer of expositions. For researchers who are preparing an exposition on the RC, the repository may also not be of importance since documents can simply be dragged into an exposition; that they will automatically end up in the *Simple Media* repository need not concern the author. Nevertheless, although appreciating the RC's underlying structure is not instrumental to working with the catalogue, not to do so could lead to misunderstanding it as simply an online, advanced html editor that sits on top of a simple file system.

Pages

Expositions consist of one or more *Pages*. In theory, anything can be arranged on those *Pages*, making it important to stress that there are no technical criteria that can be used to separate expositional from non-expositional contributions. In the context of the RC, this does not really matter, since it is a bottom-up research tool that does not prescribe to its users how it is to be employed. For *JAR*, this is different, since its editorial process as well as its peer-review procedures are there – amongst other things – to evaluate the expositionality of a submission.

It may be argued that it is easier for researchers to create web pages outside of the RC in their preferred html editor and upload those into their own domain or onto their institution's website. While this may be the case, there are a number of major incentives that make the RC a better option. Firstly, the branding and the URL that the RC provides make clear that a particular set of web pages is meant to be looked at as research. The very same pages hosted in a different context may easily be misunderstood as simply showing an artist's work, for example. Thus, the artistic, methodological and epistemological discussions that projects like ARC or the Society for Artistic Research (SAR) – which hosts the RC – provide are crucial contextual activities that support the specific reading of artistic practice as research. Furthermore, having a central site makes the research more accessible, because even if web pages and repository entries pertinent to artistic research are openly available on the Internet, they are usually very difficult to find. Since the RC sustainably preserves research for the future, allowing for stable referencing, it can support the formation of an artistic-research community outside of local contexts, raising the level of criticality and relevance of the field of artistic research through the sheer availability of its outputs.

Expositions and their associated *Pages* are objects that are situated in a researcher's practice and also in the socio-conceptual space that the RC offers.

A researcher literally starts with a first *Page* on which to place his or her documents, and this first *Page* is supported by a complex structure, which largely remains invisible, while whatever is exposed on that *Page* will receive part of its meaning from the context within which it is generated and presented.

Compared with all those conceptual implications and complications, the actual making of an exposition is very simple. After having obtained an account, researchers can simply press the 'add research' button on their profile pages to start making an exposition. Following the inputting of the most minimal metadata, the researcher is presented by the RC's exposition editor with a first *Page* in the middle of the screen and a toolbox and the repository on the left. By selecting a tool – for example, an image – and by dragging it onto the *Page*, the user can add documents in the desired place on the *Page*, repositioning and/or scaling them again, using nothing but clicking and dragging. Multiple *Pages* can be added, and the process of dragging additional tools and documents onto those *Pages* can be repeated until the researcher is happy with the result and proceeds to publish or share his or her exposition.

While the technical process is comparatively simple – although I have to acknowledge that not everybody finds it easy or is willing to learn it – how to actually *write* an exposition is difficult, if not impossible to explain in general terms. As much as the first blank *Page* enables ownership of both form and content of an exposition, it makes getting started awkward, since no guidance can be given as to what to place where so that it will make sense in the context of whatever practice is to be exposed as research as well as in the context of the RC. Such relationship to context or 'frame' corresponds to a concern deeply rooted in the history of art, where 'frame' is not only relevant in relation to the borders of an art object but also in relation to the borders of art, as is indicated by the debates around avant-garde practices (Bürger 1984; Buchloh 2000) and more recently aspects of contemporaneity (Osborne 2013). From an artistic researcher's point of view, looking at academic writing as a possible frame, it is essential to negotiate that frame in and through writing, while most other fields of research seem to find the medium through which they present their findings unproblematic, an attitude that cannot be afforded by contemporary artists.

To start with, it may be easiest to imagine an exposition as a set of empty rooms or a blank sheet of paper. When doing this, two extreme attitudes may be taken: researchers could place the above-mentioned pile of documents in the middle of that space and start spreading them out, or could stand back and think about what new objects may best suit the space and their concerns at a given point in time. Most likely, however, one may encounter a mixture between the two, where some existent material is paired with new work in a dynamic relationship in which things may be tried out and developed during the writing process. In fact, this indicates a shift in what is considered to be (academic) writing. In the RC, 'writing' is not deemed to be simply the construction of texts that are typed or uploaded into a place on a *Page*; rather, it

starts with the making of this place, since what will be written here may differ depending on where that place is, how it relates to its environment, and even how it is formatted. More radically, even before such writing has commenced, there is strictly speaking no *Page* to write upon. When using the RC for the first time, this is perhaps not immediately clear, since by default a first *Page* is suggested when an exposition is created. On a technical level, however, such an initial *Page* represents a space with zero dimensions, since at no point is the size of that *Page* defined. What decides the size of what we see is the size of the browser window through which the *Page* is displayed. It is easy to misunderstand what we see as the *Page*, a misunderstanding that vanishes once documents are placed outside of what is visible in the window by dragging a tool, for instance, towards the right margin. Suddenly, the *Page* will grow (as indicated by scrollbars that now appear) to contain what is placed within it. In effect, this means that before the researcher places a document on the *Page*, the *Page* strictly speaking does not exist, and that there is no space for writing before writing has started.

The first gesture of writing in the context of an exposition is thus a design gesture and the making of space. There is much to say about how the RC may reflect on the historic relationship between art and design, which is of course difficult to do in the context of this short chapter. Nevertheless, a number of points should be noted in relation to the designing of an exposition. Most important is perhaps the fact that the layout and design of an exposition can be read as an integral part of the meaning that is conveyed and not only as a secondary, transparent and decorative layer through which meaning appears, which is often the site of an additional (corporate) identity that is foreign to the research itself, such as logos or colour schemes. Usually, a project such as the RC displays a styled identity throughout its web pages, disallowing ownership of those pages to the 'providers of content'. While such measures tend to guarantee a professional appearance throughout, artistic engagement is kept at arm's length, relegated to content and limited to a series of pre-sets. On the RC, only pages that are about the RC are styled (such as the initial home page or the profile pages) while *Pages* as part of expositions do not display any permanent evidence of the RC's identity. Traces of the technical framework can naturally be found (for example, in the design of controls), but are kept very general and nondescript. The only clear presence of the RC's identity within the *Pages* of an exposition is a menu bar that appears initially for a few seconds after a *Page* is loaded and every time the mouse pointer is moved towards the top of the window. Outside of this, the RC makes the point of passing ownership of its *Pages* to its users. This has the interesting side effect that on average, RC *Pages* appear under-designed when compared with the usual publication of research in journals or dedicated project pages. This has partly to do with the RC software framework itself, which, in order to act as a sustainable resource, does not provide for specialist scripting. It also has to do with what may be called the skill set of contemporary artists, who tend to outsource graphic and, in particular, web design and who are now challenged to

think through and appropriate a field that is usually left to either their dealers, agents or publishers. As a result, one has to acknowledge that across the various expositions the RC may look messy, hit-and-miss, inconsistent and amateurish – which might, incidentally, support what the defenders of traditional academic standards think of artistic research. However, rather than registering this as a deficit, one can claim that the RC allows the calibration of an exposition, where this calibration forms an essential part of the research's experience and meaning. One might also want to add that a sense of integrity may be given space at the experiential core of a researcher's practice. Conversely, one may question the corporate sites of research – including those of academia – for interfering with the meaning of research through the control of the presentation.

A major trade-off needs to be mentioned, however. Since documents, displayed through tools, are placed at a particular point on the *Page*, which is expressed through the x/y coordinates at the upper-left corner of the tool, their position is absolute. Text is rendered by the browser and with it, the respective operating system. While its upper-left corner is still placed absolutely on the *Page*, line breaks may shift as the text progresses. This produces problems in the line-up of text and other documents (such as images or footnotes, for example) displayed next to a text column. Furthermore, not only might the rendered font differ in size, it might also differ in look, even if the size remains stable. Precise design, as we know it from desktop publishing, is a virtual impossibility on the web, requiring an approach to exposition design on the RC where the possibility of some variations in the appearance of a *Page* across various computer systems is accepted. As with any computer application, there is always the problem when designing on the RC that in comparison to a printed book, for example, output devices cannot be completely controlled. Although this is the case for all web design, it starts to matter more once the design of an exposition is seen as an artistic problem rather than a job passed on to a designer.

Since an author has 'complete' ownership of their *Pages* on the RC, a reader will not know what to expect when a particular *Page* is loaded. *Pages* may display a column of linear text and disregard illustrations; they may be media-heavy and engage with hypertextual, non-linear reading experiences. While the RC does not suggest a preference for the one type over the other, outside of what an author may want to do with a given material, the possibility for non-linear text suggests that not all readers will experience an exposition in the same way, making the exposition of practice as research on the RC at least to some degree a subjective affair even if text rather than media is used. If on top of this, through the use of images or sounds, additional forms of perception play an essential part in a piece of writing, one may wonder how this can still be negotiated in relation to knowledge. While *JAR*'s peer-review process asks reviewers to assess the suitability of a design in relation to the expositional point that is made, in the RC those relations may be much more experimental and open, making the RC a test bed for the possibilities of radically enhanced academic writing.

Sharing and Publication

When the RC was first conceived, emphasis was placed on the *Publication* of research expositions. In the context of the RC, *Publication* is the fixing and the making accessible of a hitherto dynamic and usually private exposition. *Publications* cannot be undone, which allows for the RC to act as a stable reference system for artistic research. During ARC, it soon became apparent that a *Publication* focus was limiting to the RC, since researching and publication appeared to be integrated more strongly than initially assumed and the publication was not simply the endpoint of a research activity. As a consequence, during the later part of ARC, emphasis was placed on the RC as research infrastructure. This has resulted in a more complex permission system.

Before discussing technical implications and possibilities in the context of the RC, it is important to stress that a 'permission system' in the form of copyright legislation already applies to material gathered outside of the RC into which it may be uploaded. It is difficult to assess the pros and cons of current legislation (which differs from country to country), but it seems certain that research relying on non-textual references is disadvantaged in comparison. While it is easy and free of charge to quote a section of text, quoting an image, a recording or a movie requires permission from, at times, multiple copyright holders, which, if it is granted at all, may cost a considerable amount of money.

After much debate, SAR, which now hosts the RC, decided to apply a fairly restricted policy in the hope that copyright holders may be persuaded to give permission for the use of protected material. Firstly, a RC user account cannot be created on the fly; rather, a signed copy of the letter of agreement needs to be sent to SAR, including postal address and proof of identity of the user. Secondly, the terms of use[7] of the RC, which all users (account holders and also readers who simply browse its content) have implicitly agreed to by employing the software, allow the use of materials provided on the RC only in the context of the RC and not outside of it. This will hopefully serve to reassure copyright holders that their material remains protected and cannot be legally distributed across the internet. Thirdly, the RC follows a clear and quick complaints procedure. Should any users believe that there is an infringement of their rights, they can complain and the content will be taken down immediately while arbitration takes place. Nevertheless, despite what SAR can do in the context of the RC, it is not unlikely that a licence to use a specific material may be refused or may be too expensive and that the exposition of practice as research may suffer as a consequence to the point where particular parts of an argument cannot be made. Copyright laws often prevent sharing, which in turn inhibits research.

While this is clearly problematic, there are, however, creative ways of dealing with the issue, which may, in effect, often be more expositional than

7. http://www.researchcatalogue.net/portal/terms.

the simple reproduction of a desired material. One possible strategy is the narration or description of a work of art, which highlights details and experiences that are otherwise difficult to convey. A second possible strategy is the sketching of the work, allowing a focus on particular features, such as the composition or key frames. Thirdly and perhaps least desirable, but nevertheless possible, is a simple reference and the suggestion that the work should be looked at in the original.

Assuming that a researcher has obtained an account, when adding new research, he or she starts by default in a private workspace – that is, nobody apart from this user will be able to access the exposition. Since research is often carried out in collaboration, it is, however, possible to add additional collaborators to an exposition who have editing rights and who will appear on the author list, and also to add additional contributors, who can edit while not featuring as authors. This construction supports collaborative work and extends an invitation to additional individuals (such as technicians or proofreaders) either to help with the exposition or simply to see it as it evolves (which may be important for supervisors or artists whose work is referred to).

It is also possible to allow reading access to an exposition beyond a limited group of named individuals by *Sharing* it either with logged-in users on the RC, or publicly with anybody who happens to load the *Page*. A *Shared* exposition may thus be public, but since it is still not fixed and may change it is not (yet) *Published*. While there are always examples on the RC of publicly shared research in progress, a visitor to the site will usually not be able to witness how the RC is used as a research infrastructure while the research is ongoing.

Sharing complicates the initially simplistic focus on *Publication* since it introduces a temporal element and, with it, a change to a publicly accessible exposition. As a consequence, it is now, for example, possible to stagger the process of *Publication* by slowly developing the exposition while inviting people to witness the event. A spacing-out in time may now correspond to a the spacing-out of documents on a *Page*, as discussed above, although at present this cannot be archived since a temporal dimension is not part of the *Publication* process – that is, whatever is done during the *Sharing* stages of an exposition is overwritten by changes made to it. This problem points to the need for technical enhancements to the RC, while also underlining a fundamental problem for the *Publication* of artistic research.

The technical solution is comparatively simple. There is a plan to enhance the RC with a versioning system that allows for the saving of particular states of an exposition. This offers the additional benefit that edits may be undone and that a user may revert back to the most recent saved version. In relation to the *Publication* of research, it would then be possible to publish versions of the same exposition and allow readers to browse through those versions, which, since they are *Publications* in their own right, can serve as sustainable points of reference.

The more fundamental problem, however, has to do with the idea that an exposition may need to terminate in one or more versions of itself and that reading, watching, listening or navigating – in short, the encounter – may be implied but is strangely absent from the experience. *Sharing*, as it were, stops when *Publication* commences. In effect, the notion of *Publication* represents a more or less controlled flow of information from a source (the exposition) to a target (the reader), while a response that can affect the exposition is not really possible. In other words, through a *Publication* focus, the RC may be biased in favour of a traditional presentation of knowledge, where the authority lies with the artist/author or work/text and where there is no space for a suitable and affective co-presence of audience or reader. The commenting system that the RC provides compensates for this to some degree, but it is clear that comments are meant to be about an exposition rather than being part of it.

This is not so much a technical issue of how change over time and activities of both authors and readers may be negotiated and presented as part of an exposition, although technical and more interactive solutions may be required; rather, it is a conceptual issue to do with the relationship between *Sharing* and *Publication* that still needs to be worked out. Personally, I suspect that a more artistic dimension to post-*Publication Sharing* needs to be imagined that would allow for expositions to play with the concept of publication just as they may do with the category of works.

In terms of repository (*Works* and *Simple Media*) and online publishing (*Pages*) the RC provides a research infrastructure that is dedicated to the artistic exposition of practice as research. However, aspects of social media (*Sharing* and *Publication*) require additional debate and development. In general, one can say that the RC attempts to offer differential constructs as a means to provide space for the artistic exposition of practice as research where no form or format is imposed and all choices of form or format may be related to an expositional labour that both brings out and creates knowledge implications within artistic practice.

The RC software framework does not define what an exposition is; rather, it offers a conceptually dynamic space within which expositions of practice as research can be made. The RC may thus illustrate and lend words to the kinds of complexities that need addressing when art is published in academia, while at the same time – as the section on *Sharing* and *Publication* suggests – it may have to be adapted to cater satisfactorily for researchers who choose to challenge existing conceptual and technical constraints. Most importantly, however, these complexities are not limited to an online space, since they are modelled as a response to the real and everyday problem of the making, dissemination and publication of artistic research. It remains to be seen what influence the RC may have on research to be carried out either on- or offline.

References

Borgdorff, H., 2012. *The Conflict of the Faculties. Perspectives on Artistic Research and Academia*. Leiden: Leiden University Press.

Buchloh, B.H.D., 2000. *Neo-Avantgarde and Culture Industry: Essays on European and American Art from 1955 to 1975*. Cambridge, MA, & London: MIT Press.

Bürger, P., 1984. *Theory of the Avant-Garde*. Minneapolis, MN, & London: University of Minnesota Press.

Busch, K., 2011. 'Generating Knowledge in the Arts – A Philosophical Daydream.' *Texte zur Kunst* (82), pp. 70-79.

Elo, M. (ed.), 2007. *Here Then: The Photograph as Work of Art and as Research*. Helsinki: Finnish Academy of Arts.

Münch, R., 2011. *Akademischer Kapitalismus: Über die politische Ökonomie der Hochschulreform Originalausgabe*. Berlin: Suhrkamp Verlag.

Osborne, P., 2013. *Anywhere or Not at All: Philosophy of Contemporary Art*. London and New York: Verso.

Schwab, M., 2008. 'First, the Second: Walter Benjamin's Theory of Reflection and the Question of Artistic Research.' *Journal of Visual Art Practice* 7(3), pp. 213-223.

Schwab, M., 2009a. 'First the Second: The Supplemental Function of Research in Art.' In: *Art and Artistic Research: Music, Visual Art, Design, Literature, Dance*. Zurich Yearbook of the Arts, C. Caduff, F. Siegenthaler, & T. Wälchli (eds.). Zurich: Zurich University of the Arts/Scheidegger & Spiess, pp. 56-65.

Schwab, M., 2009b. 'The Power of Deconstruction in Artistic Research.' *Working Papers in Art & Design* 5. Available at: http://sitem.herts.ac.uk/artdes_research/papers/wpades/vol5/msfull.html [Accessed 20 November 2012].

Schwab, M., 2011. 'Editorial.' *JAR* 0. Available at: http://www.jar-online.net/index.php/issues/editorial/480 [Accessed 20 November 2012].

Schwab, M., 2012a. 'Between a Rock and a Hard Place.' In: *Intellectual Birdhouse: Artistic Practice as Research*. F. Dombois et al. (eds.). London: Koenig Books, pp. 229-47.

Schwab, M., 2012b. 'Exposition Writing.' In *Yearbook for Artistic Research & Development*. Stockholm: Swedish Research Council, pp. 16-26.

Schwab, M., 2012c. 'The Research Catalogue as Model for Dissertations and Theses in Art and Design.' In: *The Sage Handbook of Digital Dissertations and Theses*. R. Andrews et al. (eds.). London, Thousand Oaks, New Delhi: Sage.

Sheikh, S., 2006. 'Spaces for Thinking: Perspectives on the Art Academy.' *Texte zur Kunst* (62, June). Available at: http://www.textezurkunst.de/62/spaces-for-thinking/ [Accessed 20 November 2012].

Practising the Artistic Research Catalogue

By Ruth Benschop

The second day of the conference is winding down. The chair looks around the auditorium to see if there are any more questions from the audience. Yes, here is one more but, as the speaker getting up at the back says, it may be an embarrassingly practical one. 'I've been working with the Research Catalogue software and have been adding a lot of material, mainly images, but I can't find a way to delete them. So if I make a mistake, or change my mind, I have to add another file and rename it, resulting in a quite substantial and, in my case, very messy list of files with increasingly odd names ... Is there a delete button, or am I missing something?' 'No, no!' comes the response from one of the two project leaders of the ARC project that is being discussed at this conference, Michael Schwab. 'This will be remedied in the next couple of days. What happened is this: There is in fact a button you can click on to delete files, but the designers who've recently been working on the appearance of the software to increase user-friendliness have mistakenly hidden it. So it is really there, but you just can't see it, at least not at the moment.'

Introducing: The Artistic Research Catalogue

How the invisibility of a delete button is a relevant issue as well as an appropriate metaphor will become clear later on in this chapter. To make that delete button meaningful, I will first briefly introduce the project of which that button, and the conference during which it was discussed, are a part: The Artistic Research Catalogue (ARC). ARC was an international project (running from 2010 to 2012, funded by the Dutch *Stichting Innovatie Alliantie, Regionale Actie en Aandacht voor Kennisinnovatie* (SIA-RAAK) programme) aimed at developing a digital platform that would fit the unique publication needs of a growing group of artist-researchers. The motivation of the project was the observation that to publish their work, artistic researchers mostly have to conform either to the artist's mould (exhibition, show, performance, etc.) or to the academic mould (peer-reviewed, text-based publication in academic journals or edited volumes). ARC tried to fill the gap in between. It took as its leading question: 'What kind of instrument for the documentation, dissemination and discursive signification of artistic-research projects can meet the interests of professional artists, art institutes and art students engaged with forms of art practice as re-

search? And how to build an instrument, which, at the same time, is inclusive towards the specific needs and demands that originate from the different art disciplines?' (Borgdorff and Schwab 2009: 4) The project first inventoried artist-researchers' publication needs, after which software designers created a pilot version of what would eventually become known as the Research Catalogue (the RC, see www.researchcatalogue.net). This pilot version was then tested by project members and associated prospective users. The project resulted in a user-friendly version of the software being presented at the final ARC Conference & Official Launch (1-2 March 2012, Royal Academy of Art in The Hague).[1] This meeting was at once a celebratory launch of the RC, an occasion to assess its qualities and function, and a roundup of the project. In the period running up to this launch, several researchers experimented with the platform and presented their experiences at the conference. They were all in one way or another connected to (organizations or institutions involved to some extent in) the project and had been asked to create, in the jargon of the RC, an exposition of their work and use the RC to present this at the conference.[2]

Delete buttons aside, what is fascinating about the ARC, and the RC developed within it, is that it is an explicit and reflexive intervention in ongoing attempts to found a new discipline, that of 'artistic research'. This constitutes a quite unique situation, that of discipline formation (and struggles to prevent or criticise this) at its inception. Moreover, it constitutes a situation of discipline formation fundamentally questioning the boundaries of academia (as well as the arts) as such. To get an analytic handle on this situation, I'd like to turn first to Rein de Wilde's elegant analysis (1992) of the formation of the discipline of sociology. By analysing the history of this discipline, he also develops a pragmatist science and technology studies' perspective on how to do a non-presentist disciplinary history. To summarise brutally, De Wilde argues that to understand

1. The group working on the project consisted of 'artists, art institutions, branch organisations, academies and art universities, which represent fine art, music, theatre, literature, design, architecture etc. The Hogeschool van Beeldende Kunsten, Muziek en Dans (HBKMD), Den Haag, The Netherlands [was] the applicant university of applied sciences.' Henk Borgdorff and Michael Schwab were the two project leaders. To create a broad base of support, the other participants of the project were '(a) professional artists and curators, (b) master and PhD art students and (c) branch organisations' (ARC project formulation document for RAAK funding, 2009, 1-2).

2. Within the ARC project the term 'exposition' has been introduced to name the contributions that in an academic journal would be called articles, with the explicit recommendation for researchers to investigate the term and change it to fit their own needs (see, for instance, the editorial of the first issue of the *Journal of Artistic Research* http://www.jar-online.net/index.php/issues/editorial/480 [accessed 7 October 2013]). I use it here as a shorthand to talk of the contributions created by artistic researchers within/using the Research Catalogue and thus to avoid confusion.

discipline formation we cannot assume a reality sliced into different territories to which different disciplines then lay their epistemological claims; nor can we assume different disciplines to simply address different problems. Both the object of study and the problems addressed are usually the object of a complex and heterogeneous debate that attempts to define and legitimise disciplines such as sociology. Moreover, following Gieryn (1983), De Wilde shows how such demarcations have a largely *practical* nature: routinely, differentiations are made as to what belongs to a certain field and what does not, by deciding for which grant to apply, by rejecting an abstract for a conference, etc. These demarcations, however, De Wilde argues, do not only create antagonism with and dissimilarities to other disciplines or fields, but also help to settle and manage relations between them.

De Wilde's approach thus shifts the question that was fundamental to the ARC project – 'How can we create a publication tool to meet artistic researchers' needs?' (not to mention, 'What tool has been created and what have researchers done with it?') – to this one: how is the discipline of artistic research being demarcated/defined (and negated) in the practical, mundane development and use of RC platform?

Though admittedly in the loosest possible way, I would like to use De Wilde's attention to the practical, sometimes tacit, day-to-day demarcation work and how it may result, sometimes unintentionally, in the formation of a discipline, as a useful analytical focus for my task at hand: the description of and reflection on the early adopters' use of the RC as a digital publication platform for the (anti-, trans-, non-) discipline-in-the-making of artistic research. The experiences of these early adopters are the focal point of this chapter for three reasons.[3] First, I use them to do some justice to the diversity of the field of artistic research as well as the ARC project. Secondly, I focus on examples of artistic research as a way of thinking about artistic research to counter the inclination in debates on artistic research to create or imply ideal-typical notions of artistic research. And thus thirdly, as a way into thinking about the process of discipline formation of artistic research and the role of projects such as the ARC in it.

3. I organised and chaired the presentations of the expositions of the early adopters as well as presenting my own exposition, which was concerned with a project called 'ILLBEGONE'. In the project, two groups of students from different backgrounds and theatre traditions worked together with artist Peter Missotten to create a performance at the Maastricht Theatre School. The exposition presents a documentation of the project in which the aims were 'to discuss as well as embody issues that are also at stake in performance and virtuality – such as the relationship between real/non-real and live/non-live. Moreover, the documentation tries to take seriously questions about why, how and for whom one would want to maintain what to all intents and purposes has gone: I'll be gone' (Benschop 2011). Sarah de Rijcke and Peter Peters were invited as discussants of the three sessions into which the presentations had been grouped. In the following I will take up some of the points they contributed.

Topics for Conversation

During the ARC project a lot happened. Many problems were solved, many issues addressed. Along the way, some more persistent questions also developed. Three of these were taken as starting point to address as well as order the expositions made by researchers. The first issue is to do with emergent research practices. As noted, the ARC project tried to create a digital platform that fitted the needs of professional artists who increasingly felt the need to document, disclose and disseminate their research projects. But what about the complementary question: how has using this digital platform affected or changed research practices? As documentation, dissemination and argumentation become a more inherent part of artists' research practices, the manner in which they do so, and the tools and venues available to them, may begin to infect their working practices. How does using (and thinking about) the RC challenge or change how artistic researchers work? And how does it impact on the ways in which researchers then approach and treat other research? What reading practices emerge from the RC? How are researchers encouraged by the RC expositions to engage with one other's research? What communities of research emerge from using the RC?

The second issue is about the interactivity of the RC. This issue was heavily debated throughout the ARC project and reflects debates about artistic research itself. While for some artistic researchers, the publication of their research is necessarily that of a finished product, for others, publication is part of their attempts to create input and feedback loops within their research practice, either aimed at artist colleagues or at members of the audience. The question of the interactivity of the RC is of course also closely related to questions about the finality or work-in-progress nature of artistic research as such. The question was in what way researchers managed the issue of interactivity/work-in-progress in their use of the current RC platform. And in the wake of that question, how necessary (or unnecessary) is it to make the RC more amenable to interactivity and incompleteness.

The third issue that came up was to do with the question of the content: the RC software has been developed throughout the ARC project in response to artistic-research users' requirements and feedback. The leading question has been: what do artistic researchers need to be able to make their research (digitally) public? But what has use of the RC meant in terms of substantive topics, issues, debates, arguments? Or, in other words, what is – given RC use – the emerging substantive focus of artistic research? What can and do artistic researchers – given RC use – talk about, agree or disagree upon, focus on or ignore completely? What are the issues at stake, what are the methodologies used, who are the colleagues referred to, etc.? And how should this focus be evaluated, how should it develop and what should be done – in terms of perhaps further developing the RC software – to facilitate this?

Emergent and Obdurate Practices of RC Use

These three thematic areas functioned as impetus for conversation but were, as is of course usual, converted into different but related questions during the conference, to which I now turn. The question of emerging practices was, for instance, translated into the question about what existing research practices were *challenged* by RC usage. As an example of a disciplinary habit prefiguring the way in which to relate to RC expositions, I told the anecdote about wanting – *needing* – to print out an exposition I'd been asked to review for *JAR*. Coming from an academic background and having studied at a time when pen and paper were still the ubiquitous tools of analysis, when asked to evaluate something, I tend to look for a stapled sheaf of A4 printouts, with an abstract at the top and literature references at the bottom. Needless to say, the RC does not tick all my boxes.

I wasn't the only one. Pianist Luk Vaes[4] presented two expositions-in-progress that he sees as arguments and analyses – both in text and sound recording – about problems in and proper techniques of piano playing. He talked about struggling with the non-linear qualities offered by the software to a non-visually educated researcher. What was thought of and designed as an opportunity to expand the linearity of (academic) text-based publication, here appears as a restraint.

Krien Clevis is working on her PhD in which she uses archaeological practices and debates to inflect her artistic exploration of the notion of place and how places can be accessed or made meaningful through memory and historical analysis.[5] In her exposition-in-the-making, she uses the idea of the cross to find, as well as show, her way of dealing with the differences and overlaps between academic knowledge (for instance archaeology) and artistic work. Although she found the RC a useful method of conducting her research as a crossing between visible art and academia, for her, there wasn't so much a disciplinary barrier as what one might call a technological one. Using the RC presupposes quite a lot of digital or web skills. Although there is a help function and an explanatory video for users of the RC, these options are themselves grounded in assumed knowledge of computer use.

So, in different ways, several of the presentations created awareness of what using the RC requires of researchers. Sarah de Rijcke also took up this point when she warned against a too eager and naïve enthusiasm for the newness of developments like the RC, which she argued, are always embedded in existing infrastructures resulting in remediations of existing traditions and habits. In Irene Kopelman's doctoral research, she used 'drawing as a method-

4. For information about Luk Vaes, see http://www.lukvaes.info (accessed 7 October 2013).

5. For information about Krien Clevis, see, for instance, http://www. researchcatalogue.net/profile/?person=2559 (accessed 7 October 2013).

ology for artistic thinking' (abstract conference programme).[6] That this was no mean feat became clear when she presented her attempts to draw icebergs in Antarctica until her fingers literally froze. The technique was so vital to her practice that she decided not to invest time in getting used to the RC software to create an exposition. Using the RC would require her, she felt, to acquire a new technique that would interfere with those she felt to be central to her work.[7]

An implicit assumption in the ARC project seems a bit like that of (early, but not only) Internet proponents who assume that use is a necessarily good thing and that when 'barriers to use are overcome, people will embrace the technology wholeheartedly' (Wyatt 2002: 25). They argue that focusing only on users (as a step forward from thinking only about producers) risks an uncritical acceptance of 'the promises of technology' (ibid.). They, and others, problematise the simple dichotomy of use and non-use and identify different types of non-users, enriching ideas of the diversity, in terms of agency and practice, of both users and non-users. While they focus on ICT or computer use *per se*, an analytical focus on non-users and their diverse reasons for non-use may serve as a critical point of entry to look at the RC and how the way it is made and organised includes as well as excludes possible usages.

The Question of When

In his presentation, Jan Robert Leegte also explained why he had not used the RC.[8] He is interested in critically exploring the notion of the museum space as a white cube, in and through artistic digital game design. However, he had just started this research and thus did not yet feel able to use the RC tool to structure or present it. This word 'yet' is interesting, because it introduces a different question that was addressed during the conference. The question of *when*.

A central idea in debates about artistic research is that documentation

6. For information about Irene Kopelman, see, for instance, http://www.artandresearch. org.uk/v2n2/kopelman1.html (accessed 7 October 2013) or http://www.e-flux.com/ announcements/irene-kopelman-the-molyneux-problem/ (accessed 7 October 2013).

7. This issue had already come to the fore in the *Practicing ARC* workshop (27 May 2011, KABK in The Hague, organised by Alexandra Landré and myself). There, participants spoke about how happy they were to have help in the form of this practical workshop and to be able to share experiences with peers as a very constructive means of introduction to the software. Some of them experienced the RC – particularly at that stage – as a new medium requiring a frustrating phase of induction. It is important to plan and support this phase and quite difficult for independent artists/artistic researchers to do so within their existing practice. On this issue of the important role of 'warm experts' in mediating technology use, see, for instance, Selwyn 2006.

8. For information about Robert Jan Leegte, see http://www.leegte.org (accessed 7 October 2013).

of artistic processes or artistic work may be a part of what constitutes artistic research, but that it is never in itself enough. Artistic research should be something that happens or infects artistic processes from the outset, rather than coming after the fact. The consensus about this ideal does not, however, translate simply into artistic-research practice, as became apparent in some of the expositions presented at the ARC conference. Different presentations and usages of the RC showed different ways of managing the question of when to incorporate/use the RC in one's artistic practice, and thus the question of when and how to let the RC affect that practice.

Some of the researchers presented their use of the RC as a way of finding out simultaneously how to use the software as well as what they were doing in their research-practice. These researchers, for instance, talked about how they were still in the earlier phases of their research, like Daniela de Paulis, who had recently started her PhD research at Leiden University with a project on radio astronomy and visionary architecture.[9] She talked about using the RC 'to try things out, in some ways like a diary of my research'. Some of those with a further-developed research practice created expositions that showed a clear delineation between work and work process, showing a documentation of work divided off from that of the background making processes.

Kit Hammonds presented his use of the RC very much as a working document, to the extent that he was working on his exposition right up to the time of his presentation during the conference – perhaps not only as an effect of his tight personal time-management, but also as a principle of use.[10] He described using the RC 'like a whiteboard or a scene-of-crime board'. More particularly, he used working on expositions in the RC as a way of analysing his work as a curator, as well as reflecting on and moulding his attempt to change methods of collaboration between artists and curators, creating more agency for the curator. (Incidentally, this raised an interesting and under-debated question about the bias towards individual expositions versus collaborative ones with a possibly collaborative authorship.)

From these presentations, it becomes apparent, at the very least, that the role of the RC as a tool of documentation or intervention is not fixed. How does one understand this diversity? It seems quite difficult, and possibly not that important, to find a historically correct answer to the question of how researchers have dealt with the documentary/intervention possibilities of the RC. More interestingly, we might take the expositions to present a historical argument about their relationship to the artistic work to which they are related, as well as the artistic-research practice from which they emerge.

9. For information about Daniela de Paulis, see http://www.researchcatalogue.net/profile/?person=18933 (accessed 7 October 2013).

10. For information about Kit Hammonds, see http://rca.academia.edu/KitHammonds (accessed 7 October 2013).

The RC as a Performative Container

From just about all of the expositions presented, it is apparent that researchers attempted to exploit the non-linearity of the RC software by simply but purposefully arranging material on a plane that requires the viewer to move outside of the frame, to encounter more of the exposition, for example. Yet, as Florian Dombois noted, many researchers were also quite tentative in using the RC as an aesthetic or performative tool.[11] While claiming a position that negates a representational mode of working in principle, in practice quite a few expositions tend to be more concerned with textual narration and representation/documentation of research, rather than the aesthetic or, for instance, argumentative performance of their research.

Johan Luijmes, for example, created an exposition showing twelve interdisciplinary etudes that he had practised and produced. 'The idea of the etude was taken from music praxis. The advantage of an etude is the fact that very specific skills can be developed, without arguing about artistic value directly. The etudes are a kind of game to be played' (Luijmes 2011). The exposition opens with twelve sketches of Escher's impossible staircase, allowing entry into twelve 'chapters' each documenting an etude. In the twelfth etude, Luijmes used the meta-tools of the RC (in this case the tool for navigation) to create an aesthetic effect, without further documenting the etude. In this way, his exposition problematises the use of the RC as a simple container of information. Most expositions, in more or less visibly interesting or conceptually consistent ways, attempted to explore the performative possibilities of the RC as also a representational tool.

In Joey Orr's presentation of the exposition by Sarah Alford (who was unable to attend the conference) (see: Alford 2011) we see a different way of experimenting with the non-representational properties of the RC. She creates an interesting disturbance of the neat difference between research object and researcher. Her exposition is constructed, unlike most others, almost only as a plane or surface in which, as the viewer/reader moves around, the interconnectedness of the object of study – Ellen Gates Starr – and the artistic and political practice of researcher/artist/author Sarah Alford are stressed both narratively and visually. The figure of the pigeon is used throughout her exposition as a metaphor for, as well as visualisation of, the historical figure of Starr that meanders through both her historical analyses and her re-creation of Starr's work, making it difficult to separate analysis from making, research from art, Starr from Alford.

These presentations reveal the creative ways in which many researchers juggle the representational and the non-representational qualities of the RC.

11. For information about Florian Dombois, see http://www.researchcatalogue.net/profile/?person=499 (accessed 7 October 2013).

The most interesting examples refuse to side with either a notion of the RC as container, or the notion of the RC as aesthetic or performative tool. They are, I feel, most interesting because they provide empirical examples of how we might actually *imagine* the idea (central to many discussions of artistic research, as Peter Peters also noted) that artistic research offers an alternative kind of knowledge, that artistic research constitutes a novel epistemological domain. These empirical examples show, perhaps more than the rhetorical arguments about artistic research tend to assume, academic fields such as cultural studies, science and technology studies, cultural anthropology, etc., in which sensitivity to and exploration of *forms* of knowing and *ways* of making research public are an intrinsic part of substantial argumentation.

In Michael Baers' (2011) very funny and critical reflection on the terms in which (in particular PhD programs within) artistic research are framed, he questions the too-easy collapsing of art into science, with its connotations and practices of methodological clarity, systematic articulation and reflection, and rational procedures. To allow for conceptions of art that become impossible to think or do in comparison to science necessitates a critical reaffirmation of the otherness, the ambiguity, the polysemy, the indeterminacy of artistic practice when it is *not* compared to science. Baers' discomfort with the cosy sociability of the model of the scientific research community as a rationalising and normalising collegial consultation perhaps depends on a view of science that has been amended systematically within Science and Technology Studies. There, a different image of academia appears, in which there are research communities to be sure, but to call them 'cosy' would be missing the point. How to do it, why to do it, how to position it and what can be claimed from it, are issues that are fiercely debated. Moreover, this research tradition shows the heterogeneous and underdetermined, messy work necessary to create the ideal of science as a rational discipline. In one of her comments during the conference, Sarah de Rijcke similarly drew attention to the sometimes caricatured and old-fashioned image of academic research as a neutral, non-normative, rather narrow and uncreative practice. But at the same time, she applauded a perspective that keeps asking what the movement towards academisation of art and artistic research, manifested in developments like RC, *JAR* and SAR, means for what artistic research can become, particularly as such movements of academisation include an alignment with indicator development for the assessment of this kind of work as part of public accountability.[12]

Expositions Relating to Whom?

Such academisation raises the issue of how artistic research engages with other research. In Joke Robaard's work, she observers and analyses both conceptually and materially the use of textile metaphors in public discourse, for instance about political issues.[13] She 'focuses on the interchange between such rhetoric

(social fabric) and the material consequences of this "torn social fabric" on the one hand, and the discussion on this issue on the other' (Joke Robaard, undated). Her exposition is made up of (photographs of) her own table top on which the viewer can move around over the diverse materials (texts) that she has laid out. The table top is at once a metaphor for the combination of philosophical and textile/material nature of her research argument (bringing together the physical books she is reading at her desk, as well as the notions that are presented in these books) as well as an image of her research process, showing a stage of material and conceptual organisation.

What I like about her table top is that it makes us as aware of the computer screen that we as readers/viewers use to visit her exposition as a physical plane. She does not here, as an academic might, situate her research in an academic community or position herself in a scientific argument; rather this amalgam of materials on the place of the screen/table top reveals her research as a conversation or a collage of physical stuff and ideas, concepts, arguments formulated in texts: articles, clippings, books.

Robaard's exposition thus makes us aware of how artistic researchers relate to other research in their use of the RC. Do they see themselves as part of a research community or environment? And if so, how does this appear in their publication of research on the RC?

O fado não se aprende? (*One Cannot Learn Fado?*) is the title of Brita Lemmens' exposition (presented by the supervisor of her BA research, Peter Peters).[14] Very different from Robaard's table top, it also uses the RC in an interestingly self-conscious way. In her auto-ethnographic research, Lemmens took this claim as a port of entry into Portuguese fado singing. She aimed to research this practice by way of trying to learn to sing fado. In her exposition she

12. Baers' and De Rijcke's call for careful attention to the effects of processes of discipline formation in artistic research is in fact close to a very common position appearing in debates about artistic research. As often as not, arguments are made not so much for or against a particular kind of artistic-research discipline and its commonalities and differences with other disciplines, but rather, the very idea of discipline formation as such is criticised. Artistic research is then strongly associated with a notion of art as necessarily always beyond or critically against processes of discipline formation. The stakes are to defend a notion of artistic research that manages to escape attempts to define it. The pragmatist perspective with which Gieryn's and De Wilde's approach is associated, and from which I take my analytic perspective in this chapter, however, does not entail a response to this argument. It requires that these arguments be taken, in the same way as all the others, as a practical achievement.

13. For information about Joke Robaard, see http://www.jokerobaard.nl (accessed 7 October 2013).

14. For information about Brita Lemmens, see http://www.researchcatalogue.net/ profile/?person=979 (accessed 7 October 2013).

stages her research again, using the sentence '*O fado não se aprende*' as a structure that performs and represents her research process, findings and singing. Peters stressed how the structure of the RC facilitated this rich and rigorously self-reflexive presentation of her project. At the same time, Lemmens includes at the end (although where 'the end' of her exposition is, is by no means obvious) a standard list of academic references. In exploiting a non-academic form, her exposition nonetheless insists on its academic credentials.

Something very different is going on in Natalia Calderón's exposition. In her abstract she states that her:

> artistic practice has been focused on public space as a site where differences confront and leave marks – scars. My interest in space is based on how people imprint themselves and intervene each inhabited or transited site. For my research, public space is not relevant itself, but how through it social space has been articulated. My research does not aim to produce objects; it is aware of the relevance of the in-between processes of generation of relations that cannot be reified' (Calderón 2012).

One of the questions addressed in response to her presentation was that of how this interest translates to the site of the RC. In what way can and does she use the RC itself as a public space in which to create non-reifiable relations? She responded that she sees the RC, at least potentially, as a space to experiment with new interventions. This question about how she aims to use the RC shifts the attention away from questions about (artistic) *expression* or the *creation* of a work or an argument, towards those about the institutional and public position of the RC. It is not what does the RC allow you to say, but what kind tool of verbalisation is the RC, where is it located, who gets to speak, who gets to listen?

While Calderón's presentation suggested these questions, Florian Dombois took a fundamental step in the formation of his exposition. He was the only one who purposely reduced the material exposed in the RC to foreground his exposition as an aesthetic experience (not only foregrounding it by presenting visual and auditory work, but also challenging the viewer to find the background information about his work by hiding it in his exposition). He thus made a claim through his exposition about the function of the RC. Secondly, he explicitly rejected the RC as a possible equivalent or documentation of the work he made and exhibited, embracing it instead as a different forum in which an argument can, but also *should* be made.

In general, however, the absence of situational information or references to research contexts, theoretical debates or empirical arenas in the expositions was striking. Peters suggested how in most of the expositions presented, the focus was on the formation and presentation of an individual research effort, without contextualisation of that effort, either by referring to or embedding other research, or by treating or staging the RC as an public space in some way.

Nor was there often the sense that the research presented was a reporting on the reflexive ways in which researchers were dealing with a problem they had encountered, taken on and analysed.

Back to the Delete Button

This chapter opened with a reference to the delete button that may be taken up by critics of the disciplining of art and artistic research as a metaphor for their claim. Those who take the academisation of artistic research as a move of limitation and legitimation *alone* may readily embrace the idea of the non-deletable as the essence of what is to be defended. My approach in this chapter has been to take the whole range of positions, from arguments such as these all the way to simple practical issues like that of the missing delete button, as empirical material exposing the ways in which artistic research is (or is not) becoming defined as a discipline.

In doing so, De Wilde's work helped to provide an external perspective focusing on the practical work of delineating and demarcating what belongs and what does not belong. Looking from this vantage point to the ARC and, more concretely, to the expositions presented at the ARC conference, we see a difference between what is practised and what is preached. While claims are made in discussions about artistic research and the ways in which such research should be made public, about the centrality of the non-representational, and for the interventionist role of documentation and publication, in the presentations we see something going on that is much more blurred. We see a range of ways of dealing with the axes of representation to non-representation (or from knowledge to art), as well as from documentation to intervention (or from research of the arts to research in and by the arts). This range problematises critical reflections on the relationship between academia and artistic research. Both appear as more multiply similar and different than is often assumed. Moreover, the attention to practicalities of demarcation created a focus on the ways in which researchers used or did not use the technology of the RC. It created awareness about how use is always embedded and prefigured in prior use (or non-use). It also helped pose questions about the critical role of non-users and how the ARC project might be able to attend to them not as a practical problem to be solved through software innovation, but as a substantial problem to be addressed on an institutional level.

Which brings me back to the invisible delete button. To me, it seems a beautiful metaphor for the risk of taking the institutional or normative critique indicated in this chapter as a *technical* question. But, as De Rijcke reminded us at the ARC conference, such things are never 'merely a technical question'. Sites like the RC and projects such as ARC should not be taken as innocent, apolitical discursive spaces for argument and discussion. The RC is already highly mediated by existing institutional arrangements within the art world,

and by routines from academia with which the RC is being aligned. This means that seeing problems as mundane as a missing delete button as merely technical, is itself to be understood as a move in discipline formation. The anecdote is thus a good reminder of the things that are made possible but can also be quite difficult to get rid of.

References

Alford, S. 2011. 'Taking the Book Apart.' *Journal for Artistic Research* 1. Available at: http://www.researchcatalogue.net/view/?weave=10325&x=0&y=0 [Accessed 22 October 2012].

Bears, M. 2011. 'Inside the Box: Notes From Within the European Artistic Research Debate.' *e-flux journal*, (26, June). Retrieved from: http://worker01.e-flux.com/pdf/article_233.pdf [Accessed 22 October 2012].

Benschop, R., 2011. 'I'll be Gone Again: Documenting the Virtual Body.' *Research Catalogue.* Available at: http://www.researchcatalogue.net/view/5496/5497/0/0 [Accessed 22 October 2012].

Borgdorff, H., & Schwab, M., 2009. 'The Artistic Research Catalogue.' Unpublished SIA-RAAK funding application, University of the Arts, The Hague.

Calderón, N., 2012. 'Knowledge Space Production in Artistic Practice.' *Research Catalogue* (19 February). http://www.researchcatalogue.net/view/18544/18545/0/0 [Accessed 22 October 2012].

Gieryn, Th. F., 1983. 'Boundary-work and the demarcation of science from non-science: strains and interests in professional ideologies of scientists.' *American Sociological Review* 48, pp. 781-795.

Luijmes, J., 2011. 'Interdisciplinary Etudes.' *Research Catalogue* (5 December). http://www.researchcatalogue.net/view/14497/14498/0/0 [Accessed 22 October 2012].

Robaard, J., (no date). 'Does it work, and how does it work?' (unpublished document).

Selwyn, N., 2006. 'Digital division or digital decision? A study of non-users and low-users of computers.' *Poetics: Journal of Empirical Research in Culture, Media and the Arts* 34(4-5), pp. 273-292.

Wilde, R. de, 1992. *Discipline en legende. De identiteit van de sociologie in Duitsland en de Verenigde Staten, 1870-1930.* Amsterdam: Van Gennep.

Wyatt, S., Thomas, G. & Terranova, T., 2002. 'They came, they surfed, they went back to the beach: Conceptualising use and non-use of the Internet.' In: *Virtual Society? Technology, Cyberbole, Reality.* S. Woolgar (ed.). Oxford: Oxford University Press, pp. 23-40.

Artistic Expositions within Academia: Challenges, Functionalities, Implications and Threats

By Lucy Amez, Binke van Kerckhoven & Walter Ysebaert

Introduction

Higher arts education in Europe, like other disciplines, is strongly affected by what is known as the Bologna Process. The main issues that the higher education institutions are facing in this context are the implementation of the third cycle (with the obligation to deliver bachelor's degrees, master's degrees and doctor's degrees) and the necessity of linking teaching to research, or the 'embedding' of arts education in a research environment (Lesage 2009). As a consequence, an increasing emphasis on 'artistic research' in its various appearances, and on its output, can be seen both in literature and in the policy of many European countries.[1] It also results in a need to report formally on a broader range of output, other than textual material, which leads to an array of practical questions facing research management on how to deal with the capture, evaluation and storage of artistic research output (Dickinson, Sefton, Lee, and Hunter 2011). Indeed, the emergence of artistic research has raised questions within research management contexts on what counts as research output and more importantly, on how to certify quality. The traditional flow of peer-reviewed, mainly textual, publishing has shown itself to be limited, as have the institutional databases built to keep track of publications, projects and patents.

In the academic community, research results are mainly shared through presentations at conferences or by publications in journals or books. A process of peer review is instituted to guarantee scientific quality. Artistic research, however, offers a different approach from this classic scientific research paradigm, since it allows the explicit acknowledgement of the material and the material processes as 'acteurs' of research. Artistic research can be described as a particular type of artistic practice in which many different perspectives can be present (aesthetic, hermeneutic, performative, mimetic, expressive, emotive), but through which artefacts become an artistic 'argument' (Borgdorff 2007), a potential carrier and medium of knowledge and understanding. 'Artefact' here

1. The Flemish Community is just one example of a region in which, related to the evaluation of artistic research projects and their funding, the discussion with regard to the nature of artistic research and artistic research results (output) is held in these terms. One could think of Norway or Austria as comparable examples.

is meant to cover any form of artistic expression, whether an art object, performance or exhibition (Candy and Edmonds 2011). In the process of artistic research, ontological and epistemological transformations take place. For this reason, it is difficult to streamline artistic research output along the traditional publication formats. Textual explication, if present or existing, finds its way into journals related to art history or musicology, but artists will often use different channels to share their work with the outside world.

Academia is driven by the accumulation of knowledge, the sharing of findings and the continuous test of contribution by the global research discipline. In a reflection on the relationship between professional practice and academic research, Biggs and Büchler (2008) specify that the basic characteristics that must apply to research are disseminated, original and shared. The creation of an academic community for artistic research will therefore require the initiation of communication tools and forums to activate discussion as well as to validate new ideas. New knowledge is to be disseminated in a form that allows it to be verified or challenged within its context (Candy and Edmonds 2011). In this development, the traditional scientific communication channels will be no more than an inspiration. The common modes of academic publishing prove inapt as means to express the results of artistic research where the artefact is at the core of what is to be expressed. At the same time, presenting art as research involves more than merely presenting an artefact. Borgdorff, Biggs and Büchler express this duality in terms of connectivity and selectivity: 'meaningful [artistic] research has to have certain properties in order to be recognized as research by the academic community, hence connectivity, and it needs to address certain values in order that the outcome is significant to the [art world,] hence selectivity'.[2] The newborn research community will need to organise new ways to get across the innovative nature of its research output along a certified workflow.

Over the past few years, new initiatives have been launched to present art as research in the context of academia. Whereas some projects stay within the borders of academic publishing, such as the online journals *Art & Research*,[3] *Art Monitor*[4] and the Hertfordshire *Working papers in Art and Design*,[5] others build on evolutions in digital repository technology to store and disseminate artistic research output. Institutional repositories are digital collections for the preservation of intellectual output. They share an internationally agreed-upon set of technical standards concerning the exchange of metadata, and output is often made available through open access. Whilst research repositories allow various

2. Quoted by Henk Borgdorff in JAR online discussion forum: http://jar-online.net/forum/viewtopic.php?f=4&t=14.

3. See http://www.artandresearch.org.uk/.

4. See http://konst.gu.se/english/Collaboration/Publications/Art_Monitor_tidskrift/.

5. See http://sitem.herts.ac.uk/artdes_research/papers/wpades/.

types of digital objects to be stored, the focus was initially directed towards archiving scientific publications and their related metadata. Later initiatives accommodated repositories for artistic output. The *Kultur Project* in the UK, as an important example, initiated in 2007 by JISC,[6] aimed at creating a transferable and sustainable institutional repository model for research output in the creative and applied arts by elaborating the existing *EPrints* software (Schwab 2012). Prolonged under the *Kultivate* project, it resulted in the proposition of a multimedia, open-source repository model for use in higher art institutions. The initiative addressed a need for the higher education arts sector to enter into a largely text-centred academic environment: 'Institutional repositories have traditionally been tailored towards text-based outputs and have been less proficient at accommodating the more complex multimedia outputs associated with practice-led research.'[7] Their data model was implemented at several UK arts institutions; others were inspired by it, like the USQ art repository, a collaboration between the University of Southern Queensland (USQ) and the Australian Digital Futures Institute (ADFI). Their scope was broader, however, than *Kultur* in terms of harvesting potential, web-ready renditions for various file types and search facilities (Dickinson, Sefton, Lee, and Hunter 2011).

These types of output-centred arts repositories are essentially tools to archive and display intellectual output, to document or, in the best case, link singular research objects. The stored objects themselves are mostly created outside the database and have gone through a prior certification process in either the arts or the publishing world. The Artistic Research Catalogue project (ARC), on the contrary, was launched as an initiative to combine the idea of an academic repository with publishing tools (Schwab 2012). Within this project, the Research Catalogue (RC) software has been realised: a digital platform developed specifically for research in the arts.[8] The RC represents a shift from object-centred repositories to a research-centred repository in which artistic works are presented 'as' research. The RC builds on three axes: the first aim is the development of a web editor enabling artistic researchers, as authors, to create their multimedia publication. The resulting online article is defined as 'exposition', a digital publication allowing researchers to expose art as research. Secondly, the RC-software is a tool for archiving expositions stored in a searchable digital catalogue. Thirdly, the RC aims to function as a platform to which other online portals and websites can connect. One link already established is that with *JAR*, the online peer-reviewed *Journal for Artistic Research*.

The aim of this contribution is to picture how the RC is embedded in the evolution of digital publishing currently taking place, to show how digital publications change the writing and reading process, and to demonstrate how

6. See http://www.jisc.ac.uk/.

7. See http://ie-repository.jisc.ac.uk/417/.

8. See http://www.kabk.nl/pageEN.php?id=0485.

these developments will determine the future success of the RC and similar initiatives. Success of the RC within academia will depend on the practical support it can offer users in their dealings with this new type of online publication for both authoring and dissemination. It will also have to pass the test of a number of critical success factors, which are seen to determine the value of scientific communication in general: registration, archiving, certification, awareness and reward (Roosendaal and Geurts 1997). Registration and archiving are related to the important functions of claiming precedence for a scholarly finding and having it preserved. Certification, awareness and reward refer to the academic process of giving validity to new findings, staying informed about new claims and being rewarded for making use of the medium. The latter can occur through various assessment systems at institutional or governmental level. Creating and storing an exposition in a digital catalogue also offers a multitude of opportunities to disclose research to the outside, to form communities and to organise a digital workflow for assessment. To fulfil those goals, the RC will need to comply with an array of technical standards that are the necessary conditions for it to operate as a full open repository whose content is taken up by external portals and search engines. Those issues will be discussed in more detail at the end of this chapter.

From Simple Enhancement to Rich Internet Publications

Scientific results are often expressed through artefacts: prototypes, datasets, simulations, animations or games. Some are 'digital born', others have a digital representation. Information infrastructure nowadays offers expanded opportunities to visualise, store and represent digital objects. However, evolutions taking place in digital communication have not prevented the traditional text article from remaining very much the norm in scientific publishing. Tools to integrate audio or video files, datasets or even images are very often lacking and current publishing tools are barely sufficient to deal with non-textual materials. They are generally regarded to be add-ons rather than essential parts of the publication and the supplementary material is often ad hoc (Lynch 2007; Bourne 2005). Although most of the newly produced scientific journal articles are now published electronically, the process has been taken no further than the digitisation of in essence paper-written material into a static PDF format or an HTML page at the publisher's site. On top of that, strict style guidelines are imposed by the publisher, allowing little flexibility for the author to express and illustrate scientific results outside of predefined formats. The limited options provided by formal scientific communication contrast strongly with the informal scientific communication where, through the use of blogs, wikis and social network sites, scholars debate their results in a more dynamic and creative way. It reveals the need of a segment of researchers wanting to work with both text and supplementary material in an integrated and interactive fashion.

New initiatives were recently introduced to face the issue of representing 'the full scholarly record' (Van de Sompel et al. 2004). The EU-funded Driver II project investigates a new publication model defined as an 'enhanced publication'. It concerns publications enhanced with three categories of information: (1) research data (2) extra materials to illustrate or clarify (3) post-publication data such as commentaries and ranking (Woutersen-Windhouwer and Brandsma 2009). The concept of enhanced publications is inspired by previous lines of inquiry aimed at expanding the publication format, the 'modular article' (Kircz 1998) and the 'semantic article' (Hunter 2006), two cases where files are not just added to a linear article but where different 'modules' of an article, including research workflows, are presented as composite digital objects. The concept of enhanced publications also relates to the development of repository architectures and the specification of open-access exchange protocols. In the context of the Driver II projects, an enhanced or enriched publication starts from a catalogue of objects that are linked in a meaningful way and are supported by standards of exchange and aggregation. Links between publications and other material are stored in resource maps, while editor tools such as ESCAPE or XPOS'RE are developed to compose content, structure and functionality.

Breure, Voorbij and Hoogerwerf (2011) place digital publications on a spectrum of complexity. The low end consists of a linear text, close to a printed document, with some supplementary material loosely connected to it. It is presented through a pop-up or a hyperlink reference to images, tables or datasets. A known example is the BioLit[9] portal (Fink and Bourne 2007) that, driven by the ambition to blur the boundary between publication and data, developed tools to link open-access articles in life sciences to information and visualisations of existing biological databases that are then jointly presented. The middle spectrum of enhancement is characterised by publications endowed with a higher degree of integration, where the main text is meaningfully linked to information objects. Elsevier's 'Article of the Future'[10] format serves as a case in point, introduced by the publisher as 'a new approach to structuring the traditional sections of a research article, moving away from the linear format required by print presentation to an integrated, linked navigation scheme that allows each reader to create a personalised path through the article's content'.[11] It laid the foundations for a multimedia publication portal of the journal *Cell*,[12] where the article text can be enriched with visual representations, video abstracts or reader comments. The BioLit and *Cell* projects are both high-profile initiatives that operate in the alpha sciences. The evolution towards enriched contents is, however, equally driven by a variety of small

9. See http://biolit.ucsd.edu/doc/.

10. See http://www.articleofthefuture.com/.

11. See http://www.americalatina.elsevier.com/corporate/ultimas_noticias_04.php.

12. See http://www.cell.com/.

initiatives in the arts and humanities disciplines, mainly in history, archaeology and cultural heritage. Examples include the *Journal of Archaeology in the Low Countries*,[13] an open-context platform where archaeological project information is linked to documentation, and the online cultural heritage research environment (OCHRE),[14] which encompasses written and unwritten material in a flexible coherent framework.

The highest degree of complexity is reached by what is defined as rich internet publications (RIP), in analogy to rich internet applications. They bear more resemblance to a web representation than to a traditional journal article. RIPs are distinct in that they are self-contained web applications, largely image-driven, where neither the writing nor the reading is linear. The text is superseded by a multimedia layer to provoke a more direct experience. Through the use of integrations of text and visuals, authors are able to 'show what they tell'. Breure, Voorbij and Hoogerwerf (2011) make a distinction between Type I RIPs, which are primary text-based, and Type II RIPs, where images and graphics are the core of the publication and text plays an auxiliary role. Their key features are integration, visualisation and exploration. Rich internet publications are the end of the spectrum and expositions such as those developed by the ARC project can serve as a representative. The RC graphical user interface functions as a web editor, giving the author control over the positioning of elements onscreen. It enables an artist-researcher to create single or multiple web pages, to lay them out using multimedia tools and to position them on the 'canvas', creating an online publication. Current media in the RC application include image, audio, video and slideshows as well as text. Other comparable RIP-II projects are web studios like Terra Incognita[15] and Second Story,[16] both online studios of interactive design and storytelling with museum-related content. It is not surprising that the few high-end examples are situated in the arts domain, where actual expression benefits from a multi-media approach to publishing.

Expositions: An Innovative Tool for Author and Reader

When writing for scientific journals, researchers rely heavily on conventions, and various scientific writing guides educate young scholars in matters of structure, grammar, style and language use. Academic writing is stylised and highly unimodal in the sense that the means of expression are limited to text. An RC exposition can be seen as a form of multimodal publishing (Kress 2003; Lauer 2009). Here, communication is not limited to one mode or medium, it allows

13. See http://www.jalc.nl/.

14. See http://ochre.lib.uchicago.edu/.

15. See http://www.terraincognita.com/.

16. See http://www.secondstory.com/.

the combination of several semiotic systems: textual, visual or auditory. Multi-modal publishing is not new. It is found in highly illustrated arts books, audio-books, or comic strips. It becomes an innovative tool when, as in the RC, it is delivered through digital media platforms and when it is constructed as a tool to be used by individual scientists to create an enriched reader experience surpassing that of a linear text. Guidelines for writing rich internet publications with academic purpose are non-existent, but rules on web design can be supportive. The success or failure of RIPs for artistic research will play at three levels: (1) The representation level, that is, to what extent is it possible to represent an artwork in a digital form? (2) The composition level: does it enable the artist (scientist) to create a rich publication that in a satisfactory way expresses the innovative character of the performed research and transmits the scientific as well as the artistic message to a peer audience? (3) The technological level: to what extent is the software developed in a way that makes it easy to use by reader and writer?

The representation level is often disregarded. It is implicitly assumed that in a multimedia-driven world it is straightforward to create a digital representation of an artefact. In reality, there is a high diversity in the degree to which art represents itself through digital media and some art forms are highly advantaged. Performing arts, as a case in point, can be recorded and seemingly easily included in a RIP, but the logistical demands can be intensive and when attendees' interaction is involved it becomes particularly difficult to capture the full experience. The representative gap between the artefact and its digital counterpart is much broader in art forms such as painting or sculpture compared to music or photography, for instance. Despite the fact that the technical options to digitise art are widespread and democratised, the result remains a representation of the artwork rather than the work itself: 'Ceçi n'est pas un oeuvre d'art'. This has its impact on the experience one can offer to the audience.

The main challenge for the success of RIPs plays at the composition level. In a Web 2.0 environment, users are familiar with various kinds of representations that are freely uploaded on the web. However, bringing components together in a multimedia publication in a way that is meaningful to the reader differs substantially from the linear text-writing style considered the norm in academia. Whereas classic academic writing is linear and author-driven, RIPs are generally non-linear and very much reader-driven. This confronts researchers with a change in publication traditions: moving towards multimodal media, offering parallel displays of information and extensive cross-reference elements. The image might partly replace the printed word as primary carrier of meaning and where the organisation of writing is governed by the logic of time, the organisation of the image is governed by the logic of space and the simultaneity of the visual elements in spatial arrangements (Kress 2003). Writing succeeds describing and documenting the digital objects. It is about showing what you tell rather than telling the story in a linear structure of chapters and sections. The writer has the difficult task of guiding readers through the experience in

such a way that scientific value is fully captured. The role of the author is that of a guide who helps the reader to observe the discovery process (Bezemer and Kress 2009). Bolter (1991) describes the switch in terms of a change of writing space. Electronic writing is characterised by fluidity and an interactive relationship between writer and reader. The authors create paths for the readers, whose relationship with the media is altered since they must actively choose the links to be read. The form 'does not close itself off as a heterocosm but invites the reader to participate in its own construction' (Bolter 1991).

Transactional theory (Rosenblath 1969; 1978) presents the relationship between reader and writer as interactive. The position of the reader is placed on a continuum between efferent and aesthetic reading. Efferent reading occurs when the reader's emphasis is on taking up information. It is utilitarian reading, where meaning results from an abstracting-out and analytic structuring of ideas. The aesthetic stance, on the contrary, puts its focus on what is being lived through during the event of reading. In the RC artistic exposition, both elements will have to be balanced by the author. On the one hand, as a scientific means of communication, it is basically utilitarian; it will have to contextualise the artwork and clarify the innovativeness of the finding to the scientific community. On the other hand, the exposition is to be organised in such a way that the intrinsic artistic value of the works is maximally experienced by the online reader. Additionally, a RIP potentially allows for interaction with the reader. This can be through hyperlinking but also through responsive involvement of the audience. RIP authors can build up a story in a continuous way and research publishing becomes more dynamic in that sense. Artistic RIPs can therefore be considered a new format representing a shift from static text to research publishing as a dynamic experience. The exposition is more than an enhanced text, since the sum is expected to overturn its constituent parts. The way in which the objects are represented matters as much as how they are placed into a composition. Both aspects of the composition determine the meaning. The publication is a creative object in its own right, which is expected to create feedback processes towards the artist.

Finally, computers change the technology of writing, and the success of RIPs for the arts will also be determined by technological aspects. Good usability forms the success of any software. Since most authors are not trained information scientists, the reluctance is often triggered by lack of familiarity with the tools. It is important to bring the tools to the researcher's desk, to provide good interfaces and appropriate coaching (Barish and Daley 2005). For the RC and its integrated publication editor, usability is of considerable importance: hiding complexity for the user, avoiding unnecessary steps, providing intuitive buttons. All these elements facilitate the design process for the author. Because RIPs are highly reader-driven, equal attention will have to be paid to the representation to the reader for whom an experience can be created which largely surpasses that of a written text. The reader can browse through multiple pages, and images can be viewed and zoomed in on (Gielkens and Hulman 2011). Yet science readers

often prefer reading print to reading from the screen (Tenopir 2003) and when opting for the multimedia reading they like the text short in relation to the visual aspects. As a result, the reader's orientation towards the new medium will limit the creative writer in his or her expressive abilities as much as it opens them up.

Certification and Awareness – the Essence of Scientific Writing

Certification or trustworthiness is one of the core criteria along which newly introduced publishing platforms are to be measured. It expects that the research output passes through the necessary social processes, assuring readers that they can place a high level of trust in the content of the document, based on community-specific norms (Kling and McKim 1999). To guarantee the certification process, the academic publishing model is organised in a workflow of – mostly double blind – peer review certifying the scientific contents. The organisation of quality control has traditionally been in the hands of the journal's publishers. Catalogues of RIPs, such as the RC, have the potential to subscribe to the classic lines of publishing while at the same time allowing for more open forms of certification. Portals can be linked to such catalogues, or RIPs can potentially be harvested by other applications. *JAR* is such a parallel portal, being created alongside the RC. It is an online peer-reviewed journal to which expositions edited by and stored in the catalogue can be electronically submitted, after which a web-based, single-blind peer review process is organised. The duality between the aesthetic stand and the efferent position of the reader is visible in the way in which this evaluation process occurs. In *JAR*, it is translated in the composition of the referee group, which consists of both artists and academics in a process that can be referred to as 'extended peer review' (Pereira and Funtowicz 2005). It is important that in this process of peer review, the exposition is reviewed as a whole, including textual and interrelated non-textual material, whereas often, in existing online publishing platforms the extra-textual material is added ex-post and is as such not part of the review process (Woutersen-Windhouwer and Brandsma 2009; Lynch 2007).

Nowadays, in most academic publishing, the workflow is entirely electronic, from uploading a manuscript to the organisation of a correspondence and tracking system between actors. Yet web-based systems provide the technical means for a more elaborate approach to reviewing. Open catalogues can be expanded with tools of open review, facilitating the ex-ante selections of articles to be sent to a journal, or enhancing the peer-review ex-post by adding notes, comments or discussions. Some journals such as *PLOS ONE*[17] and *Cell* allow researchers to comment after the formal peer review process has taken place. The journal *ETAI (Electronic Transactions on Artificial Intelligence)*[18] combines

17. See http://www.plosone.org/home.action.
18. See http://www.etaij.org/.

open discussion about the article with subsequent confidential refereeing where it is decided whether or not to accept the article to the journal. A limited number of current academic journals (e.g. *Philica*[19]) base their selections on fully open systems in which the entire research community is allowed to participate. The Palgrave journal *Postmedieval*[20] experimented with crowd reviewing. However, not all introductions of open-comment systems proved successful in the past. An open review experiment by *Nature* revealed high interest from authors, but the comments they received often proved insubstantial.[21]

The RC currently enables registered authors to post comments on expositions and adds peer-review reports to *JAR*-accepted publications. To support more open communication, reviewing, commenting and publishing functionality for connected portals has been integrated. Advanced open-communication tools might prove to be an added value for artistic research in the longer run. Firstly, because they can install dynamics in an emerging research community, and secondly because online articles and RC expositions 'in progress' can be publicly exposed for comment and the interaction with readers/spectators might provide new input for the author to enrich the publication. As such, the RC has the potential to become a creative spot where scholars can become informed on new artistic research findings, leveraging the growth of the community. By adding their research to the RC, artist-researchers become part of a shared environment, enabling them to communicate with other artists, and to reference and comment upon their own or other expositions or works. In this respect, and providing a sufficient user base, the RC can develop into a web-based knowledge community (WKC) centred around research in the arts: a community that allows individuals to seek and share knowledge through a website based on common interests. A WKC is usually directed to a specific knowledge domain and relies on community users as its primary resource for acquiring and exchanging knowledge in order to build a knowledge repository within the community (Lin, Fan and Zhang 2007). The use of online communities is also an emerging phenomenon in academic research and curricula: general scientific communities such as *Academia.edu*[22] and *Mendeley*[23] allow for sharing research papers and connecting with fellow scientists, while specialised networks such as *Nature Multimedia*[24] or *BiomedExperts*[25] allow scientists from a designated research community to connect and exchange knowledge.

19. See http://philica.com.

20. See http://www.palgrave-journals.com/pmed/index.html.

21. See http://www.nature.com/nature/peerreview/debate/nature05535.html.

22. See http://academia.edu.

23. See http://www.mendeley.com.

24. See http://network.nature.com.

25. See http://www.biomedexperts.com.

Referencing Expositions Through a Sustainable Archive

Artistic research presentations such as exhibitions and performances are restricted in place and time; they are fluid and irrevocably lost once they're over. This generates difficulties for future reference and post-evaluation of the research presented in the context of a research culture that starts from the presumption that research articles and books can be referenced and consulted at all times. The RC exposition – as digital research presentation – can provide a sustainable reference for research in the arts, since adding an exposition to the research catalogue implies embedding the research in a repository collection that stores information in a systematic way. This repository structure provides an ideal environment in which to handle collection management and to make the research accessible and available for years to come. It can enhance retrieval of the expositions through intelligent search interfaces, procure a network-wide dissemination of artistic research and provide a sustainable archive for future reference.

While potentially a valuable asset in long-term management, the curation and preservation of objects in digital collections presents a considerable challenge. Sustainability of a digital archive is a complex matter depending on a variety of elements such as organisational processes, technical suitability and financial sustainability.[26] RC expositions, being digital-born publications and existing solely in virtual space, are particularly vulnerable to obsolescence: 'Technical obsolescence in the digital age is like the deterioration of paper in the paper age. Libraries in the pre-digital era had to worry about climate control and the de-acidification of books, but the preservation of digital information will mean constantly coming up with new technical solutions' (Cleveland 1998). An important aspect of digital preservation is document referenceability: the fundamental requirement that online resources can be identified and located unambiguously. The well-known phenomenon of 'broken links' or 'link obsolescence' is a general problem for online content, but becomes especially problematic in a research context: citations, references and clearly defined sources are considered fundamental for research communication, while online research journals are also prone to suffer from 'link rot'. A study by James Ho (2005), for example, conducted on three established peer-reviewed exclusively online journals, *The Journal of Computer-Mediated Communication*, *First Monday* and *The Journal of Interactive Media in Education*, concluded that nearly half of all web references (online articles as well as online sources) were broken.

26. The Trusted Digital Repositories (TDR) checklist, which is concerned with certification of digital sustainability, defines seven attributes of trustworthy digital archives: OAIS compliance, administrative responsibility, organizational viability, financial sustainability, technological and procedural suitability, system security, and procedural accountability. See http://www.crl.edu/sites/default/files/attachments/pages/trac_0.pdf.

Bugeja and Dimitrova (2010: 8) warn that these risks associated with online journals pose a threat to science since 'vanishing online footnotes underline the building blocks of research, and their disappearance raises concern about the reliability and replicability of scholarship'. The use of persistent identifiers can serve as a technical antidote to this issue of 'broken links', providing sufficient administrative and organisational support from the institution implementing the scheme. A number of persistent identifier schemes have been developed in the 1990s (Hilse and Kothe 2006), providing a means for consistent document availability and retrieval, among others PURL (Persistent URL), URN (Uniform Resource Name), DOI (Digital Object Identifier) and ARK (Archival Resource Keys). Other technical issues in the context of digital sustainability involve media file formats, backup procedures, playback technologies and the addition of preservation metadata.

Metadata, literally 'data about data', plays an important role in achieving sustainability, but also in exchange and search modalities. Creating broadly accessible descriptive metadata is a way to maximise access to the objects contained in a repository. Descriptive metadata form the foundation of the search interface of an application, allowing users to browse through the collection in a relevant way. Subject-specific information can be provided through keywords, closed classifications such as simple enumerations, hierarchical taxonomies, faceted classifications, extended thesauri or topic maps (Garshol 2004). In the RC, search functionality is added, enabling users to discover research expositions, works and profiles of artist-researchers through the use of metadata fields. The RC, in its current development status, adds subject information mainly through simple keywords and enumerations, which provide less opportunity for detailed retrieval of information. Extending those search capabilities might be a future determinant of RC success, since 'search' and 'research' are closely related: adequate and efficient access to research results is of major importance in the context of a research culture in which 'knowledge builds on knowledge' and in which researchers reference and cite each other's work.

In a networked environment, metadata also reaches outside the application to gain a wider audience. A multitude of metadata-based access tools for the scientific community can be found on the net: library catalogues, article engines and search interfaces for open-access journals such as the *Directory of Open Access Journals (DOAJ)*.[27] For the art community, these include museum repositories like *Europeana*[28] and more discipline-specific portals such as *Gateway to Archives of Media Art (GAMA)*.[29] While stepping out of a singular application and reaching for other communities and portals with which to exchange metadata, the use of metadata standards becomes imperative. Standards

27. See http://www.doaj.org/.

28. See http://www.europeana.eu/.

29. See http://www.gama-gateway.eu/.

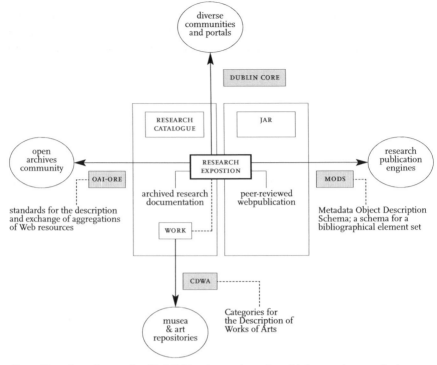

Fig. 1. Hypothetical example of RC/*JAR* exchange through multiple metadata standards.

enhance interoperability between systems as a common information structure is defined. Various metadata schemes exist at different levels. Dublin Core[30] is a widely used metadata standard supporting a broad range of purposes and objects, while other metadata standards support exchange of specialised information. Metadata standards used by the library community for research publications are MARC[31] and MODS.[32] The art community frequently describes artworks using the Categories for the Description of Works of Arts (CDWA) standard,[33] next to discipline-specific standards such as VRA Core for the description of works of visual culture.[34]

The RC content is mapped to the Dublin Core metadata standard, the *lingua franca* of applications. For reaching specific communities, however, Dublin Core will not be sufficient; it will be necessary here to speak the language of those communities and translate ('map') metadata. As such, RC

30. See http://dublincore.org/.

31. See http://www.loc.gov/marc/.

32. See http://www.loc.gov/standards/mods/.

33. See http://www.getty.edu/research/publications/electronic_publications/cdwa/index.html.

34. See http://www.loc.gov/standards/vracore/.

content can be mapped to different specialised standards, depending on the communities and portals with which the RC and *JAR* wish to interact. Strategic goals function as foundation for metadata mapping and design. Figure 1 illustrates this and sketches a hypothetical scenario for future RC/*JAR* data exchange. If the RC wants to connect with the open archives community, for example, it can choose to exchange its research expositions as compound digital objects through the Open Archives Initiative Object Reuse and Exchange (OAI-ORE) standard.[35] Another goal might be to cooperate with museums and art repositories on the level of works, which are related to the RC expositions. In this scenario, using CDWA or related art standards will be appropriate. Expositions published in *JAR* can be considered peer-reviewed digital articles and *JAR* can decide to expose these to article search engines using MODS or other bibliographic standards. As a consequence, *JAR* articles could be found next to 'traditional' academic articles, possibly narrowing the gap between 'research in the arts' and the global research community.

Good metadata design is an important factor in the future use and success of the RC. In defining those metadata and standards, sustainability, search modalities and interoperation with diverse communities provide the strategic background.

Value Assignment and Reward

The success of the RC and the *JAR*, or similar initiatives, will be equally determined by the appreciation and esteem they receive from those involved, especially at the peer level, the level of the individual researcher, and the (academic) policy level – all of these are connected with each other. From this perspective, content (the quality of the exposed research, subject to peer-review processes), methodology and transparency of the peer process, and the technical possibilities and functionality of the RC are crucial. Given the increasing interest within higher arts institutions on research output, individual researchers will probably continue to 'expose' in the RC and to publish in *JAR* only if this influences their future careers (public/artistic and/or academic) in a positive way. Peers will invest time and energy only if the peer-review process is transparent and if their evaluations are well respected by the boards involved. Institutions may show interest if the RC meets all requirements, such as to register, and especially, to publish or to disseminate, whether publicly or not, the research done by its members. (With the further growth of artistic research as a discipline, it is likely that new research journals will emerge or that other repositories will be further elaborated to suit the needs of both researchers and management). One could even imagine the possibility that in this context,

35. See http://www.openarchives.org/ore/.

new artistic-research journals, attached to certain institutions, could emerge. Finally, national research assessment panels, whether working with hybrid 'bibliometric' tools or opting for a peer-review approach, will take the expositions into consideration if quality is proven. So, considered as a publication medium or tool, and taking into account the above, the RC could play its role in the process of granting artistic research 'scientific seriousness', thus making it more acceptable to academia.

One also has to consider the additional opportunities that the RC and similar applications have to offer. The assessment of artistic research is in most countries still non-existent, problematic or questionable, while the communication channels of traditional academia are not sufficiently equipped to deal with the complexity of this research. National-level databases, in relation to which discipline-specific parameters can be developed and taking into account the particularities of artistic research, seem to be indispensable within the development of assessment models and procedures. Several experiments are ongoing (e.g. Flanders, UK) that all raise questions with regard to development, metadata or functionality; possible answers offered by the RC are interesting and inspiring.

Conclusion

All initiatives taken within the context of 'publishing' or 'exposing' artistic research should arouse the attention of scholars in other disciplines, since they offer opportunities for the presentation of their research in a multimodal way. The need to enhance text articles with visuals or data is not limited to the arts, and the availability of digital-research repositories at institutional, national and international levels will open up opportunities to link different types of objects. As mentioned above, enhanced publications as such are not new, having already been developed in other scientific disciplines. However, those new ways of presenting results and the altered degree of involvement this will imply for both reader and writer will be even more challenged in traditional academic disciplines that have a long-standing tradition of publishing in text-based journals or books. Each RC exposition can be considered an individually designed website that challenges the writing, the reviewing and the indexing process of the classic publication type. The need to express academic results through extra-textual material is, for example, potentially great for research fields such as engineering, where prototyping is important, information science, where software needs to run in parallel with the contextualisation, or medical science, where the dynamic workflow of clinical trials could benefit from presentation on a digital platform and advanced digital visualisations – such as genome structures – are fundamental to exposing results. Thus the presented case could clearly be inspirational to other disciplines.

References

Barish, S., and Daley, E., 2005. 'Multimedia Scholarship for the Twenty-First Century.' In: *Proceedings of The Internet and the University: Forum 2004* (Aspen 2004), pp. 129-149. Available at: http://net.educause.edu/ir/library/pdf/ffpiu047.pdf [Accessed 20 November 2012].

Bezemer, J., and Kress, G., 2008. 'Writing in multimodal texts: A social semiotic account of designs for learning', *Written Communication* 25, pp. 166-195.

Biggs, M., and Büchler, D., 2008. 'Architectural Practice and Academic Research', *Nordic Journal of Architectural Research* 20(1), pp. 83-94. Available at: http://hdl.handle.net/2299/4405 [Accessed 20 November 2012].

Bolter, J.D., 2001. *Writing Space: Computers, Hypertext, and the Remediation of Print*. Mahwah, NJ: Lawrence Earlbaum Associates.

Borgdorff, H., 2007. 'The Debate on Research in the Arts', *Dutch Journal of Music Theory* 12(1), pp. 1-17.

Bourne, P., 2005. 'Will a Biological Database be different from a Biological Journal?', *PloS computational Biology* 1(3), pp. 179-181. Available at: http://dx.doi.org/10.1371/journal.pcbi.0010034 [Accessed 20 November 2012].

Breure, L., Voorbij, H. and Hoogerwerf, M., 2011. 'Rich internet publications: Show what you tell', *Journal of Digital Information* 12(1). Available at: http://journals.tdl.org/jodi/article/view/1606/1738 [Accessed 20 November 2012].

Bugeja, M., and Dimitrova, D.V., 2010. *Vanishing act: The erosion of online footnotes and implications for scholarship in the digital age*. Duluth, MN: Library Juice Press.

Candy, L., and Edmonds, E., 2011. 'The Role of the Artefact and Frameworks for Practice-based Research.' In: Biggs, M. & Karlsson, H. (eds.), *The Routledge Companion to Research in the Arts*. London: Routledge, pp. 120-138.

Cleveland, G., 1998. 'Digital Libraries: Definitions, Issues and Challenges', *UDT Occasional Papers* 8. Available at: http://archive.ifla.org/VI/5/op/udtop8/udtop8.htm [Accessed 20 November 2012].

Dickinson, D., Sefton, P., Lee, C., and Hunter, A., 2011. 'Building the USQ Arts Repository.' In: *Information Online 2011*. Sydney: Sydney Convention and Exhibition Centre, 2011. http://conferences.alia.org.au/online2011/papers/paper_2011_B19.pdf [Accessed 20 November 2012].

Fink, J. L., and Bourne, P. E., 2007. 'Reinventing Scholarly Communication for the Electronic Age', *CTWatch Quarterly* 3(3), pp. 26-31. Available at: http://www.ctwatch.org/quarterly/articles/2007/08/reinventingscholarly-communication-for-the-electronic-age/ [Accessed 20 November 2012].

Garshol, L. M., 2004. 'Metadata? Thesauri? Taxonomies? Topic Maps!', *Journal of Information Science* 30(4), pp. 378-391. Available at: http://www.ontopia.net/topicmaps/materials/tm-vs-thesauri.html [Accessed 20 November 2012].

Gielkens, C., and Hulman, J., 2011. 'Identifying Requirements for Enhanced Publications.' University of Utrecht, Department of Information and Computing Sciences (ICS), online document. Available at: http://www.cs.uu.nl/docs/vakken/mdic/papers/Gielkens-Hulman-fin.pdf [Accessed 20 November 2012].

Hilse, H., and Kothe, J., 2006. *Implementing Persistent Identifiers: Overview of concepts, guidelines and recommendations*. London: Consortium of European Libraries; Amsterdam: Euro-

pean Commission on Preservation and Access. Available at: http://nbn-resolving.de/urn:nbn:de:gbv:7-isbn-90-6984-508-3-8 [Accessed 20 November 2012].

Ho, J., 2005. 'Hyperlink obsolescence in scholarly online journals', *Journal of Computer-Mediated Communication* 10(3). Available at: http://dx.doi.org/10.1111/j.1083-6101.2005.tb00263.x [Accessed 20 November 2012].

Hunter, J., 2006. 'Scientific Publication Packages – A selective approach to the communication and archival of scientific output', *Journal of Digital Curation* 1(1), pp. 3-16. Available at: http://www.ijdc.net/ijdc/article/view/8/7 [Accessed 20 November 2012].

Kircz, J. G., 1998. 'Modularity: The next form of scientific information presentation?', *Journal of Documentation* 54(2), pp. 210-235. Available at: http://dx.doi.org/10.1108/EUM0000000007185 [Accessed 19 May 2012].

Kling, R., and McKim, G., 1999. 'Scholarly communication and the continuum of electronic publishing', *Journal of the American Society for Information Science and Technology* 50, pp. 890-906. Available at: http://dx.doi.org/10.1002/(SICI)1097-4571(1999)50:10<890::AID-ASI6>3.0.CO;2-8 [Accessed 19 May 2012].

Kress, G., 2003. *Literacy in the New Media Age*. London: Routledge.

Lauer, C., 2009. 'Contending with terms: "Multimodal" and "multimedia" in the academic and public spheres', *Computers and Composition* 26(4), pp. 225-239.

Lesage, D., 2009. 'Who's Afraid of Artistic Research? On measuring artistic research output', *Art & Research. A Journal of Ideas, Contexts and Methods* 2 (2009). Available at: http://www.artandresearch.org.uk/v2n2/lesage.html [Accessed 20 November 2012].

Lin, H., Fan, W. and Zhang, Z., 2007. 'An Empirical Study of Web-Based Knowledge Community Success.' In: *Proceedings of the 40th Hawaii International Conference on System Sciences (HICSS)*. Waikoloa, HI, January. Available at: http://dx.doi.org/10.1109/HICSS.2007.65 [Accessed 20 November 2012].

Lynch, C., 2007. 'The Shape of the Scientific Article in the Developing Cyberinfrastructure', *CTWatch Quarterly* 3(3), pp. 5-10.

Pereira, G., and Funtowitcz, S., 2005. 'Quality Assurance by Extended Peer Review: Tools to Inform Debates, Dialogues & Deliberations', *Technikfolgenabschätzung Theorie und Praxis* 14(2), pp. 74-79.

Roosendaal, H., and Geurts, P., 1997. 'Forces and functions in scientific Communication: an analysis of their interplay.' In: *Proceedings of the Conference on co-operative research in information systems in physics*. University of Oldenburg, Germany, 1-3 September.

Rosenblatt, L., 1969. 'Towards a Transactional Theory of Reading', *Journal of Literacy Research* 1(1), pp. 31-51.

Rosenblatt, L., 1978. *The reader, the text, the poem: The transactional theory of the literary work*. Carbondale, IL: Southern Illinois Press.

Schwab, M., 2012. 'The Research Catalogue: A Model for Dissertations and Theses.' In: *The Sage Handbook of Digital Dissertations and Theses*. Andrews, R., Borg, E., Davis, S., Domingo M. & England, J. (eds.). London et al.: Sage, pp. 339-354.

Tenopir, C., 2003. *Use and Users of Electronic Library Resources: An Overview and Analysis of Recent Research Studies*. Washington DC: Council on Library and Information Resources. Available at: http://www.clir.org/pubs/reports/pub120/pub120.pdf [Accessed 20 November 2012].

Van de Sompel, H., Payette, S., Erickson, J., Lagoze, C., and Warner, S., 2004. 'Rethinking Scholarly Communication, Building the System that Scholars Deserve', *D-Lib Magazine* 10(9). Available at: http://dx.doi.org/10.1045/september2004-vandesompel [Accessed 20 November 2012].

Woutersen-Windhouwer, S., and Brandsma, R., 2009. 'Enhanced Publications, State of the Art.' In: *Enhanced publications, linking publications and research data in digital repositories.* M. Vernooy-Gerritsen (ed.). Amsterdam: Amsterdam University Press.

Online Resources

http://academia.edu

http://biolit.ucsd.edu/doc/

http://dublincore.org/

http://ie-repository.jisc.ac.uk/417/

http://jar-online.net/forum/viewtopic.php?=4&t=14

http://konst.gu.se/english/Collaboration/Publications/Art_Monitor_tidskrift/

http://network.nature.com

http://ochre.lib.uchicago.edu/

http://philica.com

http://sitem.herts.ac.uk/artdes_research/papers/wpades/

http://www.americalatina.elsevier.com/corporate/ultimas_noticias_04.php

http://www.artandresearch.org.uk/

http://www.articleofthefuture.com/

http://www.biomedexperts.com

http://www.cell.com/

http://www.crl.edu/sites/default/files/attachments/pages/trac_0.pdf

http://www.doaj.org/

http://www.europeana.eu/

http://www.etaij.org/

http://www.gama-gateway.eu/

http://www.getty.edu/research/publications/electronic_publications/cdwa/index.html

http://www.jalc.nl

http://www.jisc.ac.uk/

http://www.kabk.nl/pageEN.php?id=0485

http://www.loc.gov/marc/

http://www.loc.gov/standards/mods/

http://www.loc.gov/standards/vracore/

http://www.mendeley.com

http://www.nature.com/nature/peerreview/debate/nature05535.html

http://www.openarchives.org/ore/http://journals.tdl.org/jodi/article/view/1606/1738

http://www.palgrave-journals.com/pmed/index.html

http://www.plosone.org/home.action

http://www.secondstory.com/

http://www.terraincognita.com/

Practising

The choice of 'Practising' as the title of this section attempts to express our belief that notions of exposition need to be traced into the very fabric of the research that artists conduct before it is narrowed down to questions of academic publishing. As already suggested, on this level, what counts as expositional activity is highly specific and often part of long-established, individual practices, but also part of the specific materials in and with which those practices engage. In other words, the individual approaches to the issue of exposition presented in the following four chapters are so specific that in all likelihood they will not be easily transferable to other artists and practices. Yet by putting them forward as specific artistic examples, we hope to convey an emerging sense of expositionality within artistic research itself.

In doing so, this section picks up on an important point that was raised in the previous section: the fact that the publishing of research poses a challenge to artistic practice, a challenge that started when artists first laid claims on research. Thus we see in the publishing of artistic research an extension and perhaps even an amplification of basic expositional structures with which artists engage when they enter into proximity with academia.

Darla Crispin addresses in her contribution *'Scaling Parnassus in Running Shoes': From the Personal to the Transpersonal via the Medium of Exposition in Artistic Research* the question of how the artist-scholar's subjective experiences and perceptions can be taken into account when exposing musical practice as research. Drawing on her understanding as a pianist and researcher of music performance, and using as illustration an example of fingering options in Schoenberg's piano music, Crispin argues that experimental research in music is not so much a matter of objectivity as of engagement and attention.

Starting from the observation that in artistic research on music composition expressive and rhetorical affairs are critical, Hans Roels, in *Integrating the Exposition into Music-Composition Research*, makes a case for what he calls 'the open sketch' as expositional form and research tool. Here a specific composition problem can be sonified, exposed and transparently discussed with selected audiences. Through its focus on sound and through its draft status the open sketch occupies a discursive place between the scholarly text and the finished composition, between theory and practice. It thereby offers composer-researchers an interactive and performative space in which to explore the unknown in music composition.

In her chapter *When One Form Generates Another: Manifestations of* Exposure *and* Exposition *in Practice-Based Artistic Research*, Ella Joseph engages a dialectics of exposure and exposition to describe the fact that as her work and research has developed, not only a practice but also a person has been exposed. In fact, Joseph argues that modes and objects of exposition are interrelated in such a way that they generate new modes and objects – or 'forms' as she puts it. The chapter thus suggests that new forms – such as published expositions of practice as research or, even, her text in this book – are complex responses to the history of a practitioner that at the same time put that history into perspective. However, Joseph is also clear that when an artwork encounters an audience, it is not only complicit in the exposure of the artist but also in that of the viewer.

Siobhan Murphy focuses on the role of writing in artistic research. In *Writing Performance Practice*, she distinguishes exegetical from dissertational writing in an attempt to advocate the positive role that writing can play as part of the practice of an artistic researcher. By favouring the latter over the former, Murphy makes the point that a piece of writing need not interpret – that is, bring to light, what may be invisible in a practice; rather, writing can open up a perspective that engages practice in such a way that performing and writing *together* can deliver a better understanding than could any single activity on its own. To achieve this, she describes how she had to find her own suitable – one may say, expositional – modes in what she calls 'discursive writing', 'a narrative of practice' and 'poetics of practice'. The fact that many artistic researchers are locked into regulations that require them to write – for example, as part of a PhD programme – need not pose a problem if artistic practice and writing are engaged in an expositional relationship.

In this section, the issue of publishing is related to questions of practice. The final section will specifically investigate how artists and researchers engage with the more public face of 'exposition'.

'Scaling Parnassus in Running Shoes': From the Personal to the Transpersonal via the Medium of Exposition in Artistic Research

By Darla Crispin

Introduction, in the Author's Voice

This chapter explores ways of reconciling the subjective and objective elements of the twin, yet intertwined, dimensions of artistic research – namely, art and research. In this respect, it is a speculative piece about modes and media of communication that are, as yet, uncertain – and certainly non-systematised. It thus takes the form of a series of reflections on the nature of exposition in artistic research and in particular on how this might be related – by analogy or otherwise – to music. At the same time, it is in part an experiment in using some of the very modes upon which it speculates; how it is written is part-and-parcel of what it says. This intrusion of the personal act of writing into the production of the usually quasi-autonomous finished piece of written text is no accident, even though it goes against the grain. Normal conventions of scholarly writing make us diffident about introducing the autobiographical 'I' into the apparently objective sanctity of our texts. We commonly skirt around formulations such as 'I think' with phrases such as 'it may be thought that', and we would generally never even dream of speaking of those areas where our considered opinions blur into personal feelings and intuitions.

Artistic research challenges us to venture into these no-go areas. It demands that we bring something of our unique selves to the business of trying to understand the 'truth' of art and artistic endeavour better. The unique self that I bring to this task was once a practising professional pianist specialising in early twentieth-century repertoire, but when obliged through illness to abandon professional performance, I turned to musical scholarship as a way of extending in a different mode my exploration of this repertoire and eventually found in artistic research a territory where these several selves could find a degree of integration.

Another, seemingly unrelated, aspect of my unique self is my passion for long-distance running. Running keeps me strong to fight my illness, but also, I have come to realise, echoes and somehow reinforces my appetite for the 'marathon' that is the journey towards a deeper understanding of the music of the Second Viennese School. The will to keep putting one foot in front of the other when the finishing line seems hopelessly distant and the force that drives one forward towards some unattainable definitive understanding of a body of music are, for me, two sides of the same coin. In my personal world of endeavour, running shoes – both literal and metaphorical – really are an aid,

not only to covering those magical forty-two kilometres, but also to scaling the Parnassian heights of the music that I know and love, formerly as performer, now as a scholar – and, always, as an artist.

The idea of 'exposition' as a vehicle for expressing this nexus of ideas and emotions has many attractions: the word itself is multivalent; it combines notions of setting forth the meaning and purpose of an object or activity, of presenting artworks in an environment where they can be viewed from a variety of angles and, in the specific context of music, of setting up a dialectical tension between elements whose resolution then occupies the remainder of the composition. It holds out the promise of accounting for the many facets of art-making. It also carries with it intimations of an integration of those same elements, but within flexible modes that can simultaneously honour both the complex nature of art and its conception and the necessary rigour of scholarship.

An Interlude, from within Art

The road to the city of Aqua Vitae is protected by a labyrinth built from crystals and mirrors which in the sunlight cause terrible blindness. The mirrors reflect each of your betrayals, magnify them and drive you into madness. Blue walks into the labyrinth. Absolute silence is demanded of all its visitors, so their presence does not disturb the poets who are directing the excavations. Digging can only proceed on the calmest of days as rain and wind destroy the finds. The archaeology of sound has only just been perfected and the systematic cataloguing of words has until recently been undertaken in a haphazard way. Blue watched as a word or phrase materialized in scintillating sparks, a poetry of fire which cast everything into darkness with the brightness of its reflections.
Derek Jarman, 'Into the Blue' (1993)[1]

One of the last major works left by Derek Jarman before his death in 1994 was the film *Blue* (1993), the text of which appears in a nearly identical form in Jarman's written poetic meditations on colour: *Chroma* (Jarman 1993). One of these meditations, 'Into the Blue', operates on multiple levels: as a paean to colour in the form of a prose poem; as a precise, research-based account of the nature and history of colour in the arts; as an impassioned text for gay advocacy; and as a searing account of Jarman's own decline as a result of his being infected by the HIV virus, precipitating a series of maladies that, in his case, included the onset of blindness. Jarman uses the colour blue as a trope for his blindness in the film, which consists of the narration of 'Into the Blue' by a company of actors, while the screen itself displays only a deep blue frame. Its colouristic quality, as befits an artwork, is impossible to convey precisely using language alone.

1. Derek Jarman, *Chroma: A Book of Colour – June '93*, London: Vintage, 1994, p. 113; taken from *Blue*, a film by Derek Jarman, copyright Basilisk Communications Ltd., 1993.

Jarman's work, both rigorous in its research basis and imbued with a deeply personal world view, resonates very powerfully for me. It discloses aspects of the artistic researcher's vision, yet was developed at a time when the notion of artistic research had no broad terminological currency. Through both artistic and research-based means, he asks us to 'see better', to consider the various ways in which we come to make, and to know, art. Given this, contemplating his work serves as an invitation to evaluate what comprises a 'research attitude' and, perhaps more significantly, what kind of exposition of artistic research can convey aspects of that attitude. This stands alongside another aim of many artist-researchers: to shine a 'sidelight' upon the artwork's essential nature (Nyrnes 2006), whilst conveying important factual information about the work's characteristics.

In the passage quoted at the outset, Jarman confronts his readers with the idea of a maze; in considering artistic research, the idea seems all-too apposite. The maze that the artist-researcher negotiates is formed out of the tension between two imperatives: the growing pressure to communicate with the wider research community, both within and beyond one's own discipline, and the necessary refusal to compromise the essential nature of the work, which often seems to reside in the 'tacit knowledge' that leads to artistic manifestations. However, as Jarman's text also reveals through its vivid evocations of light and colour:

Art can be dazzling.

So, in contemplating art, we can be blinded by its potentially spellbinding essence. Indeed, the sense of wonder that artworks and art-making may engender within us is amongst the many reasons why artists have been increasingly interested in trying to articulate the nature of their processes through interfacing with the instruments and disciplines of the world of research.

A Contextualisation, in the Objective Voice

But there have also been more practical, earthbound reasons for this new fascination with research. Within music scholarship, the dynamic evolution of performance studies and artistic research in Europe during the past decade, and continuing transformations in musicology more widely, have led us to new questions concerning musical practice. Furthermore, due in part to the educational politics of post-Bologna Europe,[2] general interest in developing perfor-

2. The aim of the Bologna Process has been to create a European Higher Education Area (EHEA), in which students can choose from a wide and transparent range of high-quality courses and benefit from smooth recognition procedures. The Bologna Declaration of June 1999 set in motion a series of reforms that education ministers felt were needed to make European Higher Education more compatible and comparable, more competitive and more attractive for Europeans and for students and scholars from other continents.

mance-related degrees in all three cycles of higher education has increased. As a result, doctorates and advanced research in arts subjects, including music, have become something of an ideological battleground in which the intellectual, analytical and historical study of an art form, where the personal engagement of the scholar with his or her subject matter is kept in the background, has been joined, but also challenged, by a style of engagement where the scholar is also the artist. In the latter case, the artist-scholar's experiences and perceptions, derived through the making and doing of art, are not to be suppressed but, on the contrary, become the prime focus of the research.

Understandably, the tensions and debates surrounding this situation carry territorial, status-related and even financial connotations (in terms of how research funding is distributed) alongside the conceptual and ideological fault lines that they expose. The former are generally unhelpful, but there is a growing sense that the latter may be a healthy development and one that prompts an ethical call-to-arms.

The developing field of artistic research has been noteworthy for the willingness of many of its practitioners to embrace interdisciplinary/transdisciplinary approaches to their research questions as a means of generating a widely relevant discourse. Accordingly, an increasing number of print publications and online journals are conceived as being viable resources across disciplines. Despite this open approach to dissemination, some disciplines remain challenged by the complex interfaces of multiple discourses, and by the different technical approaches demanded by each discourse. The languages of art-makers (as well as those who observe them) are not always transparent; the potential bedazzlement of art is often reflected in the perplexing texts that purport to explain it. Artists who wish to function as artist-researchers thus take on the double task of art-making and of developing appropriate modes of research communication for the purposes of academia.

Furthermore, each discipline within the arts has its specific set of problems. Music, because of its non-representational character and existence as performance in 'real-time', poses many challenges to those who would present artistic research through standard dissemination mechanisms. These, up until

The EHEA was launched on the tenth anniversary of the Bologna Process in March 2010, during the Budapest-Vienna Ministerial Conference. Higher education in the EHEA is configured in the three cycles of Bachelor, Master and Doctor and quantified by a European Credit Transfer System (ECTS). Most disciplines have now been described in terms of the competences students are expected to possess irrespective of where in the EHEA they undertook their study.

The Bologna Process is now in its second ten-year phase. This decade is aimed at consolidating the EHEA in areas such as equitable access and completion; lifelong learning; employability; student-centred learning; education, research and innovation; international openness; mobility; data collection; multidimensional transparency tools; and funding.

recently, have privileged the score and its contemplation in the kind of awe-struck, hierarchical 'absolute silence' noted in the Jarman quotation. That the majority of 'serious' scholarly research in music has been conducted apart from music's sounding is one of music scholarship's most perplexing ironies. Even innovative, alternative approaches have yet to solve in a consistent manner this core problem for artist-researchers in music.

Another challenge to the communities of artistic research is the hidden, but often very strong, mistrust between those who seek to articulate aspects of their art-making 'from the inside', and those who comment upon the work of artists and artist-researchers, but as 'spectators'. To return to the quoted passage from Jarman, music has, indeed, had important new institutional innovators within 'the archaeology of sound'.[3] However, the development of consistent contexts for contributions to scholarship by music performers is more recent, and more challenged by the boundaries of existing musical disciplines, even though significant institutions have hosted projects to take forward the work of artistic research in music and others have been founded specifically for that purpose.[4]

Artistic Research in Music

On Subjectivity

It is one of the profound paradoxes of music that, apparently simultaneously, it can bring us to a deeper sense of personal identity and cause us to experience the loss of a sense of self: either through being 'lost' in listening to a performance or even through 'losing' ourselves in performing. To understand this paradox better,

3. An example is the AHRC Research Centre for the History and Analysis of Recorded Music (CHARM), which, according to its website, 'was established on 1 April 2004, supported by a five-year grant of just under £1m from the Arts and Humanities Research Council. A partnership of Royal Holloway, University of London (host institution) with King's College, London and the University of Sheffield, CHARM's aim was to promote the musicological study of recordings, drawing on a wide range of approaches ranging from computational analysis to business history.' See: http://www.charm.rhul.ac.uk/index.html.

4. For example, the Orpheus Institute launched an international research centre in 2007, the Orpheus Research Centre in Music [ORCiM]. At ORCiM, musical artists conduct individual and collaborative research on issues that are of concern to all involved in artistic practice. The development of a discipline-specific discourse and a long-term research programme in the field of artistic research in music is the core mission of ORCiM. In addition, the successor to CHARM, the AHRC Research Centre for Musical Performance as Creative Practice (CMPCP), was launched in October 2009, with a five-year research programme focused on live musical performance and creative music-making, though its orientation remains more akin to the music sciences than to artist-research.

we need to consider the role of performance in revelation, and to speculate about how performances 'speak' to us. The complexity of musical language – at first apparently related to compositional and technical phenomena – is, I would maintain, also partly a function of its propensity to arouse in us feelings and questions concerning the necessity of suffering, the nature of vulnerability and, correspondingly, the hope for joy and transcendence. Looking more deeply into these aspects should not be done with a view to ameliorating the sense of wonder to which they relate. We need to face head-on the 'shame' of writing what we *feel* about music, and the perceived judgements of gatekeeper cultures about such 'confessional' prose in a research context. All of this needs to become part of the research output, including accounts of what might be missing or beyond our grasp.

With this in mind, one might suggest that a key function of artistic research is to expose those aspects of the core subjective paradox identified above, and to propose instead the recognition and acceptance of the aporia that arises from the paradox of both finding and losing ourselves in art. Accordingly, artistic research expositions need to be presented in forms that allow these paradoxical aspects of subjectivity to be taken into account.

Artworks are under no obligation to offer solutions or comforting boundaries – indeed, they may be created precisely with a view to exposing intractable problems and proposing them as matters for reflection, rather than resolution. If we are to experience artistic research in music in this way, we must be prepared to evaluate the trope of 'music as a mode of performative subjectivity' (McKeon 2009). Moreover, we must contextualise all of this by looking critically at the manner in which music reveals its content, and by trying to separate out embodiment from subjectivity. The subject who takes action in musical performance differs in kind from the subject who speaks and/ or writes about such action, as well as being temporally displaced from him/ her: 'This doubled nature of the subject is masked by the illusion of self-presence: we conflate these two modes of self. Music's pre-eminence in articulating identity, of representing "authentic" self-expression and embodying group affiliation is central to the metaphysical conceit of a unified self' (McKeon 2009).

One might contend that, if one persists in noting the subjective, noticing it, allowing it to 'come in', then, at that point in musical interpretative experience when one is most poignantly and limitedly oneself, there is an opportunity, if only for a brief time, for subjectivity to 'flip' into its opposite. Under the kind of patient and exhaustively trained scrutiny-cum-experience envisaged, the ultra-personal in time and space might fleetingly become utterly objective, since there are common elements to even the deepest human experiences. Research demands evidence, however, and one would have to ask very specific questions about how this hidden world might become the space for scholarly research. A partial answer, or riposte, might be that a world that hides and conceals, that generates fear, that proposes only solutions (and underplays non-solution) cannot, in any discipline, be ideal for the development of robust research attitudes.

On Temporality

Another challenge for artist-researchers in music is that musical performances almost always reveal their outcomes within real-time experiences. This presents obvious problems in terms of research archiving, pointing to the broader problem of the 'dominance of eye-based information' in standard research set-ups (Berendt 1992). Artist-researchers in music have a temporal gap between their doing and their conceptualisation and dissemination of that doing. Thus the dissemination is done 'by memory'; it is never really the true practice, or rather, it is a new practice that shadows the old. Nevertheless, the gap between artistic realisations and the articulation of research content may be a site of fruitful thinking and artistic experimentation, given suitably flexible and adaptable modes of re-presentation.

Meanwhile, researchers continue to work with various kinds of proxies in their attempts to probe the nature of musical manifestations. The score (or sections of it) is the most frequently utilised stand-in for the 'sounded' music itself in the practice of musicologists and music theorists – indeed, it is common in notated music to refer to the score as though it is the work. But increasing interest in performance studies and, more recently, in artistic research, has opened a door to innovation from within the established disciplines of academia; for example, musicology has started to demand a deeper connection between the 'actual' musical experience of 'live performance' and what is written about that experience as scholarship (Abbate 2004). This, in turn, presents fertile ground for new modes of dissemination – for example, via the artistic-research exposition.

On Situatedness

Matters of subjectivity, temporality and situatedness are closely linked in artistic research in music. Artistic research necessarily probes the nature of art production. In music, performance – the 'sounded' artwork – is located within a network of situation-specific aspects, from the temporally broad placement within what might be called 'history' to embeddedness in the very precise confines of, for example, the standard concert hall (though no two halls can be considered identical in all aspects). The complexities of situatedness, the physical presence of the performing artist in a designated space and, indeed, the particular qualities of that physical body making music (including aspects of skill and artistry innate to that body and impressed upon it through years of dedicated training) all feed into the complexity of the music-making event (whether 'live' or an audited reproduction).

Within arts institutions and university research departments, there is considerable interest in the situatedness of musical production, reflected in research outputs ranging from quantitatively and qualitatively oriented studies in the area of Music Psychology to the artistically experimental works of composers who use technological extensions to map physical movement within a

designated space. Furthermore, there is a growth in research on the ways in which concert spaces themselves can be 'replicated', with a high degree of aural accuracy, thanks to innovations in acoustics. But the increasingly sophisticated interface with technology demands research dissemination vehicles that can articulate the new knowledge that arises within such innovative practices. Within this novel, complex and flexible 'performance space', artist-researchers need to be vigilant about discriminating between phenomena concerning the art-making and those concerning the art-maker.

A Proposal, Using the Metaphor of Exposition

The problems explored above point to the idea that one of the more promising ways for artistic research in music to address its questions might be through the medium of the 'exposition'. Here, the processes of deconstruction and reintegration that exemplify many artistic-research projects – and that actually shadow the working processes of many musicians – can be modified for the research purposes of musician-researchers, allowing them a rationale for presenting their works in new formats that are congruent with their work as artists. In the remaining 'development and recapitulation' of this chapter about 'musical exposition', I shall explore some of the specific challenges of artistic research in music, and some of the possibilities that the *Journal for Artistic Research* (*JAR*) and its Research Catalogue (RC) open up to musicians. I shall also seek to demonstrate how the concrete and practical enquiries of the musician may form a groundwork for new critical theories, embodied in musical practice but potentially transferable across disciplinary boundaries.

Exposition provides a potential framework through which the necessary discrimination referred to above between art-making and the art-maker may take place, while still acknowledging the subjective origins of much art-making. Furthermore, it allows for the perception of a shift that can occur when an apparently highly personalised or idiosyncratic kind of presentation simultaneously articulates more universal effects that open up lines of communication of a more public and generalised nature. This potential for transpersonal communication is a promising future direction for those creating artistic-research expositions.

Intermezzo: A Case Study Presenting a Fingering Problem in Arnold Schoenberg's *Drei Klavierstücke, Op. 11, Nr. 1*

Here is one such perception shift: how can one demonstrate that keyboard fingerings, seemingly individual matters of mere practicality and convenience, actually carry the potential to be the opposite: open-ended and affective gestures, communicable through performance to a public, as befits art-making?

In the case of my own extended study of the solo keyboard works of the Second Viennese School, I have found that experimentation both discloses

and defines a field of possibilities alongside, and inclusive of, those that I gain from the study of, say, philosophy or history. So let's consider the opening phrase of Arnold Schoenberg's first piece from the *Drei Klavierstücke, Op. 11*, and how experiments with fingering might be the seeds from which a whole performance approach may germinate.

Of course, we pianists think about fingering a great deal. A straightforward attempt at fingering this phrase might start the piece with the fifth finger, and then allow a working through of that fingering in an apparently 'natural' way:

Example 1. Arnold Schoenberg, *3 Klavierstücke, für Klavier Op. 11/1*, (Bars 1–5, standard fingering, author's own). © 1910, 1938 by Universal Edition A.G., Vienna/UE 2991, with kind permission.

But with that as a datum, different experiments with the fingering, driven by different, yet specifiable, internal logics reveal this opening phrase to be open-endedly generative of meaning. For example, setting up parameters for fingering requiring a true, overlapping finger legato and a specific, more closed, hand position for the opening phrase leads me, after trying a series of different options that are failures, to start the phrase with the thumb, then crossing over with the fifth finger, to maintain a 'red thread' of overlap until the conclusion of the phrase.

Example 2. Arnold Schoenberg, *3 Klavierstücke, für Klavier Op. 11/1*, (Bars 1–5, non-standard fingering, author's own). © 1910, 1938 by Universal Edition A.G., Vienna/UE 2991, with kind permission.

This idea, drawn initially from a study of annotated performer-scores and fuelled by a desire to imitate certain *fin-de-siècle* pianistic approaches that favoured 'extreme' legato, has had a side benefit: namely that the apparently

foolish, awkward, anti-intuitive fingering actually orients the arm to a more ergonomically efficient position in relation to the keyboard. So, temporary non-fluency generates both fluency and the potential for depth of meaning.

This uncovering of the phrase's new dimension, in association with the tactile and sonic elements that join with it, makes me realise that the process of experimentation is not a matter of 'objectivity', but of deep engagement and attention. Understanding this is an important part of grappling with what musical practice is actually about – and that, in turn, becomes another part of the puzzle of comprehending musical practice *as research*. This raises a more general point: 'We need to theorise practice in a way that allows for the engrossment and excitement, the emotional [as well as the rational] basis – of our research work' (Knorr Cetina 2001: 175). It reminds me that, in working with the sounding materials of music, I need to accommodate, and account for, such feelings in the reflective 'gap' that artistic research endeavours to explore, alongside – indeed *concomitant with* – conceiving a rigorous research methodology.

But what if I could have presented the written account above as a true *JAR* artistic research exposition, fusing together many apparently disparate elements?

Multivalent Solutions within the *JAR* Exposition and the Research Catalogue

JAR offers us new ways to think about – and through – art-making, allowing the evolution of the exposition itself to be imbued with the artwork's essential nature. The adjustable exposition does not follow page after page in the manner of a written text, but allows the viewer to experience text, sound and video files and pictures as a combined yet variable field, in which the viewer can relate to the material in a more individual way than is afforded by text alone.

In the case of my fingering example, it might have been possible to 'open' the exposition not with words, but with a sound file in which my own realisation of the piece could have launched the discourse. The conventional presentation of the score fragments as musical examples could have been transformed into a sounding animation that linked up with the different fingering attempts, perhaps allowing the auditor to make tentative aesthetic observations. A motivic analysis could have been superimposed upon the musical fragment, demonstrating that the practice of fingering was, for me, a process of musical analysis. Hyperlinks could have been made to relevant texts concerning Schoenberg's musical language at this time, to accounts of contemporary history, to texts by other performers concerning *Op. 11*, and to reference lists of writings, audio and video recordings of use to future researchers. The exposition could link to the core research location for Schoenberg studies, the Arnold Schoenberg Centre in Vienna. Finally, as just part of this web of resources, my own attempts to gloss my practice in prose might have been employed in the better service of communicating the many ideas generated by a real,

performance-based encounter with this tiny musical excerpt, demonstrating its nature as an 'incomplete object', or 'epistemic thing' (Rheinberger 1997).

Considering some of the concrete possibilities offered by the *JAR* approach in relation to the Schoenberg fingering, it is also possible to note conceptual approaches in the context of the example that could have been strengthened, or re-read, through *JAR*/RC.

Comparing 'Practice Knowledges'

It has already been noted that, in musical practice, we often – perhaps almost always – experience a temporal gap between our 'doing' and our conceptualisation of that doing into a format appropriate for research dissemination. An artist-researcher in music should study this aspect of communicability 'on purpose', extrapolating from his or her own work as an artist so as to consider the 'practice knowledges' of other disciplines. When, as musician-researchers, we do this, we find that, in common with our practice, that of other disciplines does not unfold smoothly, but has what Karin Knorr Cetina describes as 'a jagged, disjointed, yet relational quality'. The materials of experimentation become epistemic objects, characterised by 'an incompleteness of being and the capacity to unfold indefinitely' (Knorr Cetina 2001: 180-81).[5] The 'jagged' aspect of my own practice could have been brought out by archiving, as collected data within the RC, the many less-successful attempts to finger the passage. Placed alongside recorded verbal and written musings on the progress of my practice, these disjointed fragments might have acquired their own relevance.

Unfolding Representations

In musicology, the technique of immanent critique is often applied as a way of presenting musical texts within the limited frames of conventional written research outcomes – the article and the monograph. The procedure allows for a fragment to stand as a synecdoche for the larger work, positing that this can be revelatory in the manner of 'the world revealing itself in a grain of sand'. It became a stock approach of high modernism in musical research, thanks to the writings of Theodor W. Adorno (for example, *Philosophy of Modern Music*, 1973), but in a wider sense it assumes a series of unifying characteristics (*Tendenz des Materials*) that is more in keeping with the tenets of Western art music than with, for example, improvised or non-Western musics. More recent

5. Knorr Cetina also writes of 'unfolding structures of absences which continually mutate into something else' (p. 181). This noting of 'absence' prepares her Lacanian reading of epistemic objects (pp. 185-6). Cetina is thus adapting Hans-Jörg Rheinberger's *Toward a History of Epistemic Things* (1997), demonstrating a productive, affective link between experimentation and exposition.

readings of the idea describe immanence more determinedly as a phenomenon of 'ever-becoming' and perennial incompletion (see Deleuze and Guattari 2008, and a reading of their work in relation to musical composition, Nesbitt 2004). This provides a conceptual space that is more open to non-Western, non-patriarchal approaches. It does not, however, address the issue that not all art-makers would conceive of their works in terms of theories of immanence; nor does it entirely eradicate the tension of control over material that creates conflicts between artistic creativity and the tenets of research.

Despite any lingering doubts one might have about immanence as a principle, in artistic research presentation it is still often the case that the small must stand in for the monumental. So artist-researchers in Western art music may search for compositional 'nodes', or points of material potentiality. Such loci might indicate a point of collision of methods, for example, a physical approach to performing a passage on a musical instrument that also uncovers, and is uncovered by, aspects of musical analysis. In an online journal like *JAR*, such a nodal point might be designed to expand at the click of the mouse, to offer links to a more extended quotation of musical text, to a video recording of such an example, and to sources containing historical theories backing up (or contradicting) the approach taken. The creator of the exposition can also gloss the audio and video evidence with expository text, making a case for the adopted approach. The amalgam of evidence itself fuses into a 'recreative' experience, perhaps closer to the process of art-making, though still a proxy for 'live' performance.

Aural Diagrams: Envisioning Time's Passage

Music research writings often employ diagrammatic representations in order to reveal large-scale aspects of musical organisation, and to remedy some of the problems with temporality that have already been discussed in this chapter. But the diagram on the printed page can only serve as a proxy solution; so, the emergence of online resources such as *JAR* and the RC provides enticing ways to revivify this kind of approach. The animation of a flat diagram into a field of multiple dimensions acts as a corrective to embedded teleological thinking. Linking this to sound and video files further animates the exposition, as well as giving the auditor of the exposition some choices about how they navigate the research space. Although the perennial 'proxy problem' is not solved by these approaches, the interface with the musical and research material is enlivened, and the auditor is in a sense encouraged to encounter the work with a researching attitude.

Of Bricolage and Holism

Associated with the revivification of diagrams is the reframing of the artistic processes of bricolage that are associated, in music-research terms, with aspects

of postmodernism. The combined *JAR*/RC resource allows different levels of research realisation to stand together in a connected conceptual space. In artistic research in music, this has the potential to illuminate much that is hidden about musical production. It also connects to the 'jagged' aspect of artistic practice referred to earlier, since that which is left aside, or discarded during the research process, can stand alongside the 'finished' exposition without compromising its artistic and scholarly properties. The notion that the 'discarded' version might be crucially important in research terms is nothing new; one only need study the literature concerning Beethoven's musical sketches to see the truth of this. Western musical performance, however, has been highly dependent upon the generation of 'faultless' performances in keeping with the mythical status of canonical works. This creates a strong tension between the 'research attitude' and the exigencies of live performance that has yet to be exhaustively explored.

Solution and Non-Solution As Highlighting Ethical Problems

The concept of the 'faultless' performance also discloses the pressures of musical performance upon humans. No wonder that the 'health and wellbeing' movement within music conservatoires is expanding. Its compassionate aims are to be commended, though difficult questions remain. For one thing, the requirement is cure; musicians who have physical problems understandably want to be 'fixed'. So the academy becomes fixated on fixing. This emphasis can spread more widely, with the 'fixing fixation' becoming highly directive of research choices by emphasising utility. Meanwhile, the matter of non-solution, of trying to learn to observe the world in our imperfect bodies, remains an arcane topic. The supposed (but mythical) perfection of works becomes reflected in the supposedly perfect bodies and minds that articulate them. The *JAR*/RC model can be of help here, both because of the varied levels within which work can be archived, and because the nature of the online resource allows for unorthodox modes of presentation, and proposals from outside the margins of the 'normal'.

A Final Return to a Mythic Space

In its formative stages, the Society for Artistic Research (SAR) referred to an artistic research exposition as a 'weave'. There are many ways in which a 'weave' is an apposite name for what *JAR* and the RC offer. In mythology, Minerva was not only the goddess of wisdom and science, but also of the arts, including music and weaving. Perhaps the quest by artist-researchers for a productive reconciliation of their many, sometimes conflicting, creative impulses echoes a desire for her practical wisdom. But the quest has hazards: the vain Arachne was punished by Minerva for boasting of her skill with the needle. Ironically,

the contest between Minerva and Arachne took the form of the creation of a weave – a tapestry. In the creation of their own 'weaves' – their expositions – artist-researchers are bound to seek the same lines of thinking and doing as those advised by the goddess: to be wise, to create 'real' research, not tinged by vanity. This is not easy; the art-making and art-assessing acts are so often at odds with each other. Nonetheless, research in the arts should be a realm of wise risk-taking, a place of brave speculation. With new spaces for discourse such as that provided by *JAR*/RC, and with the concept of artistic research expositions to frame how we present our material, there are grounds for hope that we can make real progress up the slopes of Parnassus.

References

Abbate, C., 2004. 'Music – Drastic or Gnostic?', *Critical Inquiry* 30(3), pp. 505-536.

Adorno, T.W., 1973. *Philosophy of Modern Music*. A. Mitchell & W. Blomster (trans.). London: Seabury Press.

Berendt, J.-E., 1992. *The Third Ear: On Listening to the World*. T. Nevill (trans.). New York: Henry Holt & Co.

Borgdorff, H., 2007. 'The Debate on Research in the Arts', *Dutch Journal of Music Theory* 12/1. Amsterdam: Amsterdam University Press.

Borgdorff, H., 2008. 'Artistic Research and Academia: An Uneasy Relationship', 'Autonomy and individuality – Artistic Research Seeks an Identity', *Yearbook for Artistic Research*, Swedish Research Council, pp. 82-97. Available at: http://www.ahk.nl/fileadmin/download/ahk/Lectoraten/Borgdorff_publicaties/an-uneasy-relationship.pdf [Accessed 20 November 2012].

Borgdorff, H., 2012. *The Conflict of the Faculties: Perspectives on Artistic Research and Academia*. Leiden: Leiden University Press.

Coessens, K., (no date). 'The Agile Mind: Mapping the Musical Act of Creation', unpublished paper.

Deleuze, G. and Guattari, F., 2008 [1980]. *A Thousand Plateaus – Capitalism and Schizophrenia*. Brian Massumi (trans.). London: Continuum.

Jarman, D., 1994. *Chroma: A Book of Colour – June '93*. London: Vintage.

Knorr Cetina, K., 2001. 'Objectual Practice.' In: *The Practice Turn in Contemporary Theory*. K. Knorr Cetina, T. R. Schatzki & E. von Savigny (eds.). London: Routledge, pp. 175-187.

McKeon, E., 2009. 'Musical Performance and the Death Drive.' *Interference/A Journal of Audio Culture* 1. Available at: http://www.interferencejournal.com/articles/an-ear-alone-is-not-a-being/musical-performance-and-the-death-drive [Accessed 20 November 2012].

Nesbitt, N., 2004. 'Deleuze, Adorno and the Composition of Musical Multiplicity.' In: *Deleuze and Music*. I. Buchanan & M. Swiboda (eds.). Edinburgh: Edinburgh University Press.

Nyrnes, A., 2006. *Lighting from the Side: Rhetoric and Artistic Research*. Sensuous Knowledge Publication Series 3. Bergen: National Academy of the Arts.

Rheinberger, H.-J., 1997. *Toward a History of Epistemic Things: Synthesizing Proteins in the Test Tube*. Palo Alto, CA: Stanford University Press.

Integrating the Exposition into Music-Composition Research

By Hans Roels

Introduction

In scientific research, the exposition usually follows a logic that is different from the research itself. While a clear and well-structured discourse obviously plays an important role in the communication of the research process and its results to an audience, these rhetorical issues are negligible during the actual research. For example, while research can be done repetitively at certain stages, few people would appreciate a presenter repeating the same sentence over and over again at a conference.

In artistic research on music composition, the gap between rhetoric and research is smaller than in other disciplines. This is so because music composition, and art in general, is a form of communication in which the artist expresses concepts, ideas, emotions and feelings in the hope that the audience will be touched, intrigued or provoked. In science, the research methodology can generally be separated from the way in which the research is presented, but communication and expression are at the heart of the arts. Compared to other domains, the diversity and flexibility of communication forms in the arts reflect this central position. In the arts, communication rules are not just used, but also renewed, refreshed and even negated. Doing research in and through the arts causes communication to become part of the research domain, and thus includes exposing research and researching the exposition.

In this chapter, I claim that in artistic research the exposition can have more purposes than just presenting artefacts, knowledge and experience to an audience. For artistic researchers who give expressive and rhetorical issues a crucial role in their research and look beyond the concert hall as the sole opportunity and place for which to compose, the exposition can become an integral part of the research process. With this integration of research and exposition (which I call 'a research-exposition mode') the nature of the research and practice change, and intermediate forms emerge that are difficult to categorise as 'research' or 'practice'. Generally in artistic research the distinction between research and practice (or theory and practice) is not clear-cut. Becoming aware of the (unconscious) connections between both categories and developing them into full-blown (autonomous) research tools and exposition forms is what this chapter aims to do.

The Open Sketch As Exposition Form and Research Tool

In artistic research in music composition, the two main publication forms are texts (articles, theses, lectures) and compositions (performances, scores, recordings). Both are used to make research and practice public. There is an intermediate form, however, between text and composition, which will be referred to as an 'open sketch'. The main features of an open sketch are its focus through sound and its draft appearance. Having a clear focus is widespread in research and the usual way to expose this focus is through a text. But a focus through sound is less obvious. The composed music in an open sketch focuses on one or a limited number of composition problems or new possibilities. All unnecessary elements are backgrounded, simplified or omitted. Which elements are important depends on the focus of the open sketch. As a result, open sketches are likely to resemble fragments, sketches, or studies, forms that are considered unpresentable in normal concerts. When creating this open sketch, the composer is both an artist and a researcher as he tries to sonify the core of a composition problem.

A recent book by the American composer Henry Brant offers clear examples of this focused open sketch. In general, his *Textures and Timbres* is an orchestrator's handbook, but as the foreword explains, 'the focus is on combining tone-qualities' or mixing different timbres with acoustic instruments (Brant 2009: ix). The book is full of short score examples that illustrate the procedures. Brant states: 'I have composed the numerous musical examples in neutral twentieth-century idioms', and he continues to explain that 'these examples do not necessarily reflect my stylistic preferences or my own composing practices' (Brant 2009: ix). The examples are clearly restricted to the timbre and textural procedures. Elements like pitch, rhythm, harmony, and phrase-building are reduced to the essentials in order to emphasise the procedures. This may be the reason why Brant calls it a 'neutral' twentieth-century idiom.

An open sketch with a clear focus does not imply that only simple or technical problems are tackled. For example, problems related to the form or conceptual aim of a composition can also be pared down to the essentials, and solutions can be made audible. The composer-researcher needs to experiment intensely with the many parameters that exist in music to be able to sonify a specific composition problem. Parameters and features in music exist on different levels, and some features can only appear if others are present: a musical phrase without individual sound events is impossible. This makes the process of simplification and concentration more complicated than it seems at first sight. A focus through sound cannot mean that complex issues are broken up into atoms without any information or characteristics of the complex issue. It rather invites research on what the simplest possible form of a composition problem is in a music performance.

Music focused on a composition problem is not unusual in the history

of Western music, although it remained at the margins and was mostly embedded in a pedagogical context. Composition exercises and studies centred on issues such as melody construction, counterpoint, harmony, instrumentation, form, etc. This tradition is still alive, even though techniques, materials and goals have become very diverse in contemporary sound art. The American composer David Cope adds 'composing suggestions' to every chapter in his book entitled *Techniques of the Contemporary Composer* (1997). These exercises serve to practise the described techniques and resources and can be seen as a modern equivalent to the former exercises. In literature and journals on electronic music, computer music or music cognition, sound samples are often included to underline the compositional potential of the techniques. Although in some cases these samples are only a few seconds long, in other cases author-composers add a short composition to their text (see Sethares 1998; Keuler 1997).[1]

This tradition of the composition exercise can be more than a pedagogical tool and has important potential within the artistic-research process. This change from exercise to open sketch also requires a change in goals: from trying out existing techniques and methods as in music education to experimenting with new expressive problems or making tacit practices more explicit.[2] Educational composition exercises and research-led open sketches function in a double way: they try to expose a composition procedure in the act of music performance to the listener and at the same time they act as an invitation to the listener to try out this procedure. They create distance and attract at the same time. At first sight, this contradictory nature is linked to the kind of work needed to produce an open sketch. It has a very hybrid character: there is less personal expression than is required to make an artistically 'finished' composition and there is more neutralising distance involved, but compared to non-artistic music research, more creativity and composition skills are necessary.

Although these kinds of exercises are sometimes seen by composers as 'mere technique' and 'not artistic or creative', it is difficult to imagine who but composers could write such exercises. Apart from these negative connotations, the distance present in the open sketch can also be described positively, as distracting the composer from his usual activities and leading

1. The previous examples from electronic and computer music illustrate the fact that the 'open sketch' is also applicable in genres where the written score is of less or no importance. The only difference is that the open sketch would be more technology oriented in these contexts. For example, its focus could be on the expressive possibilities of a specific algorithm or a performance set-up.

2. This change reflects the appearance of autonomous composition exercises, studies or études in the twentieth century, for example, in the oeuvres of Conlon Nancarrow, Pierre Schaeffer or Karlheinz Stockhausen.

him to an experimental activity.[3] In a research project that I performed in the first half of 2011, six composers wrote an open sketch related to a problem of polyphony. In interviews and questionnaires with these composers, some of the respondents found it difficult to focus on a specific problem. One composer remarked that this kind of task required that he 'think differently' and 'step outside well-known terrain' (De Baerdemacker 2011). The distance of the open sketch requires artist-researchers to put some of their familiar procedures aside and break out of the way they normally express themselves. After the sketch has been produced and performed, researchers have an external sound object upon which they can reflect. At this stage this object can be matched with the original ideas and formulations of the problem or challenge. This feedback loop between sketch, performance and reflection enhances the research through a constant process of reformulation and focusing through words and music.

A Central Role for the Audience

The nature and function of the audience is a topic that has been given little attention in the literature on artistic research. The composer Leigh Landy writes:

> one of the more obvious things to state about much of twentieth-century art music's being appreciated by a very small audience concerns a side effect of the 'art for art's sake' movement dating from the century's early years: many composers chose to ignore the interests, desires, and perceptual abilities of the public, focusing particularly on whatever new protocol(s) they were involved with at the time, a manifestation of the modernist epoch (Landy 2007: 23).

Perhaps the minor role of the audience in artistic-research literature is related to the researcher being an artist and to the 'traditional' weight attached to individual autonomy and freedom of the artist in the twentieth century. But if artistic researchers want to investigate expressive and communicative issues seriously and aim to integrate exposition and research, they must be conscious of the audience and consequently involve it in the research. In fact, I propose to take control – to a certain extent – of the audience, as opposed to the usual artistic practice where the artist has a limited influence on the kind of people (social group, age, sex, musical background) that attend a performance and

3. I see several other links between the open sketch and experiments in music. The open sketch is open for discussion, it acts as a proposition upon which the audience can comment, and it is also a kind of try-out of a musical problem. Moreover, the clear focus reminds us of experimental compositions (e.g. Alvin Lucier) in the 1960s and 1970s, which often concentrated on one phenomenon.

on the setting in which this takes place.[4] In doing so the artist-researcher can consciously choose the setting and create a role for the audience.

An example from my research practice can clarify this. In the above research project that involved six composers, each writing two 'open sketches', I organised a 'collaboratory', during which these sketches were rehearsed and performed. This was followed by a discussion among the performers, the composers and other invited contemporary music specialists. This semi-structured discussion centred around a few predefined questions, but there was also enough time to tackle unforeseen and new issues. A few months after this collaboratory, I presented the recordings of the performance to classes in music schools. I used a written questionnaire to obtain an idea of what these people were hearing. Later on, the results of this listening test were fed back to the composers. The audiences in the collaboratory and in the music schools were selected, but their role in the expositions was different. The inclusion of the audience in the research process enables artist-researchers to reflect on the reactions of other people to a specific artistic problem.[36] And if they succeed in giving the audience an active role and in fascinating it with their artistic problems, it is not just researchers who are reflective but also the group of people. This can create a larger and more powerful resource pool from which new knowledge or insights can originate. The successful involvement of the audience requires the researcher to become partly a concert organiser, albeit an unusual one. The researcher creates events in which a selected audience is confronted with the performance of open sketches.

Sound Realisation and Documentation

The discussion above focused on two main topics related to the inclusion of exposition in research: the open sketch and the selected audience. To round

4. There are of course art forms where artists choose a specific place (street, public square) and thus have more impact on the audience.

5. Because of the importance I give the audience, there are some similarities between the research-exposition mode that I propose in this chapter and the research domain of music perception (and the related disciplines of psychoacoustics and music cognition). The main difference is that the goal in the former is to obtain more knowledge about music composition and the creative processes involved, while in the latter the focus is on gathering knowledge on how people perceive sound and music. But in order to obtain more insight about music composition, disciplines such as instrumentation, harmony, music history, etc. and also music perception are important. Thus there is some overlap between both. Moreover, in recent decades the use of simple, low-level sound stimuli in perception experiments has diminished, and approaches like *embodied music cognition* have started to consider the role of the body and thus of human action as vital in perceiving and processing sound. See Leman 2007.

out the overall picture of this research-exposition mode, I should highlight two additional issues that have not yet been brought to the forefront. Since they are also present in most of the common expositions in music composition, I will only briefly describe their links to the open sketch and the selected audience. First, there is the way the open sketch is exposed. The sketches are realised as sounds, meaning that the open sketches are performed by musicians or – in the case of electronic music and sound art – by the appropriate sound devices. This realisation is quite obvious but very important. Successful research results and convincing expositions in music composition cannot be achieved if the open sketch is reduced to a material form such as a score. It should be music, a form unfolding over time. Second, there is the documentation as part of the exposition. Its evident function is to describe in spoken or written words the research question, problem, context and aim of the exposition. The context needs special attention since the focus through sound in the open sketch involved the unwrapping and stripping down of the artistic problem to its essentials. The documentation acts as a counterbalance to this exposure and makes the public aware of the silent, missing elements in the exposition.

Together these four components: open sketch, selected audience, sound realisation and documentation, give shape to a research process to which the exposition is an integral part. When looking at these four components it is possible to notice a similarity between the research-exposition mode on the one hand and artistic laboratories, experimental venues, music studios and workshops on the other hand. The latter are events and places where artists experiment and show their work to one another and to an interested audience in a laboratory context. Throughout the past decades such venues have spread internationally. Examples are often self-organised practices such as Dorkbot ('people doing strange things with electricity'), which includes a large number of local groups, and the Logos Foundation in Ghent (Belgium), which organises a monthly concert with music robots, where instrument builders, dancers, performers, and composers try out new ideas. Often several of the four main components of this research-exposition mode can be traced in these laboratories, although the instances where all four components can be discerned are rare. A smooth transition between the more experimental and research-minded parts of the artistic field and the research institutions can, however, be a positive feature. Here the similarities (and thus the overlap) between both can provide links for cross-fertilisation.

In the next section I will focus on two advantages of the above research-exposition mode: it eases generation of knowledge that is both transparent and new. Producing something that had until then been unknown and having the ability to communicate this to others is of crucial importance in most research domains, including artistic research in music composition.

Transparent Communication

As mentioned before, music composition is one of two usual exposition forms in addition to text. But in contrast to the possible third form (open sketches), the compositions are finished, that is, the composer judged them to be publicly presentable to a concert audience.[6] But are these finished compositions the ideal vehicle to demonstrate and investigate an artistic problem? Are they transparent enough as an exposed research form? In these artworks several materials, techniques and expressive procedures are used together, and they interact and shape one another. A single composition may contain totally different passages and may have several aims, ideas, or feelings that the composer wants to communicate. Moreover, a composer may initially intend to make a composition centred around an artistic problem or challenge. Once he starts to compose, however, obstacles (in structure or instrumentation) may be encountered, leading to a reformulation of the original challenge and goal. This is a procedure (called problem proliferation) that has been described in the literature on the creative process in music composition (Collins 2005). In some cases, the result of this conflict may even be the abandoning of the original problem or challenge. The composer may end up with a composition that has almost no links to the original ideas, challenges and problems. In the end, a composer wants to produce a convincing sound work for the audience and not a piece of research. Thus if a conflict arises between research consistency and rhetoric, the composer chooses the latter. Therefore, finished compositions can have limitations as tools and as materialisations of a research process.[7] Sometimes it is almost impossible to communicate transparently and precisely about the research using the finished composition as the only exposition form.

All three forms have their possibilities and limitations. I can best explain this using the antonyms 'abstract' and 'concrete'. An open sketch could be described as concrete and abstract at the same time. Compared to a text it is concrete because it tries to be an accurate translation in sound, and thus in time, of a research topic, but compared to a finished composition it is abstract because this general topic is intended to be perceivable in the music. A text can be theoretical and contemplate on the music, or it can describe singu-

6. As far as I know, written preparatory composition sketches are never performed in concerts (as opposed to the visual arts where preparatory sketches are quite often part of an exposition). I use the term 'concert audience' to differentiate it from the 'selected audience' that I have described in the paragraph 'A Central Role for the Audience' in this chapter.

7. The emergent problems and procedures that arise while composing finished compositions can be used as a focus in one or more new open sketches. In this way the reflection process is no longer a purely mental process, but is also a composition praxis. More about emergence in artistic research in Barrett & Bolt 2007.

larities and details in the music, but the text always operates from outside sound and outside time; it remains external. The third exposition form, the finished composition, is internal; it operates from within the world of sound and music. In many cases it is also concrete in the sense that the finished composition consists of singular details and sections. These have their own identity based on different affects and concepts that the composer wishes to express. Such sections are not necessarily linked in a simple and straightforward way to the global musical shape. Composition procedures, construction techniques and perceptual features in these works change quickly and they do not always coincide. The composer Roger Reynolds describes this phenomenon as the 'palpability' of sections (Reynolds 2002: 11-12). In some repetitive music, minimal music and contemporary process-based music, though, there is one dominant paradigm that evolves slowly and is meant to function both as a construction technique and as a perceptual feature. In line with the open sketch, such finished compositions can be called 'abstract', since a general topic is perceivable.

Research and expositions that combine all three forms (text, open sketch, finished composition) offer a wider array of perspectives on both the artistic practice and the research topics. This combination helps to overcome the sterile dichotomy between art (composition) and theory (text) because each of the media, sound and text, can be either abstract or concrete. The intermediate form 'open sketch' has a special position within these three forms because it sheds a light on both the text (through its sonification of a composition problem or possibility) and on the artistic practice. The latter happens through its difference from the finished composition. The open sketch discloses the specific nature and the emergent features of the finished composition. Situated between theory and practice, it helps to create an interactive and performative relation in which both domains change each other.

To include the open sketch as an additional exposition form is not only a question of transparency in communication with others. It can also help the researcher to clarify and even reconcile his own research methods with his artistic motivations. As an artist and composer, the fact that I will be doing research on one composition problem for several years is a constraint on my creativity. It seems as if my future works will necessarily have to centre on this main problem. I may be intrigued and passionate about this problem at the start of my research, but it is impossible to predict if I will remain passionate and engaged enough in the future to compose new works. On the other hand, to do thorough research, it is important to focus on the main problem for a long period. Once I decided to start composing the open sketches alongside my artistic, finished compositions, the conflict was solved and the solution gave me a sense of artistic freedom in my research. By inserting the open sketches between the written text and the finished compositions, the latter no longer needed an obvious, straightforward link to the written text and the research

questions. My finished compositions could stay practice-based, and they were not forced to become research-led.

There is a final link between transparency and my research-exposition mode. The greater artistic distance in the open sketches and their sonification of artistic problems partly undermines the usual communication obstacles in music composition. Genres, styles, motivations, institutions, social roles and meta-stories often act as barriers to dissemination and acceptance of new artistic ideas and confuse the dialogue. Artists often refuse or accept ideas or techniques because they are part of a style, institute or the personal vision of a composer. Since the open sketch is more distant and detached in an artistic sense, and its focus leads to the omission or neglect of some parameters that are found in a finished artwork, the ideas presented can penetrate faster through these barriers. Based on my experience, it is easier to have a profound discussion on a well-defined musical problem in an open sketch than to discuss a whole composition, especially if the participating composers use very different procedures and have contrasting aesthetic opinions. The detached nature of the open sketch can even open the door for researchers to collaborate. Cooperation amongst composers is not a common practice,[8] but in my research project with the six composers we managed to revise several open sketches collectively without major problems. In a recorded session in which I was changing an open sketch that a second composer had made, he spontaneously remarked that he would never have allowed me to do that if this had been one of his normal compositions, but the open sketch was 'just working material ... you can do with it what you want' (Vanhecke 2011).

Innovation and Exposition

One of the main goals of research – and thus artistic research – is to deliver something new and to contribute knowledge, insight, practice, or tools to the existing body of knowledge and practices. The described research-exposition mode can help to achieve this goal. Its two main components, the open sketch and the selected audience, can ensure that something new is produced in research. Without doubt, newness in art is a complex issue because it is a social construction that transforms over time and depends on opinions, power relations, group formation, science, evolving technology and a great deal more.

8. In general the literature on cooperation in the audio arts talks about cooperation between composers and performers, composers, and dancers, etc., but not about cooperation among composers. There are some famous examples, though, such as the duos John Lennon and Paul McCartney, and Pierre Schaeffer and Pierre Henry. In the music avant-garde of the 1960s and 1970s there were some collectives of composers, e.g. Nuova Consonanza. See: Green 2001; Brooks & Laws forthcoming; John-Steiner 2000.

But the complex and transient nature of what is new cannot be used to avoid creating innovation in research. That a researcher selects an audience for his exposition and that it often consists of other specialists and artists from outside and inside research institutions, helps the researcher to distinguish between finding information and practices that are personally enriching and others that add new insights for a community of people. The large body of researchers and of articles and books in any research domain, and even sub-domain, makes it difficult for one researcher to master a profound and full knowledge of this (sub)domain. This is especially problematic in artistic research, which is not only interdisciplinary (enlarging the number of knowledge domains involved), but which also requires a profound knowledge of the artistic field and its history. But, as Timothy Emlyn Jones notes, a review of art is particularly problematic because 'it is simply not possible to determine all that has been done, because not all creative practice of this kind has been externally referenced let alone refereed' (Jones 2009: 39). Regularly involving a group of experts and other audiences in the research process during presentations is a way of building innovation into the artistic-research process.

There is a second relation between the described research-exposition mode on the one hand and innovation on the other. Innovation in art can be carried too far when artists focus too much on details and lose sight of their position in a changing society. The act of selecting an audience also creates an opportunity for the artist-researcher to become fully aware of this situation. Especially, the selection of a diverse audience ensures that 'innovative' remains a synonym for fresh, stimulating and provocative.

Conclusion

In my experience, many composer-researchers expose their research in a format that is not greatly different from that of researchers in non-artistic disciplines. They present a slide show, read a text, or give a well-structured lecture with sound or score excerpts from finished compositions to illustrate their story. It is only for 'artistic' occasions (such as concerts) that new music is composed. In this mode the *exposition* of research and practice is almost a synonym for the *dissemination*, a unidirectional action without a profound influence of the exposition on the research or the practice.

But there can be a feedback loop between research, exposition and practice resulting in a research-exposition mode that I have described in this chapter. In this mode the artist composes specific music for research expositions. I have called this type of music in this chapter 'open sketches' and described it as 'unfinished' but focused. These sketches have some attributes that are usually associated with finished compositions, for example: they are performed. In other fields they resemble text. As important for the research-exposition mode is to challenge the idea that the audience for these expositions is fixed. An

experimental space with a selected audience can be created that enables close interaction between the composer's intentions, the composer's music, and the perceptions of the audience. These kinds of regular expositions within the research process remind the researcher-composer that in art, and thus in artistic research, expression is the heart of the matter. Introducing affects, ideas and concepts to people through music, and reflecting on these modes and tools, is an essential activity in artistic research.

The way I have described the integration of exposition and research is grounded on a social vision of the arts and creativity. Mihaly Csikszentmihalyi (2001) has researched issues of artistic creativity extensively. He has stressed that creativity is not the work of individuals but functions within a social system (a 'field') and a cultural system (a 'domain'). The research-exposition mode described is an attempt to create a small-scale and concentrated version of the living creative process by incorporating meetings among the researcher, the field and the domain. Confronting researchers with the comments and actions of other communities is vital for an artistic research project that tries to obtain applicable and explicit knowledge for the field of music composition. In the end, giving the exposition a key role in artistic research is a way to bring the social dimension of both research and practice to the foreground.

References

Barrett, E. & Bolt, B. (eds.), 2007. *Practice as Research: Approaches to Creative Arts Enquiry.* London: I.B. Tauris.

Brant, H., 2009. *Textures and Timbres: An Orchestrator's Handbook.* New York: Carl Fischer Music.

Brooks, W. & Laws, C. (eds.), forthcoming. 'Productive Tensions: Co-Creative Practices.' In: *Music, Collected Writings of the Orpheus Research Centre in Music.* Leuven: Leuven University Press.

Collins, D., 2005. 'A Synthesis Process Model of Creative Thinking in Music Composition', *Psychology of Music* 33, pp. 193-216.

Cope, D., 1997. *Techniques of the Contemporary Composer.* New York: Schirmer.

Csikszentmihalyi, M., 2001. 'A Systems Perspective on Creativity.' In: *Creative Management.* Jane Henry (ed.). London: Sage Publications, pp. 11-26.

De Baerdemacker, K., 2011. Interview with, 7 March 2011 [on digital hard disk].

Dorkbot.org, 2012. *Dorkbot. People doing strange things with electricity.* Hosted by the Columbia University Computer Music Center. Available at: http://dorkbot.org/ [Accessed 20 November 2012].

Green, C., 2001. *Third Hand: Collaboration in Art from Conceptualism to Postmodernism.* Minneapolis, MN: University of Minnesota Press.

John-Steiner, V., 2000. *Creative Collaboration.* Oxford & New York: Oxford University Press.

Jones, T.E., 2009. 'Research Degrees in Art and Design.' In: *Artists with PhDs: On the New Doctoral Degree in Studio Art.* James Elkins (ed.). Washington, DC: New Academia Publishing, pp. 31-47.

Keuler, J., 1997. 'Problems of Shape and Background in Sounds with Inharmonic Spectra.' In: *Music, Gestalt, and Computing: Studies in Cognitive and Systematic Musicology*. Marc Leman (ed.). Lecture Notes in Artificial Intelligence 1317. Berlin: Springer.

Landy, L., 2007. *Understanding the Art of Sound Organization*. Cambridge, MA: MIT Press.

Leman, M., 2007. *Embodied Music Cognition and Mediation Technology*. Cambridge, MA: MIT Press.

Logosfoundation.org, 2012. Ghent: The Logos Foundation. Available at: http://www.logosfoundation.org/ [Accessed 20 November 2012].

Reynolds, R., 2002. *Form and Method: Composing Music: The Rothschild Essays*. Stephen McAdams (ed.). New York: Routledge.

Sethares, W.A., 1998. *Tuning, Timbre, Spectrum, Scale*. Berlin: Springer.

Smith, H. & Dean, R.T., 2009. 'Introduction.' In: *Practice-led Research, Research-led Practice in the Creative Arts*. Edinburgh: Edinburgh University Press.

Vanhecke, B., 2011. Interview with, 7 September 2011 [on digital hard disk].

When One Form Generates Another: Manifestations of *Exposure* and *Exposition* in Practice-Based Artistic Research

By Ella Joseph

Fig. 1. Ella Joseph, *Awaiting Your Arrival* (2011)
Cardboard portrait (of artist) distorted through the lenses of the camera

Given the division of labour in the art world, with makers on one side and those who discuss and debate their work (critics and curators) on the other, the notion of research has traditionally been attributed to the latter. In spite of that, in the last twenty years, a new movement has been taking place that acknowledges and opens up new territories to artists who are interested in the inclusion of research within their own work; new courses have been implemented in academia through Master of Arts, and most recently Ph.D. programmes that combine practice and research, often culminating in a visual work accompanied by a written work – a thesis. While welcomed by the artists involved, the new approach is less welcomed by the critics and curators who perceive these new developments as intrusive:

There are some artists that write about their own work, but these are seldom the most interesting texts. Thus, I am not sure that art would improve if artists were forced to reason about their work. I do believe that one has to be cautious in disrupting that division of labor, that distinction between the production of art and the reasoning about art [...] So, I am a bit skeptical about talking about artistic production as a form of research (De Vries 2004: 17-18).

I would like to submit the assertion that this direction does not intrude but simply adds another dimension to the discourse on the arts. Moreover, generations of artists investigated and recorded their thoughts about their work in writing: Leonardo da Vinci in his notebooks, Vincent Van Gogh in his letters to his brother Theo, Konstantin Stanislavski in his autobiography *My Life in Art*, Jean Cocteau in his diaries and Eduard Verkade in *Diary over Hamlet, Prince of Denmark*, to mention a few. The artist as researcher, curator and/or critic does not diminish the labour of others; he or she simply brings another perspective and ultimately this approach gives the formally trained art critic and historian new work in evaluating and developing ideas on artists' point of view. To exemplify, if it weren't for the letters of Van Gogh we wouldn't know that 'a painting such as *The Bedroom* [was] intended as a welcome to Gauguin and a homage to Seurat, in which he strove to convey an image of rest and simplicity'; instead it would 'be considered a model of colour enhancement and distorted perspective' (De Leeuw 1997: x).

This paper looks into possible manifestations of 'exposition' that derive from the premise that exposition narrates an artist's work and their process of creation in one form or another. The narration of a work is established at first visually (through the exhibition) and then in writing (through the exposition of the exhibition). Both the narration of the exhibited work and the narration of the process of creation hold epistemic value and therefore are valuable in terms of artistic research. The maker gains knowledge about how she and her work are progressing, the viewer gains knowledge in the experience, and the reader gains knowledge of how artistic work comes to life. Additionally, artistic research brings value and applications to domains outside the field of the arts (i.e. philosophy, psychology, anthropology, sociology). If anything, the artist 'talking about artistic production' will inspire other researchers.

From this hypothesis, I suggest that exposition takes place at any stage in the process of creation and begins with exposing oneself. Furthermore, 'The artist is the origin of the work. The work is the origin of the artist. Neither is without the other. Nevertheless, neither is the sole support of the other' (Heidegger 2008: 143). In the same way, exposure and exposition generate each other.

Since it is in the spirit of the artist to let oneself be vulnerable within the expression of one's work, the following presentation revolves around exposing

my own work and life, and is punctuated with several examples from well-known practitioners to enhance and support the proposed ideas.

Exposure 1

'A good painter has two chief objects to paint, man and the intention of his soul', wrote Leonardo da Vinci in his journal (Da Vinci 1980: 176). In the same vein, I felt that I was not ready to represent the outer world without a deeper search of the inner self. I could not 'paint another' before I had 'painted' myself.

As my academic studies and personal experiences progressed, I became preoccupied with finding ways to stage my own feelings and thoughts in the media of my choice: live events such as performance and installation. Yet unveiling the depths of my soul for myself was one thing, exposing them to another was something else. I was determined to stay true to myself, but I wasn't ready to give myself entirely away to an audience of strangers. Ultimately, to express my own thoughts, emotions and experiences visually, I developed an approach that I called 'veiling and unveiling'; just like in any relationship, although not purposely hidden, not everything is completely revealed. We can relate this to 'one of the most important requirements of Deleuze's philosophy: on a surface nothing is hidden, but not everything is visible' (Martin 1996: 19).

In the process of creation and production, I explore 'veiling and unveiling' on two levels: content and form. At the level of content, it is a mixture of fact and fiction (by exposing true thoughts, feelings and experiences one's true self 'unveils', while modifying thoughts, feelings and experiences 'veils' one's true self). At the level of form it plays with the viewer's ability to visualize the entire performance (exhibition) space at the same time. For example, viewers are placed in the middle of the work of art rather than having the whole work displayed in front of their eyes. 'Veiling and unveiling' is not a cover up but the truth of how we represent ourselves and come across in real life. A human being is a walking canvas that can tell us a story in many different ways. There are times when one may reveal oneself as happy and confident while underneath one is sad and vulnerable.

To be able to draw images out of raw emotions and then recreate them in real space and time, I searched internally for a process of creation as natural as breathing. The trick that I came up with was to slow down my anxious body for as long as it took. I remember how, during this experiment, my colleagues were continually surprised, intrigued and disconcerted to see me in the studio in the midst of a practical assignment, doing nothing much, just being. While they were feverishly working and reworking concept after concept, I was spending that time going to the depths of my soul, sorting out feelings, reading, dreaming, scribbling images of what my brain would retain from the movements of the chest, the travelling of dreams, thoughts and ideas. In the documentary film *The Quantum Activist* (2009), directed by Renee Slade and

Ri Stewart, quantum physicist Dr Amit Goswami explains that creativity requires incubation 'like [when] a bird sits on an egg doing nothing. This is a little bit hard to believe for a modern person who is convinced of a do-do-do lifestyle […] It's neither do, do, do, nor be, be, be. It's do-be, do-be, do. Alternate being and doing.'

Day after day, image after image, the *Gesamtkunstwerk* (total artwork) was taking shape in front of my eyes, only steps away from being brought to the outer and palpable dimension of the performance (exhibition) space and ready to reveal itself to the audience. All these images manifested in one form or another (performance, installation, video), were clear and simple, yet told many stories.

Exposition 1

The most direct way to look at exposition is through the body of my work. One of my first performance pieces, created at the Utrecht School of the Arts, was *E-motion* (2000). *E-motion*'s visual idea is based on the theme of Prometheus, particularly the two plays: *Prometheus Bound* and *Prometheus Unbound*.

Prometheus Bound is a tragedy by Aeschylus. Prometheus is punished and bound in heavy chains on the hill of a mountain for giving hope and fire to humanity. *Prometheus Unbound*, written by the romantic poet Shelley (and inspired by Aeschylus) is full of hope for humanity. The unbound Prometheus signifies that hate and death no longer exist among humans.

Although the idea of my piece was based on text, text in the form of spoken word or image was not part of the live event (identified as a performance installation). The result was a 'bound-unbound' metaphor that represented my search for freedom, questioning on which side I found myself ('bound' versus 'unbound'). Three bodies were physically tied by the same rope, performing a circular and cyclical movement, binding themselves while trying to unbind their bodies. The three performers (a man in the middle, a woman and man on the outside), were engulfed in darkness and only tangentially illuminated by a single source of light hanging from above that beamed over a vertical line of sand falling like salt through an hourglass. Due to the composition of light and shadow and the hourglass effect (an element whose key function was to distract the audience), the three bodies performing the circular movement were continuously 'veiling and unveiling' themselves.

My MA studies culminated in the creation of the performance-installation work *Inertia* (2001), which was presented at the Veem Theatre in Amsterdam, and a thesis – a written paper that recorded the research and development of the performance. *Inertia* is another example of exposition.

Inertia is a state defined by one's lack of energy and desire, lack of ability to move or change, apathy and boredom. Looking for ways to represent the state of inertia visually, I again used a dramatic text in the development. I came across Luigi Pirandello's *Six Characters in Search of an Author* and chose the

dialogue of the 'Father', which mirrored my own state of mind. This specific text from Pirandello's play became an important source of inspiration in the process of creation as well as rehearsal material for one of the four performers, the 'Woman in the Cage'.

At the end of the rehearsal process, the dialogue of the 'Father' was reduced to a single word: 'nowhere'. For the duration of the live performance, the 'Woman in the Cage' traversed the space above the heads of the audience, in a dolly. Pulling on a rope to move the dolly back and forth, up in the air, she pronounced the word 'nowhere' using a certain breathing technique: she uttered the word 'no' while breathing in and the word 'where' while breathing out.

In the thesis documenting *Inertia* the following research questions were investigated: 'Why and how do I create an interactive performance-installation?'; 'How do I establish communication between Form and Content?'; 'How do I break the distance between audience and performers?'; 'Why and How do I create a performance installation with no beginning – no end?'; 'How do I express the inner changes that lead to the state of inertia in Space and Time?'; 'What effect has inertia on me and how do I want the audience to experience it?'; 'How do I create awareness among the audience?'

Such research questions were woven among elements such as 'Theme', 'Content', 'Concept' and 'Form' (where Form is defined by Space and Time, Bodies and Objects, Colour and Light, Text and Sound). At the same time I was looking to make connections between theory and practice, mainly using concepts from theatre, art and philosophy.

Generated from a form of art, the thesis is the manifestation of exposition in artistic research and academia. However, within the context of 'when one form generates another', I also feel compelled to raise the possibility of the thesis as another work of art, which can also constitute the topic of another conversation.

Exposure 2

One day, while living in Amsterdam, I fell in love with an American and embarked (once again) on a foreign vessel to the faraway land called America. The vessel was fragile and the winds were harsh but in the midst of it I discovered that while the movements of my soul were deep, the act of creation was easier than ever. Perhaps it is true, to a certain degree, the popular belief amongst artists that one needs to take risks, go beyond one's safe threshold, experience life in uncomfortable ways, in order to be able to create.

A decade has passed since, a decade that in counter-play to the title of Russian theatre director Konstantin Stanislavski's autobiographical work *My Life in Art*, I describe as 'My Art in Life'. Stanislavski's written work reveals the artistic through the personal life. Going through the chronological stages of childhood, adolescence, youth and maturity, the main objective of his book was to

record his artistic evolution. His system in theatre is divided into two main parts: 1) an actor's inner and outer work on himself, 2) inner and outer work on a role.

Another example of a written work that reveals both personal and artistic life is Jean Cocteau's *Beauty and the Beast: Diary of a Film*. The book covers the behind-the-scenes activities in the making of a cinematic work, including its creator's most intimate behaviour: 'The Diary reveals everything the film disguises, possibly more than the reader asks for. It is a strange document, reminiscent in its unrestricted candor if not in scope, of Rousseau's Confessions [...] Like his great compatriot, Cocteau is presenting an unflattering self-portrait' (Amberg 1972: viii). In this case, Cocteau's diary, whose main apparent goal is to reveal the process of making, has a secondary, perhaps less apparent role: that of *exposing* his own self, which has the function of making clear what the film as *exposition* veils. After all, 'We can never derive the "story we tell about ourselves" from our "real situation", there is always a minimal gap between the real and the mode(s) of its symbolization' (Žižek 1997: 119).

Time after time, in place after place, I produced works that captured fragments of my life represented in a medium that was most convenient to me at the time of creation. My original intention was to build up a body of work true to myself. At the same time, I wanted to understand my own actions, explore the developments in my work and preserve that ephemeral moment of a live performance.

In my journeys, I carried with me at all times a small notebook to encapsulate feelings and thoughts in words and images. This was the only form of documenting the process of creation that survived the passing of time. I came to realise that in order to accomplish all of the above, as well as revive past works and perhaps attempt to fight my own mortality, I had to write.

Thus, in 2009 I published my first book, 'Parsifal Unspoken', in the series titled *Theatre of Truth(s)*. In 2011 followed the second book, 'Bogged Down & Bumpy Road', to describe the process of creation of the works with the same title, which I use in the next example of exposition.

Exposition 2

Outside academia, images continued to invade my mind from all over the place at all times, inciting me creatively. I discovered that my artistic self was not independent from my private life but a major part of it. The best example of such work, and exposure that leads to exposition, is the performance installation *Bogged Down* (2004). *Bogged Down* deals with the dimensions of everyday life where, although not hidden, not everything is completely revealed and persuades each person to bring with them and carry away their own truth. In line with the gallery experience, the viewer is not constrained by an expectation to see the whole all at once, but instead, is freed from time and given the opportunity to have multiple viewings and views of the same piece.

Bogged Down brings together Body and Text in Space and Time. Carefully chosen fragments from Pirandello's play *Each in His Own Way* were first deconstructed, in the sense that relevant words and sentences were extracted and then reconstructed into a new text to 'veil and unveil' both my external (viewed from the outside) and internal life at that time. The external life is described by the following text, delivered visually in projected video images on a white wall:

> At last! I live as sheltered a life as possible. I go out only a few hours a day. I don't go to theatre anymore. I get up early every morning and work until noon. After breakfast, I go back to my computer. In the evening, after dinner, I usually watch a movie or two until I fall asleep. I start the next day with a fresh pot of coffee. As you can see, there is nothing something in my life worth revealing.

The internal life of the artist reproduced by the text below was delivered as sound through a pair of headsets. Concomitantly with listening through the headsets, the viewer watches the virtual image of a woman (the artist herself) sitting on a stool with her back to the viewer. Imperceptibly moving her body while facing a white wall, the 'Woman' speaks softly, confessing to her viewer through a pair of headsets:

> I have always been acting in my own way under all circumstances. I am a good natured person, spiteful on occasion, although, what I am really, I am not sure I know even myself! All fussy and unpredictable, my feet off the ground! First I laugh, then, I go off into a corner and cry all by myself. How terrible that is. I hide my face ashamed of how different, incoherent and unreliable I am from time to time.

Another work, *Bumpy Road* (2004), was created based on the theme 'Alienation' for Salvador Allende Festival for Peace in Toronto, Canada. For this art event, I chose to create a video piece using footage captured during my only trip to California. Personal memories and experiences were embodied in these video images: the simple road that undulated around green pastures with trees and hills that reminded me of the place of my birth, superimposed with archival images from World War II that I found and captured one day from a documentary broadcast on a Canadian television station.

This silent video takes the viewer on a personal journey while having to confront images of a dark past. It is an example of a work where the exposition of the personal, which is fundamental to the concept and the creative process, is not apparent in the outcome. Instead, what is clearly shown to the viewer is a commentary of present and past, peace and war; life interrupted. To make the personal aspect apparent, *Bumpy Road* was presented together with the video component of the performance installation *Bogged Down*.

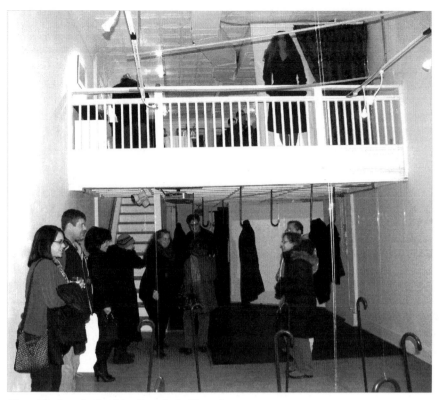

Fig. 2. Ella Joseph, *Awaiting Your Arrival* (2011)
General (front) view of the performance installation

Awaiting Your Arrival (2011) was created for an art gallery in Buffalo, New York. The installation incorporates objects (canes suspended from the ceiling), video and performative elements, including a video camera continually recording the arrival of spectators and the artist in disguise. I see this 'artist in disguise' element as another variation of exposure that leads to exposition.

A life-size cardboard cut-out of my own image (as I ordinarily look) stood on the balcony, playing the artist awaiting the arrival of her spectators. The appearance of the flesh-and-blood artist, however, was transformed into a member of the audience by a short black wig covering her long, auburn hair. The cardboard figure *exposed* me and brought me closer to the audience, while the 'artist in disguise' produced a 'distancing effect', to use a concept coined by playwright Bertolt Brecht, 'which prevents the audience from losing itself passively and completely in the character created by the actor, and which consequently leads the audience to be a consciously critical observer' (Willett 1964: 91). Moreover, in this instance the 'distancing effect' also allows the artist to be a 'consciously critical observer' and to wander around, hearing reactions from the viewers.

Exposure 3

Feelings, emotions, thoughts, ideas, live events, spoken words are nothing but fleeting moments in space and time. Text, on the other hand, is a fixed element that can be investigated and debated. The work of art comes to life in the presence of the audience and continues to live through them and their recorded impressions. Capturing in writing the audience's response becomes another form of exposure.

I present below statements of viewers in response to my performance installation work *Cotton Candy ... Cawcawphobia* (2010), which was shown at ScenoArt (my home studio and gallery), and encourage readers to imagine the work through those statements:

Viewer 1:
When we first went into the exhibition we didn't use the headphones and I felt as though I was looking at the world through a cloud from above. I was enjoying the fluff of cotton candy and feeling young and carefree again. It was a happy feeling.
When I went back in and used the headphones I listened to the world as it is, with the clouds and floaty feeling ripped away. I was closed in, riveted to what I was hearing, with the rest of the world closing in and at disparity to the cotton-candy world. I feel what the woman was feeling when she complained about what the news has become.

Viewer 2:
Whimsical, slightly unsettling and partially edible art installation.

Viewer 3:
The audio set-up was so unique, plus truly made you unaware of others – a truly solitary experience – the best audio piece I have been to.

Viewer 4:
A unique experience enticed the thought of forced group opinion by way of mass news outlets underlined by childhood wholesome nostalgic song.

Viewer 5:
Felt like I was in the Garden of Eden until I got bit by a serpent. A truly nihilistic commentary on the mainstream society.

Viewer 6:
Funny but dangerous.

Viewer 7:

This was by far my favorite one! I really liked this one. Art is subject to interpretation of the observer, and if the artist can make the observer feel any kind of emotion, then that work of art has done its purpose. I felt this one ... a LOT!

Viewer 8:

I really enjoyed it. It was something I kept thinking about over the weekend. It had great depth. I look forward to seeing more!

Viewer 9:

I enjoyed the fact that your art made me think, to feel, to look inward at what my feelings were about the world around me. Your art isn't something to just look at, say it's pretty, and move on. It requires participation. I like that. It is not something I am accustomed to, but something I might like to become accustomed to.

Exposition 3

Eduard Verkade's (1878-1961) work around *Hamlet* epitomises the title of this paper, 'When One Form Generates Another':

> one of the actors-directors who revolutionized the Dutch theatre in the early years of this century [Verkade] had a life long obsession with Hamlet. He first presented a solo recital of the play in December 1907. Within a year this was followed by a full-scale production in which he took the title role upon himself. He was still playing Hamlet in 1931, at the age of 53, and directed the tragedy for the last time in 1948 (Westerweel & D'haen 1990: 152).

Verkade also wrote a book titled *Uit het dagboek van Horatio over Hamlet Prins van Denemarken* (From Horatio's Diary Concerning Hamlet, Prince of Denmark'),[1] a sort of novel in which, inspired by Hamlet's dying request to Horatio: 'draw thy breath in pain, To tell my story', Verkade wonders how Horatio knows enough about his friend to do so. This is the question that he explores in his book, while once again recreating his favourite character, Hamlet, this time in writing and through the eyes of Horatio. Verkade's quest shows how even after his numerous projects presenting this character on stage, he still feels compelled to write about him. The obvious question, why is Verkade obsessed with Hamlet?, leads to an additional one: does the object of his obsession mirror himself? Ultimately, the question is, why do some art practitioners feel the

1. Uitgeverij Jacob van Campen, Amsterdam, 1947.

urge to pursue writing? Verkade's writing is yet another interesting example of exposition as a result of exposure.

'However, the chain never comes to an end. There is no purpose; everything feeds on itself, moving in an endless, vicious circle' (Harman 2007: 136).

The expression 'When one form generates another' first manifested itself many years ago, after the screening of my video piece *Euphoria or One Piece Always Missing* (2002) at the Nieuw Millennium Foundation in Amsterdam. Someone in the audience commissioned me to transpose images of that video into a painting. I painted three canvases (with the forth one missing, to stay true to my concept), where each canvas represented an important frame in the video. This proposition triggered the concept 'one form generates another', and once it had become a conscious element, I found myself creating practical applications of the idea throughout my work. Later on, in the same spirit, I created art prints from video stills as a way to document and freeze in time in a different format, the ephemeral aspect of a live performance.

Similarly, during the creative process, thoughts and feelings that are free in form generate each other. Text and images are processed from a fluid into a fixed form that further manifests from paper to a physical space.

Making the decision to write about past works in the process of creation involves variations of exposure (exposure of the inner to the outer) and variations of exposition (exposition of a work of art in a physical space: art gallery, theatre venue, church; narration of text and images in writing: diary, thesis). This process involves the immaterial (fluid memory) and the material (fixed documentation), subjective and objective tools.

This paper in itself is a form of exposition that manifests itself through the exposure of the artist. I started by freely incorporating many elements that could take the reader in many directions. Yet, during the process of writing it became more structured, so that one may observe throughout the three examples of exposure and exposition how the two generate each other. Ultimately the dialogue should open up new possibilities to the reader. To quote Hamlet's last words: 'The rest is silence'.

References

Amberg, G., 1972. 'Introduction to Cocteau.' In: *Beauty and the Beast: Diary of a Film*. Mineola, NY: Dover Publications.

Da Vinci, L., 1980. *The Notebooks of Leonardo da Vinci*. Ima A. Richter, sel. ed. Oxford: Oxford University Press.

De Leeuw, R., 1997. 'Introduction.' In: R. de Leeuw, sel. ed. *The Letters of Vincent Van Gogh*. London: Penguin Books, ix-xxvi.

De Vries, G., 2004. 'Beware of Research.' In: A. W. Balkema and H. Slager, eds. *Artistic Research*. Lier en Boog Series 18. Amsterdam & New York: Rodopi, 16-18.

Harman, G., 2007. 'Strange Masterpiece in Bremen.' In: *Heidegger Explained: From Phenomenon to Thing*. Chicago: Carus Publishing Company, 127-42.

Heidegger, M., 2008 [1935-6]. 'The Origin of the Work of Art.' In: D. F. Krell, ed. *Basic Writings*. London: Harper Perennial, 139-212.

Martin, J.-C., 1996. 'The Eye of the Outside.' In: P. Patton, ed. *Deleuze: A Critical Reader*. Oxford: Blackwell, 18-28.

Westerweel, B., and D'haen, T., 1990. *Something Understood: Studies in Anglo-Dutch Literary Translation*. Amsterdam & New York: Rodopi.

Willett, J., 1964. *Brecht on Theatre*. New York: Hill and Wang.

Žižek, S., 2008. 'Fetishism and its Vicissitudes.' In: *The Plague of Fantasies*. London & New York: Verso, 86-126.

Writing Performance Practice[1]

By Siobhan Murphy

Artistic researchers in the performing arts often craft academic writing as well as performance works. This dual activity raises interesting epistemological, methodological and stylistic questions; two tasks, two modes of expression and the ongoing negotiation of their interrelationship. I will discuss this endeavour in the context of PhD theses that contain both academic writing and a performance folio. I will describe some key issues both in general terms and with reference to my own PhD inquiry, in which the relationship between the two tasks underwent considerable negotiation.

All words have histories and connotations, prompting consideration regarding the name we give to academic writing in artistic research. The terms 'exegesis' and 'dissertation' are often used interchangeably in the academic context, and indeed one could argue that it is immaterial what name we give to a piece of writing, so long as it serves the project as a whole. However, the casualness with which the terms are interchanged can mask an underlying ambivalence about the role of academic writing within higher-degree research in performance. There are some insights to be drawn from examining the terms more closely, and to this end I will look at the etymology of each word. It will become clear that each mode of writing has advantages and disadvantages for artistic researchers.

I will suggest that both academic writing and performance-making should be reconfigured by virtue of their interrelationship in the research context, and describe three writing strategies that I developed during my research. These strategies arose from the exigencies of my particular project and my understanding of artistic research. I spent little time writing about the public performances that comprised my folio, focusing mainly on the larger periods of practice within which the performances resided. This choice may well be appropriate for other performance-makers for whom the practice of improvisation is a necessary bedrock for performance creation, though it will not be appropriate for all artistic researchers.

1. An earlier version of this essay appeared in Murphy 2012b.

What's in a Name? Exegetical and Dissertational Writing

The relationship between academic writing and art-making can easily become plagued by the schism between theory and practice that has long permeated Western knowledge structures. Art-making is often construed as practice, and academic writing as theory, and this splitting is detrimental to both activities. One consequence can be that artworks come to be seen as 'illustrating' theories. Another is that academic writing comes to be seen as a tool for 'explaining' artworks. Such configurations deny the degree to which academic writing and art-making can be ongoing and interrelated activities, resulting in a synthesis of multiple modes of intelligence. To confine writing to explanation or art-making to illustration reduces many rich possibilities. It is unlikely that one would deliberately seek to establish such restrictive relationships. However, as with all dichotomies, that of theory and practice can be so entrenched in one's thought processes that it remains unconsidered. To be unaware of it can diminish the overall creative force of a practice-led inquiry. Understanding what is at stake in the mode of writing one has chosen is one step towards avoiding this.

Here, I will discuss two writing modes: exegetical and dissertational writing. I use the terms in a restrictive sense. By this I mean that, in reality, artistic researchers tend to combine aspects of exegetical and dissertational writing in the one PhD text, and indeed this is what I argue for in this chapter. But for the purposes of clarity I separate the two modes here and discuss the properties of each. When assessing artistic research, I have often felt that: a) the writing could have been less painful for the researcher and b) the writing could have been more useful to the overall project if greater clarity had been reached early on about what role it was to play.

In working towards an academic document such as a PhD dissertation, one's writing becomes highly crafted, follows established academic protocols and is directed towards an audience of discerning readers. Academic writing can also become a primary site for the rigorous reflexivity that characterises artistic research. Dan Mafe has noted that this reflexivity occurs initially in the sphere of one's own practice and then opens onto the broader sphere of other thinkers and makers.[2] The labour of academic writing is a powerful means to cultivate such reflexivity: through crafting words over time, one can come to understand one's practice and its contexts in new ways. Laurel Richardson's notion that writing is itself a form of inquiry is particularly apt in this case (Richardson 1994).

As mentioned, clarity regarding the role of academic writing in the overall project is essential. What do artistic researchers seek to *do* with their writing? Often, at least in Australia, their autonomy in this respect is somewhat curbed

2. Dan Mafe, *Live Research* symposium, Creative Industries Precinct, Queensland University of Technology, Brisbane, February 2008.

by the norms that prevail within their particular research communities. That is, individual universities place quite different requirements on the researcher regarding academic writing. In some cases, writing takes the form of a straight-forward documentation of material artistic processes. I do not address this style of writing in this chapter. In other cases, the writing is like an augmented didactic: it interprets and contextualises the artistic outcomes. This is often termed an 'exegesis'. In further cases, the written and artistic components are regarded as autonomous but related modalities that together comprise the thesis. In this case, the writing is termed a 'dissertation'.

As will be seen, the dissertation is a mode of writing that offers rich possibilities for artistic researchers but it is also in need of definition and content. At some institutions, the dissertation can be a scholarly text in a field related to the artist's practice, without engaging directly with that practice. I do not address this style of dissertation, because I am interested in academic writing that expressly seeks new and productive relationships with practice. The style of dissertational writing that I want to define and support in this chapter is one that inserts itself into the interstices between the specificities of one's practice and the broader contextual field within which it is located, which often incorporates other fields of thought and/or practice.

The word 'exegesis' derives from the Greek word for 'interpret' and has associated connotations: 'a leading or bringing out of the meaning, exposition; the science of interpretation, especially of the Scriptures; explanatory' (Chambers 2001: 166). The link to scriptural interpretation is not incidental for artistic researchers. There are significant similarities between how Scriptures and artworks have historically been configured as needing interpretation. In the case of Scripture, an exegetic text serves to expose, explain and interpret the meaning contained in the scriptural text. The intellectual activity of exegesis aims to lay bare that which would otherwise remain 'hidden' in the original text. Indeed, etymologist Eric Partridge notes that the word exegesis holds the connotation of 'to guide or lead (someone) out of a complexity' (Macmillan 1966: 608).

This structure describes a very particular relationship between two texts. It is a relationship that has been extensively challenged by postmodern critiques of the primacy of original, prior texts that can be open to, and indeed require the services of, interpretive analysis. For artistic researchers, this structural relationship would construe one's artwork as a 'text' that needs interpretation, and this can be problematic on a number of levels:

— It implies that the artwork's 'meaning' is not comprehended until it is brought into language.
— It assumes that what is important about the 'original text' can be put into words. In the case of artworks, this may not be the case.
— It suggests that critique is an activity that occurs outside the artwork.

On the contrary, a common feature of postmodern production is that a degree of critique is embedded within the work itself.

– It assumes that the item of importance can only be the completed artwork, whereas some artists (including myself) seek to write about processes as much or more than outcomes.

– Finally, regarding artworks as texts has political connotations within the knowledge economies of universities. It may well make artworks amenable to commentary, but ultimately furthers the research interests of critics more than artists. This last point is detailed by Susan Melrose, who writes extensively about the knowledge politics of performance research (Melrose 2003a; 2003b).

This list of the potential pitfalls into which the exegetical mode might lead a researcher represents a worst-case scenario; it is of course possible to use exegetical approaches without falling into these traps. In providing a strong critique of the exegetical, what I am suggesting is that without careful consideration of the role of writing in a given artistic-research project, one can slip into grooves already well worn by existing writing practices, where critique has been carried out by theorists in relation to existing works of art, rather than by the artist. Because historically exegeses are so closely tied to description and interpretation of completed artworks, they often end up comprising an essay on an aspect of critical theory of import to the artist, followed by a description of each work in terms of material creation and finished 'product'. The effect is that the artworks appear to claim justification through association with the preceding 'theory', reinforcing the impression that the 'academic research' part is to be found in that essay rather than in the artwork or the to and fro between the art and its articulation in writing.

Given these tendencies, as institutions go through the process of defining what a PhD in performance practice should comprise, alternative writing modes might be considered. Dissertational writing is one such alternative. The word 'dissertation' contains the Latin root *serere*, meaning 'to attach one after the other, tie together, to arrange' and the root *dis* connoting distribution (Macmillan 1966: 608). Thus the word can mean a discussion, academic discourse or treatise, literally a joining together of ideas in a way that suits the subject at hand (Chambers 2001: 134). Partridge further suggests that dissertation connotes the intention 'to treat fully' (Macmillan 1966: 608). A dissertation does not imply any particular relationship between academic writing and art-making, instead leaving artistic researchers free to forge a relationship that suits their aims.

It is worth noting that sometimes important outcomes of artistic research are found not so much in final artworks, but rather in tools, insights, relationships to other fields or communities, etc., developed during the period of research. These aspects are often best articulated in language, where they can be communicated to others in the field and in transdisciplinary contexts. The

research in this instance is a period of development that will bear fruit in future collaborative relationships, teaching, workshops, and artworks. Dissertational writing provides scope for the articulation and dissemination of such findings.

That said, the open-endedness implied by the dissertational mode can be liberating but also daunting to a beginning artistic researcher. It can pose challenges for both the researcher and the assessment of artistic theses: without established guidelines or precedents for what a dissertation in artistic research should do, it is difficult to argue whether or not it has succeeded. The subtleties of what the dissertational writing does in relation to the artistic practice and/or outcomes is something that will need to be determined by each researcher and articulated at the outset for the reader. But the individuality of this approach does not preclude making some preliminary general comments on what a dissertation in artistic research should *do* and what it should *contain* in relation to the artistic practice and/or outcomes. As a starting point, we can say that it should meet the basic academic requirement for higher-degree research of being an extensive, original work based on independent research. Then, more specifically, it should:

— Clarify the focus of the research; what might in other academic contexts be called the 'research question'.
— Clarify the contextual field of the research.
— Engage rigorously with the artists' practice, and part of this may need to include defining how 'practice' is understood by the artist. In many institutions, the dissertation must engage overtly with completed artworks. As I will suggest below, this is appropriate in many but not all cases.
— Draw pertinent and original connections between the contextual field and the practice.

For artistic researchers, the research project often begins with an area of focus rather than a question to be tested out. Over the trajectory of a PhD project, the focus area can shift in a variety of ways. For example, it might begin broadly and become progressively more contained, homing in on a particular aspect of the initial focus. Alternatively, the researcher might dive into the initial focus only to find it is exhausted quickly but opens onto a different and more lasting focus. These kinds of shifts are common in artistic practice both inside and outside the academy, and it is important to preserve the project's artistic autonomy by accepting that these are valid ways for research foci to change over time. It is one of the roles of dissertational writing to clarify for both the writer and the reader what shifts in focus have occurred and what the significance of those shifts is. One way to do so is via a writing mode that I outline below, called 'a narrative of practice'.

Clarifying the contextual field of the research generally includes tracing a lineage of other makers within the specific artistic discipline, whose work influ-

enced or provided a counterpoint to the endeavours of the artist. Exegeses often do this comprehensively: a strength of the exegetical mode is that, through its emphasis on the analysis of artworks, it can cover a broad sweep of the artists' own work and that of others. But increasingly artistic researchers are also interested in excursions into other fields of thought such as ecology, philosophy or ethnography, which must then also be considered part of the contextual field of the research. The exegetical mode often provides little scope for doing this.

The dissertational mode, on the other hand, can be so open-ended that the art-making can become derailed by the attempt to write a philosophical text, for example, when that is not one's area of expertise. One way to avoid this conundrum is to remain focused not on the questions that exist within the discipline(s) from which one is borrowing, but on the issues that emerge over time within the artistic practice itself, and look to the other discipline(s) in a pragmatic way, as an alternative mode of thought that might provide a useful and unexpected lens through which to understand those issues. I will later suggest some ways in which to uphold the primacy of the artistic practice in this delicate negotiation.

In the dissertational mode that I am describing, the writing should engage rigorously with the artist's practice, and part of this might include defining how 'practice' is understood. For some, 'practice' means the accumulation of specific artistic outcomes over time, such as objects, events or performances, and in this case discussing the outcomes directly is essential. For example, if one's practice comprises site-specific installations, one's writing will need to address individual instances of that practice. In this case, it is primarily in the realisation of concrete outcomes that the artist's material thinking occurs, and critical reflective writing on those outcomes is an important tool for articulating and disseminating that material thinking.

For other artists, 'practice' might mean something quite different, such as studio work that may or may not have a public outcome. 'Practice' can be understood as ongoing, often daily experimental work. This understanding is common among dance-makers, where the maintenance of a lively improvisational practice is often the basis upon which a performance work might later be created. Indeed, a dance-maker will often distinguish between the 'improv practice' and 'making a work'. In the more generous time frames allowed by the research context, the dance-maker might improvise in the studio for many months, finding and discarding material or attempting to shed the somatic imprint of a previous phase of work, before feeling ready to embark on 'making a performance'. Indeed, for many dance-makers who embark on higher degree research, the possibility to focus on deeply embodied material over a stretch of time rather than being restricted by the shorter time frames usually involved in producing work for performance is a chief attraction. The studio practice is often an important site of research and one about which the maker might predominantly choose to write. This was the case for me, and it provided a

clear alternative to what I perceived as the bind of being required to explain and interpret my performance works through writing.

Having clarified the focus and contextual field of the research, and begun the process of reflecting rigorously on one's practice, the ground is prepared to draw rich and original connections between the practice, the contextual field and the shifting focus of the project. While simple to state, this stage is often challenging. To draw in what is pertinent from the contextual field while discarding what is not useful, without that resulting in a superficial treatment of others' writing, entails deft footwork. To forge original connections between different kinds of knowledge, such as that found in an eco-philosophy text and a site-specific landscape practice, for example, requires a syncretic style of intelligence. But it is often in these connections that the dissertation's claim to an original contribution to knowledge resides: they are particular to the practice in question, and have something to 'say' to the chosen contextual field that may be different from what is being said already in that contextual field.

In a rather stepwise fashion, I have laid out what I consider to be important components of dissertational writing for artistic research. The labour of crafting academic writing is rarely so orderly, however, and the 'steps' I have outlined are usually jumbled, at least in the early stages of writing. One thing upon which to insist, though, is the primacy of using writing from the outset of a research project as a means of cultivating reflexivity regarding one's practice. The articulation of what is at stake within the practice itself is the bedrock upon which other writing sits.

Experiences are transformed by bringing them into language, much as, for memory psychologist Susan Engel, memories are changed forever once they are shared (1999: 22). Choosing to write reflexively about one's practice entails a willingness to allow a transformative process to occur. If one writes about ongoing experimental studio practice, that practice will be shifted by the reflexive process of writing. If one writes about artistic objects or events, the artist's experience of and relationship to those objects or events will be transformed, however subtly, and for the reader/viewer a similar transformative process will occur. It is the prerogative of artistic researchers to decide which aspects of their practices will be laid open to the transformative process of articulation through language, so long as this decision is made consciously, is a coherent decision within the project as a whole, and is made clear to the reader.

Dissertational Strategies:
Three Examples from My PhD Project

I have suggested that academic writing should be reconfigured by virtue of its relationship to performance practices in the context of artistic research. I have suggested that the term 'dissertation' provides broader scope to do this than the more restrictive term 'exegesis'. I have made preliminary suggestions for what a

dissertation might contain. But what styles of writing might create and support that content? I provide some preliminary answers through examples from my own PhD research. This is not because my dissertation was particularly 'exemplary': indeed, it was experimental, emergent and flawed in many respects. I use examples from it because it is the only project I know from the inside out: I want to describe writing approaches that emerged *through* the practice of writing in an artistic research project. As mentioned, it is possible that these approaches may resonate most strongly with performance-makers who consider their improvisational practice to be an important site of research: artists for whom outcomes are part of a larger mix rather than an exclusive focus.

The writing strategies I describe offer possibilities for grounding academic writing in the materiality of practice. They are strategies for deriving, filtering and structuring written content such that it can extend out into the contextual field surrounding an artist's practice while also looping back into the practice itself. Such strategies do not represent the entirety of what a dissertation might or should contain: if used exclusively, such approaches might render the writing solipsistic. Rather, they intend to provide firm anchorage points from which an artistic researcher might extend into transdisciplinary contexts without obscuring the insights arising in her practice. Each artistic researcher will devise writing approaches that serve her project as a whole, but having some examples to bounce off in the first instance can be useful. The examples I give from my own PhD project are thus offered in the spirit of Brian Massumi's notion of exemplification: not as something that should be replicated or generalised, but as something that, through its specificity, might spawn new thoughts and a multiplicity of further examples (2002: 16-17).

My thesis was entitled 'Practices of tactility, remembering and performance', and comprised a folio of two performance works and a dissertation. I characterise the relatedness of performance-making and of writing in my PhD as a 'Gestalt of inquiry'. By this I mean that the two activities exist in an active relationship where the whole is greater than the sum of its parts. Much of what the practice 'meant' resided in the performance works and remained inseparable from those works. Certain meanings evade language and can only be experienced through live engagement with the particular performance works in question. However, other meanings can be pared from the practice within which the performances sit. They are of a different kind from the meanings embedded in the performances. They lend themselves to language: perhaps they are, in fact, best articulated through language. I chose to isolate and define certain aspects of my broader practice and lay them open to the transformative process of critical reflexive writing. I used writing to explore the implications of these aspects of my practice, a practice that was certainly always oriented towards performance but which could not be entirely defined or contained by the performances themselves. At the end of the dissertation, I did address one of the performance works, but this occurred through a style of speculative and

poetic writing that 'pointed towards' the performance from a variety of angles, rather than being a definitive account of it.

I structured the narrative of emergent meaning in my practice via a chronological unearthing of distinct periods of research. Performance seasons served as provisional 'full stops' to these periods. It was necessary to allow the dust to settle after a performance season. Slowly, through writing, I would attempt to make sense of the research period within which the performance had taken place. By 'making sense' I do not mean creating sense where previously there was non-sense. Rather, I mean undertaking a process of critical reflection housed in language. This enabled me to stitch together a particular *kind* of 'sense', voicing meanings that might otherwise have remained unnoticed and unnamed.

In some ways, these acts of 'drawing out' meaning can be seen as an exegetical impulse, in the sense that they seek to augment the meaning the practice could communicate on its own, providing a kind of interpretative interface between the intricacies of that practice and those who might wish to access it in writing. It is important to remember, though, that the interface I am describing here addresses primarily a collaborative improvisational practice. As mentioned in my earlier discussion of the exegetical, its pitfalls are most palpably felt when the writing usurps the completed public artwork, foreclosing what an artwork might do or might mean. The usefulness of the exegetical mode can most palpably be felt when it is used as one writing strategy among others, as one step in the process of articulating that which the researcher has decided to open to the transformative power of writing.

1. Discursive writing. By discursive, I refer to the generation of knowledge through discipline-specific epistemological paradigms. Artistic research is frequently transdisciplinary, which can mean collaborating with researchers from other fields but can also mean engaging with literature from other fields. The discursive writing included in my dissertation comes from a variety of fields that I utilise to explore the philosophical, ethical or psychological *implications* of my practice. This is in distinction to exploring the *underpinnings* of my practice. That would imply a set of ideas existing prior to the studio work. Instead, I am interested in those questions that the performance practice itself provokes and that can be best explored through writing. Often I engage with a discursive text on its own terms by 'writing with' its discursive mode and following the logic of standard academic writing. But while I engage in this logic, I attempt to particularise it so that it serves the purposes of the thesis as a whole.

One means to achieve this particularisation has been to ground the writing in the lived experience of my practice. A concrete example is perhaps the best way to clarify this for the reader. Part II of my dissertation is entitled 'Choreographic Tactility' and it comprises three chapters on touch. It arose from a studio period in which I worked intensively with touch with my collaborators

Jo White and Michaela Pegum. During and after this period, I read about touch in many discursive fields, from infant psychology to anthropology to ethics. I was then faced with the task of finding a suitable principle for ordering the ensuing mass of information.

Instead of seeking this principle from within the discursive materials themselves, I returned to the studio to see what ordering principles could emerge from revisiting my practice of choreographic tactility, inviting Jo and Michaela back into the studio at this point. We worked with touch in the ways we had established during the period of research, and directly after the movement session we recorded a conversation about the interleaving of tactility and remembering and I wrote descriptions of particular tactile encounters.

From this conversation and the rich descriptions of specific acts of touch, I distilled key qualities of our tactile practice. I then used these qualities as ordering principles or filters with which to re-approach the mass of discursive material. The filters eventually became chapter- and sub-headings in the dissertation, such as 'tact', 'connectivity', 'vocal tactility' and 'responsive agency'. I could then use writing to pry open the broader implications of each quality. Reflexivity thus occurred initially in the studio practice and then in relation to the discourses that surrounded it.

This meant that I engaged with literature in a manner that is different from how I would engage with it had my foci derived primarily from *within* a discourse. For example, if I had been writing on tactility from within the discourse of philosophy, it is likely that I would have examined Merleau-Ponty's intertwining of touch and vision as well as Irigaray and Vasseleu's re-working of that theme (Irigaray 1993; Merleau-Ponty 1968; Vasseleu 1998). But, having clarified key qualities within my practice of choreographic tactility, other sources such as Linda Holler's writing on touch and autism (Holler 2002) offered more specifically resonant material with which to unravel the implications of my studio practice. The notion of 'resonance with one's practice' as a criterion for deriving the content of one's academic writing distinguishes artistic research from research in other fields, where different criteria apply.

The notion of resonance is at once intuitive and pragmatic. On a pragmatic level, the researcher can ask questions along the lines of: does this textual source help me identify, understand, name, or otherwise articulate what is important to me within my practice? And does this process of articulation help me make useful shifts, or communicate more effectively with my collaborators, etc.? The relationship can also be less clear-cut but equally compelling to the researcher, such as: I am intuitively drawn to place this textual source alongside this studio account, though the connection is not immediately apparent. Does this connection prompt new thoughts, spur fresh improvisational strategies or performative ideas? Or, if the writing is being carried out retrospectively, does this connection help me and my reader understand more clearly what was at stake in what I did? Such questions help keep the writing answerable to the

practice, though of course they are only starting points and much will be further articulated through the process of crafting the writing.

2. *A narrative of practice.* (For a fuller treatment of this theme, see Murphy 2012a.) Halfway through writing my dissertation I noticed that what I was doing was crafting one particular story out of the many that could have been told. This story traced a specific trajectory through the period of research and its multiple strands. Rather than considering this a reductive exercise, I came to regard it as a useful process of sense-making for myself as an artist researcher. Becoming a narrator of one's own practice entails a productive tension between being inside and outside the practice at the same time, an oscillation between immersion in and reflection on practice that is useful when taking one's art-making into a research context.

As described in the previous section, the themes of my PhD were distilled over time, in the interplay between performance-making and writing. They were not posed as research questions at the beginning of the project. This reversal of customary academic procedure brings with it some interesting temporal considerations. Without research questions it is hard to pinpoint the moment at which a research theme began. For example, a major theme in my research was touch, but when writing about it I found that this theme could be traced further back in time than I had thought. Inklings existed in earlier stages of my practice, when I sought to soften the field of vision within the studio. At times, I sought to achieve this by quite rudimentary means, such as working in the dark. Noticing the links between these early visual strategies and my subsequent use of touch was not only a process of temporal ordering: it was also a recognition of the inextricability of vision and touch more generally. In this way, thinking narratively about my practice (which meant, at this point, 'finding a beginning'), helped me deepen my approach to a central theme of the research. My approach to touch came to be undergirded by an awareness of the intricate relationship of touch and vision.

Tracing the emergence of a creative entity over time is a slippery temporal experience. It renders difficult the question of origins and of ends: crafting a narrative of one's practice is both a retrospective and anticipatory activity. It is an historical project of identifying and shaping certain lines of interest from amongst a mass of experience, potentially attributing causal and chronological links to processes that may in fact be much messier. Such is the cleanliness of language. Narratives carry the benefits but also the inevitable blind spots and biases involved in hindsight. But narratives of practice are also anticipatory. They craft something new into existence, something that goes on to inflect one's future practice.

I came to regard the dissertation as a whole as a critical and reflexive narrative of my practice, with the protagonists being tactility, remembering and performance. I structured the dissertation as a chronological unearthing of distinct periods of research. It was an excavation of the lived experience of my

practice and its philosophical implications. The dissertation expands in writing on the foci that were distilled through the practice, and much of this writing follows the patterns of academic texts. But what drives it along is the desire to 'make sense' of the research period, both for myself as an artist researcher and for my reader. From this it derives its narrative impulse.

As it stands in the dissertation, the 'narrative of practice' approach was a rather awkward attempt to do something new, something that had arisen from the exigencies of my particular project. Though awkward in that first rendition, the notion of a narrative of practice has proven to be productive in a teaching context. I have found it a useful tool for assisting completing PhD candidates to articulate the shifts in their projects over time and the relationship of their practices to their contextual fields. Often, those 'shifts' are where the most interesting and original insights have taken place. For newer researchers at the outset of a project, I have found it a useful way to crack open the specifics of the emerging research interest.

3. Poetics of practice. One way to consider how academic writing could be positively influenced by its relationship to a performance practice is to think about how the two modalities relate to time. Discursive writing involves the reflection afforded by hindsight, and writing a narrative of practice is itself an act of remembering. But academic writing does not always need to be retrospective. In my dissertation, when I speak about the kind of performance presence that interests me, I describe it as a mixture of retrospection and anticipation. In some sections of my dissertation I have tried to imbue the writing with this combination of temporalities. That is, I look back at the already known while also having an eye towards generating a new understanding in writing.

This is important when writing attempts to address performance. In my dissertation I sought novel ways to write about the performance of my solo *here, now.* After the performance season, visual artist John Wolseley wrote to me about his experience of the work. This spontaneous writing seemed to be a very valuable document, and prompted me to invite two other performance-makers and a writer/curator who had all attended the work to respond to a poetic piece of writing I had drafted. My draft sought to remember from the inside what corporeal, affective and imaginative states had sustained my performance. The other performance-makers chose to craft their own remembrance of the performance before reading what I had written. I later wove all five accounts into an experimental text, a poetics of remembering.

In lieu of a traditional conclusion, this text provides a speculative ending to the dissertation and is entitled 'Coda: Reverberations'. The writing is fragmentary and visceral, reflecting my understanding of memory. It incorporates the voices of others, reflecting the intercorporeal nature of both remembering and performance. But the poetics of remembering does not evidence 'the past'. Rather, it evidences the particular dialogues with the past that I staged in the

dual modalities of writing and performance during the course of the inquiry. Though the coda deals with a performance season that has passed, it is not intended as a nostalgic gesturing towards that past point of 'expired' liveness. Rather, the traces of the live work that I orchestrate in the coda are intended to induce an experience in the present. For my assessors and others who experienced the live work, the coda will link to their experience but not replace it, gesturing towards the work from multiple directions without attempting to provide a definitive account which might erase their own memory of it. For readers of the dissertation who did not see the live work and who may not view the DVD documentation, the coda prompts an imagined performance that will contain some of the tones and qualities of the work, a melding of the reader's imagination and my own.

In crafting this experimental text, it was my hope that the present experience of reading might reverberate with rememberings of many kinds but also gather these rememberings up into a new way of 'knowing' the performance work. To remember is to create something anew each time, as noted by Susan Engel (1999: 22). Instead of the ossification implied by the memorial, I hoped that the ways in which I used language to evoke multiple experiences of the live performance might effect alternative modes of remembering it (for those who experienced the performance) or imagining it (for those whose only exposure to the performance was through writing). Through writing, the performance might exist as active trace, as current imagining, informed but unfettered by its past liveness. As mentioned, the Coda is an experimental and speculative text and I cannot be certain that it achieved these intentions. The same could be said of all writing, though in the case of this writing style, uncertainty is heightened.

Concluding Note

The writing strategies that I have outlined here emerged from the exigencies of my PhD inquiry. They form by no means an exhaustive list of how artistic researchers might write: they are simply an account of how and why I myself set about crafting writing in these ways. From the outset, I wanted both my performance works and my academic writing to contribute to knowledge on their own terms. Considerable sweat went into working out what those terms might be. And my conclusions in this regard must always remain provisional: future research projects may well provoke me to negotiate different styles of relatedness between writing and performance-making.

References

Chambers, 2001. *Chambers' Etymological Dictionary of the English Language*. J. Donald (ed.). Boston: Adamant Media Corporation.

Engel, S., 1999. *Context is Everything: the Nature of Memory*. New York: W.H. Freeman.

Holler, L., 2002. *Erotic Morality: the Role of Touch in Moral Agency*. New Brunswick, NJ: Rutgers University Press.

Irigaray, L., 1993. *An Ethics of Sexual Difference*. Ithaca, NY: Cornell University Press.

Macmillan, 1966. *Origins: a Short Etymological Dictionary of Modern English*. E. Partridge (ed.). New York: Macmillan.

Massumi, B., 2002. *Parables for the Virtual: Movement, Affect, Sensation*. Durham, NC: Duke University Press.

Melrose, S., 2003a. *The curiosity of writing (or, who cares about performance mastery?)*. Available at: http://www.sfmelrose.u-net.com/curiosityofwriting/ [Accessed 12 December 2008].

Melrose, S., 2003b. *The Eventful Articulation of Singularities – or, 'Chasing Angels'*. Available at: http://www.sfmelrose.u-net.com/chasingangels/ [Accessed 12 December 2008].

Merleau-Ponty, M., 1968. *The visible and the invisible: followed by working notes*. C. Lefort (trans.). Evanston, IL: Northwestern University Press.

Murphy, S., 2012a. 'A narrative of practice.' In: *Live Research: Methods of Practice-led Inquiry in Performance*. L. Mercer, J. Robson & D. Fenton (eds.). Ladyfinger, QLD: Nerang, pp. 21-31.

Murphy, S., 2012b. 'Writing practice.' In: *Live Research: Methods of Practice-led Inquiry in Performance*. L. Mercer, J. Robson & D. Fenton (eds.). Ladyfinger, QLD: Nerang, pp. 164-175.

Richardson, L., 1994. Writing: A Method of Inquiry.' In: N. Denzin and Y. Lincoln (eds.). *Handbook of Qualitative Research*. Thousand Oaks et al.: Sage, pp. 516-529.

Vasseleu, C., 1998. *Textures of light: vision and touch in Irigaray, Levinas, and Merleau-Ponty*. London & New York: Routledge.

Placing

The publishing of artistic research may be understood as the considered placing of an epistemically underdetermined practice in a discursive field. While the previous section looked inwards at the expositionality of creative research processes, this final section places particular emphasis on spaces of encounter. Introducing examples from the history of art and contemporary art, we suggest that bridges need to be built between existing artistic practices and those of academic publishing. Given that, over its history, art has found meaningful access to most if not all forms of expression, it is not impossible that artistic practice may, at some point, make academia its own.

In our understanding, this – admittedly optimistic – perspective goes beyond appropriation or cohabitation as a fundamental rethinking of art through academia. Just as one may say that painters are continually rethinking art through painting, the space of academia, its resources, histories and conventions continually offer new opportunities to art. At the same time, it is clear that academia, like any public space, is created and controlled by institutions and that institutional critique is necessary in all stages of the process. Rather than making artistic practice fit into academia, we suggest that academia should also fit art. Academia needs to respect artistic research practices and make space for precisely those critical manoeuvres without which art would be stripped of its worth, even if they challenge its very definition.

To open this section, we selected Andreas Gedin's text *Distant Voices and Bodies in a Market Square* in order to suggest how complex an object can become as it enters a new space. While the chapter is taken from Gedin's 2011 dissertation, *Jag hör röster överallt! – Step by Step*, it was considerably reworked for this book, now literally including the editor's voice in some passages that challenge editing processes and notions of authorship. Discussing the work of Mikhail Bakhtin, Gedin highlights the need for distance and dialogue, which creates space within texts that is comparable to the types of space we know from art. Developing this point further in the second part of his essay, Gedin argues, with Michael Holquist, that text is not only an abstract but also a physical being. With this, the author highlights the new and, to some degree, uncomfortable, implications that arise when the boundary between conceptual and physical work is negotiated.

In their contribution, *From* Wunderkammer *to Szeemann and Back: The*

Artistic Research Exposition as Performative and Didactic Experience, Pol Dehert and Karel Vanhaesebrouck discuss their practice-based investigation into the potential role of exhibitions to expose practice as research. The investigation centred around the multi-dimensional festival *(Exhibiting) Baroque Bodies* (Brussels, November 2011), which marked the close of the artistic research project *The Monkey's World*, with a focus on its exhibition *Corpus Rochester*. The authors maintain that the exhibition should not be considered as the 'output' of the research, but as a performative tool, a pedagogic laboratory that provides insights into the research and exposes its results experientially. By combining the presentation and the experience of research results, the exhibition became an event of exchange, of shared understanding. The research used Harald Szeemann's curatorial innovations as a way into a new understanding of performative research exhibitions, thereby mirroring the theme of the research project – the lived experience of the baroque, and more specifically, the baroque body.

The importance of expositionality for presentations of art can also be traced historically. In *Between the White Cube and the White Box: Brian O'Doherty's* Aspen *5+6, An Early Exposition*, Lucy Cotter unfolds the reflective thinking within and between the works that the artist and critic Brian O'Doherty chose to include in the double-issue 5 and 6 of *Aspen* magazine. Far from being a simple collection of art, the issue is set up to activate thought in a differentially organised space, in which each piece can be seen both as a work in its own right and as a reflection on the ensemble. Cotter thus suggests that O'Doherty's exposition may be seen as a self-reflective unit that breaches its tight physical confines (*Aspen* 5+6 comes in a box), affecting the space within which it is encountered – which includes the magazine's reader. Following O'Doherty's example, Cotter suggests that artistic research can successfully occupy a limited space – such as that offered by academia – if the space is given over to artistic concerns that allow art to register different modes of knowledge.

Expositions are not only units of presentation but also potential items in an archive. In his chapter *Counter-Archival Dissemination*, Henk Slager emphasises the need to deal with issues of power and control that threaten to override art as it enters academia. With reference to the history of art and also his work as curator, Slager makes clear that an academic space for art is also a contested space and that specific strategies for resistance need to be developed within artistic practice so as to self-define the workings of the archive. Emphasising specificity, the author suggests that the demands that artists place on archives do not simply require an increase in their capacity but also a re-thinking of their role and function for artistic research and society at large. The way in which artists interact with images may hint at alternative, novel relationships to knowledge.

Distant Voices and Bodies in a Market Square

By Andreas Gedin

Introduction

This essay is a revised version of a chapter of my dissertation *Jag hör röster överallt! – Step by Step* (Gedin 2011).[1] The dissertation also consists of several artworks and three exhibitions: one show of my own works, a second of some of my works together with works by others, and finally an exhibition only including works by other artists and regarded by me as an artwork in its own right. One of the purposes of my dissertation is to look closer at – and to blur – the borders between the artist and the curator. I see a possibility to understand artistic work as a kind of curatorial work and in order to explore this I have made recourse to some ideas of the Russian philosopher Mikhail Bakhtin. His discussion of the author, the hero and the novel can be applied to different kinds of works of art. Thus one of my aims is to apply literary theory (and philosophy) to fine art. The way in which Bakhtin develops the concept of polyphony in the novel is especially fruitful in this context. A novel consists of many different 'voices' organised by the author, and this demands that a certain distance must be maintained between the author and these 'voices'. One could say that in this sense the author curates the novel, and that curators and artists are editors organising the world into art.

I have used the idea of polyphony explicitly in my text, bringing a number of different voices to the surface: real comments, email conversations, quotes and some invented remarks, in order to invite the reader in and open up the text for discussion. Taken together, these different voices are intended to demonstrate how art, and lives, are constructed with the help of already existing material. My aim is to use artistic research as a way to speculate and reflect upon the making of art, and not to perform traditional philosophy. However, I do not want to withdraw to a romantic artistic position where one can sneak away from the arguments simply by pointing at one's work of art. I do argue

1. Andreas Gedin, *Jag hör roster överallt! – Step by Step*, University of Gothenburg, 2011. PDF available: https://gupea.ub.gu.se/handle/2077/25451. An English version of the dissertation (*I Hear Voices in Everything! – Step by Step*) will be published in 2014. This chapter is a revised version of the original Swedish text translated into English by Sarah Death.

for certain points of view, which is an important part of artistic research, as I see it. But even though it can be understood as a way to reflect, to organise experience and knowledge and works of art, research does not have to end up with definite conclusions. From my point of view, fruitfulness is an important criteria for different forms of artistic research. Hopefully this is the case in this re-curated text, in which I include the Editor's voice. This essay is more an example of what artistic research can produce than an explicit argument for it. This could, implicitly, be an argument for the possibility of presenting projects within the field of artistic research.

At a Distance

According to Paul Ricoeur, a text is separated from its author (who has left an impression through his or her style or intonation) and becomes objectified by means of distancing and structuring.[2] For him, text itself is a form of distancing:

> In my view, the text is much more than a particular case of intersubjective communication: it is the paradigm of distanciation in communication. As such, it displays a fundamental characteristic of the very historicity of human experience, namely, that it is communication in and through distance (Ricoeur 1991: 76).

As I understand it, distancing liberates the text from the author and the writing process, thereby making it more accessible to interpretation and understanding. Ricoeur goes even further, separating out the discursive event – which is temporal – from its significance, which extends through time. Translated to an exhibition context, this would mean that the works are wrenched free from their creator (distanced), assembled into an exhibition (the discourse) that can be experienced by visitors (the discursive event) who can interpret the exhibition, which in turn can generate meaning such as, for example, some form of insight in the visitor that persists even after he or she has left the exhibition (significance).

By means of this distancing, a sort of inevitable abandonment, the author/artist becomes a potential reader. Distancing thus creates the possibility for a kind of proximity (that, for example, of the reader) that can generate understanding. To put it in Bakhtinian terms, it creates an opportunity for dialogue for the reader. However, before this can happen, a dialogic relation must first

2. There is a serious misunderstanding of this issue on the part of some art critics. They think the artist's own narrative of his or her work, background, intention, etc., is the same as an interpretation of the work. And they shrink from that, because it leaves them unemployed. They therefore fail to see the difference between information and interpretation, and this is reflected in their writing about art.

be created between author and hero in what Bakhtin (1981a) calls a 'dialogic' novel. The dialogic relation is achieved precisely by some sort of distance:

> Whatever these authorial ideas, whatever function they fulfil, they are *not represented*: they either represent and internally govern a representation, or they shed light on some other represented thing, or, finally, they accompany the representation as a detachable semantic ornament. *They are expressed directly, without distance.* And within the bounds of that monologic world shaped by them, someone else's idea cannot be represented. It is either assimilated, or polemically repudiated, or ceases to be an idea (Bakhtin 2009: 84f.).

Without the dialogic strategy, a novel is monologic: everything is already complete, the hero and the events are instruments of a completed authorial idea, which is simply taking a predetermined detour through a novel. The lack of distance in the monologic novel stems from the control exercised by the author over his or her material. Nothing unpredicted is allowed to happen: any loopholes or lacunae into which the reader might step are plugged. The dialogic novel, on the other hand, is open to the reader's participation, a sort of ethical moment of retelling that not only allows the reader to be creative but also gives the hero more freedom of action (Haynes 2008: 106). It seems to me that works in an exhibition can be viewed in the same way, with the curator in the role of Dostoevsky as outlined by Bakhtin:

> Dostoevsky was capable of representing *someone else's idea*, preserving its full capacity to signify as an idea, while at the same time also preserving a distance, neither confirming the idea nor merging it with his own expressed ideology (Bakhtin 2009: 85).

The idea behind a dialogic text is thus to let other people – and other things – speak, rather than just the author. This can be understood as the author creating a scene in which the actors can act without being mouthpieces. It seems to me that Bakhtin's philosophy of text can equally well be applied to spatially located exhibitions and art. It is, however, not my intention to claim that an art object or an exhibition is in all vital respects conceptually the same as a text. I would simply like to add my voice to those of Bakhtin and others who seek to blur and break down the boundaries between art object and text, between author and reader, and between world and art. On the one hand, I want to point to the spatial nature of texts and, on the other, to the conceptual nature of physical (art) objects. In this way, the boundaries come under attack from both sides. And this attempt to dissolve boundaries can be made, I believe, partly with reference to the dialogic in Bakhtin. Since dialogue is situated in space, this is also a theory of language as dialogic, that is to say, by definition

spatial and, what is of great importance, social (Holloway & Kneale 2000: 75f.). And, as Bakhtin emphasises, intonation and gesture are intentional. This presupposes a certain distance or an element of spatiality since intentionality demands distance.

Mats: But how? Why?

Andreas: The directional aspect that is an essential part of intentionality, together with Bakhtin's main idea of an utterance as a social event and his understanding of language as dialogical, seem to me to incorporate some kind of spatial dimension. I find it hard to imagine the opposite. And the way I see it, this spatial dimension is capable of housing those artworks/utterances that take physical form. But *space* is not an unambiguous concept, of course.

There are, for example, important distinctions between time and space, and between a text and an object, which are not really clarified. A text is not bound to a specific physical object: it may, for example, be in the form of a manuscript, on the internet, in a published paperback, and so on. And this is fundamental to the concept of intertextuality/metalinguistics[3] discussed by Bakhtin. But some works of art are not as mobile as that: Michelangelo's statue of David, for example, is a single statue, one of a kind. And this gives it a physical, spatial presence reminiscent of the space occupied by a single person, often lacking in the case of a text. The question is whether art objects and texts can be discussed, referencing Bakhtin, in the same spatial terms.

Mats: First and foremost, a text is always in a space, even if it has only been thought. There is scarcely anything that is not spatial. And in discussing the unique qualities of works of art, one can make use of Goodman and Elgin's (1988: 65) distinction between those works that are autographic, dependent on how they came into existence (like the statue of David), and works that are allographic, and only dependent on syntax or semantics – such as the fact that a sequence of words recurs in the same order as before (in a novel by Cervantes, for example).

Andreas: That sounds reasonable (though I wonder what would happen if someone succeeded in making an exact copy of the statue of David). One could say, with Bakhtin, that a human being is autographic, but a story about her is allographic. But what interests me is discussing the spatial aspects of art and of texts, and showing that Bakhtin can be of help in that.

It is important to note how Bakhtin avoids anything linear, unambigu-

3. Intertextuality is a concept invented by Julia Kristeva when she was introducing Bakhtin in the 1960s. The essay was first published in the magazine *Critique*, 33. 'Bakhtine, le mot, le dialogue et le roman' and later republished as 'Le mot, dialogue et le roman' in 'Sēmeiōtikē : recherches pour une sémanalyse', Paris (1969). The concept of intertextuality narrows down Bakhtin's much wider concept *metalinguistics*, which includes much more than texts. It is his way of telling that language is social by nature, that language is social events beyond linguistics. That language is dialogical by nature, and dialogical relations through language are what constitutes man.

ous, monologic or developable. Events occur not only at junctures, but also at places. The texts become spatially orientated; understanding of the text then occurs between spaces. And these spatially orientated events speak for a view of the text as performative, as utterances and language in a general sense. That is Bakhtin's position, too (it was Kristeva who locked the dialogic element into the concept of intertextuality).

The spatial connotations of utterance are to be preferred to the two dimensions of text because the complex web of connections between works, and aspects of works, can be more comprehensibly formulated in three dimensions.

The Editor: In what sense do utterances have three dimensions?

Andreas: First, in the sense that utterances do not exist outside space; and secondly, I think that the intertextual/dialogical relations are so complex that they are easier to grasp or talk about as a three-dimensional pattern, like, for example, www.

Intertext, for example, is located between two texts. It is, for Bakhtin, dialogic communication. It is social. And even if this social stage is an imprecise space between, it is still hard to imagine without using spatial terms. And this is consistent with the physical law, which states that all bodies occupy a unique place in space, and that one must therefore be somewhere, experiencing the world from a particular point; one must be situated in time and space.[4] And for Bakhtin, the slightly paradoxical conclusion is that our quality as human beings of being unique and separate is also what unites us (Holloway & Kneale 2000: 74).

4. The comedian Jerry Seinfeld expressed the same philosophical insight in the Australian talk show *Enough Rope*, when he related one of his father's favourite stories: 'this joke about this guy who comes home and his wife is in the bathroom and he suspects that there's some hanky-panky going on. And he pulls back the shower curtain and there's another man behind the shower curtain. And he says to the man: "What are you doing here?" And the guy goes: "Well everybody's got to be someplace."' (Seinfeld 2007: part 1, 08:10).

5. In his essay 'Forms of Time and of the Chronotope in the Novel', Bakhtin (1981b) analyses literary history with the aid of the heroes' positions in space and time. The chronotope of the heroes/text constitutes genres in Bakhtin's analysis: the events of novels have different relations in time and space depending on which genre they belong to. In some historical genres, for example, events occur for no apparent reason, while in others there are clear causal relationships between the various events. These chronotopes enter into a dialogue with both the author and the reader. In addition to this, the positions of both reader and author are unstable, in a state of flux. By this he means that the reader, the reading and the author are also chronotopic and that they are always perpetually shifting products of their own history and that of their surroundings.

Bodies in a Market Square

For Bakhtin, consciousness is a part of, or a consequence of, the body's existence, and thus a state of being, in time and space – of being chronotopic[5] (Holquist 1991: 64f.). Dialogic relations are found from the micro-level, as a biological response to stimuli, through to linguistic dialogic relations with other people, heroes etc. I think of these places or relations or structures or networks as micro-worlds that manifest themselves as elastic nebulae.

One of Bakhtin's key concepts – that of carnival – locates language in space, in the market square, which essentially underlines the applicability of the concept to art and exhibitions. One can basically, with Michael Holquist, think of intertextual relations as purely physical, as *intercorporeal relations*:

> The body is, if you will, *intercorporeal* in much the same way as the novel is intertextual. Like the novel, the body cannot be conceived outside a web of interrelations of which it is a living part (Holquist 1991: 89f.).

Bakhtin's interest in Rabelais and folk carnival, the grotesque body and the marketplace as scene of action is also one possible way of talking about an exhibition space and relations between works.[6] Here I am referring to interrelations in a broad sense, as for the novel – that is to say, relations that can also extend through time and space, that are not merely limited by an exhibition's often-defined territory.

The Editor: There seems to be a big difference between the exhibition as marketplace or as carnival. How does looking at the exhibition as carnival influence the relationships one detects between works? Using those contexts simply to say that there are relations seems unnecessary, so I expect there to be more behind it, but what?

Andreas: To me the main point here is to follow Holquist when he moves from intertextual to intercorporal relations. If one likes this move (I do) then, what is earlier discussed about the dialogical aspects of a novel, for example, could include corps and art objects.

In his book about Rabelais, Bakhtin talks of how our way of understanding and describing change in the body has altered. In history he finds examples of the grotesque body going right back to antiquity, and believes that it is only since the seventeenth century that a distinction has been drawn between private and official languages: 'There is a sharp line of division between familiar speech and "correct" language' (Bakhtin 1984: 320). In official discourses the body is smooth, solid, flattened out and respectable. The grotesque body is its opposite: it has large organs and outgrowths (noses, genitals, warts) that protrude from the body and, as it were, transcend its boundaries. This body also

6. On spatiality in Bakhtin, see Holloway & Kneale 2000.

has numerous orifices (anus, mouth, vagina) which discharge fluids (mucous, phlegm, urine, excrement). It is the body as nature in permanent flux.

> The grotesque body, as we have often stressed, is a body in the act of becoming. It is never finished, never completed; it is continually built, created, and builds and creates another body. Moreover, the body swallows the world and is itself swallowed by the world (…) Eating, drinking, defecation, and other elimination (sweating, blowing of the nose, sneezing), as well as copulation, pregnancy, dismemberment, swallowing up by another body – all of these acts are performed on the confines of the body and outer world, or on the confines of the old and new body. In all these events the beginning and the end of life are closely linked and interwoven (Bakhtin 1984: 366).

Bakhtin speaks of a collective where there are no clear boundaries between bodies; body is born of body, life goes on, and we are a long way from the individualised, finite lives of our age.[7] It seems to me that these physical relations, too, can be applied to our understanding of an exhibition situation. Artworks can be purely conceptual, tangibly physical or a mixture of the two. One could then speak of art and exhibitions as both intertextual and intercorporeal.[8]

The Editor: This is not really an argument. The fact that artworks can be anything, how does this make them intertextual or intercorporal? Not that I am disagreeing in principle, only that these are just unrelated claims that the text needs to convincingly relate if a 'then' is used to indicate reasons.

Andreas: Well, I think that my essay is obviously not intended to be philosophy in a strict sense, but a way to discuss art and exhibitions in the frame of artistic research. Still, I do not try to push the arguments too hard and therefore I write 'One could then speak of art and exhibitions', not claiming this as a pure fact. I am pointing out this fact because I do think that it is important to move the dialogical aspects of texts into corps and other physical objects, like art objects. I am blurring the borders between text and object.

Bakhtin not only talks of bodies, but also says 'that an object [in the grotesque] can transgress not only its quantitative but also its qualitative limits, that it can outgrow itself and be fused with other objects' (Bakhtin 1984: 308).

Just as the novel is a meeting place for texts, a kind of organised quotation exercise, the body is for Rabelais a similar sort of microcosm. Even though

7. See Merleau-Ponty's notion that the body, as it were, appropriates objects: a hat or a car, for example, become in phenomenological terms parts of our bodies; we experience their location in space. In one sense, the individual body then expands.

8. I am thinking of Dostoevsky's person in the cellar, whose inner speech leaks out through his mouth in a purely physical way, as though it were some bodily fluid. This is what is generally referred to as verbal diarrhoea.

Rabelais, so Bakhtin claims, was not attracted by contemporary magical thinking about the body, he could still view the body in a materialist spirit, saying that it was 'the most nearly perfect form of the organization of matter and was therefore the key to all matter. The material components of the universe disclose in the human body their true nature and highest potentialities' (Bakhtin 1984: 366). In a transferred sense, one can think of the exhibition as consisting of bodies.

Daniel: [Your idea of the works in an exhibition] as a microcosm reminds me of the reflections in Borges' short stories or in Leibniz's *Monadology*. This notion of every part of an artwork (and why not the cosmos?) reflecting every other part is an idea we find in thinkers of the Baroque period (Birnbaum & Lundström 2000: 29).

Andreas: Yes, then the body is a sort of microcosm, which gives us the opportunity to understand the universe, and this seems to coincide with the *novelistic*,[9] with what occurs in the novel. It is this quality that is not only found in a good novel but is also the *form of knowledge*, in a wider sense, that can most persuasively impose order on diverse kinds of experience and make them engage in dialogue with each other. This is a quality that Bakhtin sees in Dostoevsky and Rabelais, but it can also be found in other linguistic, dialogic contexts. The way I see it, the grotesque body in its openness, its receptiveness and extrovert activity is a place where this novelistic element can play out.

By viewing Mary Shelley's novel *Frankenstein; or, The Modern Prometheus* through Bakhtin's eyes, Holquist is able to speak of the body as novelistic, and physically 'intertextual', as a condensed and organised structure: 'as a parable about relations between otherness, bodies and intertextuality' (Holquist 1991: 90). And this offers me, in turn, the possibility of thinking of physical objects, art objects, as intertextual. The artistic and curatorial works can then, in this sense, be seen as analogous.

Q: Of course, it is possible to speculate about the exhibition as intertextual, but what does it mean? What difference does it make? Which exhibitions are more intertextual than others and why? As it is, I feel that a belief is being repeated but that the potential of this is not developed.

Andreas: Yes, right, it could be much more developed. Intertextuality is actually a concept that Kristeva invented when she was introducing Bakhtin in the 1960s. It narrows down Bakhtin's much wider concept *metalinguistics*. This concept includes much more than texts. It is his way of suggesting that language is social by nature, that language is social events beyond linguistics, that language is dialogical by nature. And this concept is applicable to art objects as well. And what does this mean? It means that artworks and exhibitions

9. Art is for Bakhtin a kind of linguistic condensation that in a qualified version might be called *novelness*, which is a quality, a potential for a dialogic event. Through art it is possible to perceive the world in a sophisticated way. 'The world of artistic vision' lies beyond the ordinary world.

are not new, in the sense that they are constructed out of what has already been done or what already exits. They are made out of what exists and can only be understood in different contexts. A genre is an example of a frame of reference you need in order to understand works of art or literature; even if they do not fit perfectly into genres, to be understood they have to relate to genres in some way. Bakhtin gives an example of how, materially and conceptually, a sculpture is made out of what already is: the statue of David. There is only one statue like this. But it can only be sculpted, and understood, through the Bible story and historical myth. It is not any David. The marble was originally just ordinary marble, formed by myth, craft, circumstances etc. Given this way of thinking, different levels of intertextuality or metalinguistics are not relevant, if there are any. In the same manner, Holquist points out that Frankenstein's monster is not born out of nothing, and nor is he alone. Holquist wants to understand the monster as a kind of bridge, as both text and body:

> Frankenstein's monster springs from the library as much as he does from the charnel house and laboratory: he is made up not only from other bodies from the past, but like Mary Shelley's novel, from other books from the past (Holquist 1991: 97).

He notes that Frankenstein's monster is born without language and is therefore inhuman, as Bakhtin sees it, because he claims that we become human through dialogical relations based on language. But Shelley the author offers the material – the language – and the conditions that Frankenstein needs in order to succeed in the life-giving experiment, which he in turn offers to his monster.[10] Holquist makes an error here, or is at any rate unclear on one central point.[11] He switches seamlessly and without comment between the textual monster, the one written about on the pages of the book, and a potential, physically living monster. Is he talking about accumulations of words on the pages of a book, or a bricolage of body parts joined together to make a monstrous (grotesque!) body that walks the streets of the town? (Interestingly enough, Montaigne at the start of his career as an essayist writes of the essay as a grotesque body assembled out of disparate details: 'What are these essays but grotesque bodies pieced together of different members'?[12]) In the passage quoted above, Holquist

10. The idea of constructing creatures by joining together disparate fragments (bricolage?) is older than Frankenstein's monster and comes from folk mythology. The Danish-Greenlandic artist Pia Arke (1958-2007), for example, made use of the Inuit equivalent Tupilak – a kind of voodoo doll – in her art.

11. On the subject of authors, I note that Holquist has omitted Mary Shelley from the names index of his book.

12. Montaigne quoted in (Huxley 1959: vii). Note that Rabelais (1494-1553) and Montaigne (1533-1592) were partly contemporaries.

does draw a distinction between the library and the charnel house, forgetting in his haste that the charnel house visited by Frankenstein is actually *within* this library rather than beyond it. And the library is hardly in the charnel house. Holquist allows slippage between the signifier and the signified, between the word 'monster' and a monster. He apparently does not distinguish between a body in a text and a physical body. But it is clearly an easy trap to fall into, with the author's position on the boundary between text and the reality that is not text. The author as some kind of medium, or bridge …

Q: But then why take the trouble to speak with Holquist's monster at all?

Andreas: Holquist's text is an analogy that provides a useful tool for discussion.

The Editor: But you don't really discuss exhibitions.

Andreas: My aim is to establish a standpoint for doing this by blurring the border between text and object, between literature and art objects, between a novel and an exhibition.

Q: Body and text taken to the point of mix-up and confusion.

Andreas: Why not? A glorious frenzy of vivisection and deconstruction!

Q: The operation was successful but the patient died … You are losing the thread again now. Are you trying to hint again at some kind of replacement-fest in which the author, Frankenstein and his monster change places and body then becomes text, or utterance, and utterance body? You're stumbling into a pit of your own making! Or is it Holquist wavering here?

Andreas: I am well aware, as I said, that the boundary between text and body is not abolished or obscured simply because one ignores it, as Holquist does. Frankenstein's monster is not one of the snorting, stinking, guzzling bodies in a carnival. But I agree with Holquist and his interpretation of Bakhtin that bodies have interrelational connections. The important thing for me is to show that it is reasonable to apply Bakhtin's ideas to both the linguistic and the conceptual aspects. I would claim that artworks in an exhibition setting can have precisely the same range of interrelations with each other, both physically and conceptually. And it was the physical relations, specifically, that Holquist attributed to Bachtin's grotesque bodies in the carnival. The artworks perhaps have, in precisely that sense, a grotesque side, even in purely conceptual terms. These orifices, protuberances, leakages … they are interwoven with each other and with the world, including observers and artist.

Q: Fair enough!

Andreas: To summarise: I understand Bakhtin to be saying that text and concept are admittedly not identical to one another, but are dependent on each other. The bodies' *meaning* is conceptual, dependent on language. Nor do they exist without each other; they come into existence in intercorporeal relations, just as texts do in intertextual relations. 'Even the human body is not given, according to Bakhtin: it is produced through interaction with others' (Haynes 2008: 38). The body could be understood as a concrete concept, by

contrast with the abstract concepts of language. Art can perhaps be described as a meeting place for the physical and the conceptual, as a sort of virtual world. There, Bakhtin finds the reader and hero coming together in a shared desire for union: 'The heroes themselves, it turns out, fervently dream of being embodied, they long to attach themselves to one of life's normal plots' (Bakhtin 1984: 101).

References

Bakhtin, M., 1981a. *Dialogic Imagination: Four Essays*. Austin, TX: University of Texas Press.

Bakhtin, M., 1981b. 'Forms of time and of the chronotope in the novel.' In: *Dialogic Imagination: Four Essays*. Austin, TX: University of Texas Press, pp. 84-258.

Bakhtin, M., 1984. *Rabelais and His World*. Bloomington, IN: Indiana University Press.

Bakhtin, M., 2009. *Problems of Dostoevsky's Poetics*. Minneapolis, MN: University of Minnesota Press.

Birnbaum, D. & Lundström, J.-E., 2000. *Taking Over*. Umeå: Bildmuseet.

Gedin, A., 2011. *Jag hör roster överallt! – Step by Step*, PhD dissertation, University of Gothenburg. Available at: https://gupea.ub.gu.se/handle/2077/25451 [Accessed 20 November 2012]. (Trans. from the Swedish as *I Hear Voices in Everything! – Step by Step*, S. Death [trans.], publication forthcoming 2014.)

Goodman, N. & Elgin, C.Z., 1988. *Reconceptions in Philosophy and Other Arts and Sciences*. Indianapolis: Hackett Publishing Company.

Haynes, D.J., 2008. *Bakhtin and the Visual Arts*. New York: Cambridge University Press.

Holloway, J. & Kneale, J., 2000. 'Michail Bakhtin: Dialogics of Space.' In: *Thinking Space*. M. Crang & N. Thrift (eds.). London: Routledge.

Holquist, M., 1991. *Dialogism: Bakhtin and His World*. London: Routledge.

Huxley, A., 1959. *Collected Essays*. New York: Harper.

Ricoeur, P., 1991. *From Text to Action*. Evanston, IL: Northwestern University Press.

Seinfeld, J., 2007. 'Enough Rope with Andrew Denton', 26 November. Transcript and video excerpt available at: http://www.abc.net.au/tv/enoughrope/transcripts/s2099480.htm [Accessed 20 November 2012].

From *Wunderkammer* to Szeemann and Back: The Artistic Research Exposition as Performative and Didactic Experience

By Pol Dehert & Karel Vanhaesebrouck

Fig. 1. Angelo Vermeulen & Tine Holvoet, *Body Reactor,* installation featured in the exhibition 'Corpus Rochester', as part of the project '(Exhibiting) Baroque Bodies', Beursschouwburg, Brussels, November 2012. (c) Angelo Vermeulen

Fig. 2. Pol Dehert, *Denkmal for Rochester* (detail), video installation featured in the exhibition 'Corpus Rochester', as part of the project '(Exhibiting) Baroque Bodies', Beursschouwburg, Brussels, November 2012. (c) Sylvie Mathot

Fig. 3. David Bade, *Barak Bodies*, installation featured in the exhibition 'Corpus Rochester', as part of the project '(Exhibiting) Baroque Bodies', Beursschouwburg, Brussels, November 2012. (c) Sylvie Mathot

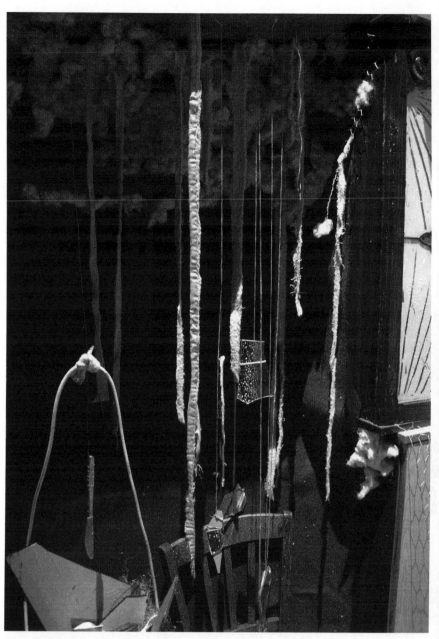

Fig. 4. David Bade, *Barak Bodies*, installation featured in the exhibition 'Corpus Rochester', as part of the project '(Exhibiting) Baroque Bodies', Beursschouwburg, Brussels, November 2012. (c) Sylvie Mathot

Fig. 5. David Bade, *Barak Bodies*, installation featured in the exhibition 'Corpus Rochester', as part of the project '(Exhibiting) Baroque Bodies', Beursschouwburg, Brussels, November 2012. (c) Sylvie Mathot

Fig. 6. Angelo Vermeulen & Tine Holvoet, *Body Reactor*, installation featured in the exhibition 'Corpus Rochester', as part of the project '(Exhibiting) Baroque Bodies', Beursschouwburg, Brussels, November 2012. (c) Angelo Vermeulen

Fig. 7. Gorges Ocloo, *Papa Legba*, performance and installation at the opening night of the project '(Exhibiting) Baroque Bodies', Beursschouwburg, Brussels, November, 2011. (c) Sylvie Mathot

Pol Dehert & Karel Vanhaesebrouck

Fig. 8. Six paintings by Jan Van Imschoot. Exhibition view of 'Corpus Rochester', as part of the project '(Exhibiting) Baroque Bodies', Beursschouwburg, Brussels, November, 2011. (c) Sylvie Mathot

Fig. 9. Workshop David Bade during the project '(Exhibiting) Baroque Bodies', Beursschouwburg, November, 2011. (c) Helena Kritis

From *Wunderkammer* to Szeemann and Back

In November 2011, the artistic research project 'The Monkey's World. Towards an archaeology of baroque culture'[1] reached its culmination in *(Exhibiting) Baroque Bodies*, a one-week festival at the Brussels-based interdisciplinary arts centre, Beursschouwburg. The festival consisted of a theatre production by the Belgian company Abattoir Fermé and Pol Dehert, the exhibition 'Corpus Rochester' on contemporary baroque culture (featuring work by, among many other artists, Guillermo Gómez-Peña, Angelo Vermeulen, David Bade, Jan Van Imschoot, Johan Muyle, Pol Dehert, Patricia Canino, etc.), a late-night programme of films and performances focusing on the idea of the political, the burlesque and the pornographic body, and a series of workshops through which film and theatre students were involved in the research questions of this project.[2]

(Exhibiting) Baroque Bodies was more than just the presentation of the concrete results of an elaborate research project; it was also an attempt to find an adequate and challenging form to allow additional insight into the process that led to the result presented, an exposition (perhaps the German word *Auseinandersetzung* is a more apt term), that simultaneously exposed the complex dramaturgical and historical research and the actual artistic 'labour' or research. It aimed at the integration of research, presentation and pedagogy, the festival being a shared experience of co-creation, discussion and collaboration, a utopian moment during which the institutionally accepted differences between teachers, students, researchers and artists became of secondary importance. This mixture of presenting (exhibiting) and experiencing (living) research results formed the heart of our research exposition. *(Exhibiting) Baroque Bodies* was conceived as a hybrid experience during which live events were integrated in the context of an exhibition, and vice versa, the exhibition aimed at a theatrical impact. In other words, the mode of presentation became part of the research process as we tried to find an event that could bring us closer to our real research object, the permanently shifting world that we describe as 'baroque'. *(Exhibiting) Baroque Bodies* was thus both an experience and a moment of meta-reflection, investigating its own status as a performative moment.

The research project took as a starting point the life, times and work of John Wilmot (1647-1680), Second Earl of Rochester, a peculiar English aristocrat whose famous portrait shows him crowning a monkey (hence the title of the project), his red eyes glassy with the effects of too much alcohol and too many venereal diseases (Greene 1998; Johnson 2004; Lamb 2005). But Rochester was far more than just another early modern drunk whose excesses

1. The project was funded by the RITS | School of Arts of the Erasmus University College in Brussels, the Free University of Brussels and several partners in the artistic field.

2. In January 2012, a second edition of the festival was organised at the Brakke Grond, Amsterdam. Partly based on the Brussels edition and partly new, this second edition offered the researchers involved a chance to re-evaluate their findings in the light of a different environment and programme.

drove him to his death. The short but stormy life of this seventeenth-century libertine, poet, pornographer, intellectual, free thinker and one of the principal wits of Charles II's court – which housed the largest brothel in England – is a frenetic succession of glorious moments, derailments and failures. In his collected works (a mere 200 pages) (Wilmot 1993) all the obsessions of his time come together: eroticism, lust, atheism, science, transgression, theatricality, sensuality and, most importantly, baroque corporality.

Our research project did not aim at a historical reconstruction of a specific performative practice, but to investigate the very notion of baroque. Can we understand our times of postmodern confusion as a genuinely baroque period? How does this idea of baroque challenge preconceived notions such as corporality, performance and (post)colonial hybridisation? What would a baroque body look like and what is its performative potential? Are we approaching a true baroque era of crisis as the distinctions between man and machine, between human and non-human life slowly dissolve? In short: how can history help us to understand the present and, most importantly, the future?

Within the framework of this chapter we will mainly focus on the exhibition 'Corpus Rochester', developed by Pol Dehert and Cis Bierinckx, which aimed at providing the visitor both with a contextualisation of the research project and a practice-based reflection on the questions and problems involved when presenting the results of artistic research projects, thus in *exposing* the artistic practice *as research*. 'Corpus Rochester' took the question of the baroque body as its starting point, bringing together artists whose work, in one way or another, deals with this question. Dehert and Bierinckx selected existing work (the *Lady Lovers* by Belgian painter Jan van Imschoot), presented rare underground cinema (such as Milton Miron's 1971 film *Tricia's Wedding*) and video work by Guillermo Gomez-Peña. They also commissioned new work by Patricia Canino (a diptych on the devastating effects of syphilis) and Gaëtan Wtoreck (a Brussels-based 'bricolage artist') and gave students the opportunity to present their vision on Rochester's time and life. Dehert himself directed four new video portraits in which actors (Gerardjan Rijnders, Dirk Roofthooft, Stef Lernous and Frank Vercruysen) perform the texts of Rochester, as well as presenting a restored version of his 1981 art documentary *Oedipe et le Sphynx*, illustrating his own shifting artistic fascinations. Finally, and perhaps most importantly, David Bade and Angelo Vermeulen presented the results of their workshops in which they worked in and with the Beursschouwburg, developing a site-specific intervention in direct interaction with both the building and the exhibition.

Investigating the question of baroque corporality – burlesque bodies, abject bodies, pornographic bodies, but also politically engaged and even activist bodies – 'Corpus Rochester' was conceived as a *satura*, literally: a mixed dish. Intermingling different genres and disciplines, a sort of visual medley for the spectator's gaze, a performative *Wunderkammer* (Daston & Galiston 1998),

it also paid homage to its primary source of inspiration: Harald Szeemann. Hence 'Corpus Rochester' triggered a practice-based reflection on the potential role of exhibitions to 'expose' artistic research processes.

The aim of this artistic research exhibition was not to illustrate or legitimise the work presented on the various stages. Rather it was a pedagogical laboratory giving insight into our learning processes, into current artistic practices, and serving as a didactic public space with its own pace and rhythm in which different artists collaborate and interact. So, rather than being about presentation, *(Exhibiting) Baroque Bodies* was all about pedagogy. In other words, the process preceding the final, albeit provisional (because, of course, research processes never end) result was as important as the result itself, since the ambition of the exhibition was to reveal the collective research labour performed by the temporary artistic community that gathered around the project. In that sense, the exhibition was not only an artistic research 'exposition'; it was at the same time a sort of social sculpture, bringing together different artists in a shared research experience. Artistic research is not developed in an isolated vacuum, but functions by means of shared space, in which teachers, artists and students work *together*, in which every participant is challenged to rethink his or her own frame of reference. It is a shared moment of 'not-knowing', of trying to find something without really knowing what to look for. That, and not the formal output generated by research, is the true essence of what we call 'experiment'.

Rochester: Living As an Experiment

John Wilmot, Earl of Rochester, lived his life as if it were an experiment, driven by a new, typically early modern desire to discover the unknown, to cross the boundaries of official knowledge and taste (Dehert 2011). He lived his life to the fullest, until on 26 July 1689, after a long and (mock-)heroic struggle, he died at the age of thirty-three, ending his wild (and thus exemplary) life as a libertine. The reason for his death is more than clear: alcohol abuse and syphilis. On his deathbed, in the presence of Bishop Gilbert Burnet, he staged his last *coup de théâtre*, theatrically expressing his remorse over his sinful life and officially dying as a good Catholic. Rochester died as a martyr, but also as a victim of his own sins, or, as Kirk Combe describes it, as 'a martyr for sin' (Combe 1998). Or did he die, as Robert Parsons claimed in 'A sermon preached at the funeral of the Right Honourable John Earl of Rochester' (Burnet & Parsons 1782), as the ultimate sinner being granted pardon by the Lord?

The texts of Rochester illuminate the extremely troubled mind of one whose boundless will to live is a long, loud scream, an attempt to obscure the doubts and fears raised by the void that we call modernity. However, his poems do not constitute an 'oeuvre' as we would call it today. There is no clear unity to be discovered, and nor is there a grand system to be laid out. Rochester didn't consider himself as a writer in the true sense of the word, but as a dilettante, an

amateur, happily lacking the artistic *sérieux* of colleagues like John Dryden. His life and his literary work are completely intertwined, his writings questioning, and sometimes even contradicting, his life. Together they constitute a series of discursive and performative actions often aimed at what one could describe as 'self-fashioning'. So there is no coherent body of writings, only 'the collection of works that we call Rochester' (Burns 1996), a living laboratory, an instrument in the long and extensive experiment that he, as a radical empiricist and a true libertine, considered his life to be, with the belief that only through *experience* can one acquire knowledge. At the risk of stretching the interpretation of his work to its limits, one could even argue that his work stems from an attitude that we could describe as (artistic) 'research', that it was all about 'exposing' his lived experiences, that every poem or prose text is an *Auseinandersetzung* in the true sense of the word, an attempt to deconstruct and reassemble (or not) the fragments that constituted his experience of modernity.

The life and work of this sinner functioned as a sort of magnifying glass for our research project, since it intensively confronts us with the question of baroque corporality, with the idea of a theatrical body that blurs the distinction between reality and mystification. With Rochester, we encounter the complexity and disturbing elusiveness of the early modern world of the baroque, a world in which the spectacular, the theatrical and the sensuous prevail, a world in which the distinction between reality and fiction, between life and art, disintegrates. Baroque theatricality and the libertine *esprit* of experimentation (both intellectual and physical) are fundamentally intertwined: both are attempts to understand a world in permanent transition. For the libertines at Charles' court, the omni-sexual Rochester included, politics was a pornographic *Gesamtkunstwerk*, as Jeremy Webster has convincingly illustrated in *Performing Libertinism* (Webster 2005), while pornography was all about politics, as Rochester brilliantly illustrates in his drama *Sodom or the quintessence of debauchery*. In a world in which the performative body functions as a central point of reference – a body that is at the same time burlesque, pornographic, satirical and political – the public and the private are anything but two distinct categories.

Baroque Bodies

All parts of the larger research project dealt in one way or another with the notion of baroque, using it as a link between the early modern past and our postmodern present (Calabrese 1992; Egginton 2010; Moser 2001; Ndalianis 2004; Wacker 2007). Baroque, then, functioned as the central tool that enabled us to understand a world, both past and present, in a permanent state of transition.

Traditionally the idea of baroque is associated with a particular period in art history featuring specific stylistic characteristics. One could think of baroque church architecture, the paintings of Rubens or the music of Monteverdi. However, rather than referring to a clearly identifiable set of stylistic

features, baroque should here be thought of as an *experience* during which the limits of reality are questioned and playfully deconstructed. Baroque is all about playing, changing and inventing. Baroque immerses its user (spectator, listener, reader) as one would jump into a pool, with the outside everyday world being reduced to a remote, shimmering reality. At the same time, baroque consciously plays with the very same rules that make this immersive experience possible. Baroque is all but the absence of rules. It plays with the rules of representation. And playing means showing. Think of the baroque predilection for *trompe-l'oeil* – artificial effects that evoke an effect of realism. Therefore baroque could be described as a fundamentally confusing experience: rather than showing reality as such, baroque questions the very idea of it by staging another reality or by showing the way in which reality is constructed.

These ideas of change and changeability, this game with ideas and identities, were not only the main preoccupations in the work of Rochester, but also within our research project. Here again, the notion of corporality proved to be of key importance. The confrontation with one's own body generates freedom, but also fear of one's own finiteness, transience and thus relativity. Rochester invested his own body, mind and life in his investigation of mortality, up to its ultimate consequences. For that reason, this 'collection of works that we call Rochester' can be described as baroque. It is not because it is sumptuous or devoid of rules, but because it radically takes this idea of transitoriness as its starting point. Rochester refused to withdraw into the all-too-simple solutions of false reason. His work could be described as a multifaceted baroque body, a body that was burlesque, satirical, pornographic and political at the same time.

While Rochester functioned as a starting point for a thorough reflection on such notions as subversion, performativity and theatricality, the work and ideas of the Swiss curator Harald Szeemann functioned as an important source of inspiration that allowed us to connect our research object – Rochester – with the question of the artistic research exhibition, or put more generally, the strategies through which artistic practice can be 'exposed' as research.

When attitudes become form revisited

An exhibition that aims to be a true artistic research *exposition* is not a museum exhibition in the classic sense of the word. Its prime goal is not presentation; it is not in the first place concerned with the presentation of new and/or existing artworks in an intelligent discursive environment. It is even less a quantifiable form of research output, even though on an institutional level this seems to be the primary (and sometimes sole) reason for the existence of artistic research, namely the possibility of measuring research output. On the contrary, the artistic research exhibition should not be considered as output, but as a *tool* that enables us to gain insight into the research process. Artistic research is a shared pedagogical *experience*, just as baroque is not a style but an experience.

The Swiss curator Harald Szeemann (Heinich 1995) was one of the first to consider the exhibition as a tool to gain insight into the research process leading to the artwork. It was not the final product that was his main interest, but the reflexive and practical processes that precede the artwork. This functioned as the driving force behind his legendary exhibitions, such as *When Attitudes Become Form* (1969), which focused on process-oriented Conceptual art, or his exhibition for the fifth edition of dOCUMENTA in Kassel. With these and other shows, Szeemann radically reoriented the idea of curatorship. Rather than simply having a nose for artwork, curatorship is all about recontextualisation, about injecting works of art with new and unexpected meanings. The curator recontextualises old and new work, and explores new connections between different oeuvres by means of association. For Szeemann, an exhibition was not just a matter of bringing together a couple of artworks in an intelligent way. Every exhibition was an attempt to recontextualise official art history, to re-inscribe it in the larger field of cultural and social history. A Szeemann exhibition becomes an Aby Warburg-like labyrinth that criticises both the hierarchy of the art world and the linearity of art history. Perhaps in this sense, Szeemann was less a curator than a postmodern anthropologist, trying to understand the rhizomatic nature of the cultural imagination of a particular period or context.

Three important aspects of Szeemann's work served as a source for *(Exhibiting) Baroque Bodies* in general and for the exhibition 'Corpus Rochester' in particular. Firstly, it drew on his keen interest in the institutional fringes of the official art world, in art brut and folk culture. Secondly, just as every Szeemann exhibition was a site-specific enterprise, trying to reinvent the space of display, 'Corpus Rochester' was conceived in permanent dialogue with the space of display, in this case the different hallways and display rooms of the Beursschouwburg. And finally, 'Corpus Rochester' was conceived as an experience rather than as an exhibition in the classic sense of the word. By integrating visual work in a theatrical environment and vice versa, the exhibition aimed at creating an experience that one could describe as baroque, i.e. an immersive experience combined with an intellectual reflection on the codes underlying the exhibition itself.

In a chapter of his book *Art Power*, Boris Groys describes how, in contrast to Szeemann, present-day curators play a less prominent role. According to Groys, the persistent modernist emphasis on the autonomy of art led to the interpretation of what a curator could or should be as 'invisible', reducing curatorial choices to 'white walls and good lighting' (Groys 2008: 45). He adds that 'curators have managed their degradation surprisingly well ... by successfully internalizing it' (Groys 2008: 45). Groys, however, reminds us of the etymological origins of the word 'curator' – namely the one who cures: 'the process of curating cured the image's powerlessness, its incapacity to present itself' (Groys 2008: 46). Rather than retreating into false neutrality, Groys asserts, the curator should make his own perspective as visible as possible: 'the main

objective of curating must be to visualize itself, by making its practice explicitly visible' (Groys 2008: 46). Curatorship is thus a matter of meta-reflection, just as baroque is a conscious reflection on the very nature of representation; it is a matter of re-activation, of re-inscribing artworks in a past and present: 'the curating of an artwork signifies its return to history, the transformation of the autonomous artwork back into an illustration – an illustration whose value is not contained within itself but is extrinsic, attached to it by a historical narrative' (Groys 2008: 47). An exhibition is not a matter of presentation but of the documentation of cultural imagination, both past and present. In that sense, 'Corpus Rochester' was an attempt to document the cultural imagination underlying Rochester's works, conceived as the product of an imaginary taste that is deliberately hybrid and eclectic, mocking, just as Rochester did, the good taste of the cultural elite, while at the same time displaying a genuine interest in the fringes of both the early modern and postmodern cultural imagination. It aimed at a material experience in which literally any overview is made impossible, accumulating unexpected links between artefacts from different contexts, and, most importantly, connecting artistic research with the didactic environment of the art school by involving students, by presenting the results of their research within the exhibition; in short, by using the artistic research exhibition as a platform for exchange, with one sole goal: exposing the collective experience that constitutes artistic research.

Conclusion

The goal of our artistic research exhibition was twofold. On the one hand, we tried to find an adequate form to present our research on baroque theatricality and immersion, using the life and work of Rochester as a stepping stone to create a baroque-like experience, both immersive and self-reflexive. The research results served as the basis for the creation of this immersive, baroque experience in which the presupposed distinction between theatricality and visuality was artistically problematised (the exhibition as a theatrical experience). On the other hand, our project was an attempt to get a better understanding of the very nature of the artistic-research exhibition, an exhibition that is not just about presentation, but that tries to provide insight into a research *process*. Our aim was to unfold a meta-reflection on the status of exhibitions within artistic-research projects. The work of Szeemann also served as a methodological stepping stone in this attempt to redefine the physical conditions of research exhibitions, taking what Szeemann called the 'controlled chaos' of baroque performativity as a centrifugal point. As such, it was an attempt to challenge predominant conceptions of research output by radically conceiving research as a shared *experience*, as a process that is in its turn *exposed* by this exhibition.

References

Burnet, G. & Parsons, R., 1782. *Some Passages In The Life And Death of John Earl of Rochester: With A Sermon Preached At The Funeral.* London: T. Davies.

Burns, E., (ed.), 1996. *Reading Rochester.* London: Palgrave McMillan.

Calabrese, O., 1992. *Neo-baroque. A sign of the times.* Princeton, NJ: Princeton University Press.

Combe, K. 1998. *A Martyr for Sin. Rochester's critique of polity, sexuality and society.* Newark, DE: University of Delaware Press.

Daston, L. & Park, K., 1998. *Wonders and the order of nature.* New York: Zone Books.

Dehert, P., 2011. 'Anatomie van een veelkoppig lichaam. Over leven en werk van John Wilmot, Earl of Rochester.' In: *Parmentier* 20(1), pp. 6-14.

Egginton, W., 2010. *The Theater of Truth. The ideology of (Neo)Baroque aesthetics.* Palo Alto, CA: Stanford University Press.

Greene, G., 1988 [1974]. *Lord Rochester's Monkey. The life of John Wilmot, Second Earl of Rochester.* London: Penguin.

Groys, B., 2008. *Art Power.* Cambridge, MA: MIT Press.

Heinich, N., 1995. *Harald Szeemann. Un cas singulier.* Paris: L'échoppe.

Johnson, J.W. 2004. *A Profane Wit. The life of John Wilmot. Earl of Rochester.* Rochester, NY: University of Rochester Press.

Lamb, J., 2005 [1993]. *So idle a rogue. The Life and death of Lord Rochester.* Phoenix Mill: Sutton Publishing.

Moser, W., 2001. 'Baroque: l'anachronie du contemporain.' In: *Résurgences baroques. Les trajectoires d'un processus transculturel.* W. Moser & N. Goyer (eds.). Brussels: La Lettre Volée, pp. 7-20.

Ndalianis, A., 2004. *Neo-baroque aesthetics and contemporary entertainment.* Cambridge, MA: MIT Press.

Obrist, H.-U., 2008. *A brief history of curating.* Zurich: JRP Ringier.

Vanhaesebrouck, K., 2013 (in press). 'Reconsidering metatheatricality. Towards a baroque understanding of immersion and theatricality.' In: *Neo-Baroques.* W. Moser & A. Ndalianis (eds.). Liverpool: Liverpool University Press.

Wacker, K. (ed.), 2007. *Baroque tendencies in contemporary art.* Cambridge: Cambridge Scholarly Publishing.

Webster, J., 2005. *Performing libertinism in Charles II's court. Politics, drama, sexuality.* New York: Palgrave McMillan.

Wilmot, J., Earl of Rochester, 1993. *Complete poems and plays.* P. Lyons (ed.). London: Everyman.

Between the White Cube and the White Box: Brian O'Doherty's *Aspen* 5+6, An Early Exposition

By Lucy Cotter

Figure 1. Brian O'Doherty, ed., *Aspen* 5+6 (1967), box exterior (left) and contents (right)
Photograph commissioned and arranged by Mary Ruth Walsh; photographer Fionn McCann

In the autumn of 1967, art critic and artist Brian O'Doherty guest edited a double-edition of *Aspen*, a magazine in a box published by Roaring Fork Press.[1] One of the most recent issues had been edited by Andy Warhol and David Dalton, the future founding editor of *Rolling Stone* magazine. Among its flamboyant contents were a flip-book based on Warhol's film *Kiss* and Jack Smith's film *Buzzards Over Bagdad*, a 'ticket book' with excerpts of papers delivered at the Berkeley conference on LSD, and a flexi-disc with music by John Cale of the Velvet Underground. O'Doherty's double-edition *Aspen* 5+6 was, in contrast, a minimalist white box (Fig. 1). It contained a thirty-two-page book with three essays, a reel of films, five vinyl phonograph records with music, interviews and readings, eight card boards that could be glued together to form a three-dimensional sculpture and ten items of printed matter, among them drawings, loose texts and scores. Its contributors were artists, critics, writers,

1. The edition was conceived, edited and designed by O'Doherty with art directors David Dalton and Lynn Letterman. *Aspen* was a multimedia magazine, ten editions of which were published on an irregular schedule by Phyllis Johnson from 1965 to 1971, each with a guest designer and editor. All citations in this chapter refer to unpaginated material from *Aspen* 5+6, unless otherwise stated.

dancers and musicians including Sol LeWitt, Susan Sontag, Samuel Beckett, Marcel Duchamp, Mel Bochner, Dan Graham and John Cage. As American critic Irving Sandler commented, 'In retrospect, [*Aspen* 5+6] summed up the sensibility of that decade and foretold much of what was to influence artists subsequently' (1996: 35). They were indeed a prophetic combination of ancestors and contemporaries, who would later be recognised as the artistic and theoretical backbone of poststructuralism and Conceptual art. Moreover, prefiguring the first Conceptual art exhibitions of the later 1960s, the box was a canny curatorial intervention.[2]

At the time he edited *Aspen*, O'Doherty was trying to develop a poststructural artistic language using installation, drawing and performance.[3] On an artistic level, the question motivating his edition of the journal was how to communicate the broader field of interest surrounding and informing his art practice. He wanted to gather together all the artists whose work he had 'passed through' – a kind of artistic ancestry – and connect them with the work of his generation. This comes close to the departure point of the contemporary artist doing artistic research, who 'distinguishes himself from other artists by taking it upon himself to make statements about the production of his work and about his thought processes' (Wesseling 2011: 3). O'Doherty's practice was a post-minimalist one that dealt with questions of language and form. He included one of his own artworks in the box, *Structural Play #3*, a performance in which a sentence is 'rotated' through several possible interpretations. *Aspen* 5+6 provides an exciting model for artists-as-researchers as they look for expository forms and face the task of translating the spatial and embodied experience of art into a publication in the broadest sense of the word.

Embracing his double position as an artist and critic, I propose that O'Doherty used *Aspen* 5+6 to stage an exposition in the gap between two primary sites of exposition – the gallery and the publication. I will look at

2. Mary Ruth Walsh notes that the only early Conceptual exhibition at this time was Mel Bochner's Christmas show at the gallery of the School of Visual Arts, New York, held in 1966. It consisted of Xeroxed copies of artists' notes and drawings from their sketchbooks displayed in four identical books, presented on four pedestals (2003: 42). Lucy Lippard refers to another early Conceptual exhibition at Seth Siegelaub's gallery in 1969, which was 'the first exhibition to exist in catalogue form alone' (1973: 79).

3. Brian O'Doherty was equally known as an artist and writer at the time of *Aspen*'s publication. This double role was later somewhat obscured by his adoption of the pseudonym Patrick Ireland from 1972 onwards for his artistic output, in response to the Bloody Sunday killings in Northern Ireland (1972). In a public ceremony he swore to use the name 'until such time as the British military presence is removed from Northern Ireland and all citizens are granted their civil rights'. On 20 May 2008 he reclaimed his birth name with the burial of his alter ego in the grounds of the Irish Museum of Modern Art, a gesture of reconciliation to celebrate the restoration of peace in Northern Ireland.

how O'Doherty translates the immediacy of engaging with the physical art-work into a publication, as well as how he uses the publication as a form to offer alternatives to restrictive aspects of the gallery experience. I will explore the author-reader/artwork-viewer relationship that *Aspen* 5+6 establishes in the process. O'Doherty maintains the integrity of the edition's content-form relationship by placing apparently unrelated material side by side, whose contents touch each other tangentially. The result is a subtle and intricate web of inter-referencing that is difficult to capture in writing. Indeed, as we shall see, it is precisely the limits of linear text that inspired O'Doherty's sequence of juxtapositions. *Aspen* 5+6 goes towards answering the question of how to deal with embodied and material knowledge in a manner that holds its own alongside the textual.

Tom Holert points out that the contemporary artists whose work has paved the way for the current interest in artistic research responded to an earlier generation of 1970s artists, many of whom were O'Doherty's peers.[4] This is of relevance to the genealogy of artistic research, for which the development of Conceptual art has been an important milestone, not least through its challenge to the purely visual conception of art. *Aspen* 5+6 can also be viewed in relation to O'Doherty's wider experimentation with artist's books and multiples in the 1960s and 1970s, as well as those by other artists, including the *Flux boxes* of George Maciunas with which it shares a number of attributes.[5] As Alex Alberro has observed: 'In his choice of participants, O'Doherty was concerned with reinstating the often maligned legacy of European modernism extending from Russian Constructivism and the Dada tradition of paradoxical thinking to the predetermined structure of serial music and the non-metaphorical writing of the nouveau roman' (2001: 170). My intention is not to provide a discussion of the historical or disciplinary context against which the propositions of *Aspen* 5+6 are made, however. I will instead explore the significance of O'Doherty's edition as viewed through the lens of contemporary conditions for artistic-research exposition.

4. Holert refers specifically to artists who came to fame in the 1990s, namely Andrea Fraser, Christian Philipp Müller, Fareed Armaly and Mark Dion, who engaged with the legacy of, among others, Hans Haacke, Martha Rosler, Mary Kelly, Dan Graham, Mel Bochner, Art & Language and Adrian Piper (2011: 46).

5. O'Doherty had been experimenting with what would later be called 'artist's books' from the mid-1960s. In 1966 he began a talking book, which he never completed. Subsequently, he made a 'flip-book', *Scenario for Sound: A Structural Film* (1967), followed by *Alphabet Book* (1968-9) and *Barbara's Alphabet* (1979-80), among others. See Moore-McCann (2009: 103-107). During the 1960s and 1970s, George Maciunas was assembling *Flux boxes* and *Flux-Kits*, small boxes containing cards and objects designed and assembled by Fluxus artists such as Christo, Yoko Ono and George Brecht. The first *Flux box* to be published was George Brecht's *Water Yam* (1963).

Opening the Box

In her influential essay 'Against Interpretation' (1961) Susan Sontag outlines the problematic relationship between interpretation and artworks. There is, in the first place, writing's tendency to take the sensory experience of art for granted and proceed from there. Sontag argues that interpretation separates form from content, with content becoming the essential and over-addressed factor and form becoming a mere accessory. Interpretation's illusory separation of the two has the result that 'to interpret is to impoverish, to deplete the world – in order to set up a shadow world of "meanings"' (2001: 7). Six years later she writes a commissioned essay for *Aspen* 5+6 entitled *The Aesthetics of Silence*, in which she argues that art is itself 'mainly, a form of thinking'. Furthermore, 'each work of art gives us a form or paradigm or model of knowing something, an epistemology'. One of the challenges facing artists disseminating their research is the issue of finding an adequate expository form to hold this, at times idiosyncratic, epistemology. There is the most immediate problem of how to translate the medium-specificity of the artwork into other media, and writing in particular. Since artistic research can also shift the locus of art and artistic knowledge from the art world to the university, there is a further issue of how to engage with academic readers in such a way as to lure them out of their disciplinary and methodological modes. How can one make habitual readers look? How does one get them to *see* words? How can one convey materiality, even the materiality of language itself? How does one make people feel the body with which they read or look?

Sontag suggests that the best art writing is of the sort that dissolves considerations of content into those of form. So, too, I want to propose, do the best artistic expositions. For an artist, the publication can be an interesting formal problem. Brian O'Doherty treats it in this manner. *Aspen* 5+6 starts with form. A square white box measuring 8 x 8 x 2 inches, *Aspen*'s container is not merely a shell to be cast aside to engage with content. The box is named in the list of contents as one of the edition's twenty-eight elements. On second glance, we realise that the box in fact echoes the white-cube space. As Mary Ruth Walsh summarily put it, 'The gallery is the box itself' (2003: 42). O'Doherty would treat the box as an alternative exhibition context, holding open a space of tension between the physical exhibition space and the publication. The format of this exhibition/book anticipated its editor's critique of the conventions of the modernist white cube in an influential series of essays entitled 'Inside the White Cube', published in *Art Forum* in 1976. The most prominent issues that O'Doherty would go on to highlight in these essays are, I propose, some of the conventions of the exhibition that he tries to challenge in *Aspen* 5+6. Let me cite a central passage that elucidates some of the central concerns of the essays that are relevant to *Aspen*'s counterstrategies:

Unshadowed, white, clean, artificial, the [white cube] space is devoted to the technology of esthetics. Works of art are mounted, hung, scattered for study. Their ungrubby surfaces are untouched by time and its vicissitudes. Art exists as a kind of eternity of display, and though there is lots of 'period' (late modern), there is no time. This eternity gives the gallery its limbolike status; one has to have died already to be there. Indeed the presence of that odd piece of furniture, your own body, seems superfluous, an intrusion. The space offers the thought that while your eyes and minds are welcome, space-occupying bodies are not – or are tolerated only as kinesthetic mannequins for further study (1986: 15).

Central among these concerns is the absent presence of time created by the spatial set-up of the gallery. We will see that the question of how to introduce time forms a thread running through many of *Aspen* 5+6's collected works. O'Doherty also critiques the disembodiment of the eye that views the artwork in standard modes and, by extension, the almost passive reception of the viewer as he/she moves from work to work. In contrast *Aspen* 5+6 acts as a space to be entered into with a consciousness that is more embodied than history has allowed the conventional exhibition viewer. We are asked to engage physically, to touch the box's contents, to make them grubby, to play. We are invited to spend time with its holdings, to listen, to watch, to read, to imagine, to make, to get lost and to discover. Or, to consider *Aspen*'s strategies in epistemological terms, we are prompted to use different registers of knowledge.

On opening the box, we find its contents dedicated to Stéphane Mallarmé (1842-1898), the French poet who dealt, not only with words, but with the spaces between and around them. Among the contents of the box is a poem entitled 'Repair' by contemporary writer Michel Butor, made up of words that are fastened together through sequence rather than linear narrative: 'break lightbeam stitch | rip | stop! | a drop of milk | burn nickel a drop of milk | soldering | a long time ago'. As Michel Foucault observes, even if statements are collectively nonsensical at an enunciative level (while making sense at a grammatical level), they are not deprived of correlations and therefore do not lose meaning (1972: 90). The poem invites us to construct meaning across the gaps between the word phrases. This literary logic reoccurs elsewhere in the box, most radically in a recording of psychiatrist Charles R. Hulbeck, formerly Dadaist Richard Huelsenbeck, reading vowel poems and sound poems made up of fictitious words, as well as in a reading of *Nova Express* (1964) by William Burroughs, which was written using the cut-up method of enfolding snippets of different texts into the novel. A further work in the box, *Poem* (March 1966) by artist Dan Graham, reassembles the poem into a schema for its own making, composing it of formal elements (the noun, the adverb and so on) arranged in a given sequence, among them:

(number of) adjectives
(number of) adverbs
(number of) area not occupied by type
(number of) area occupied by type
(number of) columns
(number of) conjunctions

Both Butor's and Graham's poems deal with the space between. In Graham's, the 'area not occupied by type' is included and the entire list evokes elements placed on a white ground.

The dedication to Mallarmé is an invitation to engage with words differently; to see them, to hear them, to play with them. More than that perhaps, it is an instruction, coyly informing us how to engage with *Aspen* 5+6. We are asked to take into account not only the box's contents, but also the spaces between them. As in the poems of Butor and Graham, the 'meaning' of the box's contents is not given. We are provided with a list of themes – 'constructivism, structuralism, conceptualism, tradition of paradoxical thinking, objects and "between categories"' – and movements – 'time (in art and "history"), silence and reduction, language' – but there is no explanatory text that specifically expounds the meaning of the box's contents. The short introductory note accompanying the list of themes and movements (presented as a vertical column, as if to discourage us from reading them) is a text by a linguist, Sigmund Bode from 1928. The text tells us that 'this invisible grammar' – perhaps the themes and movements? – 'can be read *within and between categories*' (emphasis added). Bode is in fact a pseudonym for O'Doherty himself. It is his request that we listen to *Aspen* 5+6's interstitial knowledge, to that which lies in between.

The contents of *Aspen* 5+6 are not to be considered in isolation. It is precisely through viewing them in relation to each other that a dialogue opens up between them, making us see, hear and feel aspects of the works that would not otherwise have emerged. Let us consider, for example, what happens when we view Hans Richter's film *Rhythm 21* (1921) in relation to *Site* (1964), a film documenting a performance work by Robert Morris, with which it has no apparent relationship apart from the fact that both are included in *Aspen* 5+6. In *Rhythm 21*, which is a study in geometric composition, made up of a series of black and white rectangular and square planes moving backwards and forwards against an alternating white or black background, the screen acts as a space of time. *Site* shows Morris, dressed in white, deconstructing a structure made up of three horizontally placed white boards. He removes each before rotating them against his back and replacing them again. On viewing, we are struck by the visual correspondences between the two films, brought to the fore by O'Doherty's careful selection of the excerpt from *Site* and the removal of its original soundtrack of a jackhammer. Presented in this way, both films now revolve around a series of horizontal and vertical planes framed by light

and shadow, creating a 'dialogue of occlusion and revelation, of rectangle and edge' (Walsh 2003: 46). At moments in each, the screen is eclipsed by the white plane. Both films seem to 'speak the same language' although their time frames and departure points are different. We tune into this language as we watch, feeling that we understand something, even if we cannot name it. This invitation to pay close attention, but not come to any definitive conclusion, helps to open up what Sarat Maharaj refers to as 'non-knowledge' – 'forms of knowledge that are often below the radar of our conscious thought and which can bypass our rational minds to incorporate contradiction and intuition'.[6]

Each recombination of *Aspen* 5+6's elements extends that non-knowledge, expanding outwards to form a complex network of interrelationships weaving through the box's contents. The white planes of *Rhythm 21* and *Site* are echoed again in Tony Smith's eight card boards, which can be put together to form a white cube that recalls both the modernist gallery space and *Aspen's* box. White boxes return in John Cage's scores, each representing a space of time, just as 'the screen is always a space of time' in Richter (Walsh 2003: 46). Moreover, the musical structure that formed Richter's departure point for *Rhythm 21* becomes palpable while listening to the serial music that those scores notate … and so on. The structure of *Aspen* 5+6 is almost Kafkaesque, with (visual, tactile and cognitive) 'ideas' opening onto other ideas like a series of doors leading to a further series of doors. Yet one 'reads' in a circular fashion, approaching an internally dialoguing series of ideas from different places. In a recent text on artistic research, Janneke Wesseling proposes that in lieu of the question of whether research in art generates knowledge and what kind of knowledge that might be, it could be more productive to pose the question of how artists think (2011: 8).

The desire to hold open interstitial spaces, and thus to think something differently, calls for a different form of representation. It requires something other than the logic of the book, with its order of linear text that freezes representation into a regulated succession of static ideas or images. The book's structure, like all forms of representation, has an intrinsic epistemic force which *Aspen* 5+6 is trying to work against, to undo. *Aspen's* box provides an alternative logic, offering a dynamic and interactive space for the assemblage of works. As a container it facilitates the holding open of multiple perspectives through the potential rearranging of orders and groupings.

The problem to which the box provides a solution is the constraining taxonomy of academic thinking. Bode asserts that:

6. Sarat Maharaj used this definition in a workshop entitled *New non-knowledge strategies for the European Art Academy*, held as part of *Cork Caucus*, an artistic project that took place in summer 2005, organised by the National Sculpture Factory, Cork, and curated by Annie Fletcher and Charles Esche.

This linguistics of interval and position is usually closed off by themes and titles, complex nouns that immobilize a system in a particular attitude. In this sense, explanations are modes of concealing what is accessible by removing concepts to the area of other concepts (initiating that process which eventually leads to 'meaning' in the least fortunate academic sense).

He goes on to put forward an alternative representation of things outside of disciplines and historical time; a contextual frame that comes close to the condition of art itself, and thus to the preconditions of meaning-making in art practice:

> Placement as a grammatical concept can be extended to any abstraction […] to a degree we may speak of meaning as a system of permutations, as a mathematics of placement […] It is, of course, also possible to consider how placement is concealed, how the objectified unit (a person, a concept, a period) can conceivably occur without dimensions, in no place and in no time, and thus approach the condition of art.

The pertinent question for the artistic research exposition is how O'Doherty creates those framing conditions for the material in the box, how he actualises an artistic way of thinking. How might an artistic research exposition be set up so as to enable others to think outside of the conventions of disciplinary lineage and methodology? *Aspen* 5+6 creates space for those other meanings that the taxonomies of traditional academic disciplines forego by thinking across the delineated boundaries of disciplines. If we listen to the recording of *Nova Express* while watching Robert Rauschenberg's *Linoleum* (1967), the correspondence between Burroughs's palimpsest of images and the non-surrealistic contiguity of the disparate actions of Rauschenberg's actors rises above their disciplinary differences. In fact, *Aspen* 5+6 acts in a post-disciplinary manner, as Graeme Sullivan observes of artistic research in general (2011: 96).

From the point of view of thinking about the publication as a site of artistic research exposition, O'Doherty's undermining of the conventions of academic writing is particularly interesting. He disregards the norm of historical sequencing, setting texts from the 1920s and 1930s side by side with contemporary expressions and opening a trans-generational dialogue. A commissioned text by George Kubler, *Style and The Representation of Historical Time* (1967), partly theorizes this position. Kubler argues that art-historical conventions are unable to address the duration of style and, by extension, its interweaving and transformation in the 'flow of happening'. Furthermore the three essays, presented in the form of a booklet, are given no page numbers, challenging the academic reference system and raising questions about the status of the presented texts. Side by side with artists' statements and Conceptual artworks composed of text, their status becomes ambiguous.

For the contemporary artist as researcher facing the demands of academia, O'Doherty's most radical strategy is that he refuses to write. There is of course the 'introduction', which offers a list of movements and themes, together with a short text by his alias Sigmund Bode that can be read so as to prove meaningful for the contents of the box. But there is no descriptive interpretative text that 'explains' the artworks or the box's contents. The choice to use a pseudonym and refer to this personage as a linguist evacuates the position of the critic. O'Doherty remains true to Sontag's critique of interpretation as setting up a 'shadow world of "meanings"'. In its place, a constellation of existing and commissioned texts collectively pinpoint the range of formal/content-based issues that O'Doherty saw as important to his artistic practice. Side by side with artists' statements and Conceptual artworks composed of text, their status becomes ambiguous. And, crucially, many of those texts intrinsically reflect on their own status – as text, as text-in relation to artworks, as writing. By extension, they (indirectly) reflect on their status within the box and in relation to the other contained material, textual or otherwise.

By not explicitly addressing the points of connection among the box's twenty-eight elements, O'Doherty does not fix and thus close down their potential significance for the reader-viewer. Rather, he attends to the possibility of multiple outcomes following every recombination of the box's contents. In doing so he foregrounds the position of the viewer-reader in the production of meaning. This comes close to the proposition of one of the box's three essays, Roland Barthes's *The Death of the Author* (1967), which, it is little known today, was published for the first time in *Aspen* 5+6. In what was later recognised as a key poststructuralist text, Barthes undermines the hegemony of the author as source of authentic meaning, to make way for an active role for the reader. He asserts that:

> [A] text is made of multiple writings, drawn from many cultures and entering into mutual relations of dialogue, parody, contestation, but there is one place where this multiplicity is focused and that place is the reader, not, as was hitherto said, the author. The reader is the space on which all the quotations that make up a writing are inscribed without any of them being lost; a text's unity lies not in its origin but in its destination. [...] [T]he reader [...] holds together in a single field all the traces by which the written text is constituted.

Aspen 5+6's 'reader' is asked to take up a comparable position, as an embodied mind that gathers and interacts with an assemblage of works rather than viewing/reading them as a pre-regulated succession of static ideas or images or as the output of an artist whose intention is to be seen as *the* source of meaning of the work. We find another echoing moment in Barthes's discussion of Mallarmé:

In France, Mallarmé was doubtless the first to see and to foresee in its full extent the necessity to substitute language itself for the person who until then had been supposed to be its owner. For him, for us too, it is language which speaks, not the author; to write is [...] to reach that point where only language acts, 'performs', and not 'me'.

In Barthes's text, criticism and literature become writing-as-such. Content lies in form, which means that we must take form seriously. In many ways, post-structuralist writing acts as a bridge between the word and other art forms in *Aspen* 5+6, offering an engagement with the materiality of language and its embedded content-form relationship. Although the work of Barthes and other writers central to the literary canon in France in the late 1960s was 'still regarded as marginal and suspect by the Anglo-American literary community', O'Doherty noticed how unsurprised his artist friends were by the text, which seemed to speak to their artistic logic.[7]

The *Death of the Author*'s challenge to the exclusive agency of the artist in the production of art prompts a further analogy with Marcel Duchamp's precociously early proposition that the viewer completes the artwork, outlined in *The Creative Act* (1957), another of *Aspen* 5+6's essays. Duchamp outlines that while the artist struggles through 'a series of efforts, pains, satisfaction, refusals, decisions' to bring to light his or her artistic production, it is the viewer who can see the artistic product for what it is:

> [I]n the chain of reactions accompanying the creative act, a link is missing. This gap, representing the inability of the artist to express fully his intention, this difference between what he intended to realize and did realize, is the personal 'art coefficient' contained in the work. In other works, the personal 'art coefficient' is like an arithmetical relation between the unexpressed but intended and the unintentionally expressed.

Not being able to recognise the difference between intention and outcome, the artist needs the viewer to finish or complete the creative act. Duchamp's text marks the death of the Romantic conception of the artist, making way for the anti-authorship stance of O'Doherty and his generation of Conceptual artists. It gives birth to an active viewer, whose agency is in stark contrast to the passivity of the historical exhibition visitor, addressed in O'Doherty's later essays. A

7. Brenda Moore-McCann cites this observation by Susan Sontag from her preface to a 1993 edition of Barthes's *Writing Degree Zero* (1967) (2009: 77). She explains that this may be the reason for the general critical neglect of *Aspen* 5+6 on publication. An important exception is Dore Ashton's review in *Studio International* (Ashton 1968). O'Doherty discussed the reception of Barthes by his peers in conversation with the author in September 2011.

further analogy can be made between Barthes's reader, Duchamp's viewer and Morton Feldman's listener, who occupies what the composer called 'a plane of attention', listening to a series of evocative sounds in such a work as *The King of Denmark*, a recoding and score of which is contained in the box.[8] Rather than these positions conflating entirely into one other, a highly interesting space opens up in the slippage between these active positions of receivership from one discipline to another.

While the body had seemed a superfluous intrusion in the modernist gallery space, the artists in *Aspen* often lend physicality to the viewer's/reader's task of completing the work. Tony Smith's *The Maze* and Mel Bochner's *Seven Translucent Tiers* (Fig. 2) are examples of this. *The Maze*, an installation made up of four large-scale rectangular elements, is documented by a series of drawings and a statement by the artist. But we are also provided with a set of card boards representing elements of the maze scaled down to fit the box, which can be reconstructed by gluing, following the given instructions. Once assembled, it echoes the structure of *Aspen*'s containing box, which bisects when opened to form two identical halves – two minimal forms that can be combined in various ways. The reduction of the box's printed title to minute font on one side of the white box underscores this sculptural quality. Bochner's work is a grid study on a single sheet of white paper, accompanied by a further seven translucent sheets. The numbers on the grid correlate to binary language, with the permutations of arranged pluses and minuses on the seven translucent sheets connoting absence and presence. We are invited to place each of the seven layers over the grid, giving us the agency to create different linguistic outcomes. Both Smith's and Bochner's works prompt tactile engagement and play in the process, forcing us to use our bodies.

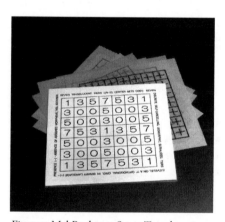

Figure 2. Mel Bochner, *Seven Translucent Tiers* (1967), 16 x 8 inches
Photograph commissioned and arranged by Mary Ruth Walsh; photographer Fionn McCann

O'Doherty had been busy with the question of embodied knowledge systems in a literal sense in his art practice with earlier artworks such as *The Body and Its Discontents* (1964), which represented the systems of knowledge through which our bodies are intercepted by medical science using a grid of small blocks.[9] *Structural Play #3* contained in *Aspen* is an attempt to highlight

8. Mary Ruth Walsh draws this analogy with Feldman's listener (2003: 43).

language as an untrustworthy locus of meaning and to reunite it with the body in space. This linguistic performance also takes place on a grid. Two performers, A and B, take turns to recite a short sentence, moving in patterns predetermined by the artist. With each movement, emphasis is placed on a different word in the sentence, subtly changing its meaning. The sentence is thus 'rotated' through a number of possible interpretations, and the performance in turn moves the body through a series of placements, exhausting language by means of a system of permutations. *Structural Play #3* is represented by schematised drawings in the box, as if to beckon viewers to reconstruct the performance, to experience this embodied knowledge for themselves. The boundary between drawings and scores collapses in *Aspen*, when the two are aligned.[10]

O'Doherty includes two recordings with choreographer Merce Cunningham, which extend the interests of his *Structural Play* by considering time and the body in space. In one, Cunningham reads his essay 'Space/Dance/Time', while the other is an interview from 1967 addressing related issues. He increases the agency of each individual dancer by proposing that no one point occupied by a dancer is inherently more important than the other and that each individual dancer can be the centre of the space he/she occupies. We start to become increasingly aware of the importance of the interstitial space – of what happens between things. Cunningham speaks about the equality of stillness with movement in a manner that reverberates with Butor's spaces between the words and with Cage's focus on silence between sounds. O'Doherty insists that we discover these points of convergence ourselves, through the act of looking and listening. We are led to grasp the imaginative patterns that underlie the works intuitively, bringing a depth of understanding that reading an interpretative text could hardly have achieved.

We also find our understanding of time expanding thanks to Cunningham's reconsideration of the formal structure of dance. He replaces the conventional notion of form as shape in space with the possibility of form as shape in time, with time constantly 'arriving and dissolving' – a notion that we have seen embodied in *Rhythm 21*. Time returns as the ordering factor in Feldman's *The King of Denmark*, where it brings about a death of the composer as exclusive author by inviting musicians to operate around a given note for

9. It consisted of a small wooden box divided into sixty compartments, each one holding a wooden block whose sides were painted in four colours as a code for one of the systems of knowledge through which our bodies are intercepted by medical science: red for anatomy, blue for pathology, white for macro-level physiology and yellow for micro-level physiology.

10. This is true of a number of O'Doherty's other drawings from the period. The most elaborate of these was *Vowel Chorus for Five Voices* (1968), an ink drawing on paper that mapped out a series of vowel sounds to be performed by sustaining the voice in a choice of pitches (Moore-McCann 2009: 112-113).

a given length of time, and in Max Neuhaus's score for Cage's *Fontana Feed Mix*, which he made by assigning a ten-second time period to each of the differentiated lines notating the frequency response of two channels of feedback on opaque sheets of paper.

The system of permutations generated by the scores of Feldman and Cage, O'Doherty's *Structural Play* and Cunningham's choreography evokes in turn the seriality of Sol LeWitt's work for *Aspen* 5+6. *Serial Project #1* (Fig. 3), a multi-part work consisting of endless permutations of a single cubic form that occupied the gallery space like the trace of movement. LeWitt had in fact taken the structure of serial music as his departure point, a piece of information that we can sense through the juxtapositions in the box. O'Doherty's choice to record readings of texts by Alain Robbe-Grillet, Beckett and Burroughs for *Aspen* furthermore enables us to hear aural correspondences between words punctuating silences and the serial sounds that made up Feldman's and Cage's music. This is true, for example, of Robbe-Grillet's reading 'Now the shadow of the southwest column' from his novel *Jealousy* (1957), which is composed of recurring images, impersonally depicted physical objects and random events. The narrator expounds the structural formation of the banana plantation where the novel is set in increasingly repetitive detail, echoing the obsessive logic of LeWitt's sculptural permutations:

> In the second row, starting from the far left, there would be twenty-two [banana] trees (because of the alternate arrangement) in the case of a rectangular patch. There would also be twenty-two for a patch that was precisely trapezoidal, the reduction being scarcely noticeable at such a short distance from its base. And, in fact, there are twenty-two trees there.

Figure 3. Sol LeWitt, *Serial Project #1* (1966), Detail, 16 x 8 inches
Photograph commissioned and arranged by Mary Ruth Walsh; photographer Fionn McCann

Robbe-Grillet's characters, named 'A' and 'B', remind us in turn of the alphabetically named actors in O'Doherty's *Structural Play*. And like them, they seem to empty out the meaning of language. The endless combining and recombining of words in Robbe-Grillet and the endless permutations of form in LeWitt exhaust the object. Both exert 'the greatest exactitude and the most extreme dissolution'.[11]

11. Deleuze refers to this aspect of Samuel Beckett's work (1997: 154).

O'Doherty has a keen respect for Samuel Beckett's ability to 'exhaust' language (Deleuze 1997: 156). Beckett's *Text for Nothing #8* (1958), contained in *Aspen* 5+6 and read by Jack MacGowran, not only shares this quality but explicitly addresses the subject of trying to exhaust words:

> It's an unbroken flow of words [...] with no pause for reflection [...] between the words, the sentences, the syllables [...]. But nothing of the kind. That's how it is. It's forever the same murmur, flowing unbroken like a single endless word and therefore meaningless. For it is the end gives the meaning to words.

Gilles Deleuze comments that this problem, 'to have done with words' dominates Beckett's later work, and that it is a search for 'a true silence, not a simple tiredness with talking, because "it is all very well to keep silence, but one has to consider the kind of silence one keeps"' (1997: 156). In *The Aesthetics of Silence* Sontag affirms that 'the artist's activity is the creating or establishing of silence', yet the silence the artist keeps is of a particular kind:

> The exemplary modern artist's choice of silence isn't often carried to this point of final simplification, so that he literally becomes silent. More typically, he continues speaking, but in a manner that his audience can't hear. Most valuable art in our time has been experienced by audiences as a move into silence (or unintelligibility or invisibility or inaudibility).

Beckett's character, too, hopes 'to wear out a voice, to wear out a head. In the silence you can't know'. By not knowing in the habitual sense, one may find other non-knowledges. Sontag proposes that the artist's silence is established 'to help bring these new ways of thinking to birth'.

Let us consider for example a short excerpt from LeWitt's description of *Serial Project #1* that accompanied its documentation through drawings and photographs: 'The individual pieces are arranged in three rows of three forms each. In each row there are three different parts and three parts that are the same. The inner forms of one row of three are read in sequence as are the outer forms.' Although LeWitt's analysis of the work *appears* rational, it does not lead to a comprehensible conclusion. It is closer, in fact, to the obsessional logic of the narrator in *Jealousy*. We can draw similar conclusions to Krauss, who observed that:

> The babble of a LeWitt serial expansion has nothing of the economy of the mathematician's language. It has the loquaciousness of the speech of children or of the very old, in that its refusal to summarize, to use the single example that would imply the whole is like those feverish accounts of events composed of a string of almost identical details, connected by 'and' (1986: 253).

Krauss argues that what looks like 'the look of thought' (as Donald Kuspit had called it) in LeWitt's or his peer conceptualists' work is often its opposite, at least if thought is taken to mean classical reason. She elaborates, '[W]hat we find is the "system" of compulsion, of the obsessional's unwavering ritual, with its precision, its neatness, it finicky exactitude, covering over an abyss of irrationality' (254). LeWitt's absurd abstract nominalism resembles classical Euclidian thought but departs from it in ways that frustrate linear thinking.

The multiplicity of outcomes of LeWitt's drawings shows us that the artwork is not only the end product of the artist's thinking but an intermediate stage, 'a temporary halting of a never-ending thought process', with which the viewer can engage.[12] The conceptual interrelationship between the breakdown of linear narrative in authors like Barthes and Robbe-Grillet and LeWitt's approach to logical thought is not elaborated on explicitly inside the *Aspen* box, yet as Krauss acknowledged almost twenty years later, to speak of LeWitt's work in relation to the *nouveau roman* was 'to help locate the real territory of its meaning' (1986: 256).

The endless permutations of LeWitt's work are echoed in the formal structure of *Aspen*'s contents, whose multiple inter-references resound with each other in ways that confound the norms of academic analysis. O'Doherty facilitates a breaking down of the barrier between works and an opening up of the potential collective creativity of *Aspen*'s material contents. *Serial Project #1*, like *Aspen* as a whole, makes tangible the fact that form is not the result of thought but the medium of its production. The artistic-research exposition, by extension, is 'not the end but the beginning of the generation of knowledge, in which what is represented is exposed to ongoing projective inscription and unexpected driftage' (Busch 2011: 76).

Closing the Box

Working like a magnet pulling all that is of a certain substance towards itself, with little regard for specific form or location of origin, *Aspen* actualises a non-hierarchical and non-taxonomic form of knowledge-making. Through it, O'Doherty explores the possibility that artistic research offers a transgressive knowledge that is different from art criticism or academic knowledge. The formal structure of *Aspen* 5+6, a multimedia assemblage in a box, enables a threading of lines of thought through different kinds of materiality. The contained materials differ greatly in origin, but the form of the exposition gathers the threads tight enough for reader-viewer to hold 'together in a single field all the traces' (Barthes). Whereas an academic essay on the same contents, or even those very contents supplied with an interpretative text, is likely to fix the outcome, *Aspen* defers any definitive conclusions. As an exposition, it functions

12. Janneke Wesseling describes artworks in general in these terms (2011: 12).

as a site for the emergence of knowledge, for its release rather than merely its containment. It opens up the prospect of gaining knowledge that was not foreseeable beforehand.[13]

O'Doherty recognises that '"the fine line between the known and the unknown", which is the true site of the generation of knowledge, is always to be found in the material representation' (Busch 2011: 76). He uses a range of strategies to keep us close to the materiality of the work at hand, translating text to voice when necessary, or removing a film's soundtrack to make us pay close attention to the visual. In doing so, he opens up the paradigms of knowing of each work by bringing them to bear on each other. *Aspen* 5+6 acts as a reminder not to take the material experience of art for granted amid the distractions of overabundant reading matter. It intimates that written words cannot capture all knowledge; that, as Jacques Derrida has highlighted, they act as a detour, 'defer[ring] the moment in which we can encounter the thing itself, make it ours, consume or expend it, touch it, see it, intuit its presence' (1982: 9). O'Doherty makes no justifications for art. *Aspen* 5+6 shows, rather than explains. As an early exposition of artistic research, it is free of the constraints of academic requirements, yet it inadvertently offers ways to subvert them.

References

Alberro, A., 2001. 'Inside the White Box', *Art Forum* (September), pp. 170-174.

Ashton, D., 1968. 'New York Commentary: The Book: Brian O'Doherty's *Aspen Magazine*; William Copley's S.M.S.', *Studio International* 175 (900, May), pp. 272-273.

Busch, K., 2011. 'Generating Knowledge in the Arts: A Philosophical Daydream', *Texte zur Kunst* 82 (June), pp. 70-79.

Deleuze, G., 1997. *Essays Critical and Clinical*. D. W. Smith & M. A. Greco (trans.). Minneapolis, MN: University of Minnesota Press.

Derrida, J., 1982. *Margins of Philosophy*. A. Bass (trans.). Sussex: The Harvester Press.

Duchamp, M., 1973 [1957]. 'The Creative Act.' In: *The Writings of Marcel Duchamp*. M. Sanouillet & E. Peterson (eds.). New York: Da Capo, pp. 138-140.

Foucault, M., 1972. *The Archaeology of Knowledge and Discourse on Language*. A.M. Sheridan Smith (trans.). New York: Pantheon.

Holert, T., 2011. 'Artistic Research: Anatomy of an Ascent', *Texte zur Kunst* 82 (June), pp. 38-63.

Krauss, R.E., 1985. *The Originality of the Avant-Garde and other Modernist Myths*. Cambridge, MA: The MIT Press.

Lippard, L., 1973. *Six Years: The Dematerialisation of the Art Object from 1966-1972*. New York: Praeger.

13. In my formulation, I draw on Kathrin Busch's discussion of representation: 'Representation [...] is less a fixation than a release of knowledge, which means we must [...] attribute a certain agency to it. In this regard representations play a certain role in the emergence of knowledge, and only representations open up the prospect of cognitive attainments that were not foreseeable beforehand' (2011: 76).

Moore-McCann, B., 2009. *Brian O'Doherty/Patrick Ireland: Between Categories.* Surrey: Lund Humphries.

O'Doherty, B., 1986. *Inside the White Cube: The Ideology of the Gallery Space.* San Francisco: The Lapis Press.

O'Doherty, B. (ed.), 1967. *Aspen* 1 (5-6, Autumn-Winter). Repub. on UbuWeb. Available at: http://www.ubu.com/aspen/aspen5and6/index.html [Accessed 20 November 2012].

Sandler, I., 1996. 'Book: Art Since 1945', *Patrick Ireland: Gestures Instead of an Autobiography.* Exhibition catalogue, Youngstown, OH: Butler Institute of American Art.

Sontag, S., 2001. 'Against Interpretation.' In *Against Interpretation and Other Essays.* New York: Picador, pp. 3-14.

Sullivan, G., 2011. 'The Artist as Researcher: New Roles for New Realities.' In: *See it Again, Say it Again: The Artist as Researcher.* J. Wesseling (ed.). Amsterdam: Valiz, pp. 79-101.

Walsh, M.R., 2003. 'A Labyrinth in a Box: *Aspen* 5+6', *Circa* 104 (Summer), pp. 42-47.

Wesseling, J., 2011. 'Introduction.' In: *See it Again, Say it Again: The Artist as Researcher.* Amsterdam: Valiz, pp. 1-15.

Counter-Archival Dissemination

By Henk Slager

The concept of archive often evokes an image of control, survey and organisation. For example, in *The Order of Things*, Foucault describes the archive as a system introducing order, meaning, boundaries, coherence and reason into that which is disparate, confused, contingent and without contours. Thus his 'critique of power' observes that the archive is not just a passive collection of records from the past, but is an active and controlling system of enunciation that gives ever-changing form to the 'great confused murmur' that emanates from the 'Discursive Formation' (Foucault 1989: 44).[1] In other words, the archive has a set of meanings – a 'form' – that changes with the mental frame that is brought to it.

In Derrida's *Archive Fever*, another distinct connection is made between archival reason and the rhetoric of power. According to Derrida, this connection is genealogically underscored by the fact that the word 'archive' is derived from the Greek *Arkheion*, the residence of the superior magistrates. It is in this location, where the rulers reside, that the documents are stored:

> The archive more often than not preserves the history of the victors, while presenting it as historical reality or scientific truth. The archive is a realist machine, a body of power and knowledge, and it sustains itself by repetition. More precisely, the authority of traditional archives controls and regulates the reproduction of their items (Steyerl 2008).

Obviously, this implies that there are criteria for how to reproduce those objects 'faithfully', according to specific, hermeneutic protocols. 'Technologies of inscription and the undoing of certain protocols of reading, writing, and thinking that they occasion must be thought together, so that, in addition to the affirmative, gathering, preserving dimension of the archive, there is the violence of the archive itself, as archive, as archival violence' (Derrida 1996: 7).

With such features of archival reason, both Foucault and Derrida seem

1. The archive is for Foucault the institutional site of the 'Discursive Formation' – a rule-governed set of material practices located in social spaces with their objects and architectures, behaviours and norms, class interests and prejudices.

to refer to Nietzschean thought. From a philosophy of power, the archive could be understood as a product of the will to represent, the desire to survey and for transparency that is emerging in modernity as a rigid scopic regime where multiformity and diversity have been reduced to levels of equivalence. In line with Nietzsche, the scopic regime is related to Cartesian thought by both philosophers: the perspectivist philosophy of the gaze, the disembodied eternal point of view, directed since the seventeenth century towards generating clear, linear, solid, fixed and planimetric forms of perception. Such an ocular-centric, retinal form of thought, as both Derrida and Foucault observe, finally found its ultimate and visual coherent form of appearance in an archiving mediality in the course of the twentieth century.

However, that does not mean that Cartesian thought could have command of a full hegemony at all times. There is also a continuous oscillation with a different form of movement: the ocular desire for divergence, the glance, the multiple and the blank. Such a movement that draws attention to the visual potentialities concealed by the retinal repression of the Cartesian regime acts as a transgressive impulse not only meaningful during a certain historical period of time, but continuously presenting itself as an alternative precondition for a dynamic form of artistic thinking.

Since Marcel Duchamp, twentieth-century visual artists have been engaged in attempting to transgress the archival order. Artists do not comply with disciplining rules of ordering, boundaries and coherent categories; they present physical aspects and qualities of an archival transformation previously unacknowledged or repressed. Because of that, they appropriate, interpret, reconfigure and interrogate archival structures and materials aiming at deconstructing compulsive, taxonomic knowledge systems. In the manner of Duchamp's *Boîte-en-valise* and Broodthaers' *Museum of Modern Art. Department of Eagles,* artists still oppose a canonising and archiving impulse that is constitutive of the museum institution's logic of display that focuses on 'a holding back from "known" genres, keeping them at bay – circumventing known forms that reduce "difference" to "sameness"' (Maharaj 2004: 49).

Therefore, artists developed para-archives as a demonstration of the impossibility of categorising the contingent for the sake of representation and to draw attention to a non-hierarchic heterogeneity and an anomic form of knowledge production. These artistic archives juxtapose the archive and its ambition to register the contingent with a set of objects for which there seems no assigned place in it, and create a series of supplements that question the foundations of archival hermeneutics. Thus, as Hal Foster argues in *An Archival Impulse,* by focusing on unacknowledged and repressed qualities, artistic archives show the essence of the archive as 'found yet constructed, factual yet fictive, public yet private' (Foster 2004: 5).

In the same article, Foster lists three well-described characteristics of how current archival thought plays a role in visual art of the twenty-first

century: an emphasis on connectivity, an introduction of novel affective orders, and a continuous attention to what Deleuze has called 'becoming'. These three characteristics – specifically from the perspective of today's research-based practices – could be situated as follows:

1. The methodological trajectory of artistic archiving seems to be characterised by another type of will; not a will coloured by thinking in terms of hegemonic power and a meticulous control, but a frivolous will, the will of a *gaya scienza* concentrated on artistic probing, establishing connections, associating, creating rhizomatic mutations, producing assemblages and bringing together that which cannot be joined. The methodology of artistic archiving connects with a tendency designated by Nicolas Bourriaud as 'postproduction'. 'These practices have in common the recourse to already produced forms. They testify to a willingness to inscribe the work of art within a network of signs and significations, instead of considering it an autonomous or original form' (Bourriaud 2002: 16).[2]

2. Against the Foucauldian perspective where a clear connection is made between an archiving rhetoric and the dispositive of power, artistic archiving adds the perspective of 'desirology', a thinking in terms of new orders of affective associations, of fluid taxonomies, and above all, a thinking in terms of intellectual and artistic pleasure, linked to derange the symbolic order. Barthes describes such pleasure – and he emphatically speaks in terms of pleasure, since after an era of scientific positivism, it is extremely urgent to ascribe new epistemological dignity to the concept – as an intellectual one that can be found in a temporary suspension of the repetitive machines of knowledge production, a pleasure resulting from hovering in the in-between, a brief balancing in the chasm or the faultline of the feno- and geno-text, producing, as Barthes states, a 'staging of an appearance-as-disappearance' (Barthes 1975: 10).

The practice of artistic research also continuously takes place in an in-between; the space between archiving knowledge production and active artistic thought ceaselessly able to adopt different contours. With that, artistic research characterises itself in terms similar to Barthes' 'textuality' as a *gaya scienza*: a disputing and transmuting science able to withdraw from canonical structures since it is situated on the blind spot of the systems.

3. In addition, Barthes points out that in *Gaya Scienza*, Nietzsche has elucidated that the current meta-linguistic character of every institutional research prevents conceiving a science of becoming:

2. The issue of dissemination of artistic research was central to *DARE* (Dutch Artistic Research Event) # 5, Utrecht, 2010. The keynote lecture, 'Artistic Delay', was delivered by Nicolas Bourriaud. A report of this presentation is published in *MaHKUzine, Journal of Artistic Research*, # 9, Summer 2010, pp. 6-9.

We are not subtle enough to perceive that *probably absolute flow of becoming*: the *permanent* exists only thanks to our coarse organs which reduce and lead things to shared premises of vulgarity, whereas nothing exists *in this form*. A tree is a new thing at every instant: we affirm the *form* because we do not seize the subtlety of an absolute moment (Barthes 1975: 60-1).

According to Barthes, an artistic answer would be to invert nouns into verbs so that a textuality emerges where opposing powers no longer exist in a state of repression but in a state of becoming: 'nothing is really antagonistic, everything is plural' (Barthes 1975: 33). A similar dynamic could be observed in the current practice of visual art: analogous to how Barthes' textuality opposes writing against text, this practice opposes recording against record, identifying against identity, and archiving against archive.

But how does the current strategy of artistic archiving relate to thinking in terms of a research-based practice? This more specific question was the premise of the exhibition project 'Critique of Archival Reason' that took place in the Royal Hibernian Academy in Dublin in 2010.[3] The hypothesis that a research-based practice gives rise to new forms of archival display is the starting point of this chapter. Clearly, with such a practice, an archiving consciousness can no longer be placed in the supportive narrative of a contextualising info lab developed parallel to the exhibition. Ultimately, the problem of such a contextualising narrative is that it still offers room for a taxonomic and thematic manipulation of reality, that is, a rhetoric able to translate the exhibition space into a disciplinary and educative space for the sake of the production of a certain public and a related worldview (Rancière 2008). Not surprisingly, the way in which a current research-based practice deploys the curatorial logic of the archiving display system is completely different in nature. No longer is a focus on or the construction of a certain worldview at stake, nor is there any intention to change institutions. Conversely, today the archiving display strategy directs itself towards the verb, that is, on how we institute, and thus also on how imagination and artistic thinking can be instituted in a different way, and how this leads to 'different partitions of the sensible' (Rancière) and different notions of spectatorship.[4] As a consequence, any approach to 'publishing in academia' (the subtitle of this book) needs to take into consideration in-between perspectives, where the focus of 'ex-

3. 'Critique of Archival Reason', Royal Hibernian Academy, Dublin, 18 February-15 March 2010, curated by Henk Slager. Featuring works by Herman Asselberghs, Jeremiah Day, Cecilia Gronberg, Shoji Kato, Irene Kopelman and Sean Snyder, this project understood 'critique' in the pure Kantian sense: as an activity not determining its criteria a priori, but a posteriori, in a form of experimental and immanent research into decisive and separate faculties.

Sean Snyder, Index, 2009

position' or dissemination of artistic research should be on the dynamics of thought processes and avoidance of 'archival' control. With this goal in mind, research-oriented artists currently produce rhizomatic presentation models while presenting various constitutive segments such as photographic material, drawings, performances, videos and texts in a fluent and integral manner.

At the same time, many of these research projects could be characterised by an explicit attention to the analysis and deconstruction of scientific iconography and the medium-specific traits of the mass media. The presentations of Irene Kopelman's *Ubx Expression* (2010), Jeremiah Day's *Fred Hampton's Apartment* (2008) and Sean Snyder's *Index* (2009) in the exhibition 'Critique of Archival Reason' offer good examples of such integrative practices.

Do natural sciences allow an artistic intervention and re-verification of visual representation? That question was the starting point for Kopelman's

4. With this description, the exhibition as medium is again aware of its medium specificity. In 'Exhibition as Medium', Simon Sheikh (ed.), *Capital (It fails us Now)*, Helsinki: Nifca, 2006, p. 59, Simon Sheikh speaks of the production of a counter public. 'A counter public is a conscious mirroring of the modalities and institutions of the normative public, but in an effort to address other subjects and indeed other imaginaries, where the classic bourgeois notion of the public sphere claims the opposite, and in concrete terms this often entails a reversal of existing spaces into other identities and practices.'

doctoral research trajectory.[5] She investigated how various natural science collections have based their display system on nineteenth-century forms of categorisation and logics of identity, a classifying logos that excludes differences and singularities:

> During the 19th century, a scientific project needed to force things into categories (of sameness) in order to visualize the rules they followed and which organized the world in a logical system. This was a fundamental process to schematize how we look at things and simplify it to the extreme, thus overlooking any singularities. My research project concentrates on reopening some of these categories, and [aims] to look upon differences and singularities. The project uses elements from the history of science as resources and attempts to generate, from both art practice and artistic thought, a type of knowledge extrinsic to the field of philosophy or history of science, but still touching upon issues they all share (Kopelman 2009: 49).

In the form of a concentrated series of artistic interventions and deconstructions of device systems, Kopelman presented alternative forms of archiving and display for a number of natural science collections in Dublin. As she noticed a year later during her presentation for *As the Academy Turns*, that form of artistic archiving appears to play a more prominent role in artistic research than considering the (medium) specificity of the drawing process as a thinking tool (her original research question):

> There is a constant building up of an archive; much of it remains unused or just waits for a moment to be taken into the work. Knowledge on parasite behavior, pollination, pattern formations, evolution, all of it contains information and stories I definitely like to use on one level or another. Their impact on the work might not be direct or obvious, but there is translation in a variety of ways emerging from a constructed mental space that allows projects to develop into display systems. An archive is like a backstage to the work; it remains hidden while it keeps growing.[6]

5. Irene Kopelman defended her doctoral research in Utrecht on 3 September 2011. (Supervisors: Mika Hannula, Jan Kaila and Henk Slager.) Part of the final assessment was the exhibition 'The Molyneux Problem' at BAK, Basis voor Actuele Kunst, Utrecht, 20 August-25 September 2011.

6. Presentation during 'As the Academy Turns', Manifesta 8, 'A Short Story of a PhD Trajectory', published in *MaHKUzine, Journal of Artistic Research* #10, Summer 2011, pp. 17-20.

Jeremiah Day, Fred Hampton's Apartment, 2008 and Irene Kopelman, Ubx Expression, 2010

Forms of narrativity and fiction can sometimes be developed by mass media even based on an absolutely empty archive, as Jeremiah Day's work *Fred Hampton's Apartment* shows. This press image of the apartment of the Black Panther leader played an important role during the 1960s in police statements around his liquidation. In the same turbulent 1960s, Hannah Arendt published a crucial text on *The Crisis in Culture*; a text where she, in the presence of the mass-media image, draws attention to the cultural-critical capacity of visual art and the role of the artist as active and committed participant in the public debate. It is exactly this statement that Day intends to actualise in his research practice – that is, to develop novel forms of storytelling and critical imagination in the light of the current role and status of art in public life as opposed to the fiction of mass media. Because of that, he chooses photographic images of history-laden locations, such as Hampton's apartment, as a departure point for narrative performances taking place in the exhibition space. For example, in the Royal Hibernian Academy, they are ultimately presented in the form of a documenting, but not instrumentalising, video.

Another question is, how should an artist relate to the role that ubiquitous digitisation plays in producing a documentary practice? Sean Snyder's *Index* addresses and displays that question through various formats of storage of media images from his physical archive. In a quasi-rigid grid, nondescript photographic representations are exhibited, showing how his documentary archive has been recorded. On another wall is a monitor with a typical 1960s Soviet-documentary on a Mexican art exhibition in the Ukraine. To that a subtle commentary is added – audible through headphones – contemplating

the rituals and conventions of the contemporary art practice. The interaction between mass-media propaganda, photographic presentations of archival devices, and the art-critical commentary ultimately present the situation and condition of systems that make, produce, manufacture, articulate and exchange images, allowing them to exist in the world as images of the world, and show how history, politics and ideology intersect with those systems.

The situation of image production and circulation presented and deconstructed by these artists makes clear that the practice of current fine-art research should concentrate on the issue of specificity of the artistic image. In the three discussed artistic research projects, media are utilised so that a topical iconography can be developed, able to open up new registers of perception related to novel possibilities of orientation. Thus, with respect to the issue of the specificity of the artistic image, one could claim that because of the current research-based practice, a novel, differential iconography is emerging; practices able to bring phenomena without precedent – such as ubiquitous mobility and connectivity – within the reach of experience. But that iconography is also demanding novel forms of presentation and display, since the realm of presentation has to find modes of dealing with the various modalities of artistic thinking and artistic knowledge production. In the search for artistic answers to such questions, the most important categorical imperative of an artistic research practice seems to be an awareness of the urgency to draw attention to novel models for imagining otherness or to generate other forms of imagination through the potentiality and multiplicity of the artistic image.

References

Barthes, R., 1975. *The Pleasure of the Text*. Richard Miller (trans.). New York: Hill and Wang.

Bourriaud, N., 2005. *Postproduction. Culture as Screenplay: How Art Reprograms the World*. J. Herman (trans.). 2nd ed. New York & Berlin: Starnberger Press.

Derrida, J., 1996. *Archive Fever: A Freudian Impression*. Chicago: University of Chicago Press.

Foster, H., 2004. 'An Archival Impulse.' *October* 110 (Fall), pp. 3-22.

Foucault, M., 1989. *The Archaeology of Knowledge*. London & New York: Routledge.

Kopelman, I., 2009. in: *MaHKUzine* #7, Journal of Artistic Research, Nameless Science, Summer 2009, p. 49.

Kopelman, I., 2011. 'A Short Story of a PhD Trajectory.' *MaHKUzine* #10, Journal of Artistic Research, Summer 2011, pp. 17-20.

Maharaj, S., 2004. 'Unfinishable Sketch of "An Unknown Object in 4D": Scenes of Artistic Research.' In: *Artistic Research*. Lier en Boog Series 18. A. W. Balkema & H. Slager (eds.). Amsterdam & New York: Rodopi.

Rancière, J., 2008. 'Aesthetic Seperation, Aesthetic Community: Scenes from the Aesthetic Regime of Art.' *Art and Research* 2(1, Summer).

Steyerl, H., 2008. 'Politics of the Archive. Translations in film.' *Transversal* (March). Available at: http://eipcp.net/transversal/0608/steyerl/en [Accessed 20 November 2012].

Biographies

Lucy Amez

Lucy Amez works as a research-reporting analyst for the R&D Department of the Vrije Universiteit Brussel (VUB), Brussels, and for ECOOM, the Centre for Research and Development Monitoring. Her research topics encompass bibliometrics, publication policy and research evaluation. On those subjects she has published in leading journals such as *the Journal of the American Society for Information Science and Technology* and *Research Evaluation*. Amez has also authored economic studies on the subject of preference patterns for the arts and performed impact assessments for the creative industry and tourism sector.

Ruth Benschop

Ruth Benschop is Senior Researcher at the Research Centre Autonomy and the Public Sphere in the Arts / Zuyd University in Maastricht. She completed her PhD (with honours) at the University of Groningen in 2001. Her thesis *Unassuming Instruments: How to Trace the Tachistoscope in Experimental Psychology* analyses the role of technology in visual psychological experiments. In this thesis, she develops a 'method of inattention' to create a historical ethnography that is able to detect the role of the ordinary. Later, at Maastricht University, she carried out postdoctoral research into the role of genetics in the workplace, and of recording technology in sound art. She has been involved in a variety of research and educational projects reflecting on artistic practices of research and documentation, and she is interested in ethnography as a site of experimentation and reflection for academics and artists alike. Moreover, she is concerned with the relationship between qualitative research and community art.

Michael Biggs

Michael Biggs is Professor of Aesthetics at the School of Creative Arts at the University of Hertfordshire. He is Visiting Research Professor at Mackenzie Presbyterian University, São Paulo and at the University of Lund and Member of the Board of the National Research School in Architecture, Sweden. He has

extensive experience as a professional artist and academic, and has published widely on research theory in the creative and performing arts.

Henk Borgdorff

Henk Borgdorff is Professor of Research in the Arts at the University of the Arts, The Hague, and was until September 2013 Visiting Professor in Aesthetics at the Faculty of Fine, Applied and Performing Arts at the University of Gothenburg. He is editor of the *Journal for Artistic Research* and has published widely on the theoretical and political rationale of research in the arts. In 2012, a collection of his articles was published as *The Conflict of the Faculties: Perspectives on Artistic Research and Academia* (Leiden University Press).

Daniela Büchler

Daniela Büchler is Senior Research Fellow and project leader at the School of Creative Arts at the University of Hertfordshire; Visiting Research Fellow at Mackenzie Presbyterian University, São Paulo; and Guest Scholar at Lund University. She has degrees and experience as practitioner and researcher in architecture, urban planning and industrial design.

Marcel Cobussen

Marcel Cobussen studied jazz piano at the Conservatory of Rotterdam, and Art and Cultural Studies at Erasmus University, Rotterdam. He currently teaches Music Philosophy and Auditory Culture at Leiden University and the Orpheus Institute in Ghent. Cobussen is author of the book *Thresholds. Rethinking Spirituality Through Music* (Ashgate, 2008), editor of *Resonanties. Verkenningen tussen kunsten en wetenschappen* (Leiden University Press, 2011) and co-author of *Music and Ethics* (Ashgate, 2012) and *Dionysos danst weer. Essays over hedendaagse muziekbeleving* (Kok Agora, 1996). He is editor-in-chief of the open-access online *Journal of Sonic Studies* (www.sonicstudies.org). His PhD dissertation, *Deconstruction in Music* (2002), was presented as an online website, www.deconstruction-in-music.com.

Lucy Cotter

Lucy Cotter trained as an artist and exhibited internationally before turning to writing and curatorial practice. Her PhD dissertation from the University of Amsterdam offered a cultural analysis of curating from the 1950s to the present, drawing on Pierre Bourdieu's sociological view of the art world, postcolonial theory and Gilles Deleuze's notion of minor art. She was co-curator of *Here as the Centre of the World*, a two-year artistic research project in six cities

worldwide (2006-7), and is currently developing a series of new curatorial projects. Cotter has written extensively on contemporary art and guest-edited such journals as *Third Text* and *The HTV*. She is currently editing a book on artistic research, to be published by 17, Institute for Critical Studies, Mexico City, in 2014 and is writing a further book entitled *Art and Non-Knowledge*. Cotter is head of the Master Artistic Research at the University of the Arts, The Hague. See also www.lucycotter.org.

Darla Crispin

Darla Crispin is an Associate Professor in Musicology at the Norwegian Academy of Music (NMH), Oslo. A Canadian pianist and scholar with a Concert Recital Diploma from the Guildhall School of Music & Drama, London, and a PhD in Historical Musicology from King's College, London, she specialises in musical modernity, and especially in the music of the Second Viennese School. Crispin's most recent work examines this repertoire through the prism of artistic research in music. Her publications include a collaborative volume with Kathleen Coessens and Anne Douglas, *The Artistic Turn: A Manifesto* (Leuven, 2009) and numerous book chapters and articles, the most recent of which is 'Allotropes of Advocacy: a model for categorizing persuasiveness in musical performances', co-authored with Jeremy Cox, in *Music & Practice*, Vol. 1 (1) 2013. She is currently working on a book entitled *The Solo Piano Works of the Second Viennese School: Performance, Ethics and Understanding.*

Pol Dehert

Pol Dehert is a theatre and film director. He is a lecturer and researcher in the Performing Arts section of the RITS department of the Erasmus University College, Brussels, where he trains young actors and directors. He has coordinated artistic research projects on David Mamet, on the tragic and the political, on performance and outsider art, amongst others. He is currently finishing a practice-based PhD at the Vrije Universiteit Brussel on John Wilmot. Dehert has acted as artistic director of Arca N.E.T, Ghent, and Noordelijke Theatervoorziening, Groningen, and director and dramaturge at Theater Teater, Mechelen. He has also directed two award-winning art films: *Art Nouveau* and *Oedipe et le Sphinx*.

Mika Elo

Mika Elo is a lecturer in visual culture at Aalto University School of Arts, Design and Architecture, Helsinki, and Associate Professor in Media Aesthetics at University of Lapland, Rovaniemi. His research interests include the theory of photographic media, philosophical media theory, and artistic research. He

participates in discussions in these areas in the capacity of curator, visual artist and researcher. He has published articles in Finnish, German and English, on Benjamin, Nancy, artistic research and photography theory, among other subjects. His doctoral thesis *Valokuvan medium* (*The Medium of Photography*) was published in Finnish in 2005 (*Tutkijaliitto*, Helsinki). In 2009-11 he worked on the *Figures of Touch* research project (figuresoftouch.com). Since 2011 he has been a member of the editorial board of *JAR*. Most recently he co-curated the Finnish exhibition *Falling Trees* at the Venice Biennale 2013.

Andreas Gedin

Andreas Gedin is a Swedish artist who lives in Stockholm. His works combine an interest in ideas, communication, logistics, text and power relations. Often his works interfere with given rules. They can be presented as small actions, videos, text, objects, photography, and Gedin's practice also involves curating and writing. He has made several exhibitions nationally and internationally and is currently participating in Göteborg International Biennial for Contemporary Art, 2013. In 2011 Gedin recieved a PhD in Fine Art at The Faculty of Fine, Applied and Performing Arts, at the University of Gothenburg. His dissertation consisted of several artworks, exhibitions and a book, and artistic and curatorial practices were discussed and performed, mainly in the light of the philosophy of Mikhail Bakhtin. Since 2012, Gedin is part of *Living Archives: Pontus Hultén at Moderna Museet Stockholm and Centre Pompidou* in Paris, 1957-81, a research project at Sodertorn University, Sweden.

Rolf Hughes

A widely-published prose poet, writer, and essayist, Rolf Hughes is today Guest Professor in Design Theory and Practice-Based Research at Konstfack University College of Arts, Crafts and Design (Sweden's largest university for the arts, craft and design), where he teaches professional education courses in artistic research for practitioners across the artistic disciplines. He is also visiting Senior Professor at KU Leuven, Brussels, Belgium, where he has helped create an international, practice-led doctoral programme for architects, artists and designers, on which he has taught and supervised since 2006. From January 2013 he has been employed (50%) at the Swedish National Research Council as scientific advisor and research officer for Artistic Research and Development to strengthen and extend the field through developing the strategic dimensions and international reach of Swedish artistic research. He is Vice-President of the international Society for Artistic Research (2011-2015).

Ella Joseph

Ella Joseph trained in visual and physical performance at the Utrecht School of the Arts (HKU), photography and video art at the School of Art and Design Zurich (HGKZ), and painting at the George Enescu University of Arts. She holds an MA in Scenography from Central Saint Martins College of Art and Design, University of the Arts London, a MFA in Theater Design from the University of British Columbia, and a MSc in Textile Design from the Gheorghe Asachi University of Iasi. In 2004 she founded *ScenoArt*, with the mission to create works that push the boundaries of contemporary arts, where theatre, performance, art installations and fine-art exhibitions cohabit and influence each other, and titled her works and writings series on the process of creation under the collective name *Theatre of Truth(s)*. Consisting of over twenty-five original pieces across time-based genres, her work has been featured in Europe, Canada and the US. Since 2005 she has lived in Buffalo, New York.

Siobhan Murphy

Siobhan Murphy is a dance artist and academic based in Melbourne. Her dance career began with the Deutsche Oper Ballet in Berlin in 1992. She completed a Bachelor of Arts in Philosophy and Spanish at the University of New South Wales in 2000 while beginning her independent choreographic practice. In 2008 she completed a practice-led PhD in Choreography at the University of Melbourne. Her live performance works are small-scale, intimate events, often taking place in unusual venues. Increasingly her practice focuses on dance screen works for single-channel and installation presentations. As a teacher, her principle focus is on the use of writing as a complimentary and illuminating modality for researchers in performance.

Brita Lemmens

Brita Lemmens was born in Zeist, and grew up in a Portuguese/Dutch household. During her bachelor studies in Arts and Culture at the Faculty of Arts and Social Sciences of Maastricht University, she undertook her thesis research as an intern at the Instituto de Etnomusicologia (INET-md) at Universidad Nova de Lisboa, Lisbon. The focus of her research was the learning process in fado singing, which she studied through artistic research. She published the results of her research project as an exposition in the Artistic Research Catalogue and as a contribution to the *Journal for Artistic Research* (*JAR2*). Within the broader field of cultural studies, Lemmens focuses on researching singing techniques in various cultural contexts. Currently she is living in Ecuador where she is studying the indigenous South American language Kichwa and researching indigenous singing techniques.

Peter Peters

Peter Peters studied sociology in Groningen, the Netherlands. He is Senior Lecturer at the Department of Philosophy of the Faculty of Arts and Social Sciences at Maastricht University. Currently, he is teaching in the Arts & Sciences Bachelor and Masters programme and in the Bachelor European Studies programme of the Faculty. Publications include *Eeuwige Jeugd: Een halve eeuw Stichting Gaudeamus* (Donemus, 1995), a history of post-war contemporary music in the Netherlands, and *Time, Innovation and Mobilities* (Routledge, 2006), in which he combines insights from social theory and science and technology studies in order to analyse cultures of travel. In 2008 he was appointed Professor in the research centre Autonomy and the Public Sphere in the Arts at the arts faculties of Zuyd University, Maastricht. In his inaugural address 'Grensverkeer: Over praktijkonderzoek voor de kunsten' (2009), he critically considered the discourse on artistic research. His research topics are artistic research and its relation to the broader field of science and technology studies, site-specific art as context for engaged research, and art in relation to mobile worlds.

Hans Roels

Hans Roels is a PhD researcher in the School of Arts, University College Ghent (www.schoolofartsgent.be), where he teaches live electronic music. Since 2010 he has also worked as a researcher in the Orpheus Research Centre in Music (ORCiM) (www.orpheusinstituut.be). Roels studied piano and composition and during the fifteen years that he was active as a professional composer his works were played in several European countries by ensembles such as Champ d'Action, Spectra ensemble, the electric guitar quartet Zwerm and Trio Scordatura. Between 2001 and 2008 he was responsible for the concert programming in the Logos Foundation, a centre for experimental audio arts (www.logosfoundation.org). See also: www.hansroels.be.

Michael Schwab

Michael Schwab is a London-based artist and artistic researcher who investigates postconceptual uses of technology in a variety of media, including photography, drawing, printmaking and installation art. He is a tutor at the Royal College of Art, London, and the Zürich University of the Arts, as well as research fellow at the Orpheus Institute, Ghent. He is co-initiator and editor-in-chief of *JAR, Journal for Artistic Research*. Educated in both philosophy (Hamburg University) and art (Royal College of Art, London), he focuses on the methodologies and epistemologies of artistic research. Concentrating on experimentation and the exposition of practice as research, he has developed

a conceptual approach that links artistic autonomy with academic criticality in support of what has been called the 'practice turn in contemporary theory'. Together with Florian Dombois, Ute Meta Bauer and Claudia Mareis, he co-edited *Intellectual Birdhouse: Artistic Practice as Research* (Koenig Books, 2012). He is the editor of *Experimental Systems: Future Knowledge in Artistic Research* (Leuven University Press, 2013).

Henk Slager

Henk Slager is Dean of MaHKU (Utrecht Graduate School of Visual Art and Design) and Visiting Professor of Artistic Research (Finnish Academy of Fine Arts, Helsinki). He was curator of the exhibitions *a.o. Flash Cube* (Leeum, Seoul, 2007), *Translocalmotion* (7th Shanghai Biennale, 2008), *Nameless Science* (Apex Art, New York, 2009), *Critique of Archival Reason* (RHA, Dublin, 2010), *As the Academy Turns* (Collaborative project, Manifesta, 2010), *Any-medium-whatever* (Georgian Pavilion, Venice Biennale, 2011) *Offside Effect* (1st Tbilisi Triennial, 2012), *Temporary Autonomous Research* (Amsterdam Pavilion, Shanghai Biennale, 2012), *The Judgment is the Mirror* (Living Art Museum, Reykjavik, 2013) and *Joyful Wisdom* (Parallel Event, Istanbul Biennale, 2013). Recent publications include: 'Differential Iconography', in Henrik Karlsson and Michael Biggs, *The Routledge Companion to Research in the Arts*, New York/London, 2010; *Agonistic Academies* (ed. with Jan Cools), Sint Lukas Academy Books, Brussels, 2011; *Context Responsive Investigations*, in *Intellectual Birdhouse, Artistic Practice as Research* (eds. Ute Meta Bauer, Claudia Mareis, Michael Schwab and Florian Dombois), Walther Koenig, Cologne/London 2011; *The Pleasure of Research*, Finnish Academy of Fine Art, Helsinki, 2012; and *Doing Research* (Documenta, 2012).

Karel Vanhaesebrouck

Karel Vanhaesebrouck is a Professor of the History and Theory of Performance at the Université Libre de Bruxelles, Brussels, where he holds the chair in Theatre Studies. Before taking up that post he was an Assistant Professor in Cultural Studies at Maastricht University. He also lectures in cultural history and theatre history at the RITS department of the Erasmus University College, Brussels, where he coordinates the performing-arts section. He published *Le mythe de l'authenticité. Lectures, dramaturgies, représentations de Britannicus en France* (2009) and edited, together with Ruben De Roo and Lieven De Cauter, the widely discussed volume *Art and Activism in the Age of Globalization* (2011). His research has been published in *Poetics Today, Textyles, Phrasis, Théâtre / Public, Acta Fabula, Image & Narrative, Critique, Journal for Early Modern Cultural Studies, Etudes Théâtrales* amongst others. He occasionally works as a dramaturge for various artists and/or companies.

Binke van Kerckhoven

Binke van Kerckhoven studied at the KU Leuven, where she obtained a Masters in Communication Sciences. She worked as a scientific collaborator at the HIVA institute of the KU Leuven and as IT analyst for the UiTdatabank: a digital platform for cultural events in Flanders, hosted by CultuurNet Vlaanderen. Since 2010 she has been a researcher at the Vrije Universiteit Brussel, Brussels, where she works on a project covering IT (digitisation, CRIS) for research in the arts. She was also involved in the development of the Research Catalogue.

Walter Ysebaert

Walter Ysebaert works at the Vrije Universiteit Brussel, Brussels, as a historian (History Department) and as the head of the Research Unit Data and Policy (R&D Department). He is also affiliated with ECOOM, the Centre for Research & Development Monitoring, where he coordinates the research project with regard to the development of output and impact parameters and a database for Research in the Arts in Flanders. Ysebaert was formerly postdoctoral fellow of the National Research Foundation Flanders, lecturer at the Arteveldehogeschool Gent, and policy advisor at the Cabinet of the Flemish Minister of Science Policy and Innovation.

Index

Polanyi, Michael 59, 68

politics 25, 42, 45, 112, 113, 116, 141, 180, 212, 213, 215, 216, 244

Popper, Karl 41, 84

Postmedieval (journal) 127

postmodernism 54, 151, 179, 180, 213, 215, 217, 218

postproduction 239

post-publication data 122

power 73, 161, 194, 217, 237-40

practice as research, *see* art practice as research

practice-led research 58, 120, 178

presentation 10, 13, 25, 26, 29, 34, 37, 48, 49, 54, 57, 62, 70, 75, 80, 92, 97, 100, 103, 111, 115, 122, 123, 128, 132, 146, 148, 150, 151, 162, 194, 212, 214, 216, 218, 241, 244

process, *see* research process

publishing, *see* artistic research: publication of

Programme for Art-based Research (PEEK) 12

Putnam, Hilary 14 n. 14

quality control 126

Quantum Activist, The (Slade and Stewart) 167-68

Rabelais, François 200-202, 203 n. 12

Rancière, Jacques 17 n. 16, 67, 70, 72-74, 76, 240

Aesthetic Unconscious, The 72, 73

rationality 15, 26, 34, 73

Rauschenberg, Robert 227

Linoleum 227

re-doubling 15, 16

reflective doubling 96

referenceability 128

reflection-in-action 65

reflective practice 59

reflexivity 15, 54, 55, 178, 183, 186

Reger, Max 65

relationality 42, 43

repositories 94-98, 103, 119-22, 127-32

representation 39-41, 46, 47, 50, 55, 58, 60, 67, 70, 74, 93, 112, 116, 121-25, 142, 149, 150, 197, 216, 218, 226, 227, 235, 238, 241, 243

Research Assessment Exercise (RAE) 79, 82, 83, 85-88, 90

Research Catalogue (RC) 46, 49, 50, 59 n. 8, 79, 80, 92-103, 105-17, 120, 121, 123-32, 146, 148-52, *see also* Artistic Research Catalogue (ARC); expositions (online objects on the Research Catalogue)

Research Excellence Framework (REF) 14

research management 118

research process 10, 49, 61, 68, 75, 95, 114, 115, 151, 153, 155, 157-59, 162, 163, 193, 212, 214, 216-18

resistance 13, 194

reviewing 62, 85, 89, 126, 127, 132, 162, *see also* peer review

Reynolds, Roger 160

Rheinberger, Hans-Jörg 17 n. 16, 37 n. 13, 149

Toward a History of Epistemic Things 149 n. 5

rhetoric 24, 42, 53, 54, 62, 113, 137, 153, 159, 237, 239, 240

Richardson, Laurel 178

rich descriptions 186

rich internet publications (RIP), *see* digital publishing: rich internet publications (RIP)

Richter, Hans 225, 226

Rhythm 21 225, 226, 231

Ricoeur, Paul 196

Rijnders, Gerardjan 213

Robaard, Joke 113, 114

Robbe-Grillet, Alain 232, 234

Jealousy 232, 233

Rochester, John Wilmot, 2nd Earl of 212-16, 218